The Glamour of Italian Fashion Since 1945

This book is published to coincide with the exhibition
The Glamour of Italian Fashion 1945–2014
Sponsored by

BVLGARI

With support from

NESPRESSO.

With thanks to the
Blavatnik Family Foundation

First published by V&A Publishing, 2014
Victoria and Albert Museum
South Kensington
London SW7 2RL
www.vandapublishing.com

HB ISBN 978 1 85177 776 1
PB ISBN 978 1 85177 817 1

10 9 8 7 6 5 4 3 2 1
2018 2017 2016 2015 2014

Front jacket illustration: Advertisement for the Gianfranco Ferré
ready-to-wear collection, Autumn/Winter 1991 (see p.148)
Back jacket illustration: Brunetta Mateldi, advertisement for
Roberto Capucci's Autumn/Winter 1956 collection (see p.56)

Designer: Charlie Smith Design
Copy-editor: Alex Stetter
Index: Hilary Bird

New photography by Jaron James, V&A Photography Studio

Printed in Italy

V&A Publishing
Supporting the world's leading
museum of art and design,
the Victoria and Albert
Museum, London

The Glamour of Italian Fashion Since 1945

Edited by Sonnet Stanfill
V&A Publishing

Sponsor's Foreword – 7
Introduction Sonnet Stanfill – 8

1

Italy's Fashion Identity

Great Dressmakers of Italian Fashion Sofia Gnoli — 32
**Reorienting Fashion: Italy's Wayfinding
after the Second World War** Vittoria Caterina Caratozzolo — 46
The Italian Fashion Revolution in Milan Simona Segre Reinach — 58

2

Materials of Fashion

Textiles: The Foundation of Italian Couture Margherita Rosina — 76
Craft and 'Made in Italy' Catharine Rossi — 94
Prato: Between Tradition and the Future Filippo Guarini and Laura Fiesoli — 104

— **Knitwear** Elizabeth Currie — 115
— **Fur** Oriole Cullen — 121
— **Leather** Helen Persson — 129

3

Fashion and Image

Portrait/Self-portrait: The Image of Fashion Maria Luisa Frisa — 136
Italian Fashion Designers in Hollywood Stella Bruzzi — 162

— **Anna Piaggi** Judith Clark — 171
— **Paolo Roversi: An Interview** Sonnet Stanfill — 175

4
Italian Menswear

The Return of the Courtier: Men and Menswear *Christopher Breward — 180*
'In the Things That Go Over Other Things' *Alistair O'Neill — 194*
From Tennis Court to Football Terrace:
Italian Sportswear and British Male style *Jonathan Faiers — 208*

— *Tailoring and Craft* Glenn Adamson — 217
— *The Man in the Street* Gianluca Longo — 221

5.
The Fashion Business

The Business of Fashion *Emanuela Scarpellini — 226*
Communication in the Fashion System *Elena Puccinelli — 240*

— La Moda in *Vogue* Lucia Savi — 249
— Nattier: Textile Innovators *Margherita Rosina and Lucia Savi — 255*
— The Sozzani Sisters *Oriole Cullen — 261*

Notes — *266*
Biographies — *274*
Bibliography — *279*
Acknowledgements — *282*
Picture Credits — *283*
Index — *284*

Sponsor's Foreword

At Bulgari, we feel a special affinity for the story of *The Glamour of Italian Fashion*, which brings to light the rise of Italian style over the past 60 years, from the ravages of the Second World War to the sophistication and abundance of fashion today. This exhibition renders this story with sparkling clarity and reminds us that it is a story we have all, in some way, shared.

The creativity of Bulgari design following the war was deeply intertwined with emerging trends in art and fashion. From the colour revolution of the 1950s and '60s to the daring innovations of the 1970s through the opulent '80s until today, Bulgari has strongly influenced the modern history of jewellery. The flourishing Dolce Vita years, when Rome became 'Hollywood on the Tiber' and countless international movie stars started a love affair with Bulgari, will remain forever engraved in my memory. The charismatic couple Richard Burton and Elizabeth Taylor, the ethereal Audrey Hepburn and the elegant Grace Kelly and Ingrid Bergman are just some of the movie stars who visited the via Condotti store to purchase Bulgari creations as precious treasures from the Eternal City.

It is Bulgari's privilege to be the lead sponsor of the first major exhibition that traces the sweep, imagery and substance of 'Made in Italy' style, prestige and craftsmanship. In viewing *The Glamour of Italian Fashion*, we are possessed by the truth that beauty will always enrich people's lives. We hope it brings the spirit of Italian glamour to you.

Nicola Bulgari

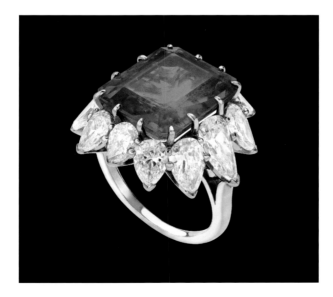

BVLGARI

Introduction

Sonnet Stanfill

The fashion world is always eager for the fresh, exciting originals that Italy offers today. This demand has led to the rise of a new group of Italian designers, heretofore known only to those Italian aristocracy and fashion-wise foreigners visiting Europe.[1]

— *Giovianni Battista Giorgini*

1 Fausto Puglisi, Autumn/Winter 2013

The subject of this book is fashion made in Italy from 1945 to the present day. The chapters that follow chronicle a period during which Italian-made clothing first gained currency and then became a signifier of fashionable taste. The project suggests the broad parameters that have defined Italian fashion from post-war poverty to modern-day abundance. The country's fashion production has been varied; chief among its strengths have been couture and its associated textile industry, fine tailoring, artisanal leather production and designer ready-to-wear.

While Italy has experienced tremendous creative growth since 1945, it has also experienced social, political and economic disorder. At the end of the Second World War, Italy's conception of itself as a nation was in flux. Fascism's nationalist ideology had aimed to unite the nation around a common party and leader, masking in part the country's history as a series of independent states with diverse regional traditions, languages and cultures. However, in the post-war period, with Fascism a source of deep national unease, a unified definition of nationhood was elusive, resulting in the marked return of Italian regionalism and an accompanying proliferation of semi-autonomous regional governments.[2] With the signing of the Paris Peace Treaties of 1947,

Italy lost the territories it had gained through its project of colonization, a policy which began in the late nineteenth century and extended into the 1940s. Further, the 1947 treaty forced Italy to accept the redefinition of its borders, ceding territories to Albania, Greece and Yugoslavia.[3] Although Italy's 1946 referendum established the Italian Republic as a parliamentary democracy, this did not ensure stability.

At war's end, Italy might have seemed an unlikely future source of leading fashion. Its population remained poor, literacy rates hovered just below 50 per cent and millions of its citizens worked as agricultural labourers.[4] The country's economy, like those of other European nations, was in disarray, suffering from a $500 million trade and payment deficit.[5] During the war, uniformity and self-sufficiency in production were valued over creativity. The country's national fashion authority, the *Ente Nazionale della Moda*, had attempted to regulate Italian fashion and textile manufacture and promote its independence from Paris.[6] As fashion historian Eugenia Paulicelli has noted, the fascist regime viewed the regulation of fashion as part of its effort to create a sense of nationhood.[7] From 1936, the government awarded a 'mark of guarantee' label to obedient producers who adhered to wartime restrictions and conveyed a sense of 'Italianness' in

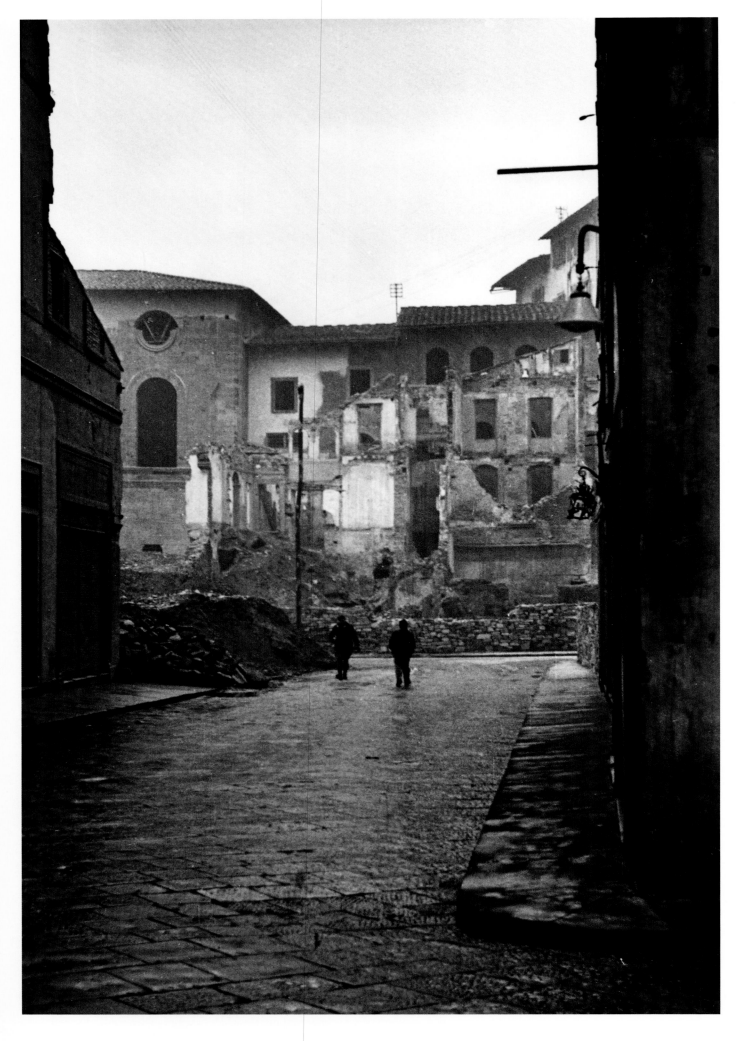

Introduction

2 A view of Florence bombed during the Second World War, February 1946

3 View on to the terrace of a café, Rome. Photograph by Henri Cartier-Bresson, 1953
V&A: PH.606–1978

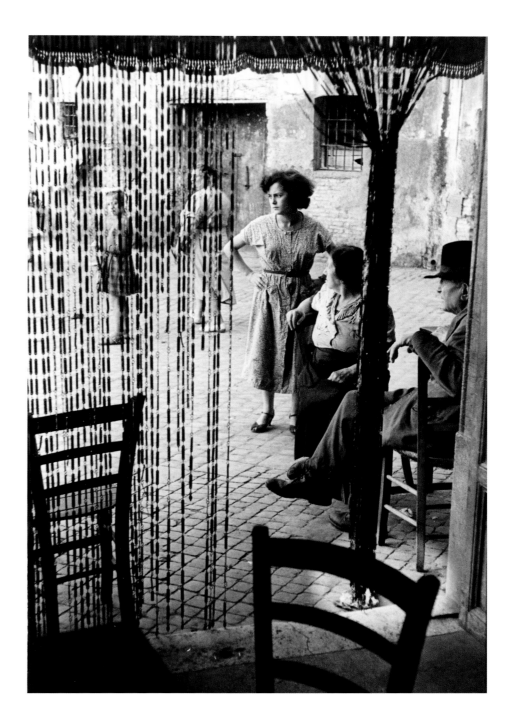

4 Mark of Guarantee from Tortonese day suit, *c.*1939

Opposite above
5 Matilde Giorgini and Henry Morgan at Giorgini's first Florence fashion show, Villa Torrigiani, Florence, February 1951

Opposite below
6 Influential Americans at the first Florence fashion show: Julia Trissel of Bergdorf Goodman, Gertrude Ziminsky of B. Altman and fashion manufacturer Hannah Troy, Villa Torrigiani, Florence, February 1951

their designs (pl.4). From 1941, a *marca d'oro* or 'mark of gold' was given to those who were particularly adept. As Sofia Gnoli has written, these efforts were only marginally successful, for few of these marks were actually awarded.[8] Further, among Italian couturiers and dressmakers the established practice of copying Paris lines and frequently purchasing the *toiles* or patterns needed to faithfully re-create the French originals continued.

After the war, the Italian and American governments worked in concert to repair Italy's reputation and establish the country as an American ally and trading partner. Italy's fashion industry was an integral part of this focused effort. Though the Italian economy was weak, it grew steadily as European market liberalization brought goods and capital to a wider group of consumers. The rapidly changing economy brought waves of migration, mainly from rural areas to the industrial north; at least nine million Italians transplanted their households between the mid-1950s and the mid-1960s in search of employment and other opportunities.[9] Between 1950 and 1973, the period of Italy's 'economic miracle', the Italian economy experienced an average rate of growth of between 5 and 5.8 per cent per year, well above the European average.[10] In the words of historian Emanuela Scarpellini, 'In the Italy of the economic miracle the time had come to "buy" happiness.'[11] The initial post-war success of Italy's fashion industry and its related textile production owed much to governmental cooperation and Marshall Plan aid.[12] Surviving documents show that the two governments valued fashion as both an economic and diplomatic rehabilitator. A 1951 memorandum issued by the Commercial Office of the Italian Consulate asserted: 'Various circumstances advise us to establish without delay a programme of rapid execution intended to give Italian fashion a foothold in the United States.'[13]

A turning point in this cooperative effort arrived in the form of a fashion show. In the autumn of 1950 Florentine buying agent Giovanni Battista Giorgini

launched Italy's first internationally significant fashion event. Giorgini's initial intention was to present a collection of Italian couture to accompany the exhibition 'Italy at Work', which opened in November 1950 at the Brooklyn Museum and then toured the United States for three years. This exhibition was an important event in the American design world, a complex undertaking that saw more than 2,500 objects travel to Brooklyn and then go on tour. The project encouraged numerous American magazines to begin chronicling Italian production. Design historian Rosalind Pepall notes that Americans were impressed by 'the Italian love of decoration and colour, the adventurous breaking of old rules and codes of design and above all, the distinctiveness Italians brought to industrial design in the face of uniform mass production'.[14]

On the subject of a corresponding fashion show, Charles Nagel, the Brooklyn Museum's director, wrote to Giorgini with his support, calling it 'a splendid idea'.[15] While this project had to be shelved when hoped-for sponsorship from New York's B. Altman department store did not materialize, it sparked Giorgini's imagination.

A few months later, he announced plans for several days of showings of collections by notable Italian fashion designers, to be held the following February at his home in Florence, on via dei Serragli. Using his pre-war connections with North American department stores, Giorgini garnered an audience that was small but deeply influential: New York's Bergdorf Goodman sent buyers Julia Trissel and Ethel Frankau and B. Altman sent Gertrude Ziminsky (pl.6); I. Magnin of San Francisco sent buyer Stella Hanonia; Henry Morgan & Co of Montreal sent John Nixon. The guests saw high fashion by Carosa, Fabiani, Sorelle Fontana, Marucelli, Noberasco, Schuberth, Simonetta, Veneziani and Vanna. They saw boutique fashions by Mirsa, Pucci and Tessitrice dell'Isola. The elegance of the clothing presented at the show was in stark contrast to the wartime rubble still marking Florence's cityscape. Six years after the end of the war, much of Italy's own populace could still only dream of affording the vision of luxury paraded in this fashion show. Thus Giorgini's sights were firmly set on the vast and comparatively wealthy American market.

The American buyers and press responded warmly. B. Altman wrote to Giorgini immediately after the February 1951 show: 'This morning Miss Ziminski returned from her trip full of enthusiasm about the Italian collections. We trust that you will get the things she has bought off by air with all possible effort, particularly the beachwear.'[16] Word of the event quickly spread. Bettina Ballard, well-known fashion editor of American *Vogue*, wrote to Giorgini in March 1951 to express her regrets at not having attended. 'I had very good reports of your show,' she wrote. 'Everyone seems very interested in Italy. *Vogue* is too and I'm sure we can do something in the near future.'[17] This early enthusiasm gathered momentum. Giorgini's second show, held in July 1951, this time at

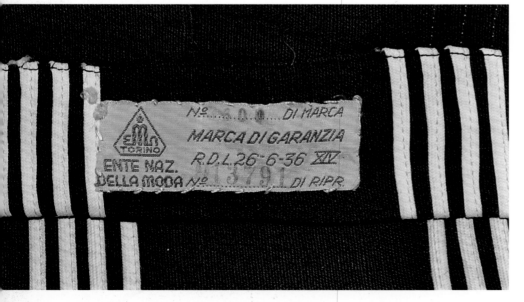

Introduction

7 Gowns on the catwalk at
the Grand Hotel, Florence,
18 January 1952

Opposite
8 Maria Grimaldi, satin evening
dress (detail), 1950s
V&A: T.120A–1978

9 Maria Grimaldi, gabardine jacket
(detail), 1950s
V&A: T.122A–1978

10 Maria Grimaldi, skirt interior
with maker's mark (detail), 1950s
V&A: T.123B–1978

Florence's Grand Hotel, was an even greater success. Buyers from New York and San Francisco were joined by those from Chicago, Dallas, New Orleans, Philadelphia, Montreal, Zurich and Johannesburg. With collections shown over three days by Italy's prominent high-fashion houses, the event exceeded expectations.[18] These showings met with some criticism from Paris, where fashion designers expressed general disdain for their new competitors. 'Let the Americans play around with baby bonnets in Italy,' Parisian couturier Pierre Balmain declared, 'they'll come to us for their serious buying.'[19]

Despite such sniping, Giorgini's early presentations were generally praised by both fashion buyers and the press for promoting a viable and less expensive alternative to Paris fashions.[20] 'Had we known what the Paris collections were going to show and what the Paris prices were going to be,' Hector Escabosa, the director of I. Magnin, wrote to Giorgini in August, 1951, 'we would have bought a lot more in Florence'.[21] By the 1952 presentations, Giorgini had negotiated use of the opulent, chandelier-lit *Sala Bianca* (or white hall) in the historic Palazzo Pitti, where he would continue to organize fashion shows until his retirement in 1965. One year after Giorgini's first catwalk presentation, Italian fashion had secured its place on the international stage. In his pursuit of the American market, Giorgini enticed its representatives not only with fashion presentations but also with grand balls, performances and suppers planned over the same period. Intent on impressing his foreign guests, Giorgini made sure that numerous Italian aristocrats were in attendance. By entertaining jaded buyers and journalists, Giorgini ensured continuing goodwill and press coverage like that of *Los Angeles Times* fashion critic Fay Hammond, who wrote in August 1952 of the ball held in the Boboli Gardens in July of that year:

> *Looking back on a summer in Europe . . . the Boboli Ball seems even less real now than it did on that magic night in Italy when the international fashion press, buyers from all parts of the world and Florentine society mingled in the moonlight in the gardens of the Pitti Palace.*[22]

In summary, Hammond proclaimed, 'No royal entertainment had surpassed this unforgettable scene.' By 1955, within four years of Giorgini's first event, the number of attendees at the *Sala Bianca* had swelled to 500 buyers and 200 press representatives, who came from around the world to view over 1,300 models of Italian high fashion.[23]

The legend of Florence's *Sala Bianca* as the birthplace of Italian fashion is so well established that it has nearly eclipsed all other narratives. But as Sofia Gnoli's chapter, 'Great Dressmakers of Italian Fashion', shows, Italy's post-war fashion landscape was more complex. Gnoli reminds us that fine production within Italian high-fashion houses began well before the Second World War. Further, Florence did not retain its monopoly over the presentation of collections and would continue to struggle with the

11 Federico Forquet sketch, Autumn/Winter 1964

Opposite
12 Paulette Goddard at the Salvatore Ferragamo boutique, Florence, 1954

13 Audrey Hepburn trying on shoes with Salvatore Ferragamo, at his boutique, Florence, 1954

intransigence of the Roman couture houses, which sought and then secured an independent fashion show schedule of their own. Certainly, the media sensation of the *Sala Bianca* fashion shows overshadowed the traditional *sartoria* or dressmaker, the main source of quality fashionable garments for well-to-do Italian women in the decades preceding and immediately following the war. A small, local *sartoria*, by virtue of its regional location and limited clientele, may not have held the status of a Milanese or Roman couture house, but nonetheless usually had highly skilled staff and a loyal following. Such patronage is exemplified by the wardrobe of Margaret Abegg, wife of the Turin textile magnate and art collector Werner Abegg. Mrs Abegg frequented Turin dressmaker Maria Grimaldi (pls 8–10) for her meticulously constructed suits and evening gowns.[24] Abegg wrote of her tasteful wardrobe that it was 'considered by some to be rather exceptional not only in New York, but when worn in Paris'.[25]

A crucial contributor to the Italian fashion industry's evolution from a series of local dressmakers to international tastemaker was the American market that Giorgini had so assiduously pursued. By the late 1950s American women increasingly favoured 'wearable' clothes that allowed for the ease of care and movement required by active lives. Vittoria Caterina Caratozzolo's chapter, 'Reorienting Fashion: Italy's Wayfinding after the Second World War' describes the Italian response: the so-called 'boutique' designs, defined as high-quality ready-to-wear fashions produced in modest quantities. This new type of fashionable, well-made, factory-produced clothing answered the American demand for stylish practicality. 'Boutique merchandise, including coats, suits, dresses, skirts and sweaters were big favourites of United States retailers,' *Women's Wear Daily* reported in 1956.[26] The *Chicago Daily Tribune* concurred: 'Season after season,

the real strength of Italian fashion is confronted in the sports and casual wear market. The great number of export sales are made in this field, where inspiration comes from Italy's sunny atmosphere.'[27] After the war, America's large stocks of raw cotton entered Italy's textile market. The resulting modish cotton beachwear and sports clothing created by designers such as Emilio Pucci graced the beaches that in peacetime once more became a locus of fashion display. According to *The New York Times* in 1955, 'The Italian flair for making feminine, functional sportswear of gracefully handled materials in subtle color combinations brought applause from foreign buyers.'[28]

The American influence on the fortunes of Italian fashion continued throughout the 1950s and '60s, furthered by the numerous American films shot on location in Italy. Images of Hollywood stars on and off set in Rome, and their shopping trips to Florence and holidays on the Amalfi coast, became the common currency of gossip columns and fashion magazines. Such press coverage brought accidental but welcome publicity to the Italian designers favoured by the Hollywood glitterati. A generation of Italian fashion designers benefited from the ambient glow of this media spotlight (pls 12–15). In 1966, Milanese designer Mila Schön dressed two high-profile clients for Truman Capote's Black and White Ball: one was Marella Agnelli, wife of the chairman of Fiat. The other was Princess Stanislas Radziwill (pl.16), sister of American First Lady Jacqueline Kennedy. For Lee Radziwill, who usually favoured French haute couture, to choose an Italian to dress her for what author and attendee Gloria Steinem called 'The Party of the Year – possibly of Several Years', was significant.[29] The sinuous sequinned pattern of Radziwill's gown reveals Mila Schön's geometric facility, while the accompanying quilted coat demonstrates her austerity of cut (pl.18).

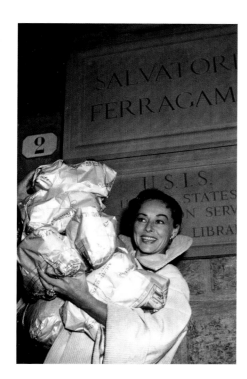

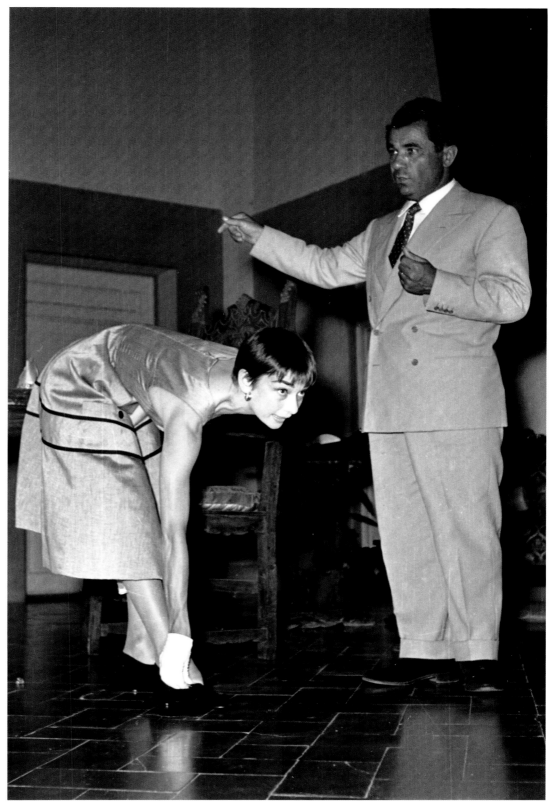

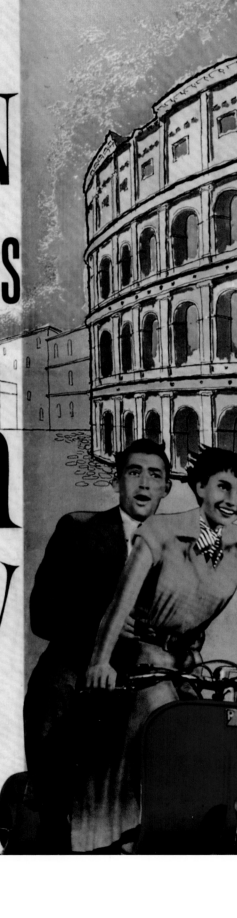

PARAMOUNT PRESENTS

gregory PECK

audrey HEPBURN

IN

WILLIAM WYLER'S

PRODUCTION OF

Roman Holiday

WITH EDDIE ALBERT

SCREENPLAY BY
IAN McLELLAN HUNTER AND JOHN DIGHTON
STORY BY IAN McLELLAN HUNTER
PRODUCED AND DIRECTED BY WILLIAM WYLER

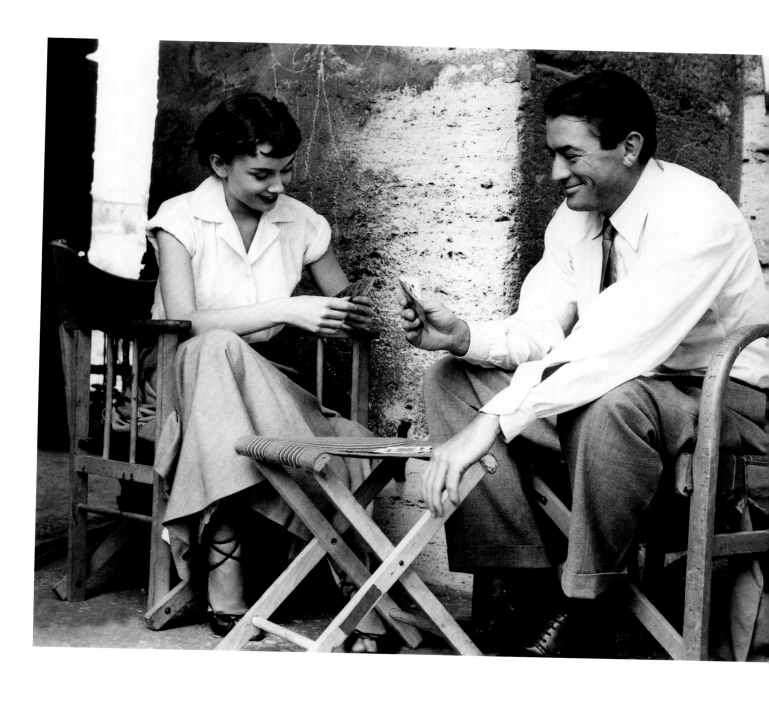

14 Poster for the film *Roman Holiday*, 1953

15 Audrey Hepburn and Gregory Peck playing cards off set during the filming of *Roman Holiday*, 1953

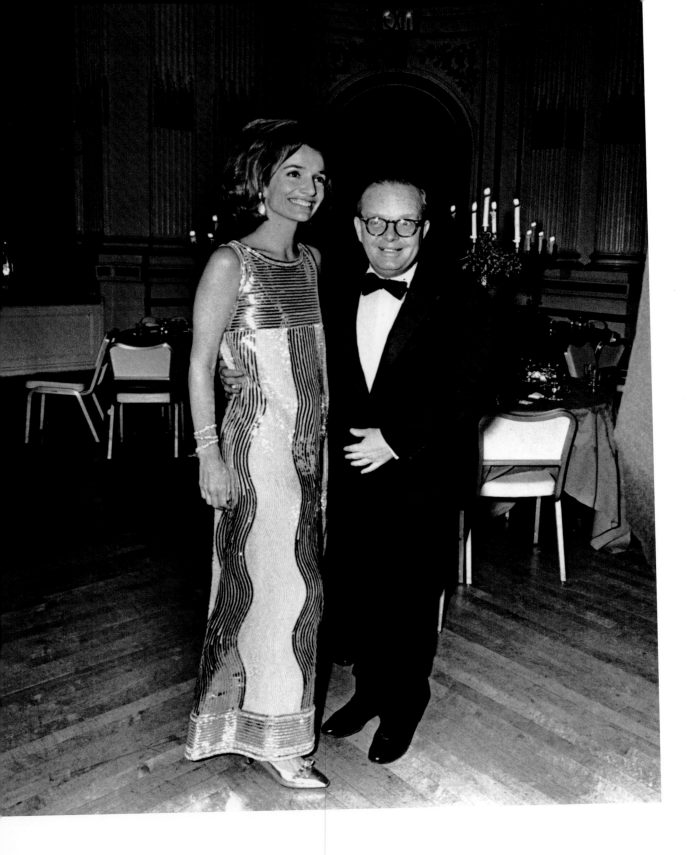

16 Lee Radziwill and Truman Capote in the Plaza Hotel's Grand Ballroom during Capote's Black and White Ball, November 1966

Opposite

17 Black and White Ball, American *Vogue*, January 1967

18 Mila Schön, silver sequinned evening dress with quilted white silk coat, 1966
V&A: T.400&A–1974

Introduction

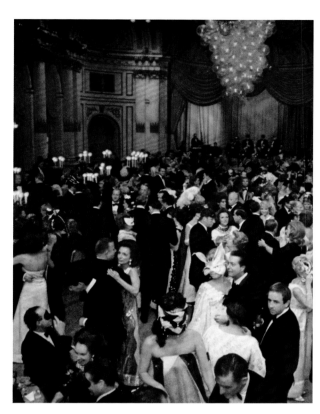

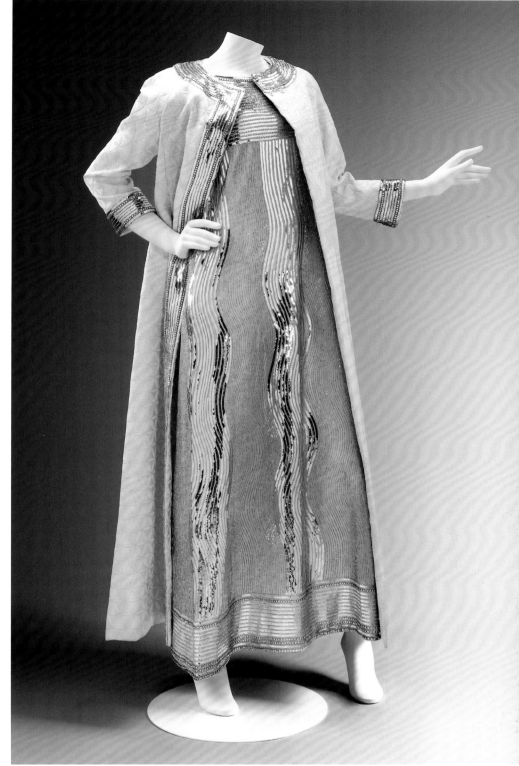

Schön, who founded her enterprise in 1956, first showed on the *Sala Bianca* catwalk in 1965, three years after newcomer Federico Forquet (pl.11) first showed there. These debuts were among the last of note at this venue. By the mid-1960s, Italian fashion's geography had changed. In contrast to France, Britain and the United States, which in the post-war period claimed Paris, London and New York as their respective fashion centres, Italy's cities had long vied with each other for prominence. Florence and Rome each proclaimed themselves Italy's premier fashion city and Turin once boasted of its status as the country's wartime fashion capital. But designer defections from Florence's *Sala Bianca* to Rome and even to Paris began as early as 1952. As Simona Segre Reinach's chapter 'The Italian Fashion Revolution in Milan' indicates, Italian fashion's geography shifted still further. From the early 1970s, as the fashion cognoscenti embraced designer ready-to-wear as a new fashion language, Milan took centre stage. The city's role as the epicentre of Italy's fashion press and advertising industry, combined with its proximity to some of the world's most inventive textile production, would ultimately give Milan undisputed prominence.

The period when the fashion industry's centre of gravity was shifting to Milan coincided with disruptive changes in Italian society. The Europe-wide student protests of 1968 began in Italy as a reaction against fee increases and planned restricted entry to university education. Throughout the year, the universities of Milan, Turin and Trento, soon followed by those of the provinces, were occupied by students. More violent and longer lasting was the widespread terrorism of Italy's so-called *anni di piombo*, or years of lead. From the late 1960s into the early 1980s political violence, which included bombings, assassinations and street warfare, claimed thousands of lives. The violence of these years was accompanied by periods of high unemployment, frequent changes in government and related mass strikes.

These disruptions made up the tumultuous backdrop against which Italy's fashion industry and related textile production blossomed. The parallel success of these two Italian sectors over the second half of the twentieth century is charted in Margherita Rosina's chapter, 'Textiles: The Foundation of Italian Couture'. During this period, Italy's factories produced some of the best textiles on the market, vying with Lyon for pre-eminence. Writing as early as 1953 about the Italian collections, fashion editor Carmel Snow asked: 'Why do buyers and private customers flock to Italy? The prosaic fact is that Italian fabrics are of the most tempting quality.'[30] Como's silk producers excelled at creating specialist prints and innovative techniques, and Biella's wool was equally celebrated. By the 1970s and '80s, Italian textile manufacturers continued to work directly with fashion designers to craft bespoke weaves and finishes. An example is textile firm Etro, which collaborated with many fashion designers, including Pino Lancetti and Walter Albini, to create textiles for their collections.[31]

Albini was the prototype of a new breed of designer that emerged in the 1970s, the figure of *lo stilista*. The Italian word *stilista* is more nuanced and multifunctional than either the English translations 'designer' or 'stylist' suggest. It came to refer to someone who mediated between the practicalities of industry, the requirements of retail buyers and the

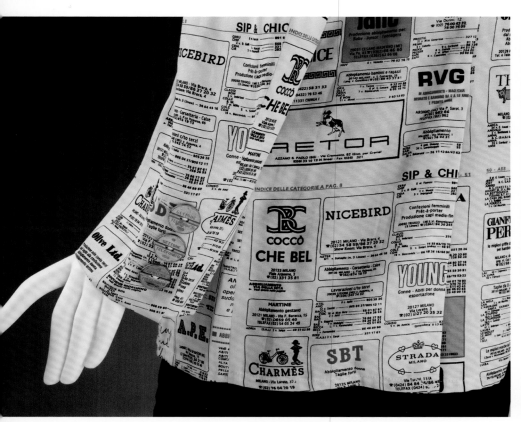

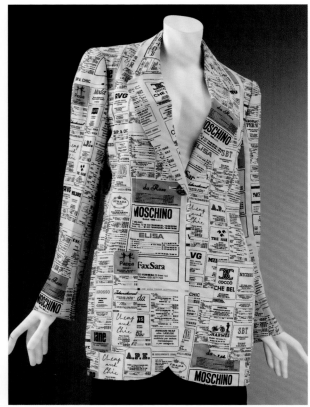

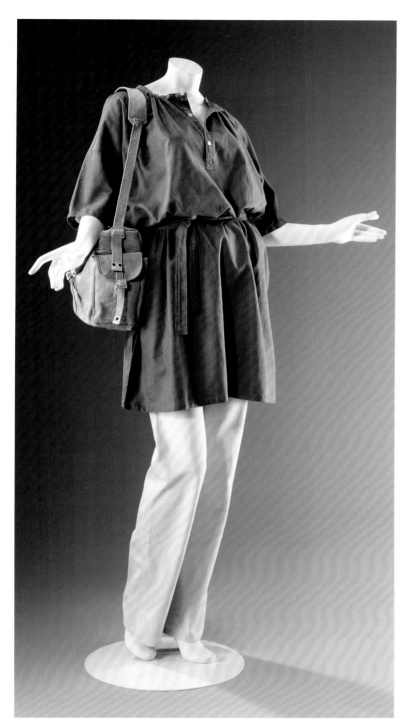

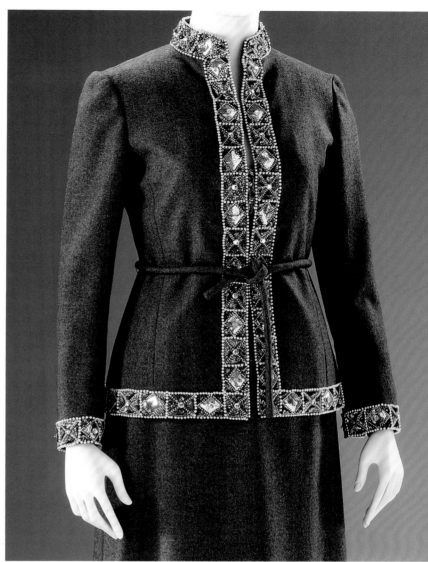

23

needs of the public, while also being aware of the
importance of the press. Like Albini, retailer-cum-
designer Elio Fiorucci was also an innovator in his field
(pls 21 and 23). Influenced by the boutique culture of
Swinging London, Fiorucci opened stores around the
world that attracted a party atmosphere and celebrity
clients, and where he sold jeans, T-shirts and other
informal wear. Modernizers like Fiorucci and Albini
were instrumental in moving elite consumers towards
a novel category of fashion: designer ready-to-wear.

A fashion designer who also profited from this
new enthusiasm for ready-to-wear with a designer
label was Gianni Versace. Like Albini, Versace sought
out specific textiles for his collections. He sourced
the houndstooth fabric for his Autumn/Winter 1983
collection from Prato wool specialist Faliero Sarti &
Figli. The company's founder Roberto Sarti recalls
Versace rejecting their standard colours and requesting
a black-and-white version instead (pl.24).[32] The
resulting daywear ensemble typifies the 1980s penchant
for contrast and juxtaposition: leather combined with
wool, pattern with solid colour and diagonal detailing.
As Filippo Guarini and Laura Fiesoli's chapter
indicates, this kind of flexibility and creative innovation
remains an important part of Italy's contemporary
textile manufacture.

For this book, Catharine Rossi undertook further
research into the demand for craft professionals
within Italian production. This theme is echoed in
the investigations into specific materials and
techniques: Elizabeth Currie writes about Italy's
strength as a producer of fine knitwear; Oriole Cullen
chronicles the innovations of Italian furriers; and
Helen Persson describes the famed leather-working
skills of Italian makers.

This publication discusses a wide spectrum of
clothing types and related industries, including couture
design, boutique fashions, fine textiles, specialized
artisanal production and ready-to-wear. In addition,
with gender as a prism, several chapters examine
another important aspect for this discussion: leading
Italian menswear. Christopher Breward's chapter,
'The Return of the Courtier: Men and Menswear'
assesses the iconography of Italian menswear from
its emergence in the post-war years via its zenith in
the 1980s to the present day. In his contribution 'In
the Things That Go Over Other Things', Alistair
O'Neill analyses the legacy of Italian fashion's modern
male wardrobe: tailoring and knitwear. Jonathan
Faiers's research into the influence of 1980s Italian
sportswear brands in Britain brings active sports attire
into the debate. The details of cut and construction

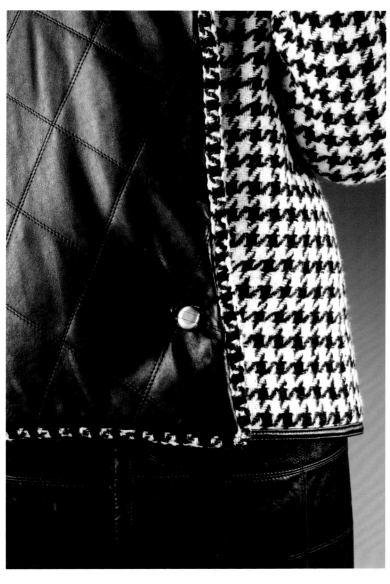

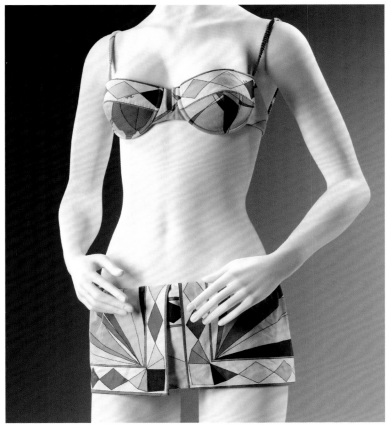

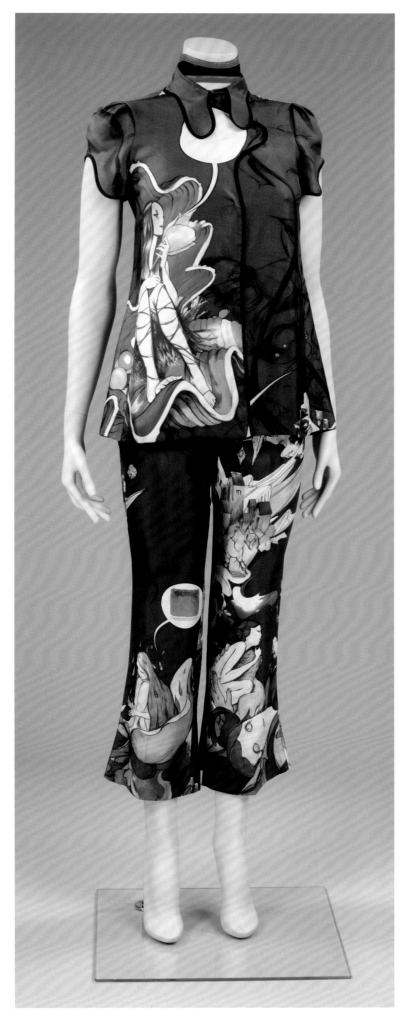

27 Roberto Capucci, evening dress of fuchsia and green silk, 1987
V&A: T.96–1988

that distinguish Neapolitan tailoring are the focus of Glenn Adamson's piece, entitled 'Tailoring and Craft'. Gianluca Longo furthers this line of enquiry in his case study 'The Man on the Street', in which he contrasts regional tailoring preferences as seen on the streets of Naples, Milan and Rome.

Within this book, the relationship between image and fashion is investigated from different vantage points. In her chapter 'Portrait/Self-portrait: The Image of Fashion', Maria Luisa Frisa analyses some of the most notable photographs chronicling the past half-century of Italian fashion and moves them canon-ward. Complementary research into this relationship between fashion and image is contained in Stella Bruzzi's chapter, 'Italian Fashion Designers in Hollywood'. Judith Clark extends this theme with her analysis of the image-making of a single Italian fashion editor in her essay on Anna Piaggi. There then follows an examination of the work of Italian-born, Paris-based photographer Paolo Roversi, who draws direct inspiration from the religious iconography of his childhood.

In addition to their facility with working with skilled image-makers, Italian designers have also benefited from an inventive, entrepreneurial verve. Certainly, Italian fashion's business tradition has valued risk-taking, along with family and personal connections. In her chapter 'The Business of Fashion', historian Emanuela Scarpellini reflects on other key business characteristics unique to twentieth-century Italy's fashion industry: a skilled female workforce, and the networks or districts of related industries. Clusters, or geographic concentrations of interconnected companies in a particular field, are the production system that drove Italy's fashion and textile industries to success.[33] From the early 1980s onwards, this infrastructure featuring clusters of complementary industries, combined with Italy's expert factory production, made the country a preferred place of manufacture not only of its own designer fashions but of the world's best designer ready-to-wear. More often than not, if it was designed in Paris, it was made in Italy. Furthering this investigation into the industry's behind-the-scenes workings, Elena Puccinelli's chapter illuminates the crucial role of Italy's fashion press and highlights the country's key fashion publications, while Oriole Cullen's interview with gallerist and fashion retailer Carla Sozzani and her sister Franca, the editor-in-chief of *Vogue Italia* provides an insider's perspective.

Although today's marketplace is international, Italian fashion companies still exert an important influence. In recent years, this influence has come most notably from the repositioning of existing fashion brands. Miuccia Prada channelled the millennium's modern woman through her family's leather goods company, founded by her grandfather in 1913. From the early 2000s Tomas Maier used the august leather brand Bottega Veneta as a vehicle to express a novel kind of stealth luxury, a no-logo, 'functional essence' that exorcised labels, hardware and unnecessary frippery.[34] Frida Giannini, Gucci's creative director since 2005, became known for reinterpreting the company heritage via a penchant for 1970s style. The collections of Maria Grazia Chiuri and Pier Paolo Piccioli, joint designers for Valentino since 2008, have associated the house with a new, youthful spirit within the confines of a traditional couture salon. The designs of the occasional newcomer, such as Fausto Puglisi's experiments with print, colour juxtaposition and elaborate surface embellishment, also bring fresh energy to Milan's catwalk presentations.

Thanks to the success of these fashion houses and the continuing appeal of Italian leather products, Italy remains Europe's largest producer of clothing and textiles, representing 30 per cent of the sector's annual turnover, and the second-largest exporter of fashion worldwide after China.[35] However, its once famed clusters of production networks are thinning. As the twenty-first century began, these networks have faltered and began a precipitous decline. As Filippo Guarini and Laura Fiesoli's chapter highlights, a city like Prato saw roughly half of its textile firms close in the decade prior to 2012. In 2012, the country's textile sector suffered a further decrease of 8.4 per cent compared to the previous year, and over the same period the textile and fashion sectors combined lost more than 23,500 jobs.[36] These business failures took the post-war generation of manufacturers by surprise. Edoardo Nesi, a former Pratese textile industrialist, described his peers thus:

> *A generation of wild entrepreneurs who knew perfectly well that the miraculous growth that their companies had enjoyed was the result of a set of extraordinarily favourable, once-in-a-lifetime conditions, a long and lucky cavalcade on the crest of a wave of epochal growth that sprang from the ruins of post-war Italy and which had lifted everyone, capable and inept, industrialists and employees, well beyond their own limitations.*[37]

Nesi sold his family's textile firm in 2004, part of a wave of closures and restructurings that took place in the first decade of the millennium, marking the end of Italy's 'long and lucky cavalcade' of growth.

In Italy, the years since 2000 have been marked by political scandal and economic problems. The global financial crisis hit the country particularly hard, as Italy's economy continued to lumber under the burden of rigid labour markets and an over-generous social welfare system. While these conditions have challenged all sectors of the economy, they have made navigating today's rapidly changing business infrastructure all the more difficult for Italian fashion companies. As Italy's business class absorbed the lesson that it could not compete with countries such as China on price, it decided that quality was the answer, betting on the strength of the 'Made in Italy' label, believing that the coveted emerging market customer would favour the prestige associated with Italian products.

Despite the determination of some fashion companies to maintain Italian production, recent

changes in the way fashion is designed, made and sold may well make the consumer question whether 'Made in Italy' is still an accurate description. In the present day, there is a significant blurring of national fashion borders. This is the result of several factors: first, as Catharine Rossi's chapter suggests, it is difficult for the consumer to determine how much of a garment that carries the 'Made in Italy' label is actually made within Italy's borders. While the United States requires a garment to be fully produced there to earn the 'Made in the USA' tag, in contrast a product can be largely manufactured overseas before being imported to Italy for seams to be sewn or buttons added and still meet the 'Made in Italy' criteria. A garment can also be produced illegally in Italy's clandestine economy, in unregulated working conditions, and still carry that same label. The inconsistencies of labelling requirements, which differ country by country within the eurozone, also create uncertainty. Extending the confusion still further is the continuing spectre of counterfeit goods. Fashion houses were battling imitation products even before Madeleine Vionnet placed her thumbprint on the labels of her garments in the 1920s in an effort to thwart the copyists.[38] Because of their small size and high profit margin, leather goods are particularly vulnerable to counterfeiting and thus are the focus of intense protectionist efforts.

A further cause of ambiguity in relation to the perceived authenticity of Italy's premium fashion houses comes from their increasingly foreign ownership. By the early 2010s many of Italy's best-known fashion companies had been purchased or were part-owned by foreign investors. The French holding company Louis Vuitton Moët Hennessy (LVMH) boasts ownership of or controlling stakes in the fashion house Emilio Pucci, the furrier Fendi and cashmere specialist Loro Piana. The French-owned investment firm Kering (formerly known as PPR) oversees shoe brand Sergio Rossi as well as Gucci, Bottega Veneta and the menswear label Brioni. Valentino and Gianfranco Ferré are owned by Middle Eastern companies, while the menswear firm Cerruti is Chinese-owned.[39] Though many of these firms are foreign-owned, they are still solidly connected to an Italian identity: their company headquarters and design studios remain in Italy, they continue to produce predominantly in Italy, and their goods are promoted using their Italian heritage to a global marketplace.

The future of Italian fashion, like that of most of Europe, lies in selling luxury products to this global marketplace. The affordable Italian boutique fashions and sportswear that caused such a stir on the *Sala Bianca* catwalk of the 1950s have given way to a future devoted to the deluxe. The success of this model is wholly dependent on retaining the reputation of Italian-made goods. Because the emerging market consumer perceives 'Made in Italy' as a mark of prestige, in order to sell to this customer, the making of luxury Italian fashion products will need to remain in Italy, even if goods are much more expensive to produce there. Prada's listing on the Hong Kong stock exchange in June 2011 sought not just the highest possible financial valuation but also greater consumer awareness in the region. Staking a company's fortunes on Chinese consumption (and that of other emerging markets) is a bet that many fashion houses have made. By 2015 sales of Italian luxury goods in China will likely have reached 13 billion euros.[40]

Given this market dynamic, lowering costs by outsourcing production overseas is not a sound strategy for growth. While it is undeniable that some companies take advantage of Europe's porous labelling laws, those at the higher end of the market are the most committed to crafting their products in Italy. The country's premium leather goods sector remains particularly faithful to Italian manufacture. Gucci perpetuates its own tradition of Italian-made quality and continues to produce its leather bags and other accessories near Florence, as do Bottega Veneta and Ferragamo. Tod's, the shoe company founded by Diego Della Valle, makes its signature driving moccasins and other leather goods entirely in Italy.[41] Leather products provide higher profit margins than clothing and therefore represent the largest portion of business for most Italian fashion brands. For example, 80 per cent of Prada's 2011 sales came from leather accessories.[42] Prada, a company which is relatively open about the overseas production of some of its garments, uses a significant quantity of Italian materials. Miuccia Prada recognizes that Italy's textile producers 'have incredible knowledge' and that Italy's best textile firms are nimble and responsive. These are the firms that allow a design house like Prada to experiment. Miuccia Prada describes this process as 'to do and redo'. She explains: 'We experiment with so many different techniques with these producers. One of the advantages of being a big company is that you ask for two or three things and you get 20 or 30'.[43]

The survival of Italian fashion companies in the twenty-first century is not just a question of geographic authenticity but also one of finance. Maintaining an international brand's profile can require hundreds of millions of euros in operating costs, to fund not only the design and production teams but also the seasonal fashion show presentations and the press and marketing campaigns necessary to gain the attention of fickle fashion consumers. To claim a global presence, fashion houses require a shopping bag that reads 'London, New York, Paris, Tokyo'. Rents in the prestigious shopping locations of these expensive cities are ever increasing. As a result, such stores are often loss-making but are valued by their owners as a crucial form of advertising. It is the rare fashion house that can shoulder these costs on its own. The financial strength of a parent company offers the possibility of international expansion, of built-in expertise to coordinate marketing and purchasing as well as existing networks that can be used to build up a brand's retail presence.

The heritage of a premium Italian fashion house holds strong commercial appeal. New owners expand

28 Tom Ford for Gucci, white silk viscose dress with gold dragon brooch, Autumn/Winter 2004
V&A: T.6:1–2005

these companies by promoting and highlighting this heritage. While this dynamic is not unique to Italian fashion brands, their influence is particularly alluring to investors. The two and a half year tug-of-war between LVMH and PPR for majority ownership of Gucci suggested how highly sought after such companies could be. This very public battle, which culminated in PPR's victory in September 2001, made it the most high-profile acquisition within the Italian luxury goods sector.[44] Other Italian fashion houses have also been bought for the appeal of their Italian tradition. In explaining their more straightforward purchase of Loro Piana, founded in 1924, LVMH referenced the Italian cashmere company's 'family roots that go back six generations'.[45] Kering executives marked their acquisition of menswear brand Brioni by praising its Roman tailoring heritage, which the new owners pledged to 'preserve'.[46] Similarly, in

announcing their success in securing a majority stake in Fendi, LVMH referred to the furrier as 'one of Italy's greatest luxury brands'.[47]

Today, as the third-largest economy in the eurozone, Italy's faltering domestic economy threatens the financial stability of the region. The country grapples with an exceptionally large public debt, high unemployment, a continuing battle with an inflexible labour market and widespread tax evasion.[48] These challenges will not impede continuing future growth for Italy's fashion industry. The bright spot in a generally sober economic outlook is the seemingly limitless demand from consumers abroad for a taste of Italian style, echoing the circumstances of the period chronicled at the beginning of this introduction. In the words of Carmel Snow, 'If there were no other reason to go to Florence and Rome just when Spring begins to whisper, Italian fashion would fully justify our going.'[49]

1

Italy's Fashion Identity

Great Dressmakers of Italian Fashion

Sofia Gnoli

After the Second World War, alongside figures such as Emilio Schuberth and Roberto Capucci, Emilio Pucci and Alberto Fabiani, a new generation of female dressmakers began to flourish. Some were continuing a family tradition, like the Fontana sisters, others were women of noble birth, like Simonetta Colonna di Cesarò and Irene Galitzine. Drawing on their different aesthetic sensitivities and training, all these entrepreneurial women helped to revolutionize Italian fashion and bring it to the attention of the world.

The Women of Hollywood on the Tiber

An event that brought abundant international attention to Italian fashion was the January 1949 wedding of Tyrone Power and Linda Christian. They married in the basilica of Santa Francesca Romana in Rome. The groom wore a Caraceni morning suit, while the bride wore a dress by a relatively new local atelier of dressmakers: the Fontana sisters. Italian fashion was on the ascent, with newsreels and international magazines describing the dress in minute detail.

From that moment, the defining features of Italy's fledgling fashion industry started to take shape, including its links to America and Hollywood, which were particularly evident in Rome at the Cinecittà film studios, which had opened in 1937. Against a backdrop of war ruins, Italy returned to life, capturing the American imagination as a perfect country for holidays and escapes, with the capital city of Rome as the ideal location, just as it had been at the time of the Grand Tour. Hollywood on the Tiber was born, and together with Emilio Schuberth and Roberto Capucci, the Fontana sisters were its main fashion protagonists.

Zoe, Micol and Giovanna Fontana were all born in Traversetolo, a small town in the province of Parma, between 1911 and 1915. Having learned tailoring skills in their mother's workshop, the sisters moved to Rome, where Zoe served apprenticeships at Zecca and Battilocchi, historic dressmakers famed for their copies of French styles. In 1943, the Fontana sisters established their own fashion house. In the early years they referenced French couture. In 1949, at the Palazzo Grassi in Venice, the Fontana sisters presented a collection inspired by the Italian *Risorgimento*, albeit a reinterpretation of Dior's New Look.[1] Among their first clients were the Marchesa Marita Guglielmi and Princess Marella Caracciolo di Castagneto; soon, many actresses joined these two noblewomen. By 1950, the atelier had 100 employees. When Giovanni Battista Giorgini organized the first internationally attended catwalk show of Italian fashion in Florence the following year, the house of Fontana was included among the participants. During this period, every star who went to Rome, from Audrey Hepburn to Elizabeth Taylor, visited their atelier. The unique character of the Fontana garments was connected to refined tailoring and eveningwear embellished with lace and elaborate embroidery.

In addition to serving as a gathering point for Hollywood stars, Fontana's premises also served as a backdrop for film, featuring in Luciano Emmer's *Le Ragazze di piazza di Spagna* (*Three Girls from Rome*, 1953). Film projects also brought the atelier the patronage of another important client, Ava Gardner. The actress met the Fontana sisters in 1953, when the director Joseph Mankiewicz asked them to create her costumes for *The Barefoot Contessa* (1954). A strong link was established between Gardner and the sisters, who continued to design for her both on and off the set. The V&A holds an elegant black evening dress designed by the atelier for Gardner (pl.32). One particularly notable design the atelier created for the American actress was a severe black *pretino* or

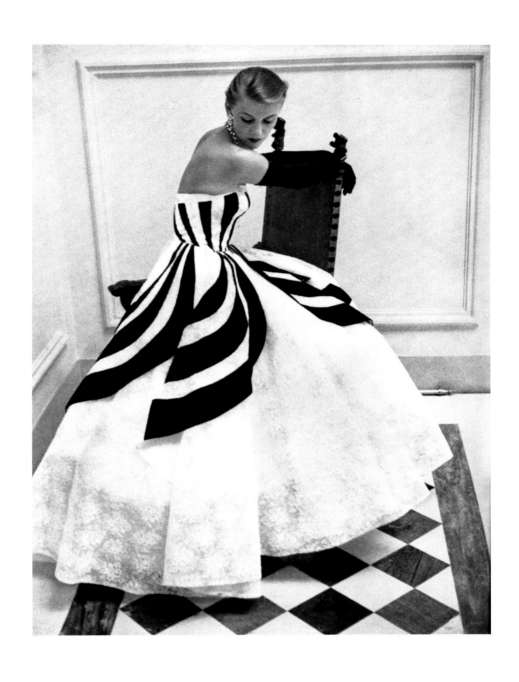

29 Model wearing a Maria
Antonelli gown, 1951

page 30
Simonetta, cocktail dress and
jacket made from brocaded
sari silk (detail), *c*.1955
V&A: T.762:1,2–1995

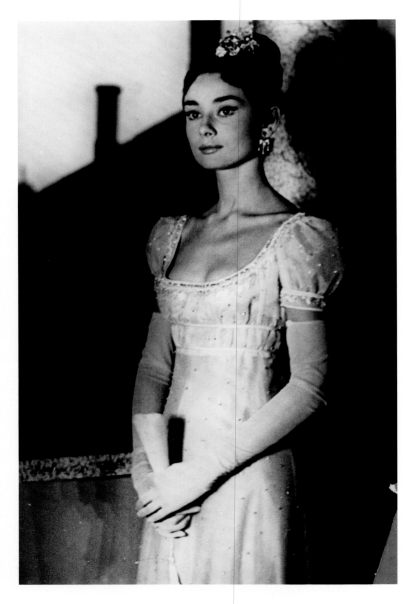

'cassock' dress, later referenced by Piero Gherardi for a provocative Anita Ekberg in Fellini's *La Dolce Vita* (1960; see pl.152).

Another important representative of Hollywood on the Tiber was Fernanda Gattinoni. Born in Cocquio Trevisago in the province of Varese in 1907, she moved to London with her family when she was very young. She began her career as an apprentice at Molyneux before returning to Italy in the late 1930s. She established herself in Rome, where she found work at the famous dressmaker Ventura, before setting up independently in 1944.[2] Gattinoni was known for both soft drapery and refined tailoring. If her draped eveningwear was inspired to an extent by the contemporary innovations of Madame Grès[3] in Paris, her tailored daywear was probably informed by her years as an apprentice in London. Gattinoni's propensity for a minimalist style of clothing was highlighted by the fashion journalist Irene Brin,[4] who wrote in 1951: 'Fernanda dressed the Maharani of Palampur, known for her love of gold trappings, in typically British-style grey flannel. She also dressed Eva Peron,[5] usually decked out in feathers and flounces, in ultra-simple Lombard silks'.[6]

Although she never took part in the group shows at the *Sala Bianca*, during the course of her career Gattinoni dressed many actresses, including Anna Magnani, Lana Turner and Ingrid Bergman. For the latter she designed film costumes, including those for *Europa 51* (1952) and *Viaggio in Italia* (1953), directed by Roberto Rossellini. Commissioned by costume designer Maria de Matteis, Gattinoni also created Audrey Hepburn's costumes for King Vidor's *War and Peace* (1956; pl.30). She was inspired by the Empire line and soon afterwards created a classically-influenced collection entitled *Nike* (Autumn/Winter 1956). In July 1956, Eugenia Sheppard, the fashion correspondent for the *New York Herald Tribune*, wrote: 'Today Rome has presented a new look for goddesses . . . With this collection, Fernanda Gattinoni has paid a gracious tribute to the style of Ancient Rome, it is certainly the beginning of a new look.'[7] In the early 1960s when boutique fashion began to compete with haute couture, Gattinoni adapted to the changing times and launched a ready-to-wear line.

During the 1940s, Maria Antonelli, a dressmaker from Siena, also became more established in Rome. Absent from the first Florentine catwalk show organized by Giorgini, she took part in the shows from July 1951 onwards (pl.29). In 1958 she successfully launched Antonelli Sport, her line of leisurewear, which appealed to the American taste for stylish but informal clothing. From the beginning of her career she dressed famous actresses such as Anna Magnani and Alida Valli.[8] The hallmarks of her style lay 'in the minimalist silhouettes and refined details, which in the 1960s became even more striking, due to the presence of the young André Laug in her atelier'.[9] Laug would go on to an independent career designing clothing that helped define the 1960s taste for structured, streamlined silhouettes.

The Noblewomen of Italian Fashion
In 1949 an article in *Grazia* declared that 'any noble-woman who chooses to work becomes a dressmaker. In Rome four princesses, three countesses and two marchionesses are involved in fashion.'[10] A notable feature of Roman fashion immediately after the Second World War was the close link between fashion and nobility:

> *Italian haute couture is born poor but of good lineage, under particularly favourable auspices. Right after the armistice, a group of brave young women used their talent and ingenuity to pull elegance out of the ruins of Italy . . . Let us salute forthwith, donna Aurora of the Princes Giovanelli and donna Stefania of the Princes Colonna di Sciarra, donna Simonetta Colonna of the Dukes of Cesarò, donna Giovanna of the Princes Caracciolo Ginnetti; the Countess Desalles and the Baroness de Reutern.*[11]

Other examples were the Marchesa Olga di Grésy,[12] creator of Mirsa, a key name in knitwear in the early years of Italian fashion, the Baroness Clarette Gallotti, known as the *Tessitrice dell'Isola*

30 Audrey Hepburn wearing a gown designed by Fernanda Gattinoni in the film *War and Peace*, 1956

31 Theo Graham wearing an outfit by Simonetta. Photograph by Leombruno Bodi, 1961

32 Sorelle Fontana, black crêpe
evening dress designed for Ava
Gardner, 1960s
V&A: T.291–1990

Opposite
33 Simonetta, cocktail dress
and jacket made from brocaded
sari silk (detail), c.1955
V&A: T.762:1, 2–1995

(the weaver of the island),[13] and the exotic Russian princess, Irene Galitzine.

Among the noblewomen of Italian fashion, the Countess Gabriella di Robilant, founder of the Gabriellasport brand in 1932, played a pioneering role. Born in Florence in 1900, she moved to Venice in 1920 after her marriage to Andrea di Robilant. There she became part of the international jet set passing through the Venetian Lagoon, which included the composer Cole Porter and the waspish American journalist Elsa Maxwell, the Italian poet Gabriele D'Annunzio and the fashion designer Jean Patou. The latter, together with Coco Chanel and above all Elsa Schiaparelli,[14] greatly influenced her decision to dedicate herself to the world of fashion. In 1932, by now separated from her husband, she opened her atelier Gabriellasport on Milan's via Santo Spirito. Simple, practical, elegant: her creations enchanted legions of women, among them Edda Ciano, Benito Mussolini's eldest daughter, who soon became a faithful client of the house. In 1937, Gabriella di Robilant gained international fame when Bergdorf Goodman, that New York temple of luxury, invited her to present her designs in New York. After relocating to Rome in 1942, she took over the workshop of the famous dressmakers Ventura on Piazza di Spagna. Madame Anna, the renowned director of Ventura since the 1920s, continued to work in the new fashion house. From then on, sportswear ceased to be the hallmark of Gabriellasport and the atelier started to create haute couture garments, often buying patterns from the most famous French fashion houses, following the tradition established by Ventura. In 1948, the day after marrying her second husband, Francesco Starrabba di Giardinelli, the designer moved to Palermo and drifted further away from fashion, until the atelier finally closed in 1952.

Many other Italian noblewomen also opened fashion houses, including Simonetta Colonna di Cesarò. Beautiful, dark-haired and proud, Simonetta, as the duchess was known professionally, opened her first atelier in 1946 at 5 via Gregoriana in Rome. Because of a lack of fine materials due to the war, for her first collection Simonetta repurposed dishcloths, gardening smocks and the jackets of domestic servants. It was an instant success. The day after the catwalk show, Irene Brin described Simonetta's creations as 'the tricks of ingenious poverty'.[15] In 1948, British *Vogue* paid homage to her with a feature shot in Capri. The following year, American *Vogue* followed suit.

In the early 1950s, American department stores such as Bergdorf Goodman in New York and Marshall Field's in Chicago began to flood Simonetta with orders. Shortly afterwards *Harper's Bazaar* dubbed her 'The Glamorous Countess'. Bettina Ballard, fashion editor of American *Vogue*, called her 'the best businesswoman in Italian couture'.[16] By this time, the international jet set aspired to wear her clothes. Simonetta's collections, famed for their refined and pared-down silhouettes – often emphasizing a single detail such as a striking neckline or a repeated bow – soon impressed women as diverse as actress Lauren Bacall and American Ambassador to Italy Clare Boothe Luce, Argentine painter Leonor Fini and one-time Madrid resident Mrs J.K. Robinson who, on her return from a voyage to India, ordered a cocktail outfit of gold brocaded sari silk, now housed in the V&A's permanent collection (pl.33). The true hallmark of Simonetta was high-end boutique fashion of the relaxed and casual look that made Italian style so appealing in the 1950s (pl.31). In 1962, at the height of her fame, she moved to Paris with her husband Alberto Fabiani, to open the atelier Simonetta e Fabiani. The Parisian atelier, which counted the Duchess of Windsor and Estée Lauder among its clients, failed to build on its initial success and closed in the early 1970s.

During that first fashion show organized by Giorgini in 1951, another brand made its catwalk debut along with Simonetta: Carosa, which was launched in Rome in 1947 by Princess Giovanna Caracciolo Ginnetti di Avellino and Countess Barbara Rota Angelini Desalles. While the latter withdrew not long after, Caracciolo continued working in fashion until the 1970s. Although its designs were

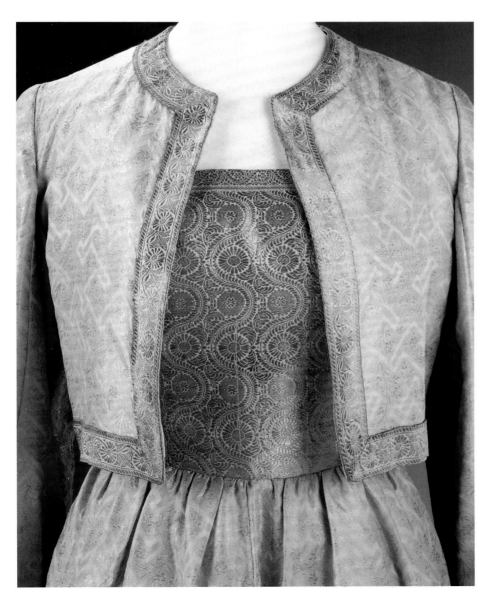

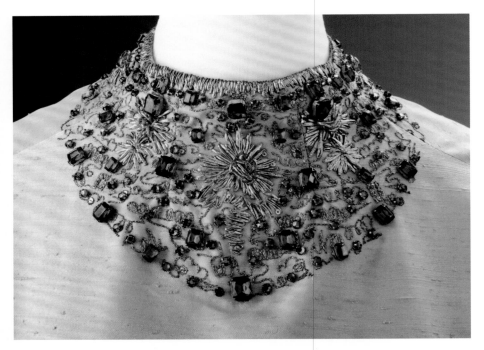

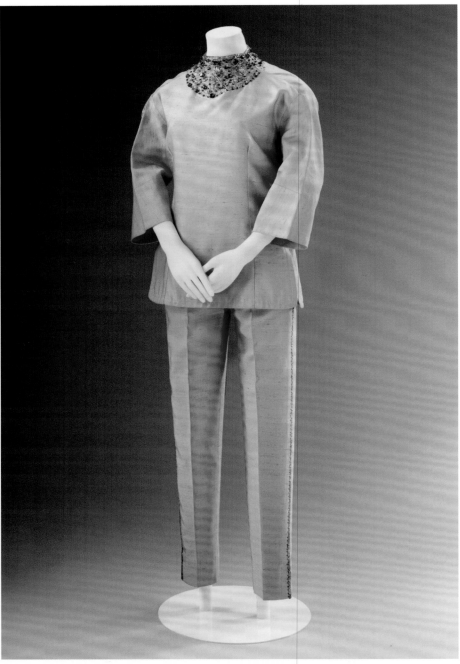

34 (detail) and 35
Irene Galitzine, silk palazzo
pyjamas (detail), *c.*1963
V&A: T.221&A–1974

Opposite
36 Irene Galitzine wearing
one of her signature palazzo
pyjama ensembles, 1961

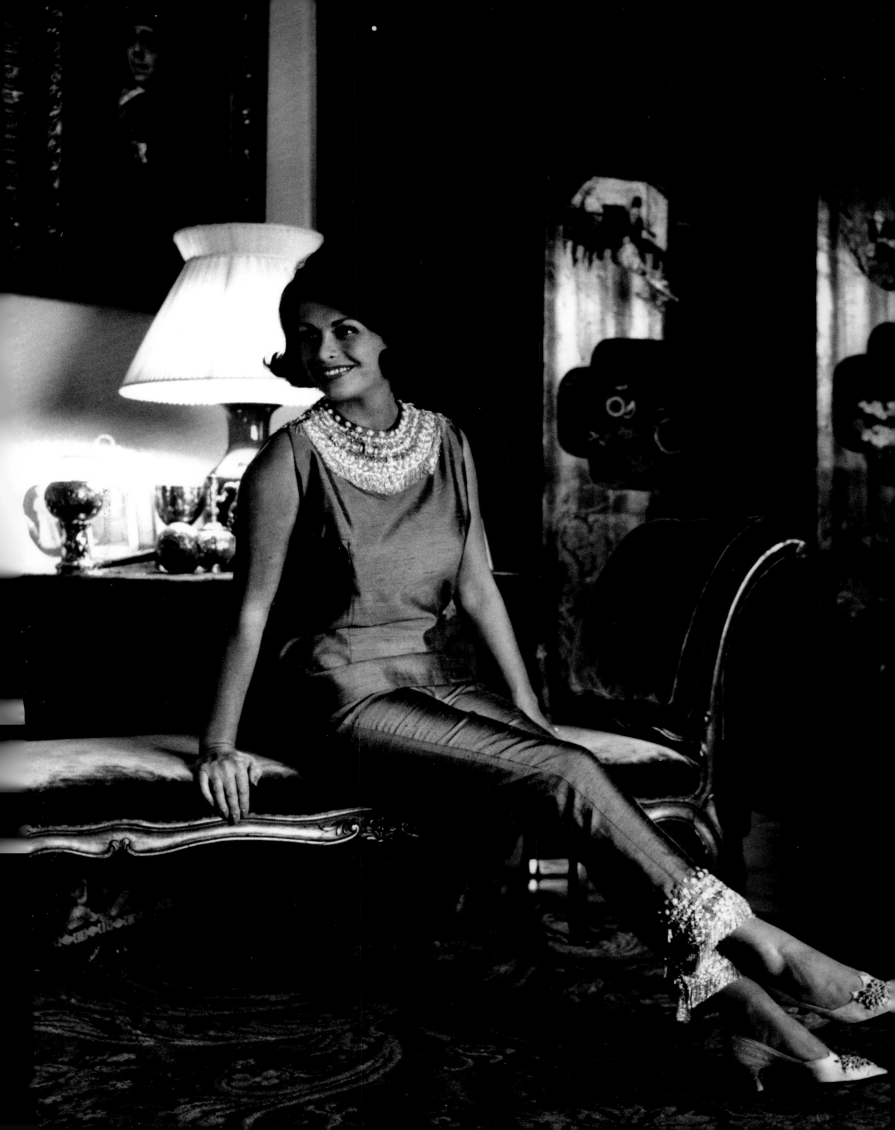

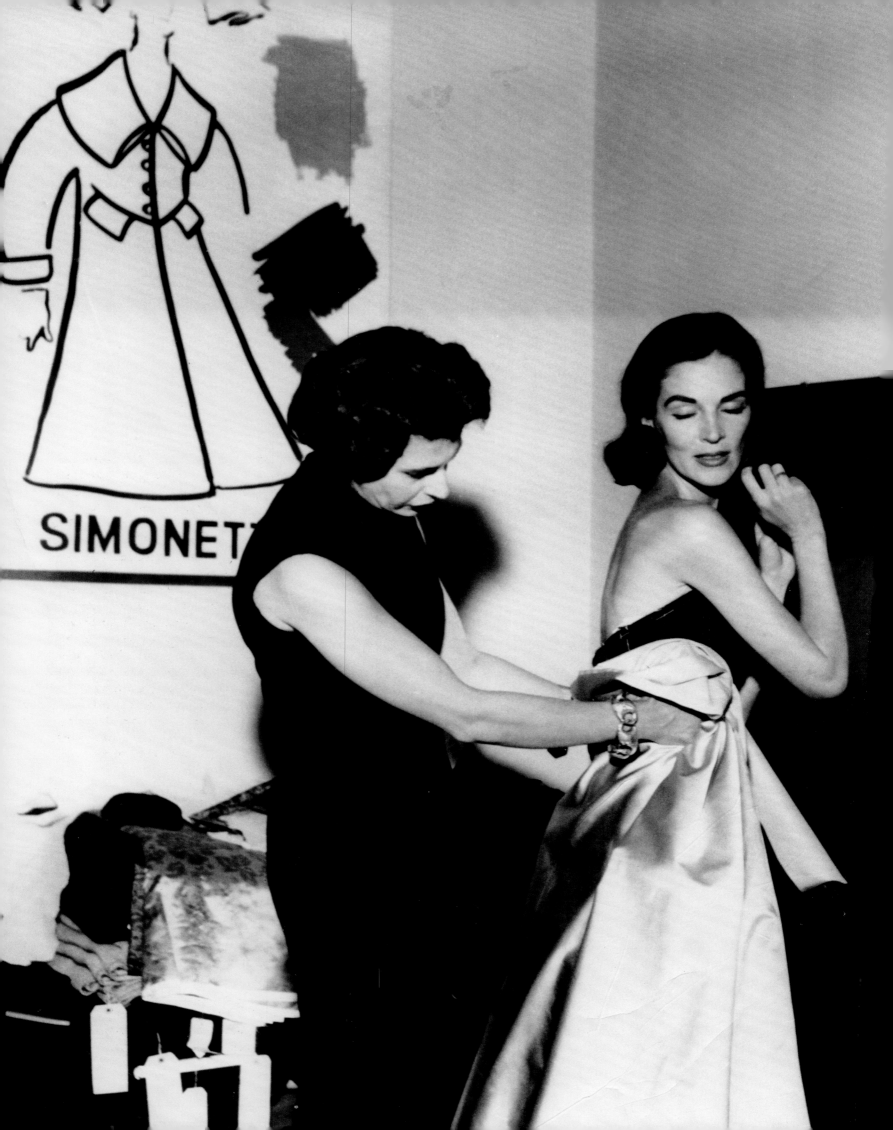

influenced by French tailoring, Carosa was one of the houses that made the biggest contribution to the international reputation of Italian fashion. Angelo Tarlazzi, who worked for Carosa in the second half of the 1960s, described Caracciolo as 'the closest Italian representative of a certain style of French fashion, made up of strong lines and extreme refinement . . . her favourite tailors were Balenciaga and Yves Saint Laurent'.[17] Thanks to her innate good taste and sober, minimal style, Caracciolo ran one of the most popular dressmaking ateliers frequented by high society in the era of *La Dolce Vita*.[18]

Another important Roman fashion house was that of Irene Galitzine. With a life story to rival one of Tolstoy's heroines, the Russian princess arrived in Rome when she was three years old, following the Bolshevik Revolution of October 1917. She was little more than 20 when her striking beauty and cosmopolitan education caught the attention of the Fontana sisters, who were keen to confer some aristocratic allure on their atelier. Galitzine began to work for them as a model, as well as helping with public relations. In the mid-1940s, she opened an atelier under her own name, where she meticulously reproduced the designs of French couturiers.

Galitzine's love of French style meant that she was not involved in Giorgini's first fashion show in 1951. In 1959 she met Federico Forquet, a young couturier who had worked with Balenciaga. Together they began to create designs that were independent from French fashion. She presented her first entirely Italian collection in the *Sala Bianca* at the Palazzo Pitti. 'These were designs created with real life in mind, including holidays in Capri, office work, lunch at the British embassy', Irene Brin wrote the following day.[19] Soon after this debut, Galitzine received the prestigious Filene's Talent Award, established by the American

department store of the same name. But her real triumph came in 1960, when she launched an outfit consisting of trousers and a tunic – with embroidered neckline and cuffs – in brightly coloured silk shantung woven by a Como silk manufacturer (pls 34–6).[20] Diana Vreeland, fashion editor of *Harper's Bazaar* at the time, enthused about the new creation, christening the look 'palazzo pyjamas'. The minimalist luxury of palazzo pyjamas soon won over royalty and first ladies alike. Jacqueline Kennedy wrote to Galitzine on White House headed notepaper on 4 January 1963: 'I was so touched at your thoughtfulness at sending me your marvelous [sic] pyjamas for Christmas. Thank you so much. You should see us down here; it's like a convent: me, Jayne, Marella and Lee are in uniform every night!'[21] Thanks to these influential figures and film stars such as Elizabeth Taylor and Audrey Hepburn, Claudia Cardinale and Monica Vitti, palazzo pyjamas became the must-have uniform of women of the international jet set in the 1960s.

The Queens of *La Scala* and the Others

Four Milanese ateliers presented their designs at the February 1951 catwalk show in Florence: Marucelli, Noberasco, Vanna and Veneziani. Among these Germana Marucelli and Jole Veneziani stood out, two women who had adopted Milan as their home and who made a great contribution to the rise of Italian style.

Born in 1901 in Taranto into a well-to-do family, Jole Veneziani moved to Milan at a very early age. She later worked for a French fur house in the city and in 1937 she set up on her own, opening a fur workshop to which she added a dressmaking department in 1943. Veneziani was influenced by French fashion, while at the same time distancing herself from it (pls 38 and 40).

Her clients included Josephine Baker and Wally Toscanini, who was the daughter of conductor Arturo Toscanini and wife of pianist Vladimir Horowitz, and Italian actresses such as Anna Proclemer and Giovanna Ralli. The designer was one of the first to appreciate that the American market wanted simple designs and by 1951 she had already launched a second range, Veneziani Sport, a kind of ready-to-wear line. Its success was soon noted in the pages of *Bellezza*, where Elsa Robiola wrote about 'an overwhelming debut for the collection Veneziani Sport, which has literally galvanized the American buyers'.[22] Not longer after, American *Vogue* published an article about Veneziani.[23]

Unlike the collections of many of her colleagues, Veneziani's style was pared down to the essential. For this reason, she has often been compared to Roberto Capucci, and is regarded as being one of the few creators of fashion who succeeded in distinguishing themselves from the majority at that time. She often collaborated on films, working for example with actress Lucia Bosé on Michelangelo Antonioni's *La signora senza camelie* (*The Lady Without Camelias*, 1953) and with Sandra Milo on Federico Fellini's *Giulietta degli spiriti* (*Juliet of the Spirits*, 1965). Veneziani's star began to fade in response to the rebellious spirit of the late 1960s, beginning with the student protests of 1968. That same year, rotten eggs and tomatoes were thrown at women wearing furs and evening gowns to the opening of the opera season at *La Scala*. It was the end of an era.

'The word "pioneering" is sometimes overused, but in the case of Germana Marucelli it is deserved because she was the first, the most courageous and combative, to believe in and create Italian fashion,' Maria Pezzi wrote about one of the first dressmakers to develop ideas unchained from the influence of French fashion.[24] Art played a major role in Marucelli's creations, which were characterized by a very original and defined silhouette. This and other aspects of her work bring to mind the designs of Elsa Schiaparelli. Following a precise philosophy, Marucelli's designs contained 'a little bit of architecture, because a garment is signed space; painting because it is colourful, music because it is harmonious, sculpture because it is form, poetry because it creates and qualifies'.[25] This cerebral approach to fashion was perhaps due to the fact that Marucelli was formed by a different climate: Milan, the city of industrial development and design,

rather than Rome, with its cinematic influences. 'Before being a dressmaker Germana was an intellectual,' noted writer Fernanda Pivano, 'as imaginative and committed a creator as an artist, a sculptor or a writer'.[26] Marucelli's salon was frequented by artists, authors and poets, from Giò Ponti to Felice Casorati, from Lucio Fontana to Alberto Savinio.

Born in Settignano in Tuscany in 1905, Germana Marucelli learned the basics of clothes-making at the dressmakers Failli of Florence and Gastaldi of Genoa, before for a time making her living by selling designs in Italy copied from Parisian patterns. As Maria Pezzi explained:

> She had a formidable eye, so that she sometimes bought, sometimes copied. One day Germana visited her most important client, the Milanese dressmakers Ventura, to offer them some French designs. Madame Anna, the fearsome director of the atelier, chose one out of the bunch, counted the little plissé folds, measured the width of the drapes and asked her: 'Did you buy this or copy it? This dress is already one of our exclusives.' Germana confessed that she had copied it from memory. Anna thundered: 'I could denounce you, but you are too good.'[27]

In 1938 Marucelli opened an atelier in Milan. She was forced to close it during the war but reopened in 1945.[28] An important element of Marucelli's work, collaborations with artists, is exemplified by two famous collections, *Optical* (1965) and *Aluminium* (1968), created with artist Getulio Alviani. Other notable collections include *Impero* (Empire, 1951), *Vescovo* (Bishop, 1960), which was inspired by the sculptures of Giacomo Manzù, and *Scollo a tuffo* (Plunging Neckline, 1963), characterized by a neckline so low that Fernanda Pivano observed they would make Rudi Gernreich, the inventor of the first topless swimsuit, envious.[29] Although she continued to experiment with new lines, from 1972 onwards Marucelli reduced her participation in official fashion shows.

Biki and Gigliola Curiel were two other important figures in Milanese fashion. Nicknamed Biki by her grandfather, the composer Giacomo Puccini, Elvira Leonardi Bouyeure became part of the fashion scene in 1933, when she founded a lingerie atelier with Gina Cicogna, which was christened Domina by Gabriele D'Annunzio. A few years later, Leonardi extended her production range to include clothing, calling the

with a cotton ground and silk pile for her bags. In the 1950s, Camerino started to experiment with the *trompe-l'œil* effects that would become her trademark. Within a short time her bags became famous around the world. One of the most successful was the *Bagonghi*,[31] a style loved by Grace Kelly, who was by now the Princess of Monaco,[32] Elsa Maxwell and actress Eleonora Rossi Drago. Thanks to this design, which won the prestigious Neiman Marcus Award in 1956, the handbag was established as a popular fashion accessory: 'By now everyone knows that Mrs Giuliana Camerino can take the credit for the reinterpretation of the handbag. She has collected prizes, Oscars, recognition for having created and continuing to create the most beautiful bags in the world.'[33]

In 1963 Camerino presented an accessories collection for the first time in the *Sala Bianca* at the Palazzo Pitti and shortly afterwards, she began to design clothing as well, creating garments printed with *trompe-l'œil* effects. Mostly made in jersey, the garments had simple lines, with prints that replicated pleated skirts, jackets and little shirts with bows and double cuffs or elegant smoking jackets. Camerino explained the reasoning behind her idea of creating simple tubes that gave the impression of being very elegant outfits:

> *[T]here were no more patient servants to do up rows of little buttons, to do up the cufflinks. With my clothes you just had to put them on. I drew everything on top: from buttons to belts . . . double cuffs and even the undone buttons on suit sleeves, a practice adopted by the most refined men.*[34]

These women began a completely female tradition,[35] which was taken up by designers such as Mila Schön, a significant representative of the aesthetic clarity of the 1960s; Krizia, famous for her daring use of knitwear; and the five Fendi sisters, who revolutionized the concept of fur. Today the story of great women designers continues with Silvia Venturini Fendi; Frida Giannini, the brilliant mind behind Gucci; and Maria Grazia Chiuri, the artistic director of Valentino together with Pier Paolo Piccioli. Its star can be found in Miuccia Prada. Inheriting the leather goods company her grandfather Mario founded in 1913, Prada has been able to open up new avenues in fashion with unusual brilliance, challenging all conventions. 'Most of my work is concerned with destroying – or at least deconstructing – conventional ideas of beauty', she has explained. 'Fashion fosters clichés of beauty, but I want to tear them apart'.[36] She has succeeded, creating an inimitable style made of a new, discordant harmony.

Sofia Gnoli is a fashion historian and journalist. She teaches history of fashion at Sapienza University, Rome

brand Biki. In the 1950s and '60s, the designer and her son-in-law Alain Reynaud became known for their restyling of Maria Callas.

Born in 1919, Gigliola Curiel did not establish her fashion house until after the Second World War. In the 1950s and '60s, she achieved fame with her little black dresses, nicknamed *curiellini* – the journalist Camilla Cederna called them *scemarelli*, meaning 'silly little things' – which became essential wear for well-to-do Milanese women.

It is impossible to discuss the women of Italian fashion without mentioning Roberta di Camerino, the professional name of Giuliana Coen. After a carefree childhood in Venice, in 1943 Coen had to leave Italy to escape the racial laws established by the fascist regime, which took away the rights of Jewish citizens. She and her husband took refuge in Switzerland, where she set up a small firm creating bags in embroidered velvet. After the war, the couple returned to Venice. Inspired by the film *Roberta* (1935)[30], a musical comedy starring Fred Astaire and Ginger Rogers, the designer combined the name with her husband's surname, Camerino, to launch the fashion label Roberta di Camerino. She opened a leather workshop and began using Venetian velvets woven on antique handlooms

39 Biki gowns at *La Scala*, Milan. Photograph by Gian Battista Colombo (Giancolombo), 1962

Opposite
40 Models in dresses by Jole Veneziani, 1956

Reorienting Fashion: Italy's Wayfinding after the Second World War

Vittoria Caterina Caratozzolo

Whoever deals in fashion is someone who is strongly aware of what's going on and can translate this awareness into something people can wear.
— *Emilio Pucci*

In the aftermath of the Second World War, the cards of the international game of fashion were reshuffled. Although Parisian haute couture was still the undisputed and dominant influence of Western fashion, the French fashion industry had to rebuild its image and its business connections after the German occupation from 1940 to 1944, and other countries, in particular Italy, were offered new opportunities to step into the limelight. The war had disrupted the aesthetic and economic balance that had shaped and regulated the international fashion market until then. It had also significantly affected the relationship between Paris and the United States, the country where new designs were in the greatest demand at the time. Oriented towards mass production, the formidable American fashion industry was eager for new trends and constantly in search of new partners and suppliers, as Bettina Ballard noted in her autobiography, *In My Fashion* (1960). Named fashion editor of *Vogue* in 1946, Ballard witnessed the emergence of Italy as one of the new European style centres, together with Spain and Ireland: 'Although Paris was the main objective of each trip, it was the door to all of Europe. I very soon found, along with the post-war travel-starved buyers and the fashion press, how pleasant it was to travel on an expense account with the legitimate excuse of looking over new fashion markets'.[1] Ballard's insight reveals the extent to which the international fashion system was configured as a 'centre-to-periphery framework',[2] where the quintessence of style trickled down from Paris haute couture as the authentic 'benchmark for any other fashion attempting to emerge'.[3]

The post-war social and economic situation therefore led to a redefinition of the international fashion scene and encouraged the emergence of new contributors, among which Italy stood out as a creative force hoping to claim a role for itself. In order to achieve this goal, however, Italy was not only required to reconstruct its own fashion industry, but also to redefine the cultural implications of a system that played a pivotal role in the relationship between producer and consumer – the idea of style as the merging of individual drives, collective attitudes and representations of national identity.

No less importantly, this complete reconfiguration of the Italian fashion industry required a process of emancipation from the dominance of Paris that went far beyond the self-sufficiency imposed by the fascist regime's policy on fashion. When Italy started on its path of self-awareness, independence

41 Simonetta dress designed for international travel. Photograph by Pasquale De Antonis. *Bellezza*, June 1955

and internationalization during the years of reconstruction, a cultural terrain for fashion had not yet been clearly defined and the language of fashion had to rely on other cultural frameworks, such as art and architecture, swinging between tradition and modernity as a result. 'The power of the [Italian] icon, its enormous allure, lies precisely in the coexistence of these opposing elements,' wrote historian Peppino Ortoleva, pinpointing how these two forces have determined Italy's success on the international scene.[4]

Over the last century, the modern and the traditional have been woven not only into the fabric of Italian fashion, but also its representations. At the beginning of the twentieth century, for example, the dressmaker and socialist activist Rosa Genoni applied elements she had seen in the paintings of the great masters of the quattrocento to her evening gowns, as illustrated by 'La Primavera' (1906), her embroidered dress inspired by Botticelli's masterpiece. By imbuing her new language of fashion with a Renaissance aura, she also wanted to boost the sense of national identity through style. In today's very different cultural context, a revamped evocation of Renaissance

artisans' workshops has helped convey the added value of craftsmanship in the promotion of current Italian fashion collections in Asian markets.[5]

In the post-war years and into the 1950s, the interweaving of old and new was particularly influential. This idea was also promoted in fashion magazines, which depicted Italian fashion and Italian culture as sharing the same vital core of national creativity. Writing in 1947 in *Bellezza*, a magazine devoted to Italian high fashion, Michelangelo Testa advocated a blend of traditional and modern outlooks in an article entitled 'Italia internazionale'.[6] While supporting the idea of Italy entering into a process of internationalization, which had been inhibited for a long time by the fascist regime's 'programmatic xenophobia', Testa emphasized the importance of avoiding any form of standardization, thus safeguarding the country's own cultural identity. 'Environment and tradition are secretively at work to construct for us a unique personality that can be retrieved in our gestures, in our taste, in the fruit of our work' – these words reflect the need to construct a national cultural identity, yet they also reveal how the

image of Italian fashion was not entirely represented by an autonomous, self-referential language, but was rather located in an external creative dimension.[7] The country's cultural and artistic heritage, exhibited in its ancient cities and sites as well as in its 'picturesque' views – for centuries both idealized and stereotypical backdrops in representations of Italy – became thus the objective counterpart of Italian prestige in fashion.

Testa's article was illustrated with Pasquale De Antonis's photographs (accompanied by narrative captions) of the most elegant styles featured in Italian couture collections of the day – from Sorelle Botti to Sorelle Fontana, from Marta Palmer to Gabriellasport. The choice of these designers was representative of Italian couture's cultural transition from the styles that dominated the interwar years to its post-war reconfiguration. On the one hand, Sorelle Botti – a fashion house established in 1911 in Rome by two sisters, Augusta Carlotta and Fernanda Botti – and Marta Palmer, the Milanese designer and dressmaker, embodied the best examples of the coexistence of French and Italian models. The latter is also known

for connecting fashion creation with her research on the notions of 'pure line and colour' advocated by avant-garde artists.[8] On the other, Gabriella Sport was a label founded in Milan in the early 1930s by cosmopolitan countess Gabriella di Robilant to promote sporty and resort lines inspired by Chanel and Patou – her 'spiritual masters' and international pioneers of sportswear.[9] Her garments embodied the glamour of the era's modernist bias in favour of simple, elegant and practical design, and paved the way not only for the post-war international consolidation of sportswear and casual chic but also for its international recognition. In 1937 department store Bergdorf Goodman invited Di Robilant to present her collection in New York, a precursor of Simonetta Colonna di Cesarò (who first starting producing clothes under her married name, Simonetta Visconti) and Emilio Pucci's successful experiences in the city in the 1950s. Although still in the early years of their careers, the three Fontana sisters, who founded their fashion house in Rome in 1943, were already engaged in the representation of Italian high fashion and craftsmanship.

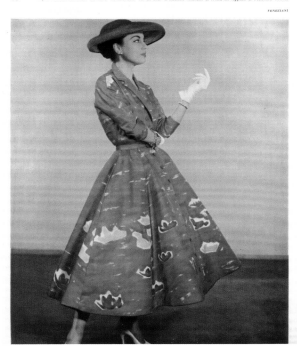

AZZURRO MEDITERRANEO

Sull'abito redingote azzurro luminoso in leggerissimo shantung di seta dipinta a mano di "Lini e lana", galleggiano le ninfee rosa pallido tra le foglie verdi del fondo azzurro oltremare nel clima "Mediterraneo" che dà nome al modello. Contrasto di verde, nel cappello di Francesca Maria.

VENEZIANI

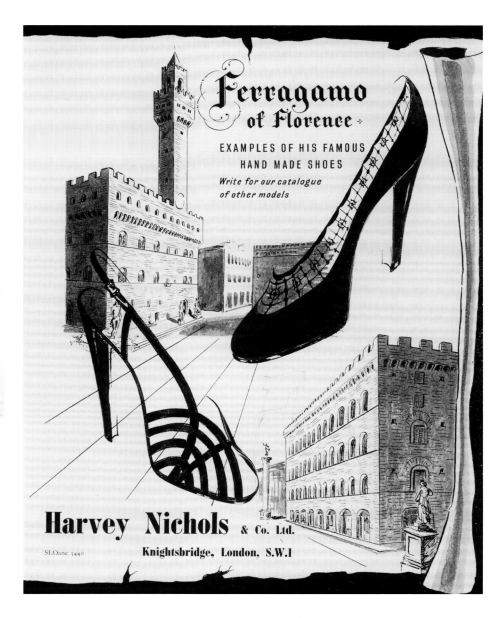

However, the evocative array of these designers' models, photographed in an ideal conversation with the masterpieces of Baroque and Neoclassical sculpture at the Galleria Borghese in Rome, did not effectively convey the drive for modernization that informed Testa's article, with one exception: the picture of a white fox fur cape by Balzani draped over the marble body of Paolina Bonaparte Borghese as carved by Canova (pl.42). Unlike the other pictures, which convey the feeling of an aestheticized stage built for this fashion parade, the surreal and even camp idea of 'dressing up' Paolina does represent more than a mere device to introduce and legitimize a fashionable item of clothing. This photograph appeals immediately to the beholder as 'an exercise in displacement'[10] – a pivotal practice addressed to the Italian fashion consumer. Wartime rationing and the regime's stigmatization of individual personality had subjugated the imaginative projection of the self (which lies at the basis of the consumerist drive) to

the paradigm of 'truth' or transparency in fashion, that is to say the perfect correspondence between the person and the dress. Fashion consumption, however, draws from the very asymmetry between these two entities. Disrupting any conventional and referential associations, De Antonis's picture of a perfect marriage between a marble body and a fur uncannily sets off 'a play in transitions between the real and the artificial', between fact and fiction.[11] With this photograph De Antonis audaciously shifts his focus from the object he depicts to the effect the picture has on the beholder. The image can be interpreted as a startling expression of the modern idea that the dynamics of fashion consumption are rooted in fiction, as well as in facts.

The many practical and theoretical issues explored in this groundbreaking article in *Bellezza* magazine testify to the complexity of the metamorphosis Italian fashion was undergoing in these years and also encourage us to take a closer look at some of the more significant strides it was making towards consolidation and international affirmation. By the late 1940s, some key names of Italian design had already been singled out by the international fashion press and – mainly American – fashion experts. Simonetta Visconti (pl.41), Emilio Pucci and the footwear designer Salvatore Ferragamo (pl.44) were among the first to earn good reviews in American reports from Italy. This was no coincidence: their approach proved better suited to the American taste and lifestyle, and they were also perceived as being 'glamorous' designers, unlike others who, though admirable, still appeared to be anchored to handicraft rather than moving forward into the modern sphere of glamour. As Marya Mannes made clear in a 1947 article for American *Vogue*, entitled 'The Fine Italian Hand', Italian fashion was immediately appealing for its 'wonderful materials' and presented itself as 'a seemingly inexhaustible pool of "handlabor".'[12] In this respect, it paralleled the success of the concurrent market in traditional domestic artefacts such as glass, ceramics, embroidery, straw and leather goods. Yet in her article Mannes forges a definition of Italian style that is only partially flattering: 'Italian clothes are inclined to be extrovert as the people who wear them – gay, charming, sometimes dramatic, but seldom imaginative and arresting.'[13] She goes on to say that 'it was difficult to discover any strong native current, except in the beach clothes'. It is interesting to note that about five years later, Mannes's insight was echoed by the influential editor-in-chief of *Harper's Bazaar*, Carmel Snow. Invited to attend the third Italian fashion show organized in Florence by Giovanni Battista Giorgini – the first of these important group shows, held in February 1951 at his impressive mansion, the Villa Torrigiani, was widely hailed as the birth of Italian fashion – Snow emphasized how 'the best of these fashions had a casual, yet aristocratic air, an offhand opulence that was all the more striking for being understated'. In particular, she applauded 'Italian fabrics and knitwear, especially the delicate work

Modello di Jole Veneziani
in tessuti Bemberg

L. 350
N. 44 - Giugno 1954
Editrice Novità
Spedizione in abbonam. postale - Gruppo III

of Marchesa di Grésy as well as, in a different vein, Emilio Pucci's smart, original sportswear'.[14]

Both opinions, though betraying an exoticizing outlook, are remarkable as external indicators of Italy's position in the international fashion system. While the Italian textile industry confirmed the traditional high quality of its production, consolidating a successful export sector, 'the Italian fashion industry was still in an embryonic state', as Nicola White has noted.[15] One of the most controversial recurring topics in the general debate about Italian fashion was, for instance, its dependence on the latest styles from Paris. Since the late nineteenth century, Italian fashion houses had felt obliged to satisfy well-off Italian women's yearnings for prestigious Parisian designs. After the Second World War, some commentators and journalists complained that although the regime's policy of self-sufficiency meant to demonstrate the possibility of an independent 'Italian' inventiveness, many domestic fashion houses had resumed the established practice of sending illustrators to the Paris shows twice a year to produce *croquis* (the term indicates the sketches made by the designer before a collection is produced as well as sketches based on the finished garment, called *croquis d'après* – while they convey the main impression of a garment, sketches do not reveal the technical details required for its actual construction) or buy original *toiles* (that is to say, early versions or patterns of a garment, made up in muslin or white cotton canvas in order to perfect the fit or for making copies) and accessories. Writing for the fashion magazine *I Tessili Nuovi* in 1949, Vera Rossi suggested that the pilgrimage to Paris was to be considered as the main cause of the 'laziness or inferiority complex that paralysed their creative faculties and to be regretted'.[16] Instead of leading to constructive criticism, however, the persistent stigmatization of Paris risked serving as a mere scapegoat. For many dressmakers, Paris meant an opportunity to improve their skills and a vital cultural exchange: 'copying' its styles could even stimulate their own creativity, since the models needed to be 'adapted' to the Italian lifestyle. Adaptation belongs to the same semantic field as 'translation', and soon became of fundamental importance in the relationship between Italian fashion and the production of ready-to-wear collections for the American market. In the history of Italian fashion, developments in style and industry went hand in hand.

However, domestic criticism became valuable when it was able to point out to Italian designers elements of their own art of which they were not yet conscious. Such was the case with a piece by Irene Brin entitled '*Obiettivi puntati sull'Italia*' (Cameras focused on Italy), published in *Bellezza* in 1950. Brin took the perspective outlined by the photographic gaze of Karen Radkai, who was in Italy with her husband Paul on assignment for *Harper's Bazaar*:

Last month two great American photographers, Paul and Karen Radkai, again came to Rome to take pictures of people and things considered important in America . . .

Karen Radkai photographed for her magazine and acquired for herself only those works from the designers that she found 'sufficiently Italian': and she must have used this phrase, in essence definitive, almost continually, and it could become a motto for our high fashion, certainly not for reasons of patriotism or rigor, which would become irritating, but out of calculation, out of astuteness, and with reason. Karen Radkai's personal shopping could symbolize and summarize that of all American women in Florence and Rome: . . . large, soft leather bags . . . comfortable, agreeable and inexpensive shoes. Fabiani's suit in green wool, with a black belt. Fontana's light and dark outfit. The low-necked and sleeveless dress of black wool, but enlivened by a few pieces of costume jewellery from Gabriellasport. The two little shantung dresses from Gattinoni . . . Gucci's umbrellas . . . Roberta di Camerino's buckets. She liked our artisans . . . She liked everything that matched an image that was indeed established in advance, but at the same time suggested very new possibilities. That Italy is now enjoying an almost romantic vogue, we all know: and so let us try to keep it that way, by deserving it.[17]

Brin took the opportunity to confront the world of Italian fashion with the best image of its own creativity, until then still elusive and too fragmented, as it reverberated from an external vantage point. Was it possible, at this point in history, and through this reciprocal gaze, to identify any authentic Italian style of dress? It was, at least to Brin as well as to both Mannes and Snow, who highlighted some of the most creative features of Italian design. The five years that separated their two appreciations was a particularly innovative time. The original touch of Italian beachwear, an apparently 'peripheral' line of clothing prized by Mannes, became one of the springboards of *moda boutique* or boutique fashions – the novel and exclusively Italian genre that inspired Snow's enthusiasm. It can be defined as high quality, small scale and artisan-made ready-to-wear: just a level below high fashion, it insisted on wearability, simplicity of cut and versatility, and ranged from casual daywear chic and sportswear to resort fashion. From the moment these clothes were presented at the shows in Florence along with the high-fashion collections, these features could not but appeal immediately to American tastes and to the buyers for the great department stores. In 1994, Luigi Settembrini described the centrality of this distinctive high-style genre:

The boutique collection did the most to differentiate the Florentine shows from their Parisian equivalents: they provided a venue for the unfettered expression of fanciful shapes and colours, the inclusion in a humorous and irreverent vein of the boundless resources of Italy's history of art and folklore, the surprising juxtaposition of a wide array of diverse fabrics, from the plainest to the most exquisite. The boutique collections were forums for freer experimentation in terms of materials and in terms of production and cut . . . The idea was to position Italian fashion as the modern expression of an aesthetic taste well

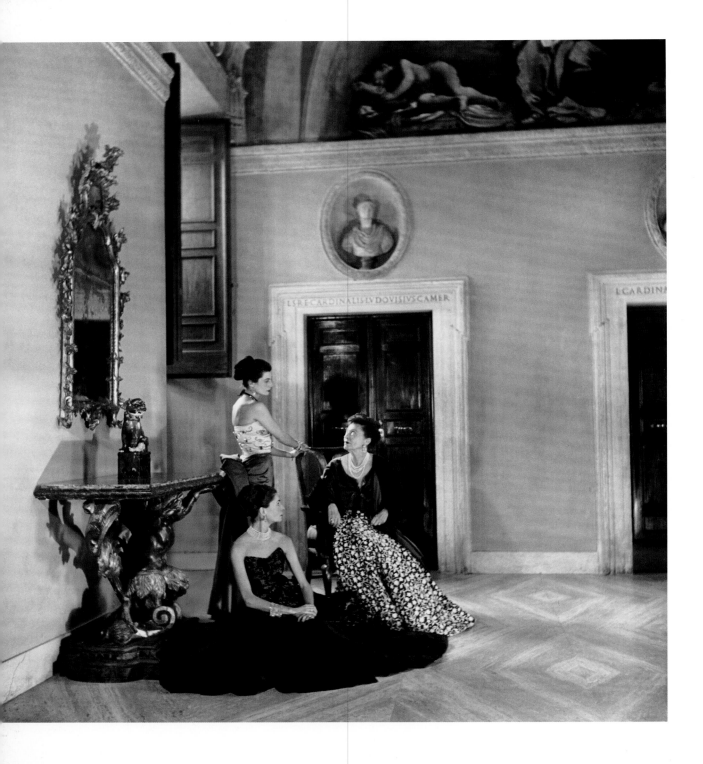

46 Duchess Colonna di Cesarò and
her daughters, Mita and Simonetta,
wearing designs by Simonetta.
Photograph by Clifford Coffin.
American *Vogue*, March 1949

47 Simonetta, short red faille jacket
and black silk taffeta matador
trousers. Photograph by Norman
Parkinson. American *Vogue*,
February 1952

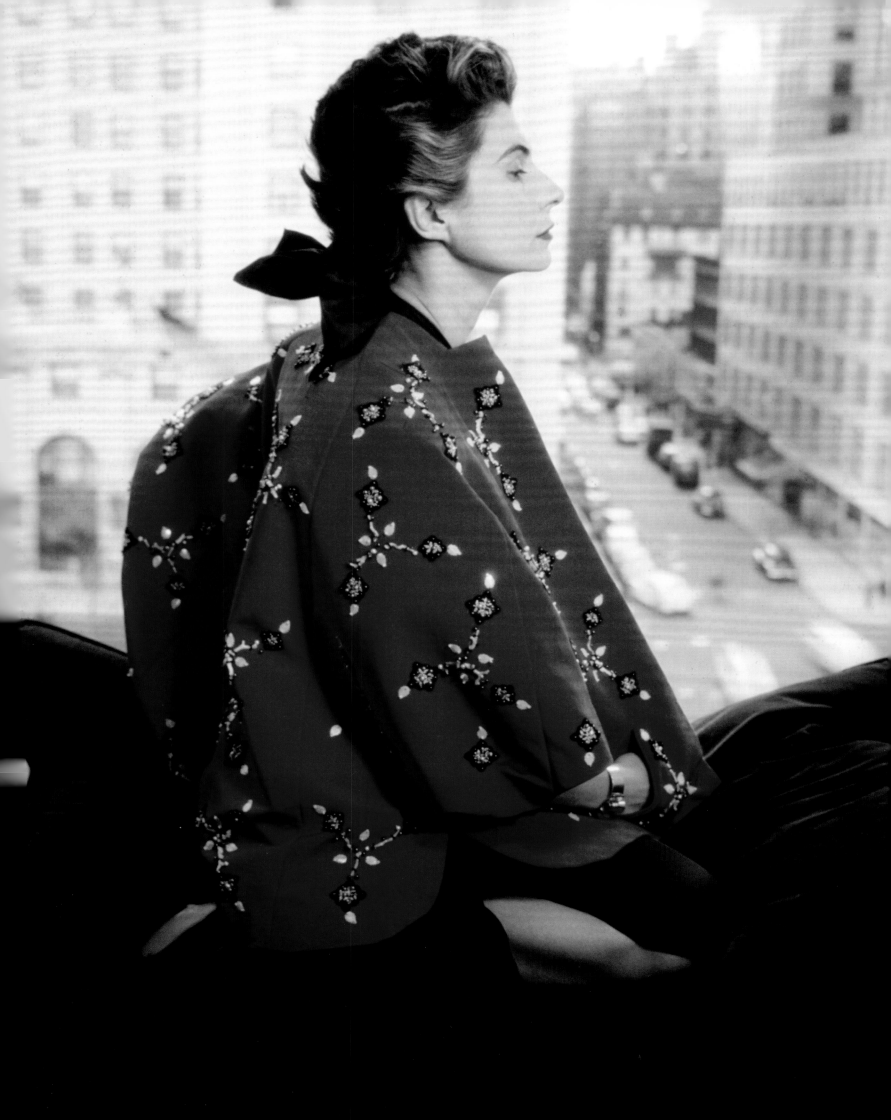

48 and 49 (detail)
Emilio Pucci, beach playsuit of white printed cotton with poodle motif, 1958
V&A: T.68–2009

Opposite
50 Mirsa, hooded knitted jackets. Photograph by Giovanni Maria Fadigadi. *Novità*, February 1958

51 Germana Marucelli, black canvas dress with coloured inserts of black masks designed by the painter Pietro Zuffi. *Bellezza*, May 1951

trained in the natural elegance of line, in the harmony between shape and concrete function, in an expressive use of colour, and in an inventive relationship with materials.[18]

Settembrini's appreciation of boutique fashion has the merit of interpreting the sartorial language of this fresh genre without anthropologically naturalizing its style, which could endow it with stereotypical and anti-modernist connotations. This emphasis on the garment and its construction not only contributed to highlighting this unique, innovative formula in the international marketplace, but also ascribed its national connotations to an element of local craftsmanship. This idiosyncrasy also matched the success of Italian interior and furnishing designers of the time, who were experimenting with the industrial production of fresh and audacious combinations of forms and materials. The interaction between fashion and design was evident in the two-week exhibition dedicated to Italian design organized by the Stockholm department store Nordiska Kompaniet in 1953. Examples of new furniture and home furnishing designs by Giò Ponti, Ignazio Gardella, Franco Albini, Vito Latis and the lighting designer Gino Sarfatti were complemented by a presentation of the latest fashion designs by Pucci, Fabiani, Simonetta and Veneziani. In the magazine *Novità*, a review of the event was accompanied by a picture highlighting the union of these two arts: a model wearing a Pucci boutique ensemble appears to be juggling with three of Giò Ponti's *Leggera* chairs – the forerunner of his more famous *Superleggera* chair of 1957 – which are suspended from the ceiling like a mobile. It is interesting to note that the article pointed out how Italians' appreciation of their country's fashion design lagged behind the praise from America.[19]

In his capacity as a buying agent for grand American department stores before and after the war, Giovanni Battista Giorgini was a reliable interpreter of both the requirements of the American fashion market and the Italian desire to affirm its own creativity abroad. Under his keen direction, the shows in Florence became the main event at which Italian self-perception met external recognition. Not only did this event produce a significant advancement in business relationships, but it also revolved around methods of industrial production and the replication of designs, of which Italian fashion houses that used to copy French couture and translate it for the Italian market still had no experience at the time. Italian fashion designers were instead in a position where their own models were being copied. As Nicola White notes, 'it is apparent in *WWD* [*Women's Wear Daily*] coverage that from 1951 US ready-to-wear manufacturers (predominantly from Seventh Avenue) came to Italy in increasing numbers to buy both boutique

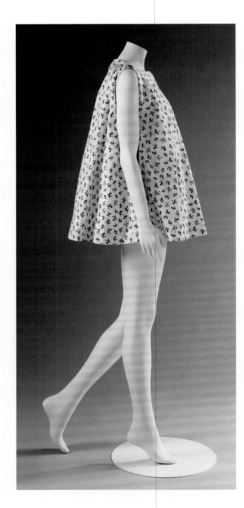

and high fashion design for translation and "volume reproduction"'.[20]

While their designs underwent the close scrutiny of manufacturers interested in the 'good body' of their garments, Italian designers had the opportunity to learn new and different modalities of clothing construction, production and distribution. This enlightening experience also represented a crucial step towards Italian serial production, which had been neglected until then, seeing as Italian fashion still hinged on the supremacy of made-to-measure and one-off production. The designers appreciated manufacturers' skills in distilling a model down its most well-balanced and succinct essence, bringing out its full potential and translating it in the language of standardization. In a 1956 article entitled '*America insegna*' (America's Lesson), journalist Elsa Robiola wondered whether it was finally time for Italy to learn the lesson of how to dress in the future from 'a country which does not dress like us, but takes ideas from us'.[21] In short, if ready-to-wear turned out to be the most appropriate clothing formula for the modern American lifestyle, then it was very likely that the same idea of fashion would prove successful in the rest of the world. Out of this fruitful confrontation, Italian designers gained a new awareness of their own couture. Through a technological process of abstraction and simplification,

reproduction channelled their sartorial ingenuity into a self-reliant language capable of mobilizing their style as a circulating token, and 'circulation is the life of fashion', as Paula Rabinowitz has pointed out.[22] The boutique fashion formula, now plotted on the international fashion map, translated the transition from local artistic and environmental heritage to sartorial creativity that had inspired it into an international 'wearable' way of life. As exemplified by Pucci prints that reproduced the glass mosaics of the cloisters at Monreale, Sicily, the colours of the Palio di Siena or crests and emblems from the Renaissance, boutique collections could release a stylized formula of Italian beauty and charm into the world, made available for immediate consumption.

Boutique fashions thus played a central role in democratizing the glamour and the sense of remoteness conveyed by the early iconographic repertoire of Italian high fashion, as represented, for example, by a Clifford Coffin picture of designs by Simonetta, published in *Vogue* in 1949 (pl.46). He showed Simonetta herself, along with her mother, the Duchess Nina Colonna di Cesarò, and her sister, the Countess Mita Corti, wearing sumptuous evening gowns from the designer's collection. The women were photographed at the Villa Boncompagni Ludovisi in Rome, under the vaulted ceiling of the Casino dell'Aurora with its frescoes by Guercino. The

Continuità di gusto e di eleganza

Per i giochi sulla spiaggia due camiciotti con righe colorate a lavorazione alternata liscia e in rilievo. Destinati alle giovanissime hanno incontrato un successo grandissimo in America.

53

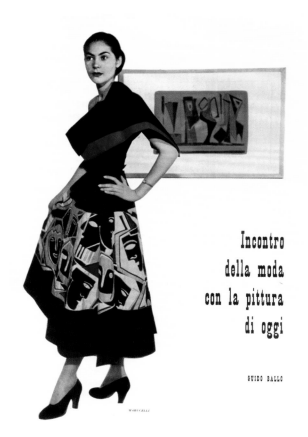

Incontro
della moda
con la pittura
di oggi

GUIDO BALLO

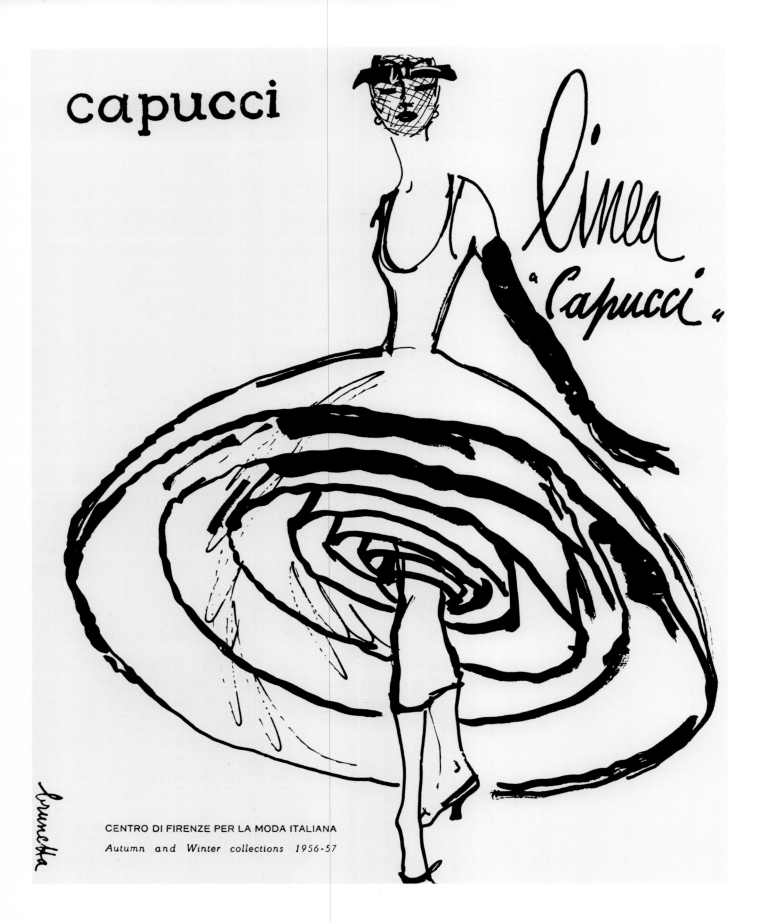

52 Brunetta Mateldi, advertisement
for Roberto Capucci's Autumn/
Winter 1956 collection

53 Mila Schön, evening dress
of embroidered net with crêpe
petticoat, 1966
V&A: T.401&A–1974

aristocratic world, as exemplified by the conversation-piece-like quality of this image, was now within reach of every woman who could wear a boutique playsuit by Simonetta or Pucci, available at Bergdorf Goodman in New York or Simpson's of Piccadilly in London, as well as in Florence or Rome. This crucial cultural shift contributed to the dissemination of Italian heritage in the form of a fashion commodity and, pulverizing the elite experience of the Grand Tour – a cultural phenomenon from the late seventeenth century until the middle of the nineteenth century – it turned the country into a desirable destination for mass tourism and consumption. Over time, the increasing denaturalization of taste as a central aspect of the modern meaning of fashion also contributed to the deconstruction of the role played by a generation of aristocratic entrepreneurs devoted to fashion design, including names and titles such as Duchessa Simonetta Colonna di Cesarò, Marchese Emilio Pucci di Barsento, Marchesa Olga di Grésy and Principessa Giovanna Caracciolo (founder of the Carosa label), who 'traded on their sophisticated notion of exclusive Italian "good taste"' (see also pp.34–41).[23] Fashion as a commodity now began to be invested with the glamour historically embodied by aristocracy, as Reka Buckley and Stephen Gundle have explained: 'More important was the semblance, or reproduction, of distinction, stylishness, wealth and breeding that could be manufactured by commercial culture or through the media. This artificial aura, detached from the class that had created it and turned into a manufactured property, was the essence of glamour.'[24]

Moreover, this new role of fashion, which affected the cultural and social background of Italy in the post-war years, not only brought about fruitful new exchanges between designers and the textile industry, but also had an impact on the relationship between high fashion and ready-to-wear. On the one hand, it prompted the production of fashionable mass-market women's ready-to-wear, elevating its status in the world of style; as early as 1951, the middle-market Italian department store chain La Rinascente began advertising its first fashionable ready-to-wear collections in *Bellezza*. On the other hand, high-fashion designers embarked on imaginative collaborations with artists: for instance, in 1951 Germana Marucelli, who had previously cited Fra Angelico as one of her major sources of inspiration, began collaborating with painters such as Pietro Zuffi, Massimo Campigli and Getulio Alviani (pl.51). Around the same time, L'Obelisco, one of the leading art galleries in Rome, run by Irene Brin and her husband Gaspero del Corso, began promoting joint exhibitions of art and fashion. In 1947, for example, the opening of an exhibition of posters by Toulouse-Lautrec was celebrated by a runway of models, wearing the latest collection of hats by the milliner Clelia Venturi.

The time had come for Italian fashion to embark on a relentless course of growth and the mobilization of its resources, from visual media to the establishment

of institutions representing and promoting the fashion industry. Domestic and international shows started appearing in the calendars of many Italian fashion designers, who, more intrepid and confident in their creativity, began spreading their style worldwide, as Irene Brin wittily noted:

Following the activity of Italian couture designers now requires a lot of patience, a good grasp of geography and a sense of timing. Soon we are going to hang a huge map of the world up on the wall and stick little flags onto it: Faraoni is in Tehran, Schuberth in Johannesburg, Emilio Pucci at St Moritz, Roberto Capucci in Stockholm, two Fontanas in Pittsburg, Simonetta and Fabiani are awaited in Tokyo, Olga di Grésy has just left Tahiti.[25]

In the 1950s, Italian fashion succeeded not only in exporting its traditional high-fashion collections, but also in experimenting with the creation of garments designed to meet all the needs of a modern life on the move. Further, it was also interested in meeting the aspirations and desires of people with different lifestyles, and in registering the ongoing blend of ideas and influences. This inclination, however, did not evaporate in a vague form of exotic eclecticism in fashion trends, but was received instead as a constructive challenge to the traditional sartorial language of Italy. 'It's through technique,' the dressmaker De Luca explained to the writer Gianna Manzini, 'that I strive to gain control of what has flashed through my mind as a poetic fantasy'.[26]

This survey of Italian fashion in the years following the war set out to trace its path as an emerging country on the map of international fashion. Italian fashion became aware of its own style: a pivotal notion working synergistically on its own multilayered language and on the appropriation of the consumer's 'aim towards singularity', as the emergence of *stilismo* consummately demonstrated from the 1970s onwards.[27]

Vittoria Caterina Caratozzolo teaches courses in Fashion Theory at Sapienza University, Rome

The Italian Fashion Revolution in Milan

Simona Segre Reinach

The making of an Italian fashion identity

Fashion is without doubt an important aspect of contemporary Italian identity. The very expression 'Made in Italy' evokes an image discrete from the majority of past opinions. 'Through fashion, Italians in the 1970s "lost their accent",' the journalist Silvia Giacomoni wrote in 1984, 'and in the process they transformed their image from the most proficient manufacturers of textiles and fashion goods, which bore the prestigious Made in Italy label, but translated their talents to construe an idiomatic Italian Look.'[1] What *accent* did Italy lose in the 1970s?

In the past, and I refer to the tales of foreign travellers in the sixteenth and seventeenth centuries, Italy mainly used to signify Ancient Rome and above all the Renaissance, as Walter Pater in the mid-nineteenth century clearly demonstrated. In the eighteenth century the tradition of Italy as the 'Land of the Renaissance' still prevailed, despite the growing concerns of those venturing to a country where one could easily encounter poverty and altercations, especially in the south. Naples was somehow the impassable limit, beyond which anything could happen to the unsuspecting traveller. The concept of the picturesque, however, manifests itself in many works of art. For example, the famous painting by Zoffany, *A Florentine Fruit Stall* (c.1777), contributed to bringing together, in a manner of speaking, Italian art and everyday life, as in an *ante litteram* exercise in cultural studies. However, in the nineteenth century this vision began to crumble and Italy was suddenly confronted with the loss of its reputation. The Grand Tour, a fundamental experience for many young men of the upper class, had already lost its significance. Visiting Italy was no longer so important for the personal growth of the European elite. On the one hand there was the Italy of Byron's narrative poem 'Childe Harold's Pilgrimage' (published between 1812 and 1818), but on the other there was the 'Land of the Dead', the description of Italy famously used by the French poet Alphonse de Lamartine in *Le dernier chant du pélerinage d'Harold* (1825). Italy could no longer rely on its history: 'In his work, Lamartine presented Italy as a place "asleep in the midst of a universe in motion"; he called the country a land of the past and Italians a shadow of a people who had slumped to insignificance.'[2]

Le dernier chant du pélerinage d'Harold was just the beginning of the dismantling of the myth of the aesthetic and moral superiority of Italian culture. Despite Byron and Stendhal, who loved Italy and identified himself as Milanese, Klemens von Metternich's statement that 'Italy is just a geographical expression', made on 2 August 1847 at the dawn of the *Risorgimento*, the movement that led to the unification of the country under the Savoy Kingdom in 1861, paved the way for a long series of negative stereotypes about Italy.

In 2011, the year Italy celebrated 150 years of unification, Francesco Bonami titled an exhibition he curated at the Fondazione Sandretto Re Rebaudengo in Turin, not by chance, *Un' Espressione Geografica* – a geographical expression. It offered 'a composite portrait of the social, political and cultural panoramas of modern-day Italy, relating the marvellous contradictions that characterize a country in constant dynamic conflict between tradition and innovation, history and contemporaneity'.[3] Bonami's purpose was to highlight, through the eyes of certain foreign artists, the richness of the Italian background and its diverse traditions, which in today's global culture are considered a valuable quality. However, less than a hundred years after unification, Italian complexity was still primarily viewed as a contradictory

59

X

ETRO
MILANO

Qiana®

55 Walter Albini, Advertisement
for Qiana and Etro, *Vogue Italia*,
May 1973

56 Illustration for Walter Albini
press release, 1973

Opposite
57 Rocco Barocco with models,
New York, 1972

reputation between beauty and backwardness, excitement and danger, especially by the Americans who were to become the most important partners for the construction (or the reconstruction, as Nicola White calls it) of Italian fashion.[4] Mass migration of disadvantaged Italian workers seeking opportunity in the United States helped to consolidate the negative side of the Italian stereotype.

For the fashion industry to succeed, it required a strong ideology to sustain it, to transform the manufacturing industry into a cultural industry. Today, fashion is recognized as a 'total social fact', to adopt the anthropological categories of Marcel Mauss, and this is especially true for Italy. Although Italian fashion after the Second World War arose from a context seemingly unattached to history or politics, and more specifically from a business opportunity glimpsed by the visionary Giovanni Battista Giorgini, the relationship between ideology, nationalism and the economy proved once again of great importance. Since its inception at whatever date, *ex post facto*, the beginning of a specifically Italian fashion is seen – during the 20 years of fascism, or the Florentine fashion shows of the post-war years, or the invention of ready-to-wear in Milan in the 1970s – fashion for Italy has been an identity issue.[5] In any case, the discussion of Italian fashion as a foundational aspect of the country's identity became possible only thanks to the invention of ready-to-wear by *stilisti*, with the rise of Milan as a fashion capital, a system that sheds light both on Italy's sartorial past and its future development.

Under the fascist regime, Italian fashion was unrealistic from the point of view of the structures on which it could rely. It was lost insofar as it was hopelessly flawed by the ideology of totalitarianism;[6] the aim was to depose French fashion by physically preventing the import and purchase of Parisian clothes. With the post-war reconstruction and American aid, the Italian fashion industry tried to bracket off the fascist bankruptcy and resume competition with Paris on a different basis. However, as a result the modern instances that fascism had implemented in the meantime, perhaps against its will and among irremediable contradictions, were also lost.[7] Italian fashion in the 1950s revived the comfortable old 'Ruins and Renaissance' construct. This was an aristocratic fashion created by aristocrats, like the Duchess Simonetta di Cesarò, Marquis Emilio Pucci, Princess Giovanna Caracciolo and many other couturiers and Italian tailors of noble lineage. The Renaissance thus returned as a rhetorical figure for Italian identity, in spite of the fact that a new phenomenon– namely the fashion boutique[8] – was becoming the strong point of Italian fashion, breaking with the rituals of the atelier and haute couture in Paris to ensure that Italian fashion could establish itself through differentiation. Fashion in the 1950s was still viewed as an expression of good taste and the cultural capital of Italy, in the words of Pierre Bourdieu. In this sense, Florence was perfect as the first location of

58 Walter Albini, Milan.
Photograph by Alfa Castaldi, 1971

Opposite
59 GFT, Turin. Photograph by
Alfa Castaldi, 1983

nascent Italian fashion. Like a young Poiret, Giovanni Battista Giorgini organized costume parties in the pure Renaissance style that drove foreigners into ecstasy. The most famous was held on 25 January 1953 at the Palazzo Vecchio, where guests dressed in sixteenth-century costume re-enacted the famous wedding of Eleonora de' Medici to Vincenzo Gonzaga, which was celebrated in Florence on 29 April 1584.

'As I was looking out the window it seemed normal to me that a beautiful city like Florence should be the centre of fashion. The French had Paris, but Italy had Florence!'[9] So stated fashion publisher John B. Fairchild. It was not yet clear at the time that French fashion was not so much a matter of taste as the result of a historical decision and a political thought formulated as early as the days of Louis XIV, which laid the foundations for what would become the system of haute couture created by Charles Worth in the mid-nineteenth century. In the 1950s, Italian fashion was far from being a system; it was just beginning to craft its future identity. However, in under 20 years, with the growth of companies and the growth of the textile and leather industries – the two main sectors of Italian fashion favoured by the Marshall Plan – and thanks to the success of the Florentine fashion boutiques, the ingredients were ready to be assembled. Even if the

ingredients and the recipe were in place, there was still no container in which to put them for the alchemical transformation from beautiful, high-quality clothes into a new concept, available for a booming middle class, not just in Italy, to take place. Florence, the city of art, was too small and antiquated to support the development of the nascent ready-to-wear sector, an innovative project that had to do with both French luxury *prêt-à-porter* and American ready-to-wear. As the journalist Adriana Mulassano wrote in 1979, 'High fashion, that fantastic showcase for our finest textiles, soon gave way to ready-to-wear.'[10]

The first to leave Florence for Milan was Walter Albini (pls 55, 56 and 58). A transitional figure between the so-called Florentine fashion boutiques and the brand system that did not yet exist, he is considered the first Italian fashion *stilista*. His aim was not to create the perfect outfit, as a couturier would, but to invent the perfect style, as the new creator of new Italian fashion, the *stilista*, must do. The word *stilista* is impossible to translate: the English word 'stylist' means something completely different, and so the term is conventionally translated as 'fashion designer'. But the word is in itself a key to understanding the core of the Italian fashion identity, namely the creation of the ready-to-wear system that developed in Milan. 'Putting It Together' is how *Women's Wear Daily* chose to define the experiments of Albini, the forerunner of the *stilisti* and the inventor of the Italian Look.[11] This meant consolidating the collections offered by companies such as Basile, Escargots, Callaghan, Misterfox, Diamant's and others he collaborated with under the single label 'Walter Albini for'. Albini was the precursor of a process that began in 1972 and was completed in 1978 with the creation of Modit, the organization that regulated the scheduling of Milan fashion shows, by Beppe Modenese (pl.54). By 1974, the shift towards Milan was already substantial: among the first to follow Albini to the city were Krizia (pl.60), Caumont, Trell and Missoni. The famous contract between Giorgio Armani (pl.61) and Gruppo Finanziario Tessile (GFT) of Turin (pl.59), the company that more than any other helped create the system of Italian fashion design, was also signed in 1978. John Potvin described the role the company played at this time:

Carlo Rivetti, son of Silvio Rivetti, the founder of one of Europe's leading textile manufacturers, recently noted that in the late 1970s, faced with the oil crisis and a general and significant decline in textile production and fashion consumption, GFT was compelled to think of new ways to increase sales and fill what he identified as the void left by French manufacturers in the 1960s and 1970s. According to Rivetti, what they did was 'to incorporate fashion' into the mix. Their first initiative was to sign one of the most significant and lucrative licensing agreements in history with a then fledgling designer, Giorgio Armani. GFT continued its licensing manufacturing with the likes of Ungaro and Valentino, paving the way for the birth of the 'Made in Italy' phenomenon.[12]

Giorgio Armani with GFT represents the ready-to-wear model, distinguished by the link between a designer and an industry. In 1979, Adriana Mulassano explained the designer's great importance for the future of 'Made in Italy':

> As of last year, [Armani] has re-entered corporate ranks, signing a contract with the Gruppo Finanziario Tessile, where incredible technicians and highly skilled workers make it possible for him to devote every ounce of his energy to designing his collections, and where fool-proof mega-mechanisms of distribution have allowed him to expand his market to the full potential of his prestige.[13]

The *stilisti* were often linked with the figure of an entrepreneur. In addition to Giorgio Armani and his business partner Sergio Galeotti, a few examples are Valentino and Giancarlo Giammetti, Gianfranco Ferré and Franco Mattioli, Mariuccia Mandelli (Krizia) and Aldo Pinto, Rosita and Ottavio Missoni, Alberta and Massimo Ferretti, Franco Moschino and Tiziano Giusti, and Domenico Dolce and Stefano Gabbana. One result of this combination was the so-called industrial aesthetic that characterizes Milanese ready-to-wear. In particular there are four fashion designers who are often described as 'having developed that style so similar to the design and industrial design that became the characteristic feature of Italian ready-to-wear: Giorgio Armani, Mariuccia Mandelli (Krizia), Missoni (Ottavio and Rosita) and Gianfranco Ferré'.[14]

Milan as a Fashion City

Italy could be considered as the sum of its diverse locations and talents – as in the view of Francesco Bonami, cited earlier – where the vernacular represents the richness of a country whose capital, Rome, is only one of many beauties. This is, to some extent, the prevailing view today: every city, large or small, and every region has a different historical and cultural background, a different aesthetic and different skills. In a globalized world, this is greatly appreciated. However, when it came to Italian fashion, in the 1970s and '80s, there was only Milan.[15] In 1979, journalist Natalia Aspesi wrote:

> In Milan, from morning till night, the sacred rites of prestige fashion are performed. Fashion is not that of great designers any more, but of the small and medium garment manufacturers who have imposed upon the whole world the idea that to dress in the Italian style is a sign of intelligence, taste and keeping up with the times.[16]

Competition with France, only imagined during the fascist era and rumoured in Florence in the 1950s, became a reality in Milan beyond any expectation:

> Since 1975, when the first calendar of events was organized by the National Chamber of Italian Fashion, the success of ready-to-wear fashion in Milan has become so firmly established each season, that it equals – and even outshines – that of Paris, in the minds of both buyers and the press. As

an example, one need only quote the figures for the October 1978 season: some 50 fashion shows in five days, 1,500 buyers, 100 Italian and 197 foreign press correspondents.[17]

Why Milan? Post-war Milan was already the scene of several experiments. In the 1960s, the department store La Rinascente offered clothes by Pierre Cardin for the first time: the same as those sold in the boutiques, but at a lower price. Since the 1950s, La Rinascente had also been producing its own ready-to-wear line under the Apem brand name. Biki of Milan designed for the celebrated Cori label, owned by GFT, from 1960 to 1966. Compared to other Italian cities, Milan was open-minded and cosmopolitan. Elio Fiorucci, sensitive to youth sub-cultures, had already opened his famous store influenced by Carnaby Street and Biba in the city in 1967. The Giamaica bar in the Brera district was the meeting place for writers, photographers, journalists and artists. It was frequented by Alfa Castaldi and Anna Piaggi (pl.62), two characters central to constructing the image of Italian fashion, which was at once Milanese and cosmopolitan. Piaggi wrote:

When I think of the glorious and animated history of the Italian Look, a host of episodes and images appear before my eyes: a model standing on top of a Land Rover in the courtyard of the Palazzo Strozzi in Florence, wearing one

of Lancetti's military coats, Verushka in a Ken Scott tiger-print, on the grand stairway of the Brera, Walter Albini's 40s styles photographed in front of Kafka's home in Prague in that fateful May of 1968, Ali McGraw in a Capucci in Tivoli, models in Missoni pullovers waving starter flags, an Emilio Pucci against a sunset in Baalbeck. There were many hours spent with Alfa sitting at the Biffi Scala Café or at the Giamaica bar, eagerly flipping through the Bibles of fashion . . .[18]

If in Florence fashion was associated with Renaissance art, in Milan the model was industrial design. Milan was Italy's capital of design before becoming the fashion capital. Industrial design rose to prominence in Milan in the early 1950s, with names like Ettore Sottsass, Marco Zanuso, Vico Magistretti and Achille Castiglioni. Companies such as Arflex and Cassina, with whom Giò Ponti worked, experimented with formula design and manufacturing. Fashion made this formula its own and developed it on a mass level.

Interesting hybridizations between industrial design and fashion were developed in the 1980s, like the soft design of Alessandro Mendini at Studio Alchimia, the experiments by Paola Navone and members of the Memphis group with radical architecture, the magazine *Modo*, and innovations by fashion designer Nanni Strada, winner of the *Compasso d'Oro* prize in 1978.[19] As Paulo Volonté writes on this subject:

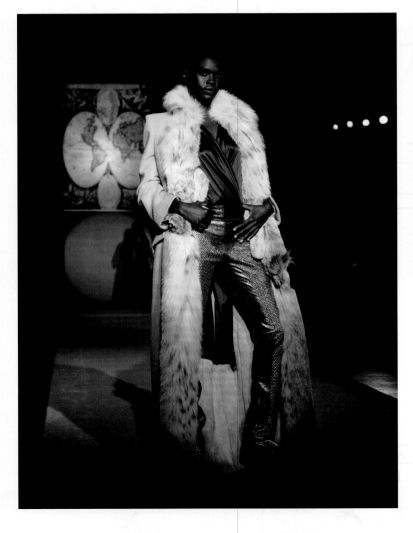

TRUSSARDI

MILANO FIRENZE ROMA PARIGI MONTECARLO NEW YORK TOKYO HONG KONG

66 Enrico Coveri, Florence. Photograph by Alfa Castaldi, 1978

Opposite left
67 Pino Lancetti, fashion plate, Autumn/Winter 1968 collection

Opposite right
68 Max Mara sketch for SportMax coat, Autumn/Winter 1969

The contiguity of the two systems [fashion and industrial design] and a kind of cross-fertilization between them has certainly favoured the positive attitude of Milanese fashion designers toward the production system . . . In Milan – as said is even more a capital of design than of fashion – there have always been examples of product designers turning their hand to the design of clothes. The examples are particularly frequent in the 1970s and 1980s, the same economic and cultural turn in which Italian prêt-à-porter was born. A typical case is that of Archizoom Associates, an avant-garde group of architects and designers who conceived design in the service of the needs of everyday life, logically including clothing as well.[20]

The expansion of Italian fashion took place in a pattern dictated by necessity. On the one hand, there was the increasingly powerful imagery of celebrity models – supermodels were 'invented' by Gianni Versace and Enrico Coveri – along with spectacular fashion shows, like Trussardi's; on the other hand a very structured business vision developed, divided into first lines, second lines, jeans (which became designer jeans), perfumes and licences that made fashion designers into sellers of lifestyles in addition to being creators (pls 66–7). 'Designers, then, bear the important responsibility of communicating an idea. Theirs is like a secret society, a special ethnic group made up of pioneers, a few inventors and a few poets,' wrote Anna Piaggi. 'They are the new phenomenon and the new elite.'[21]

By the 1980s, the process was complete. 'Made in Italy' became its best-known product – excess, transgression, glamour.[22] The brand-name system was internationally consolidated and at the same time an evolution began that transformed it radically. Almost

imperceptibly, the most experimental and innovative phase of Italian fashion gave way to the needs of marketing and internationalization. Any designers who didn't want to adapt, like Romeo Gigli, who found himself in disagreement with what increasingly looked like a Milanese dictatorship, chose Paris as their main venue. Many names of the time were lost: I am thinking of Basile, Bellotti, Correggiari, Lancetti, Massei and others who constitute what Paola Colaiacomo called the '*fatto in Italia*', as opposed to a 'Made in Italy' that was being emptied of its original meanings.[23] Emerging from this change was Prada, a Milanese leather goods company founded in 1913 that was relaunched by Miuccia Prada in the 1990s under the banner of minimalism and a cerebral concept of feminine beauty (pl.69). Still in *stilismo*, Prada already was a solution of continuity with the system of brand names. Outsourcing of production and financial outlays in fashion did the rest and the Italian fashion invented in Milan took on a new role.

The Italian Pipeline and the Textile Districts

The Italian fashion sector is composed of two main supply chains or pipelines: textiles/clothing and leather/footwear/accessories. A supply chain, in the definition of Stefania Saviolo and Salvo Testa, is 'a system of interrelations separable into multiple parts' situated upstream and downstream of the production cycle.[24] Each stage is thus a sector unto itself and can be related both to those aspects involved in the production of fibres up to the finished product and those of support, like the textile machinery sector, for example, with a tertiary sector including publishing, advertising and public relations. The development of supply chains and their integration was made

possible by the existence of both ancient and recent production districts. These districts have enabled Italian companies to compensate for the disadvantages typical of small- to medium-sized organizations, with their family character. The transformation of the supply chains and production districts influenced the evolution of the Italian fashion industry.

The major Italian textile industries started to develop between the mid-nineteenth century and the early twentieth century, with wool being the oldest sector. This so-called light industry, the silk and cotton industry, based on the work of women and girls, was located in towns and small cities in northern Italy. Biella was known for producing fine wool by the late nineteenth century and knitwear was already being manufactured in Turin, Milan and Genoa in the second half of the nineteenth century.[25] The textile company Marzotto di Valdagno was founded in 1836, Lubiam di Mantua in 1907 and Ermenegildo

Zegna di Trivero in 1912. In the late nineteenth and early twentieth centuries, the production of footwear became mechanized. This led to a decline in the previous regional production of shoes, in the Marche region, for example, and the emergence of new centres in northern Italy, where tanneries grew significantly. The main centres were Milan, Brescia and Varese. In Vigevano, the *Calzaturificio Società manifatturiera pellami e cuoi* was founded in 1892, and in 1899 the organization that went on to become the *Calzaturificio di Varese*. As well as in Lombardy, in the early 1900s shoemaking also developed in Turin and Piedmont, Veneto, Emilia and Tuscany. Montebelluna, a town in Veneto that specialized in the manufacture of military boots during the war, would become the production centre for sports shoes and ski boots, with companies like Lotto reaching considerable size.

Yet despite the entrenchment of some industries and the presence of very old production islands, on

the eve of the First World War the Italian textile industry still produced goods of poor quality, with scant specialization. This was one of the main reasons for Italy's inability to compete with Paris fashion, even though French couturiers widely used Italian fabrics – silk and wool in particular – due to the quality of the product and the refinement of finishes and leather accessories. Although from the point of view of the textile and clothing industry the First World War represented not only an increase in production but also an opportunity to strengthen production equipment, it did not change the Italian production system substantially.[26] While it did become more articulated, the system remained undersized until the Second World War.

In Italy, the post-war era, especially the period between 1945 and 1963, was distinguished by significant economic growth, which was accompanied by a major structural transformation. In 1951, agriculture was still the dominant sector by number of employees; that was surpassed in 1963 by the manufacturing and service industries, both in terms of employees and profits. The main innovations that enabled expansion in the clothing, textiles, leather goods and footwear industries were the development of a mechanized textile sector and the new relationship between textile production and the clothing industry that was created in the 1950s. The introduction of the sizing system, a method imported from the United States, made possible the series production of clothes (among the first to adopt the system were Marzotto, Lanerossi, Miroglio and GFT). Thanks to the sizing system, which it customized to meet the physical and cultural needs of the Italian market, the Turin company GFT, which had produced the Facist brand since 1932, was able to promote itself after the Second World War as 'the most modern factory in Europe of industrial clothing for men'.[27] The operation was extended to women's clothing in 1958 under the brand name Cori. Max Mara, founded in 1951 in Reggio Emilia by Achille Maramotti and specializing in women's outerwear, was among the first companies to hire young designers for industrial production (pl.68).

In the late 1950s, knitwear was one of the strong points of Italian production and one of the cornerstones of Italian style. The knitwear sector had increased in importance for fashion in Italy after being separated from the underwear sector as early as the 1930s: freed from exclusively producing items to be worn under clothing, it could now include 'outer' garments, such as sweaters, dresses, sports clothes and swimwear. Until the early 1900s, the Italian textile industry worked almost exclusively with natural fibres, primarily silk (especially in Como) and wool (areas of Biella and Prato), and to a lesser extent cotton. At the beginning of the 1930s, it started adding man-made fibres, with synthetic yarns and microfibres appearing in the 1960s. Mixes such as linen with silk and nylon, chenille with wool and cashmere with silk were destined to become particular strengths of

the Italian textile industry. Stockings that until the 1960s were mostly made of cotton or wool, or less frequently of expensive silk, were now produced in nylon. Nylon, which had been developed in the United States by DuPont in the mid-1930s, was taken up very successfully in Italy in the 1950s, where it gave rise to Castel Goffredo, one of Italy's most important areas for the production of women's hosiery.

After the Second World War, Como stopped producing silk and instead established itself as a major manufacturer of silk products. It began to import materials from China and Japan and specialized primarily in dyeing, printing and finishing. Como remained a major producer of silk goods for the global luxury market until the late 1980s, when increased competition from China became an issue. In the 1950s, the Marche region also experienced a revival, becoming one of Italy's most important centres for the production of shoes and leather accessories. The shoemaking business Della Valle, set up in the region in 1940, was later developed with great success by Diego Della Valle, the founder's son. He invented a style of driving moccasins with rubber-studded soles and in the 1980s he renamed the company Tod's.

The Future of Italian Fashion Identity

The rise of big international brand names since the 1990s ended the democratization of fashion, which is the strength and essence of *prêt-à-porter*. The break with the rules of good taste, evident in the work of many fashion designers (especially Gianni Versace and Franco Moschino), gives way to the need for a new global luxury culture. The *Impossible Conversations* between Miuccia Prada and Elsa Schiaparelli, exhibited at the Metropolitan Museum of Art in New York in 2012, emphasized an important truth.[28] Schiaparelli was an Italian who found success in Paris because there was no fashion yet in Italy;[29] Miuccia Prada is a Milanese who stands out internationally with fashion that speaks a globalized language. The big brands today (I'm thinking especially of Prada and Zegna) are international rather than Italian, although they are deeply rooted in Italy. Other companies were sold to international groups, such as Valentino, Gucci and Brioni. Their aesthetics and communication are clearly geared towards a globalized elite and not the 'secret society' alluded to by Anna Piaggi. The references reflect those of the pre-industrial craftsmanship, like the *tableau vivant* of the cobbler's shop that Ferragamo presented in Shanghai for the exhibition *Salvatore Ferragamo Evolving Legend*.[30] Innovation is considered less desirable than what I would call a vintage ideology.

The Milanese model is no longer dominant in Italy or abroad. Its characteristics, such as the vertical supply chain – that is to say, control of all the stages, from production to distribution – the seasonal collections and divisions for lifestyles are commercially outdated and naive representations: we think, for example, of the polarity, more imaginary than real, between Giorgio Armani, the symbol of understatement, and

Gianni Versace, the symbol of glamour (pl. 70). The role of the *stilista* in the original sense, namely as the link between creativity and industry, is rapidly evolving. Nowadays, they are called creative directors or fashion designers. Fast fashion, of which Italy has its own version, with local brands that are not replicas of Zara and H&M,[31] has assumed the role of democratizing fashion that was once the domain of ready-to-wear: not equal in creativity, but lower in price.

Italian fashion currently presents an extremely fragmented picture, in which it is difficult to track the coordinates of a typical Italian system.[32] Instead of a compact system, as during the 1970s and '80s, we are faced with a composite fresco, the result of many paintbrushes. Should we infer that Italian fashion is suffering from an identity crisis? Or that Italy no longer knows how to be recognized in its own fashion? Actually, one direction is clearly visible: the quality expressed in the fabrics and in the work, that is to say, what already existed before Italian fashion and what continues to be a prerogative of the Italian manner of making fashion, but enriched by the experiences of the golden age of Italian fashion. Just think of the many excellent examples of Italian craftsmanship, from Rose's Roses shoes to knitwear by Massimo Alba. All the new names – the handbags of Benedetta Bruzziches, the clothes of Andrea Incontri, Tommaso Anfossi and Francesco Ferrari, the shoes and accessories of Reinhard Plank, to name only a few of many recent talents – have inherited a specific and unique way of making fashion which many gratefully recognize. There are difficulties, and the model is not replicable. Yet something remains, as is evident in the words of Andrea Incontri:

> *I believe strongly in Milan and I would never think to show in Paris. Of course for emerging* stilisti, *though I prefer to call myself a designer, the start-up is difficult to begin with: to make beautiful high quality things the initial investment is quite high. Money is the biggest obstacle and right now I have a lot of outstanding accounts even from major stores. But money is not enough. You also need someone to deal with your worries: otherwise there is the risk that operational concerns will get the upper hand on creativity.[33]*

In conclusion, I would say that the Italian fashion system – alongside that of Japan, although with different characteristics – constitutes the most significant events after the end of the exclusive domain of Paris from the 1960s until the end of the 1980s. As Marco Ricchetti and Enrico Cietta explained, the Italian system was a model for modern fashion: 'From the synthesis between the fashion world and the world of industry arose therefore this complex apparatus of production activities and services which today is called the fashion industry, but which we can also call, for its Italian origins, the fashion model 'Made in Italy'.[34]

For this reason, paraphrasing the title of the 2006 book by Yunika Kawamura on Japanese fashion,[35] I think we can talk about the *Italian fashion revolution in Milan*, in reference to the emergence of the system of the *stilisti* of ready-to-wear. Perhaps we do not know what Italian fashion will be in the future, but whatever direction it takes, it will be solidly based on what was created during the period Anna Piaggi called 'the glorious and animated history of the Italian Look'.[36]

Simona Segre Reinach is a cultural anthropologist and Professor of Fashion Theory at Bologna University. She also teaches Global Fashion at Milan University

2

Materials of Fashion

Textiles: The Foundation of Italian Couture

Margherita Rosina

page 74
Emilio Pucci, 'Dalia' motif printed
shirt (detail), 1965
V&A: T.1,2–1995

Opposite
71 Mila Schön advertisement,
dress using Nattier fabric and yarn
by Orlon® Du Pont, *Vogue Italia*,
September 1968

Arriving from London, the three things that struck me about the Italian haute couture collections were their perfect execution, purity of line, and the imaginative concept of luxury. Once again, and most importantly, the richness and beauty of the textiles give a particular and unmistakably Italian elegance to the garments.[1]

So wrote Joan Juliet Buck, then a journalist for *Women's Wear Daily*, when asked for her opinion on 'the state of Italian fashion's health' in spring 1974. Writing about the same collections, Francine Crescent of *Vogue* Paris confirmed: 'The prints and fabric are excellent and are a constant source of wonder to the French'.[2]

It was only just over 20 years since the successful launch of Italian fashion on the international stage and once again it was clear that Italian textiles played a fundamental role in the industry's achievements. There were historical roots to this success story, given that Florentine, Lombard, Genoese and Venetian silk merchants had been exporting their products across Europe since the Renaissance period. However, France had dominated the manufacture of dress fabrics for the last couple of centuries.

Over time, Italy had cultivated and maintained a vast network of wool, silk, cotton and linen manufacturing industries, which spread out in the nineteenth century across specific geographical areas: the zones of Biella, Prato and the Veneto specialized in wool and the area around Como in silk, while linen and cotton were based in Lombardy, around Busto Arsizio and Bergamo. These were traditional products, mainly destined for the domestic market, which looked to France for inspiration and innovation in the field of women's fashion and to Britain as the leader in fine woollens for men's clothing.

The end of the Second World War constituted an important moment for the development of excellence in Italian textiles, in part because production had continued during the war, although almost exclusively using substitutes for natural fibres because the country had been unable to produce or import anything else.[3] The aid that Italy received as part of the European Recovery Programme (the Marshall Plan) was a fundamental impulse for growth, not only in financial terms but also in the form of raw materials and machinery to use for weaving. Both factors contributed to unprecedented growth in the textile sector. This help was extended to Italy despite British resistance to the idea of supporting the Italian textile industry, which could have threatened the Lancashire cotton industry.[4] Between 1947 and 1951, Italy received more than $250 million in American aid, of which more than $20 million went to the textile industry. It was the fourth sector to benefit, after the electrical, engineering and steel industries.[5] France, the leader in textile production until the outbreak of the Second World War, preferred to prioritize other industrial sectors, as it held the view that its own textile sector was destined to collapse.

The 1950s: Couture and Boutiques

Italian fashion made its debut against this background of great buoyancy in manufacturing and finance. The first catwalk shows were held in Florence at the house of Giovanni Battista Giorgini in 1951, an event that is now generally accepted as marking the beginning of the story of Italian fashion.[6] Foreign buyers, particularly Americans, who came to the first Florentine fashion shows were fascinated by the Italians' ability to create designs that were sporty, more practical and less expensive than those from Paris. In a word, they were more suited to American women's lifestyles. Above all, the brilliant choice of textiles represented one of the key strengths of the embryonic

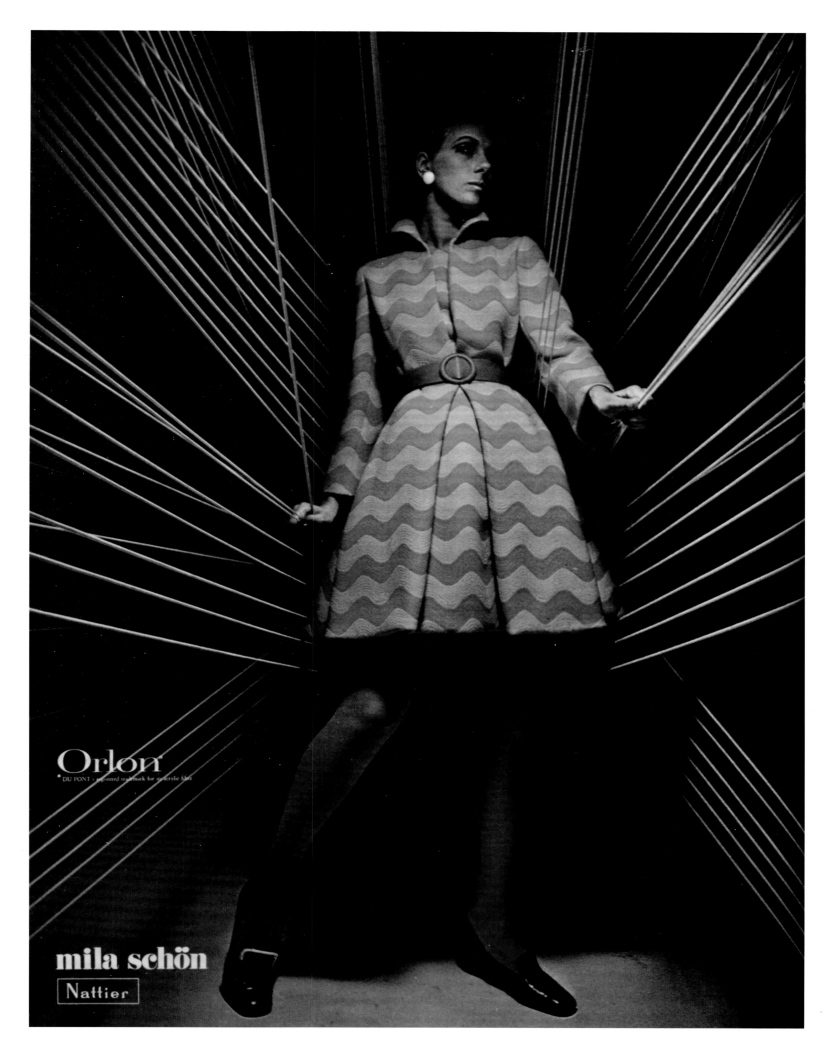

Orlon®
* DU PONT's registered trademark for acrylic fiber

mila schön
Nattier

Italian fashion world. The buyers who came to Florence displayed 'an almost pathological interest . . . in the textiles that they never let pass unobserved. They tried out their softness and flexibility, their stretchiness and the way they draped'.[7]

The textiles for these catwalk designs had been made by the most important Italian manufacturers: the collaborative relationship that had immediately been established between textile companies and fashion designers allowed the latter to use fabulous textiles that were supplied by wool, silk and cotton producers who in turn benefited financially from the publicity, as well as in terms of their image. In both cases it was a question of utilizing the manufacturing and design potential that had been refined in the years before the war and now had the chance to compete on an international stage.

The main silk manufacturers, for example, based in the Como area and founded over the nineteenth century,[8] took advantage of their effective production organization and highly specialized workforce, identifying in local designers like Carla Badiali [9] or in foreign ones like Andrée Brossin de Méré [10] the professional figures who could close the creative gap with France. In a few short years, Como firms like Fisac, Costa, Bernasconi, Mantero, Braghenti and Rosasco, to name just a few, achieved success not only in Italy but also in the French and American markets.

In the short term, the access Como silk manufacturers had to the Parisian haute couture houses was more of a coup in terms of image rather than commercial success. The actual quantities ordered for French haute couture were modest; often the creation of these stunning fabrics, printed by hand and produced in countless colour variations, required an investment of time and money that was difficult to recoup. The textiles piled up in warehouses and the originality of the designs made them difficult to sell the following season. At that time, the ability to risk everything and create enticing designs in order to capture a significant position in prestigious markets was one of the keys to the success of the Italian textile industry. In a 1952 interview, Brossin de Méré recalled 'how pleasant it was to work with technicians who were attentive, careful, anxious to succeed and resolve problems and with understanding manufacturers who wanted to create innovative products'.[11]

Other companies like Taroni, one of the oldest silk mills in Como, chose instead to plunder their own rich archives of weaves that had brought them success between the wars, reinterpreting these designs in new yarns and colour variations. Taroni specialized in yarn-dyed, monochrome textiles. Focusing on this sector, the company now produced striped and tartan silks in new colours, as well as fabrics such as faille, taffeta and monochrome satin, or very refined faille ombré-dyed in subtle colour gradations, used in the 1950s and '60s by Gattinoni and Capucci, and still used by Valentino in the 1980s (pl.79).[12] Alternatively, firms reprised earlier technical innovations such as warp-printing to produce designs with indistinct outlines; firms like Clerici Tessuto and Verga made these types of fabrics some of their key products. Destined for a market of refined connoisseurs, these designs were kept as part of the range for decades.[13]

The developing fashion boutiques also took advantage of the mix of creative and technical possibilities offered in the Como area. Emilio Pucci's label probably would not have reached the extraordinary levels success it did without the help of an extremely skilled Como printer, Ravasi (pl.72). The firm started out in the 1920s producing jacquard textiles for ties and 'art textiles', which were presented at the International Exhibitions held between the two World Wars. In 1946, after the death of founder Guido Ravasi, the firm continued under the direction of his son, Giuseppe, who expanded its printing activities in order to meet market demand.[14] Encountering a manufacturer in the late 1940s who was able to create multicoloured screen prints perfectly interpreting his designs enabled Pucci to create unforgettable collections, such as his *Siciliana* or *Palio* ranges (pl.72).[15] Ravasi's skill was particularly tested in the 1950s, when prints were characterized by thin, calligraphic lines that required extremely precise tracing and engraving.[16] As well as collaborating with Pucci, Ravasi also printed fabrics for other boutique fashion firms that took part in the catwalk shows at the Palazzo Pitti, such as Valditevere, for whom he created

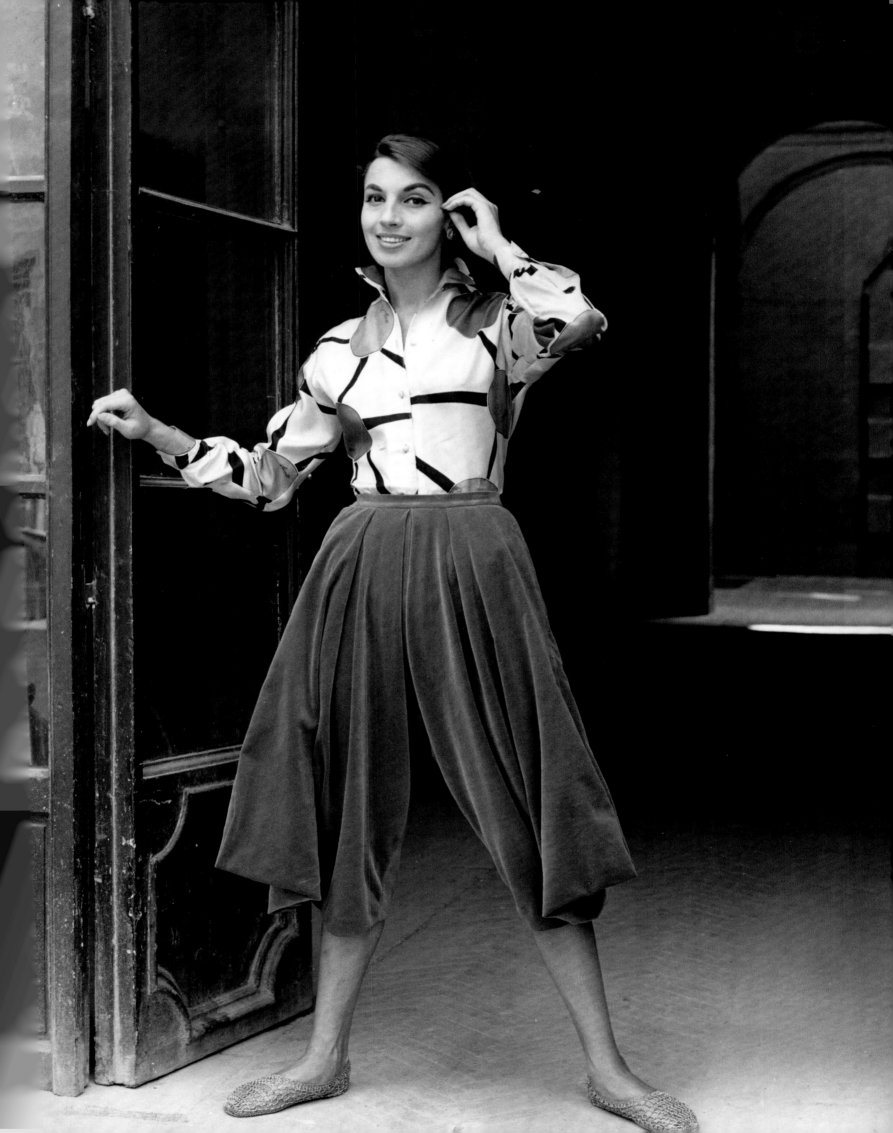

74 Emilio Schuberth, dress of
yellow Terylene and wool fabric
by Lanerossi, 1958

75 Germana Marucelli, dress in silk
jersey designed by Getulio Alviani
and produced by Verga. Photograph
by Gian Paolo Barbieri. *Linea
Italiana*, Spring/Summer 1966

LUREX

CARATTERIZZATO DA: LUREX GOLD - ORANGE - WHITE GOLD - GREEN GOLD - COPPER E BRONZE

®
LUREX is a Registered Trade mark

irene galitzine

TERRAGNI

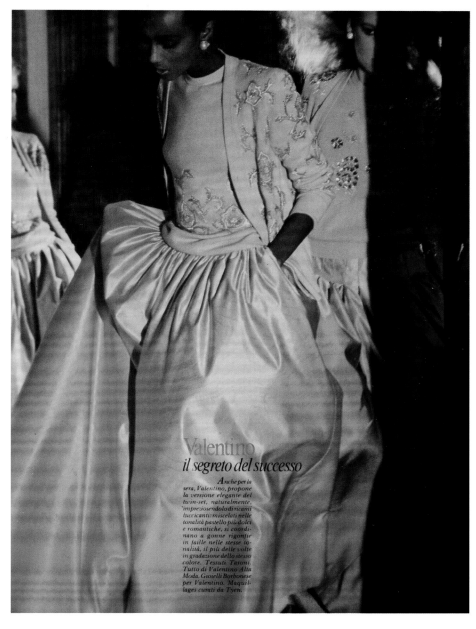

Opposite
76 Advertisement for Lurex® –
Terragni featuring palazzo pyjama
ensemble by Irene Galitzine.
Photograph by Gian Paolo Barbieri.
Linea Italiana, Autumn/Winter 1967

Above left
77 Advertisement for Confezioni
Marzotto Italianstyle. *Linea Italiana*,
Spring/Summer 1966

Below left
78 Advertisement for Lanificio Rivetti.
La Donna, April 1958

Above right
79 Valentino evening ensemble 'in
faille ombré by Taroni. Photograph
by Mike Reinhardt. *Harper's Bazaar
Italia*, September 1980

extremely beautiful printed textiles in very vivid colours, often identifiable by the brand's distinctive 'V' logo.[17]

Wool manufacturers also immediately understood the importance of supplying their textiles to the burgeoning Italian fashion industry. Firms including Rivetti (pl.78), Pria, Lanerossi and Marzotto sought to create new textures and above all to maximize the technical possibilities offered by synthetic fibres, which when combined with natural fibres offered up new and interesting results. When mixed with wool or cotton, for example, a crease-resistant polyester fibre like Terital (which is also known as Terylene) could be used to create permanent pleats. It was mainly produced in the late 1950s and throughout most of the 1960s.[18] Rhodiatoce, the company that produced the fibre, had started collaborating with Italy's principal wool manufacturers and with leading tailors and seamstresses, who created designs to showcase the unique properties of Terital (pl.74). Fashion magazines did the rest, publishing simple but attractive designs created by famous couturiers, which could be copied by less skilled seamstresses, enabling

Rhodiatoce to push the product on to the market in the hope that the association with a great tailor would encourage people to make clothes using Terital fabric.[19]

The 1960s: Sculpting Textiles

The years between 1960 and 1970 were some of the most successful for Italian textile firms. Although haute couture and boutique fashion houses suffered from the dualism created by a calendar of catwalk shows divided between Rome and Florence, which did not help the movements of foreign buyers, each season many designs were presented that met with the approval of the international press and buyers.[20] Taking its lead from the designs of the great couturiers, ready-to-wear was able to provide wearable, cheaper options, reinterpreted to suit the requirements of serial production, with textile manufacturing companies like Marzotto and Rivetti developing their own in-house clothing lines, called Italianstyle and Cori respectively (pl.77).[21] Once again, textiles constituted the strong point of Italian fashion.

Opposite

80 De Rossi, dress in printed chiffon designed by Gianni Dova and produced by Industria Serica Asnago. Photograph by Gian Paolo Barbieri. *Linea Italiana*, Spring/Summer 1968

81 Enzo, dress in mohair wool printed with paisley motifs by D'Este, a Ratti division, 1964

82 Advertisement for Lanificio Loro Piana, featuring ensemble by Antonelli Alta Moda Pronta. Photograph by Enrico Cignitti. *Linea Italiana*, Autumn/Winter 1967

Halfway through the decade, a new magazine appeared on the newsstands. *Linea Italiana* was expressly designed to 'support and showcase Italian-produced textiles, placing them centre stage through the creations of haute couture tailors'.[22] The result of an agreement between the *Centro Italiano Tessile Abbigliamento Alta Moda* (Italian Centre for Textiles, Ready-to-Wear and Haute Couture) and the Ministry of Foreign Commerce, for 20 years the magazine represented the official voice of the Italian textile industry. Through its advertisements, paid for by textile producers, as well as its features, shot by the best fashion photographers of the time, *Linea Italiana* underlined 'the overwhelming presence of textiles, of these beautiful Italian fabrics, the pride of an industry that, out of artisanal traditions, has succeeded in evolving to reach a very high level in terms of quality, the potential for extremely varied technical solutions, and an international and high-level market position'.[23] Leafing through back issues of the magazine, it is possible to trace, season by season, the different trends proposed by textile manufacturers and to map the existence of myriad firms, only a few of which, unfortunately, still survive today (pls 75–7, 80, 82–3).

During the 1960s, silk manufacturers almost entirely stopped making jacquard textiles, replacing them with prints in boldly contrasting, vivid colours. Only silk fabrics destined for evening wear were figured, woven mainly with Lurex yarns to give them a surface that looked rather like aluminium foil. They were matelassé fabrics, with a quilted appearance, in large-scale geometric or striped designs in fluorescent colours. This was probably a response by textile manufacturers to the appearance of Paco Rabanne on the fashion scene. Rabanne became famous for his use of non-textile, shiny materials and for having designed the 'outer space' costumes for the film *Barbarella* in 1968. The fashionable new silhouette, more linear and square than that of the previous decade, was perfectly suited to the patterns proposed by Como silk producers, which were often developed around abstract themes. Famous artists such as Getulio Alviani and Gianni Dova collaborated on the designs (pls 75 and 80). The large-scale motifs were printed on to heavy fabrics suitable for A-line dresses, or very light organzas and chiffons, more suited to evening wear. Frequently the same design was offered on different fabric types, making it possible to create outfits combining different textiles with the same motif. The majority of these fabrics were exported directly or indirectly for the French haute couture market.

As in the previous decade, Como manufacturers made their machinery and expertise available to create silks commissioned by the most important international distributors, waiving their right to appear as the real producers of the fabrics. Abraham, for example, for decades the Swiss supplier for French haute couture, collaborated closely with the firm Ratti, considered to be 'one of the few, highly specialized printing plants' still in existence in Europe.[24] Gustav Zumsteg, Abraham's owner, met Antonio Ratti in the mid-1960s and found that the industrialist – like him an art enthusiast – was able to immediately visualize his creative ideas. In order to be able to execute the requests of important clients quickly, one person on the Ratti creative team was allocated the task of

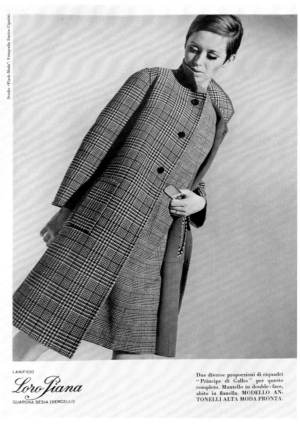

following the development of textiles destined for specific couturiers, using their significant artistic sensibilities to bring industrial manufacture in line with the taste and requests of the individual designer. Most of the printed silks used by Yves Saint Laurent at this time were the result of the Ratti-Abraham collaboration.[25] The Como firm was able to combine the production of textiles made exclusively for Abraham with others sold under the D'Este label, which included highly original geometric and floral prints as well as the large paisley motifs that became one of Ratti's trademark designs, both in clothing and accessories (pl.81).

By the mid-1960s the Como silk sector had consolidated its prestigious position in Europe, rivalling its traditional competitors in Lyon in terms of the quality and quantity of production. Old factories were renovated and new ones built in order to directly control all the stages of the production process. The history of Mantero, one of the largest silk manufacturers in Como, is a good example of this.[26] In 1967, the *Associazione Italiana Fabbricanti di Seteria* (Association of Italian Silk Manufacturers) launched Ideacomo, a specialist trade fair that used the splendid backdrop of the Villa d'Este in Como to display examples of the highest-quality domestic

production. However, the new initiative deprived another fair of meaning and prestige. Held in Milan since 1957, MITAM (the initials stand for *Mercato Internazionale del Tessile per l'Abbigliamento e l'Arredamento*, or International Market for Furnishing and Fashion Fabrics) had previously been the most important showcase for Italian textiles. Over the course of a few years, however, the best Italian wool manufacturers also chose to display their products at Ideacomo, which benefited from a series of accompanying events whose glamour was a source of fascination for foreign buyers and the specialist press. *Women's Wear Daily*'s assessment that 'if Interstoff is the supermarket of material, Ideacomo is the Fauchon' epitomized the refined atmosphere of those years.[27]

The wool sector was also of major significance at that time: thanks to highly skilled technicians keen to emerge from the rut of tradition, new solutions with great potential were being developed.[28] Reversible fabrics, sometimes even with different motifs on each side, were the biggest success story of the decade. In the 1930s, Como silk firms had used double-faced weaves to create fabrics with small patterns, often in two colours, producing a positive-negative effect. By taking advantage of the different ways in which natural and artificial fibres absorbed dyes, it was possible to

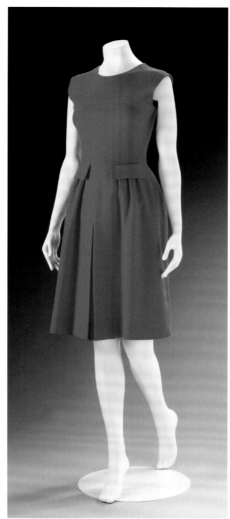
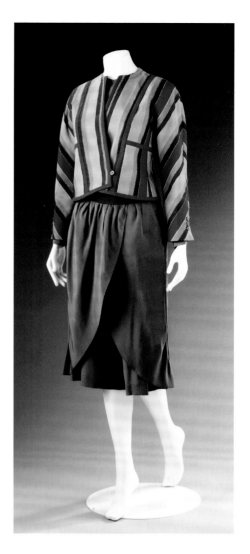

obtain patterns by dyeing fabrics after they had been removed from the looms, with a significant reduction in cost.[29] Wool manufacturers had been creating double-faced fabrics since the late 1940s, but it was not possible to create reversible garments with these as the seams underneath needed to be hidden with linings. Thanks to technological advancements, it became possible to weave double-faced wool the two layers of which could be separated at the hem, then trimmed and sewn together again in order to make completely reversible garments, with the seams forming a decorative piping (pl.84).[30] It was a clever conjunction between a technical solution that lent itself to multiple interpretations and a fashion trend that prized geometric shapes for necklines and dresses that were not merely decorative but also functional. In practical terms, textiles revolutionized the structure of garments.

One of the most successful interpreters of this kind of fashion was Mila Schön.[31] 'I never liked linings and this meant that clothing had to be as perfect inside as it was outside,' the Milanese couturier declared.[32] Indeed, her clothes were designed to be completely reversible, transforming every cut and stitch necessary for the construction of the garment into an element of decoration. Chino Bert, the designer and illustrator who collaborated with her right from the beginning,

translated his input into a series of coats, suits and dresses with rigorous and pared-down silhouettes, whose distinctive character lay in the Agnona and Nattier textiles from which they were made (pl.83).

Italian designers also expressed their imagination through the revival of traditional weaving techniques, which were applied in innovative ways. In the early 1950s, Giuliana Coen, better known by the name of the company she founded, Roberta di Camerino, started using *ciselé* velvets woven on handlooms by Bevilacqua, a historic Venetian firm, for her famous bags. She updated the designs and colour combinations, radically transforming the function of textiles originally conceived as furnishing fabrics to be used in historic houses or in an ecclesiastical context.[33] Playing ironically with *trompe-l'œil*, she decorated her bags with small fake belts and pockets and little tassels. When she launched a ready-to-wear line suited to a dynamic woman – a traveller who needed to take simple but elegant clothes out of her suitcase, ones that did not need ironing – she developed the same *trompe-l'œil* conceit, decorating simple little tubes of jersey with fake jackets, shirts and pleated skirts, created by placing prints on large panels corresponding to the different parts of the garment (pl.85).[34]

88 Max Mara beaver coat in fabric by Lanificio Piacenza, Autumn/Winter 1983. Photograph by Mike Yavel

Opposite
89 Gianfranco Ferré Couture, coat with fox trim in moiré taffeta by Clerici Tessuto, Autumn/Winter 1987

The 1970s: Ready-to-wear

The late 1960s and the early years of the following decade represented a period of rapid change for Italian textiles, essentially linked to developments taking place in the fashion industry. Up until then, producers tended to present their seasonal samples based on the input of an internal design office or by collaborating with haute couture houses, supplying them with a limited quantity of splendid textiles. The following season, the haute couture offerings could be utilized again, perhaps by simplifying them to create samples that were less ostentatious but sure to succeed, destined for the garment trade, boutiques, retail fabric shops and the seamstresses who still formed an important commercial outlet.

Slowly but surely, Italian couture was losing the leading position it had enjoyed in previous decades, unable to transform itself from a creator of unique garments for the elite into a creator of prototypes for industry.[35] At the same time, in the mid-1960s a new, uniquely Italian phenomenon, that of *stilismo*, the emergence of the designer,[36] was beginning to

play an influential role.[37] For several seasons, the same textiles (particularly woollen ones) were used for both couture and ready-to-wear collections and when some manufacturers realized that it was not possible to diversify between the goods supplied to the two different strands of the market, they opted for the one that seemed to have the most promising future: ready-to-wear.[38] The situation for Italian textile firms was shaping up as follows: haute couture used exclusive, luxury fabrics, ones that could justify the cost of the finished garment and also served as a publicity vehicle for the textile producer, creating or strengthening its brand. Luxury ready-to-wear companies were just as demanding in terms of image and product quality but, thanks to the larger quantities ordered, they were more rewarding clients for textile manufacturers. The close link forged between designer and textile producer was advantageous for the manufacturers but it also became increasingly limiting, forcing them to gradually retreat from the retail market, where the fabrics could not be sold as designers often required them to be exclusive products.[39] In Italy, a country where artisanal traditions had always been very strong, seamstresses and small dressmaking shops survived much longer than elsewhere, encouraging the growth of a large number of draper's shops where it was possible to buy Italian and foreign fabrics by the metre.[40]

The figure of the *stilista*, the fashion designer, a link between the creative arena and industrial practice, breathed new life into the Italian textile industry. For example, the Roman couturier Pino Lancetti collaborated with many important Como silk firms, for whom he designed sophisticated, themed collections.[41] Another important collaboration was the one between Walter Albini and Etro. Albini did not merely create new textiles, he also devised coordinating fabrics in order to give stylistic unity to collections produced by different companies.[42] The relaunch of printed textiles at an international level can be attributed to Albini, whose cultural references led to a renewed interest in the fashions of the 1930s and '40s.[43] The multiplicity of ideas that flowed from Albini's creative mind was a reflection of the level of specialization achieved by Italian textile firms at this time. The arrival on the Milanese catwalks of new brands and the growing success of creative ready-to-wear altered the panorama of dress fabrics: not only were firms producing textiles in wool, silk, cotton and linen, following the input of designers, but materials like jersey were coming back into fashion due to specialist manufacturers like Sartimaglie, Lanificio Giuseppe Gatti (pl.86), Dondi and Marioboselli.

As in previous decades, Italian textile producers in all sectors remained eager to experiment and to fulfil their clients' needs. Furthermore, the establishment within the same geographical area of textile manufacturers and small engineering firms that produced machinery and accessories for looms made it possible to find technical solutions for commissions and any problems they presented, both quickly and cost effectively.[44]

People working in the industry as well as the general public began to reassess the function of textiles. A great deal of Giorgio Armani's success was founded on the idea of abandoning the centuries-old tradition that linked menswear with heavy, dry, rigid fabrics and womenswear with soft, flowing, lightweight fabrics. Having begun his career as a designer for Cerruti's Hitman line,[45] Armani was particularly sensitive to the qualities of textiles. From the mid-1970s onwards he began to use fabrics primarily destined for womenswear for men's jackets and trousers, which lost their rigidity as a result. At the same time he began to create a new template for women's suits, using textiles that seemed to come from the male wardrobe, or were inspired by it for design and colour combinations (pl.87).

The relationship between textile firms and a new kind of fashion, no longer focused on made-to-measure but produced industrially, was not only characterized by designs, fabrics and customs. The impact was felt along the whole production chain, something that became evident above all when the partner was a large fashion company like Max Mara (pl.88). The Reggio Emilia company had first introduced the idea of entering the fashion market with a collection produced by a designer in the mid-1960s.[46] Max Mara adopted the strategy of not linking itself to an individual designer, instead making use of a series of emerging young designers, selected so that their creations would not overshadow the brand's image, which needed to remain constant and recognizable over time. It was a success.

For a textile firm, having a fashion house of this size as a client could become both a blessing and a burden. In many cases, trying to produce and deliver on time the large amounts of textiles required each season by this kind of industrial manufacture was problematic.[47] The pace of ready-to-wear, which required timely deliveries otherwise boutiques would not place orders, compelled many small-scale textile companies to reorganize and prepare for larger production. As the ready-to-wear industry flourished, it was not uncommon for these growing businesses to become increasingly dependent on producing textiles for one or more fashion houses. Because the loss of this custom could be ruinous, smaller textile manufacturers were more vulnerable when it came to negotiating prices.[48]

For all these reasons and also as a result of the kind of fashionable look that was developing at the end of the 1970s, the production of more fanciful textiles began to develop. Another factor was the reduction in the quantity of couture creations. High-street fashions and ready-to-wear clothes were being made from masculine-type textiles, in a single colour, printed but not particularly showy, in classic or natural, woody shades. Sometimes Italian fashion companies, as in the case of Max Mara, used English, Irish and Scottish woollens, such as Harris or Donegal tweeds, to create a rustic effect that Italian textiles were unable to achieve at that time. Soon, however, with their usual adaptability to market demand, producers in the Veneto, such as Paoletti, Ferrarin, Cini and Marzotto, and the Prato firm Marini & Cecconi started manufacturing wool fabrics for fashion.[49] It was Max Mara again who introduced 'democratic cashmere' to the market at the end of the decade. Up until then, this noble fibre was only used for couture creations because of the high cost of the finished textile. Thanks to the obstinacy of the company's owner, Achille Maramotti, who was absolutely committed to giving a wider segment of the market the possibility of owning a cashmere coat, cashmere was produced by Biella woollen firms in lengths that were so consistent it was possible to significantly reduce the costs both of the yarn imports and the production of the textile.[50]

The 1980s: International Success

When Giorgio Armani made the cover of *Time* magazine in April 1982 (see pl.230), it marked not only the consecration of one fashion designer's work, but of a whole generation of Italian creativity. The textile industry, which had played such an important role in the expansion of Italian fashion, celebrated its success in the most important magazines of the sector, with advertisements illustrating the most beautiful clothes by Italian designers.

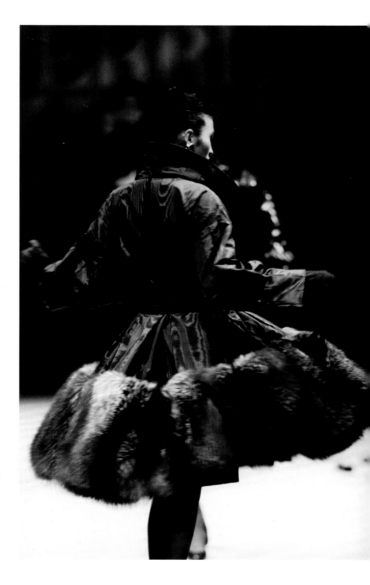

Gianni Versace was one of the most refined interpreters of Italian textiles during those years. An examination of the list of Italian manufacturers from all sectors that supplied him with fabrics for different collections demonstrates how much Versace cared about textiles, from Solbiati's figured linens to jacquard woollens by Loro Piana, Agnona, Faliero Sarti and Fila, all custom made. For silks, he used Como producers such as Canepa, Menta, Bini, Ratti and TJSS, often commissioning highly complex prints.[51] His research stimulated the industry: he not only encouraged companies to experiment with new mixes of prestigious yarns and unusual materials or to revolutionize classic themes like the Prince of Wales check, but he also asked for prints based on works by Delaunay and Warhol, for baroque motifs interpreted in unusual colours, for animal, geometric and floral patterns that were always original. All these interventions made Versace's textiles highly recognizable, not to mention his bold use of non-textile materials such as leather, rubber, plastic and metal. With the latter, thanks to a collaboration with a German artisan, he invented Oroton, a metallic mesh as flexible as a fabric.[52] His intelligent contribution to finding new paths through which to express all the capabilities of the Italian textile industry came with some drawbacks, however, in the form of the high costs that research of this kind generated, even if these costs could be partially defrayed in the market for diffusion lines and accessories, which was significant at this time.

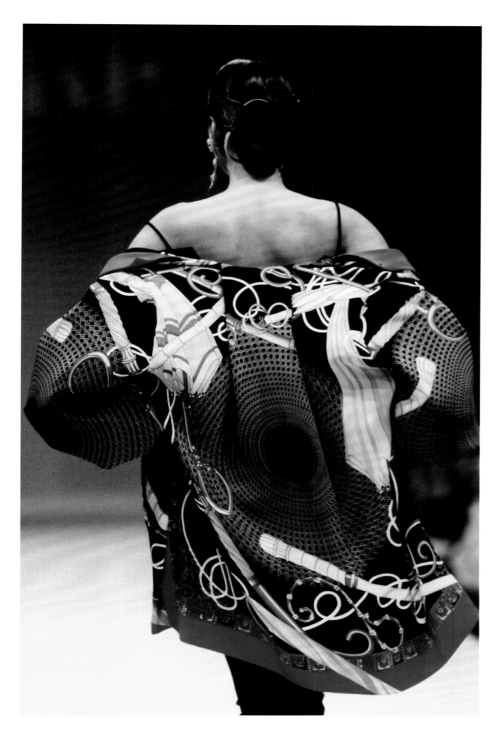

Opposite
90 Sketch for Gianfranco Ferré
Couture, Spring/Summer 1989

91 Gianfranco Ferré Couture,
technical sheet of models in
fabrics by Ratti and Taroni,
Spring/Summer 1989

Above
92 Gianfranco Ferré Couture
ensemble, Spring/Summer 1989

focused on demolishing or redesigning the 'barriers between male and female fashion, between night and day, between formal and informal clothing'.[55] The Como textile producers were a constant frame of reference for him: he commissioned exclusive fabrics from Clerici Tessuto, Mantero, Ratti, Taroni and Verga, which drew on a range of inspirations, where the same motif – Vienna straw, for example – could be realized in a figured textile, a print, in jersey or an embroidery.[56]

This decade in Italian fashion and textiles was characterized by an opulent, aggressive taste, a branded and immediately recognizable look, with clothing more than ever before becoming a status symbol, a sign of economic success and wealth. It was a euphoric moment that sometimes culminated in excess.[57] Particularly in the silk sector, extraordinary textiles were being produced, prints with very large-scale repeats, figured textiles that were extremely expensive to weave, always linked to designers' exclusive commissions.

A few Italian designers ploughed their own furrow. Among these was Romeo Gigli, who represented an ethnic-minimalist taste in which fabric was used to underline the mood of his collections, both those created under his own name and those he designed for Callaghan from 1987 to 1995.[58] For his enveloping dresses and fitted shirts, Gigli often used stretch fabrics, which at the time were mainly used for sportswear, created in collaboration with the Valsesia firm Reggiani. His thorough research in the textile sector led him to re-evaluate figured silks with a nineteenth-century feel that were originally created by the Como firm Canepa for ties, but which he used for trousers and jackets, soft devoré velvets produced by the firm Pontoglio near Brescia, light cottons and silks with floral motifs by Clerici Tessuto and printed crêpe de Chines with hints of India. As was often the case in his collections, the same model was produced in different textiles, representing different price points. For example, a pair of trousers appeared on the catwalk in a refined taffeta, whose red and brown stripes alternated with bands warp-printed with a motif that recalled Indonesian ikats. The fabric was produced by Verga, one of the Como manufacturers that Italian fashion designers gravitated towards (pl.93). Very few examples of this version were made because of the high cost of the fabric and the large amount of it required to create a bias-cut sash that was wrapped around the waist. The design was, however, made commercially viable in the version produced in more economical shantung silk.[59]

The international success of Italian designers made it possible for them to create second lines that allowed a younger section of the population with more limited resources to dress in major labels at a lower price. At the same time, the profits from these diffusion ranges meant that the labels could continue to finance production requiring research, such as their main or 'signature' lines. It was necessary to make a distinction between the textiles used, creating a phenomenon that

Another leading figure of 1980s ready-to-wear was Gianfranco Ferré, who represented a very different kind of taste but was just as attentive to research and the quality of materials as Versace. 'Inventing, creating does not mean ignoring the fact that elegance has always thrived on noble and precious materials,' he said in 1998.[53] It was this kind of research that led him to design in 1984, for two seasons and exclusively for the American market, an eveningwear collection based around exclusive, bespoke textiles. The next, almost inevitable, step was his couture debut in 1986, encouraged by the insistence of textile manufacturers, who saw in him a figure capable of bringing new life to the sector (pls 89–92).[54] Both as a ready-to-wear designer and a couturier for his own label, and as the creative director for Christian Dior from 1989 to 1997, Ferré had an extremely rigorous approach to textiles,

reversed the journey from haute couture to ready-to-wear. To set the garments apart, the main lines began to request ever more distinctive fabrics from the textile industry, moving towards a production that in terms of the refinement of materials and cut, the almost artisanal attention to the finishing and the retail prices became ever closer to haute couture, while the diffusion lines, more commercial and sporty, required manufacturers to supply cheaper, easy-care fabrics.[60] There was also an increasing use of man-made fibres, particularly in the silk sector, and the proliferation of myriad small firms that tried to take advantage of the favourable moment to expand their client lists, turning to the many clothing and accessories companies that were springing up in those years in the wake of the success of 'Made in Italy'. In the Lario area, there were many manufacturers that shifted from prints on silk to those on artificial and synthetic fibres, taking the risk of struggling to keep up with competition from the lesser quality, lower-priced fabrics and materials exported by Asian countries that were about to explode on to the market. Companies also began to look beyond Italy to identify countries that could supply cheaper raw materials, such as Turkey and Pakistan for cotton or China for silk and cashmere yarn, and to outsource production to areas where the cost of industrial real estate and labour were lower than in Italy.[61]

The 1990s: Towards the New Millennium
The era that had been evolving as one long triumphal cavalcade of innovations, creativity and ever more spectacular textiles was cut short by the economic crisis provoked by the First Gulf War. The resulting rise in the cost of petrol signified a rise in the cost of raw materials and labour for the international textile industry, making it difficult to find a balance between production costs and retail prices: the industries serving the medium-to-low-cost market, where the profit margins were the smallest, were the ones who suffered the most.

This was not the only sign that the world was changing. Even Italian fashion, until then characterized by a joyous exhibitionism, had to accept that ways of dressing were being revolutionized. The Japanese designers who started showing on the Paris catwalks in the early 1980s and the minimalist styles launched by some fashion designers were signs that the fashion public was searching for a more sober and sophisticated look. Jil Sander and Zoran were followers of a 'sartorial philosophy' symbolized by a certain degree of understatement, a purity of line, the absence of gaudy colours and above all by a very sophisticated choice in terms of textiles. Attention was focused on the quality of materials rather than the originality of the fabrics: the area around Como, traditionally the home of printed silks, had to explore new sectors, such as beachwear or printed scarves and polyester foulards for the Middle East in order to develop new markets.

In Italy, Prada was one of the representatives of this new minimal tendency. In 1988 this long-established Milanese leather goods company, which was known for producing accessories, decided to present a collection of womenswear.[62] The brand's choice of fabrics until 2000 was very rigorous, from technical textiles – perhaps the most innovative product of those years – to monochrome fine worsted wool for winter and lively organzas for the summer collections, inspired by the colours and geometric patterns of the early 1970s, and with some nods to ethnic fashion with the appearance of tie-dyed motifs. Wool products, particularly high-quality ones, could be adapted more easily to the new type of demand and some textile companies, like Loro Piana, decided to produce their own clothing lines that focused on exclusivity of the raw materials used rather than on the originality of the designs.[63]

The silk sector experienced different problems: until recent years, it had sold printed fabrics in extraordinary designs and colours, which had required significant investments in terms of technology and design. Now the wind had changed and the fashion world was populated by figures mainly wearing black. 'In those years at the stands of Première Vision [the fashion fabrics trade fair in Paris] you would only see workers dressed in black, journalists dressed in black, clients dressed in black,' recalls Donatella Ratti, president of the Ratti Group.[64] The textile manufacturers of Como had based their growth on the success of Italian ready-to-wear in the 1980s and on the glamorous image that it transmitted: now it was necessary to adapt to a new reality.

The problems did not only stem from a need to adapt to new demands from the fashion world but were also due to the changes that were taking place at a global level, with the growth in importance of the Asian markets. In the 1970s, China in particular had already begun to be a source not only of silk yarns but also of printed fabrics, produced at extremely competitive prices. The rapid growth of Asian exports to Europe reached a peak in the mid-1990s and the Italian silk industry had to confront the massive quantities of textiles and clothing made out of low-cost silk imported from China. The issue of silk imports from economically developing countries was one of the most complex of that decade, with origins reaching far back into the past. Every European country tackled the problem with different protectionist policies, given that silk, which represented only 0.02 per cent of global textile production, had been excluded from trade agreements such as the Multifiber Arrangement (MFA) signed in 1974 precisely because of its insignificant percentage value.[65] Much earlier than other sectors of the textile industry, the silk companies therefore experienced the effects of the liberalization of commercial exchanges and the inclusion of China in the World Trade Organization in November 2001. The last barriers fell in January 2005, with the total elimination of the MFA. China and other Asian countries were free to export silk textiles and clothes to Europe at extremely competitive prices made possible by lower labour costs

93 Romeo Gigli for Callaghan, trousers in striped taffeta by Verga (detail), Spring/Summer 1987

and quality controls, thereby creating great difficulties for the European markets.[66]

The New Millennium:
The Global Market and Fast Fashion

Just as the 1990s were marked by the First Gulf War, the new millennium opened with an event that deeply affected the whole world: the destruction of the Twin Towers on 11 September 2001. The general atmosphere of insecurity, fuelled by the fear of new terrorist attacks, caused havoc in the global markets and contributed to a long-term decline in consumer activity and investments, which directly influenced the fortunes of the Italian silk sector. In terms of silk production, each of the Lario companies followed a different approach, according to their size. For example, there were those like Taroni, who preferred to concentrate on producing yarn-dyed pure silk textiles of a very high quality, refusing to print on Chinese silk imports. The company was therefore not subject to the ebb and flow created by Asian competition.[67] Its market remained, and still is, that of haute couture and a niche market of luxury ready-to-wear. Large companies like Mantero and Ratti, which had now been operating for more than 50 years, acted on different fronts. On the one hand, using their own archives intelligently, they offered designers exclusive patterns from their own historic collections or, in the case of Mantero, they equipped themselves with special machinery in order to be able to screen-print on PVC for the high-end market.[68] On the other hand, in order to compete at a global level and with China, these companies had to broaden and diversify their manufacture. If the market for men's ties experienced a dip, they could instead focus on new markets such as beachwear or printed polyester scarves for the African and Middle Eastern markets. The new frontier was therefore to open up to different forms of fashion production represented by the new fast fashion chains, such as Zara and H&M, characterized by immense production volumes at greatly reduced costs – a challenge to supply a quality product at a lower price. Paradoxically, it was in fact the strong internal competition within the supply chain that forced manufacturers in the Como silk sector to renew themselves in order to survive this difficult period.

One point in favour of Italian producers currently involved in fast fashion is that transporting Chinese textiles to Europe is both expensive and time-consuming. Furthermore, the gap in labour costs between Europe and China has narrowed. In addition, there are growing concerns regarding social and environmental problems in China, such as child labour and the use of toxic dyes. It is likely that even medium-quality Italian textiles will soon become competitive again.

The capacity to adapt to new market conditions combined with a skilled heritage, sophisticated technology and creativity contributed to the establishment of Italian textiles in the second half of the twentieth century. The same factors enable the sector to remain competitive at the beginning of the third millennium. Many Italian companies now supply the large international clothing chains, opening special divisions within their organizations specifically for this purpose: thanks to the large production volumes, this allows them to continue to invest in the research that represents the founding characteristic of Italian textiles.

Margherita Rosina is the director of the Museo Studio del Tessuto at Fondazione Antonio Ratti, Como

Craft and 'Made in Italy'

Catharine Rossi

In September 1946 an article entitled 'The Fine Italian Hand' appeared in British *Vogue* (see also pp.249–53).[1] It opened by describing the good fortune of Italy's female followers of fashion: 'The sophisticated Italian woman has, at the outset, two great advantages: wonderful materials and an apparently inexhaustible pool of hand labour.'[2] The author of the article, the American journalist Marya Mannes, went on to extol the virtues of firms including Gucci and Salvatore Ferragamo before finishing with her outlook for the industry: 'Italy has, in summation, everything necessary for a vital and original fashion industry; talent, fabric, and beautiful women. With post-war easing of materials and labour, and more expert direction, Italian clothes should command a distinguished audience.'[3]

Fast-forward to the twenty-first century and Mannes's prediction has more than borne out. Amid challenging economic conditions, Italy's luxury fashion brands appear in fine health. In 2012 sales grew by 72 percent to over 400 million euros, and the figures are predicted to rise with expansion into emerging markets such as Brazil, China, India and Russia.[4] 'Italy is the only significant exporter of clothing among the advanced industrial countries, sustaining a large share of an industry that is almost wholly the preserve of low-wage, developing nations,' the sociologist Andrew Ross noted in 2004. 'All the more remarkable is that it has done so under the rubric of small-scale craft, rather than mass production.'[5]

This artisanal aspect of Italian fashion is key to understanding its desirability: as fashion historian Valerie Steele notes, its allure is as much about the productive quality of 'Made in Italy' as the refined allure of the 'Italian Look'.[6] Yet the industry's craft foundations also present a challenge. 'We cannot make enough to keep up with the demand from the

Chinese,' said Ferrucio Ferragamo, CEO of the Florentine shoe brand founded by his father, in 2011. 'They want their shoes not just made in Italy, but often made in Florence.'[7] Ferragamo faces a problem felt throughout the luxury industry: how to meet the desire for goods handcrafted in Italy when this outstrips what its artisans can supply.

This imbalance between mass-scale demand and craft-based supply is not new: the challenge of how to scale up artisanal production to meet growing international interest was, as this chapter will show, a problem that Salvatore Ferragamo himself had faced even before the outbreak of the Second World War. As the decades progressed, technological advances and changing socio-economic conditions have provided both clues and further challenges. From the post-war period to today, 'Made in Italy' has therefore been as much an obstacle as an opportunity for Italian fashion, one that has been instrumental in shaping its history.[8]

This chapter charts this persistent demand for craft from the 1940s to the present in two key Italian fashion industries: garments and accessories. It will focus on a small number of companies – including Ferragamo, Gucci, Missoni and Prada– that are not only among Italy's best-known luxury brands, but also represent the different ways this demand has been negotiated. Conventionally overlooked in accounts that tend to champion rather than scrutinize Italian fashion's craft associations, this aspect is significant: it both showcases craft-based innovation but also raises questions about the reality of a production set-up that makes such claims to place-based craftsmanship. If, following Ross, Italy is alone in an industry fuelled by ever-cheaper labour, then this chapter seeks to find out how it has maintained its position.

94 Emanuele Pantanella, 'Egg'
belt, rosewood and leather, 2008
V&A: T.110–2012

95 Emanuele Pantanella, handbag,
rosewood and pearwood, 1994
V&A: T.64:1–1997

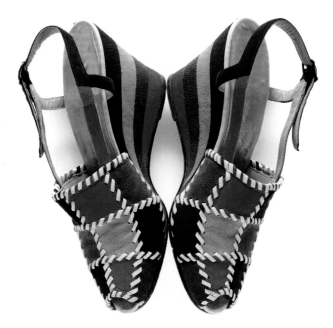

'Made in Italy': A Historic Concept

The term 'Made in Italy' was officially introduced in the 1980s through a campaign organized by bodies including the Italian Trade Commission and the *Ente Moda Italiana*.[9] It built on a reputation for craftsmanship that dates back to the Renaissance, when cities such as Florence and Venice dominated the silk and wool trades – and continued to do so as time progressed.[10] Even amid nineteenth-century industrialization, the artisanal nature of Italy's industries remained intact. In Como, north of Milan, the slow nature of Italy's industrialization enabled the continuation of agriculture-associated and family-based crafts, such as silk production and weaving, which were erased in the more rapid process that took place elsewhere in Europe.[11] This has persisted: while countries such as China, India and Thailand have taken over Italy's primacy in this industry, Como is still home to several family-run, high-quality manufacturers.[12] These include the small-scale silk producers Mantero and Ratti as well as the fashion house Etro, which has set up a number of production plants in the area since it was founded in 1968 and first began making textiles for labels such as Walter Albini, Lancetti and Valentino.[13]

Mantero, Ratti, Etro and the other producers in the area constitute a clustered manufacturing set-up known as a *distretto industriale* (industrial district). This is largely a post-war phenomenon: amid a wave of industrialization in the 1950s, the number of artisanal manufacturing firms actually grew to become Italy's defining mode of production in the 1960s.[14] Concentrated in northeastern and central Italy, these firms constitute highly flexible and locally specialized manufacturing networks; alongside Como's silk producers these include Brianza's furniture industry, Le Marche's shoe specialization and Tuscany's textiles and clothing trade.[15] In the 1980s these manufacturers of the 'Third Italy' became its economic engine, championed by economists as the model for decentralized, post-Fordist production.[16]

The 'industrial districts' are reproduced across all manufacturing industries and at all scales; from the relatively large scale of Como's silk industry to the workshops of individual designers and makers. The latter include Emanuele Pantanella, a self-taught Roman artist-craftsman who has been designing bags, belts and other accessories since the 1970s, following his departure from the family's pasta and grain business.[17] Initially Pantanella worked with a number of young goldsmiths creating jewellery for Gucci, before setting up his own luxurious line for a select clientele.[18] He makes much use of precious materials in his designs, which are made by a number of local Roman artisans, such as the carved pear and rosewood evening bag from 1994 or the more recent rosewood and leather 'Egg' belt from 2008 (pls 94–5).[19]

Although they operate at different scales, what these networks have in common is not just a separation between different makers, but between makers and designers. This dates back to the early twentieth century; by the 1920s it was no longer viewed as economically viable for artisans to produce their own designs: instead, artists and architects began providing designs to ensure faster and more market-friendly results, as the design historian Marianne Lamonaca has noted of the furniture industry.[20] The shift from dressmakers to fashion designers in the 1970s represents a similar phenomenon, making collaboration between designers and artisans a cornerstone of all Italy's design industries.[21] These collaborations thrive on the specialist knowledge that is contained in each realm. This is as true of Pantanella as it is of Ferragamo, a trained shoemaker who increasingly relied on others to meet growing demand from the 1920s onwards. Yet his early artisanal experience remained important, as it endowed him with a first-hand understanding of materials and manufacturing methods that made possible his company's post-war success.

Salvatore Ferragamo: Materials and Man-Made Mass production from the 1930s to the 1950s

Today his name is a global luxury brand, but Salvatore Ferragamo had humble beginnings. Born in a southern Italian village in 1898, he was apprenticed to a shoemaker before joining his brothers in the United States in 1914. Following a negative experience at a Boston shoe factory, Ferragamo ended up in Hollywood, making shoes for film stars both on and off set, before moving to Florence in 1927 to further develop his business.[22]

The 1920s were very different in America and Italy, where the decade was dominated by the all-powerful hand of fascism. Fashion was not free from its nationalist ideology: a policy of economic self-sufficiency affected the availability of materials, which were further restricted following the trade sanctions the League of Nations imposed on Italy after her 1935 invasion of Ethiopia.[23]

Prevented from using imported materials and with others at a premium, Ferragamo and Gucci turned to less conventionally luxurious materials such as canvas, plastics and raffia, the latter supplied to Ferragamo by Fede Cheti, the Milan-based weaver and designer.[24] Ferragamo overcame the humble status of these materials with overt craftsmanship, as in the elaborate weave of the green cellophane uppers of a pair of slingbacks, and through typological innovation, as in the Sardinian cork wedge heels of a pair of multicoloured patchwork suede shoes, a response to the scarcity of steel stiffeners needed to make high heels (pls 97–8).[25] Tellingly, both Ferragamo and Gucci continued to use these materials in the post-war period; Gucci's bamboo-handled leather handbags became a signature part of the company's output (pl.96), as did Ferragamo's wedge heels and use of woven cellophane, by now produced by the hand-weaver Elda Cecchele – who, like Cheti, is another overlooked but key figure in post-war Italian textile production.[26]

The value of the handmade persisted in Ferragamo's international post-war expansion. In an

99 Missoni, machine-knitted
cardigan in blue, brown and
black mohair and nylon, 1984
V&A: T.431–1995

100 Advertisement for Salvatore
Ferragamo at Saks Fifth Avenue
department store, New York, 1960

advertisement from 1960 announcing the company's
new collection at New York's Saks Fifth Avenue store,
a map of Italy and roughly sketched hands signify the
handmade quality and *italianità* (Italian-ness) of its
products (pl.100). This impression is bolstered in the
copy: 'Not satisfied with machine-made techniques,
Ferragamo designs unique shoes, handmade by Italian
master craftsmen'.[27] Yet the advert did not tell the
whole truth about Ferragamo's shoe production.

In the 1920s, Ferragamo had been faced with the
problem of meeting increasing demand. Although
'appalled' by the 'bedlam of rattles and clatters' of
the American factory set-up and the 'heavy, clumsy
and brutal' shoes it produced, incomparable in
quality to those of his native Italy, he devised what he
described in his autobiography as 'a system of making
handmade shoes by mass production' that bore more
than a passing resemblance to it.[28] Ferragamo sought
out first Neapolitan, then Florentine, shoemakers
to participate but they all refused, and he found the
workmanship of those who did agree wanting.[29]
Eventually Ferragamo assembled 'a number of good,
clever boys in Florence' and trained them up into a
Taylorist-style 'assembly line'.[30] As the craft historian
Glenn Adamson has identified, the systems Ferragamo
imposed on his semi-mechanized artisans are early
examples of the exploitative labour conditions exposed
in the fashion industry in recent years.[31] As such, they
are reminders of the need to attend to the conditions
of all workers – be they on the factory floor or in the
craft workshop (pl.104).

Gucci, Pucci and Missoni: Embracing Mechanization in the 1950s

As Nicola White notes in her research on Italian
fashion's post-war reconstruction, Ferragamo was key
in developing America's appetite for goods from Italy

in the early 1950s.[32] This was when Italy challenged
the fashion supremacy of France and the United
States and thrust itself into the international limelight,
aided by the fashion shows held at Giovanni Battista
Giorgini's palazzo in Florence in 1951 and then at
Palazzo Pitti from 1952 (see also Introduction).[33]

Among the designers taking part in Giorgini's
inaugural show was Emilio Pucci, a Florentine
aristocrat who began selling his skiwear to American
stores in the 1940s before setting up his own fashion
house in 1954 in his family's ancestral home. Initially
both design and production were based in the palazzo;
Pucci sketched designs that were translated by a
team of women overseen by a *maestra* called Signora
Ida.[34] In the 1950s Pucci expanded into scarves,
ties, blouses, dresses and other products, all in his
signature psychedelic prints, made from silks and
synthetic materials processed in the fabric mills
of Como (pl.101).[35]

Like Ferragamo, Pucci faced the issue of how to
meet rising demand on an artisanal manufacturing
base. As White recounts, in the 1950s '"important"
items were still cut by hand, sewn and fitted at the
palace' but increasingly production was outsourced to
female homeworkers, who used sewing machines to
assemble pattern pieces for his clothing and accessory
designs, and in 1956 production of ready-to-wear
shirts was shifted to a Florentine factory.[36] This
move was necessary: as the fashion historian Simona
Segre Reinach notes, it was this 'liberation from a
purely artisanal model' that ensured the company's
fortunes.[37] And it did not compromise quality, as using
machinery was the only way to reach a standard level
of production across such a large scale.[38]

One of the first companies to realize the creative,
as well as the productive, potential of machinery
was Missoni, established in 1953 by husband and

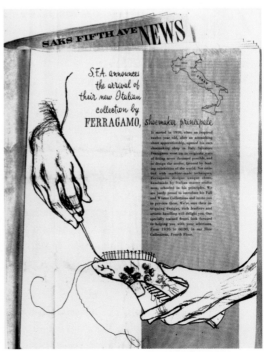

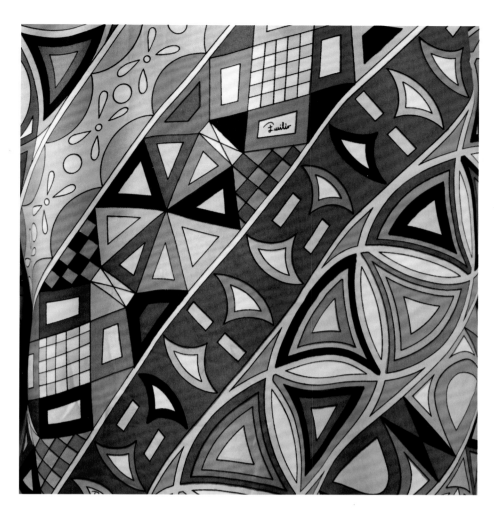

101 Emilio Pucci, 'Dalia' motif printed silk shirt (detail), 1965 V&A: T.585:1–1995

used computers to design all its handbags and map out the placement of pattern pieces on fabrics, ensuring both consistent quality and an economical use of materials.[44] The implementation of such technologies has seen a stratospheric leap in productivity – between 1994 and 1998, Gucci's annual leather goods output rose from 640,000 to 2.4 million items.[45]

These increasing scales of production attest to a deeper structural shift in the industry that took place in the 1990s. While some fashion houses, such as Armani, Etro and Marni, have remained privately owned, many have been submerged into large, listed conglomerates seen as better suited to deal with the increasingly stiff international competition.[46] This new ownership has had a significant impact, as shareholders' desires for profits have become the main drivers of decision making.[47] Crucially, while these brands continue to market their products on the *italianità* of their manufacture, they have undermined this quality in two distinct, but interrelated, ways in the last two decades, compromising the claims to integrity and authenticity on which their provenance-associated production is premised.

1990s to 2000s: From 'Made in Italy' to 'Made in India'

The globalized economies of the late twentieth and twenty-first centuries have affected fashion production on an international scale.[48] As Simona Segre Reinach noted in 2005, 'Italian ready-to-wear is struggling in the twists and turns of the de-location of production, Chinese competition, counterfeiting and the fluctuating meanings of the idea of "Made in Italy".'[49] However, while Italy has been a victim of this situation it has also been involved in its perpetuation – a complicity enabled by the diluted production chains of its celebrated industrial districts.

These days, Italian fashion is no longer necessarily made in Italy. As Dana Thomas revealed in her 2007 exposé of the global luxury industry, since the 1990s many brands have shifted elements of their manufacturing to cheaper producers in countries such as China.[50] These include Valentino, who in 2004 started producing men's suits in Cairo, where seamstresses cost just a fraction of their Italian counterparts.[51] This development is problematic not only because of the working conditions that such decentralized networks could engender, but also because of its duplicity. Until 2007 many consumers were unaware of this productive reality and firms did little to make it known: when Valentino's suits arrived in Italy, the 'Made in Egypt' tags were removed.[52]

Stricter regulations have reduced such mislabelling, but they have not prevented another phenomenon: the hands of that 'Made in Italy' are not necessarily Italian.[53] Take the town of Prato, in the heart of Tuscany's textile production district. In addition to historic firms such as Lanificio Luigi Ricceri, a wool mill set up in 1840 whose clients include Armani, Max Mara and Prada, today the city is also home to several thousand Chinese-

wife team Ottavio 'Tai' Missoni and Rosita Missoni. The couple initially produced knitted ready-to-wear clothing in Gallarate, just north of Milan. Both had experience in the textile industry, Ottavio as co-founder of a knitwear company and Rosita as the offspring of local factory owners, whose output included shawls, bedspreads and other embroidered fabrics (see also p.118).[39] In the early 1960s, Missoni moved to larger premises in nearby Sumirago. Here Rosita started experimenting with the Raschel machine her family's firm had used for embroidering fabrics, and in 1962 she repurposed it to create the striped, wavy and zigzagged patterns in silk, wool and synthetic fabrics that would become the company's hallmark.[40]

Like Ferragamo's woven cellophane shoes, Missoni's elaborate designs demand knowledge of materials and processes and drawn-out production methods. Each garment requires up to 20 different yarns, which are dyed and made up on a handloom before the piece is produced on an industrial loom.[41] This complex production is evident in the finished garment's appearance, for example in the different knit directions of the squares of a women's mohair and nylon cardigan from 1984 (pl.99). As Ottavio said at the time, 'They're machine-made garments, but they have a handmade look about them.'[42]

Since Missoni's 1960s experiments, advanced technologies have become an everyday ingredient in Italian luxury production.[43] Since 1995, Gucci has

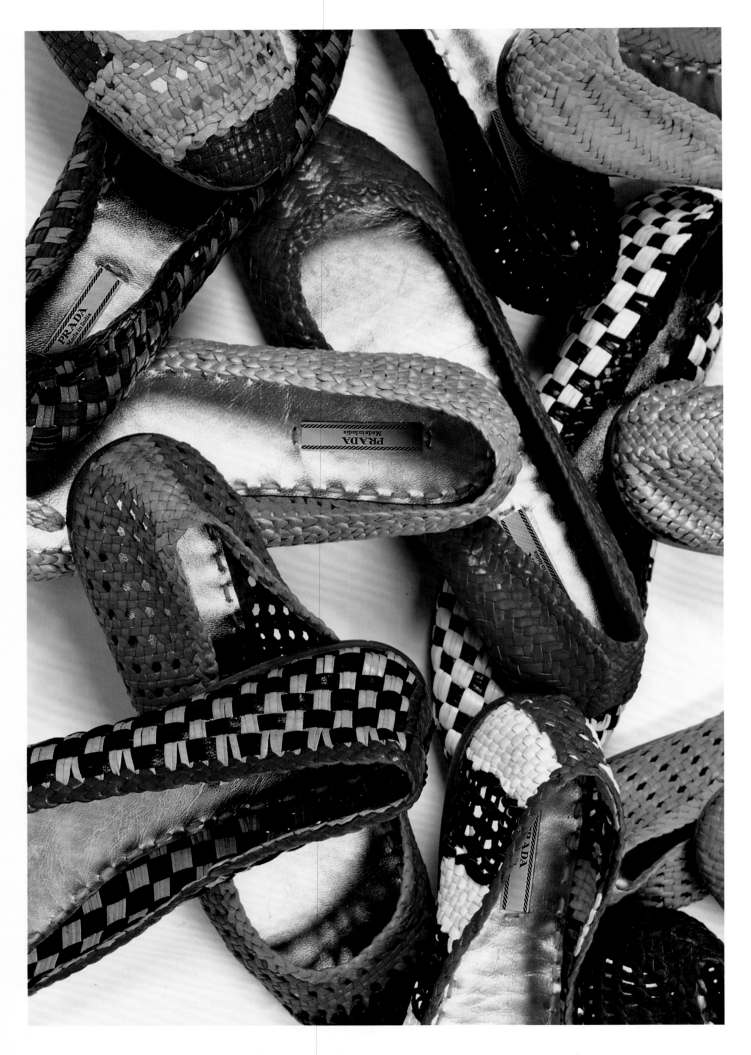

Materials of Fashion Craft and 'Made in Italy'

Opposite
102 Shoes from Prada's
Made In . . . range, 2010

Below
103 Labels from Prada from
the *Made In . . .* range, 2010

Following pages
104 Workers in Ferragamo
Workshop, Palazzo Feroni,
Florence, 1937

owned factories and workshops that have allegedly produced goods for companies including Dolce & Gabbana, Ferragamo and Prada.[54] As with the shift in manufacturing location, the problem is not provenance per se but rather the potential compromise to authenticity and the working conditions of those who make up this hidden, unregulated supply chain – be they Italian or international, legal or illegal.[55]

Following the eruption of these scandals, several brands have sought to reassert their integrity, and used craft to do so.[56] In 2010 Prada launched the *Made In . . .* line, embracing the artisanal traditions of Scotland, India, Japan and Peru through collections based on tartan, woven leather and embroidered cotton, printed cotton and Alpaca wool respectively (pls 102 and 103). This is not the first time Italy has engaged with the craft cultures of elsewhere. Following travels to India by the company's founder Gimmo Etro, since the 1980s Etro's output has centred on its interpretation of Indian paisley print, such as the *Indo-n-Asia* series, a reference to the hybridity of today's 'global village'.[57] While this exoticist cultural conflation deserves further scrutiny, the Italian location of Etro's production does save the company from criticism regarding the economic implications of such an Orientalist outlook – unlike Prada. In 2010, Miuccia Prada, head of the Milanese firm since 1978, described *Made In . . .* as being based on an openness and lack of 'hypocrisy' towards today's globalized production, yet some accused the firm of precisely this.[58] As design journalist Caroline Roux pointed out in *Crafts* magazine in 2011, *Made in . . .* allows Prada to capitalize on the added value craft brings, yet, in the case of the pieces made in India and Peru, to do so at a lower cost,[59] with the potential of economic advantage.[60]

If Prada has embraced non-Italian artisanal traditions, other companies are actively asserting Italy's own. Established in 1968, Bottega Veneta was bought in 2001 by the Gucci Group, who appointed German designer Tomas Maier as creative director of the then-ailing leather goods house. Maier launched the *intrecciato* bag, named after a leather-weaving technique invented at the firm in the 1960s.[61] Applied across a range of goods, *intrecciato* transformed Bottega Veneta's fortunes, thanks to an embrace of conspicuous craftsmanship in an otherwise logo-saturated industry.[62]

In addition to these established brands, newer names such as the Milanese tailoring label Aquiliano Rimondi and handbag designer Benedetta Bruzziches are among those of the next generation asserting the importance of Italian craftsmanship in their collections.[63] This advocacy of the artisan is to be commended for ensuring the preservation of traditions and livelihoods that would otherwise be endangered today, yet there are those who argue that the ongoing reliance on 'Made in Italy' is not necessarily a good thing. For Segre Reinach, foregrounding craft production has meant foregoing innovation at some brands, a strategy that in the long run 'cannot but have repercussions for the future of Italian fashion'.[64]

Yet as Segre Reinach would recognize, craft is not antithetical to innovation. As this chapter has demonstrated, it has been firms' ongoing innovation through their artisanal manufacturing set-up that has allowed Italy to retain its global fashion primacy. However, she is right to question the assumption that craft always represents a good production model, particularly when it leads to strategies that undermine the ethical associations of the artisanal workshop – an unsavoury reality Ross and others have unmasked.[65] It is important, therefore, to persistently attend to the reality of production, in Italy and elsewhere: for as long as Italy's fashion industry continues to create a craft-based demand for its goods, it is its responsibility to make sure that reality matches expectations.

Catharine Rossi is Senior Lecturer in Design History at Kingston University, London

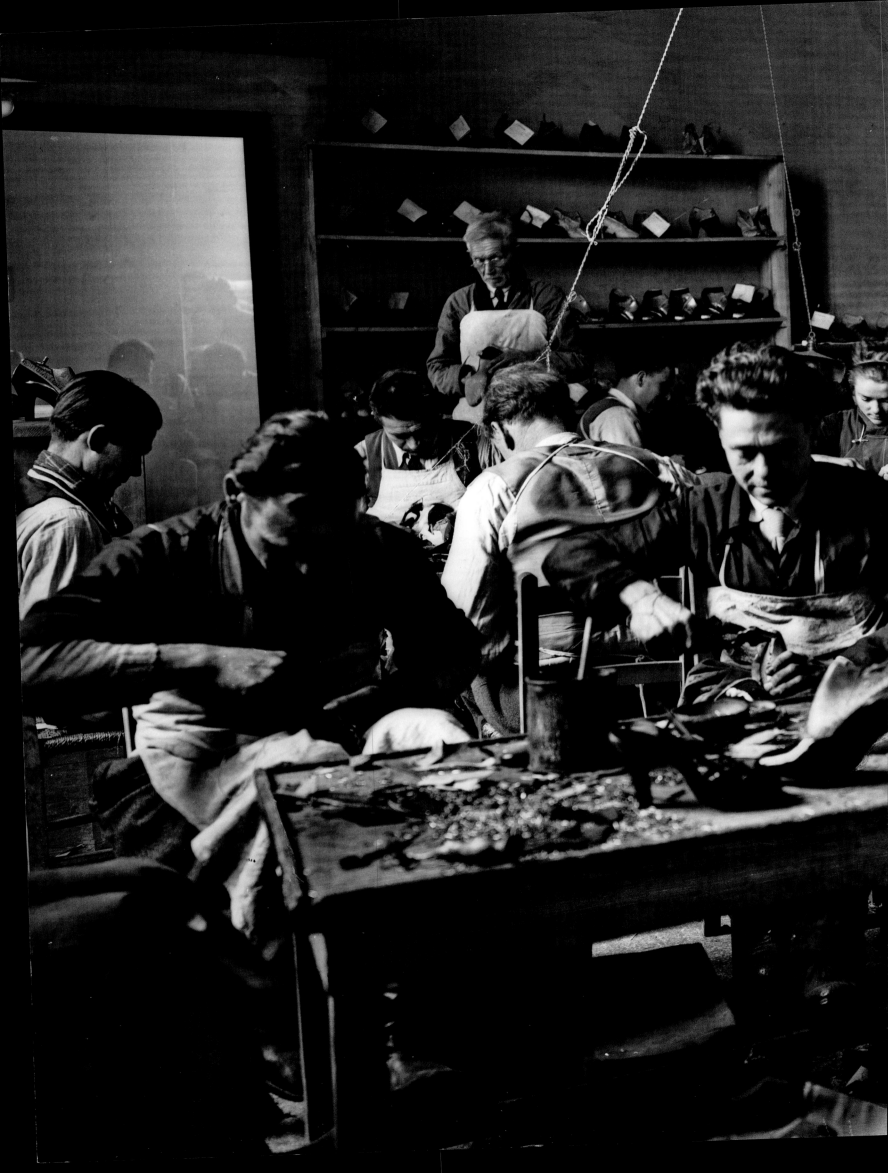

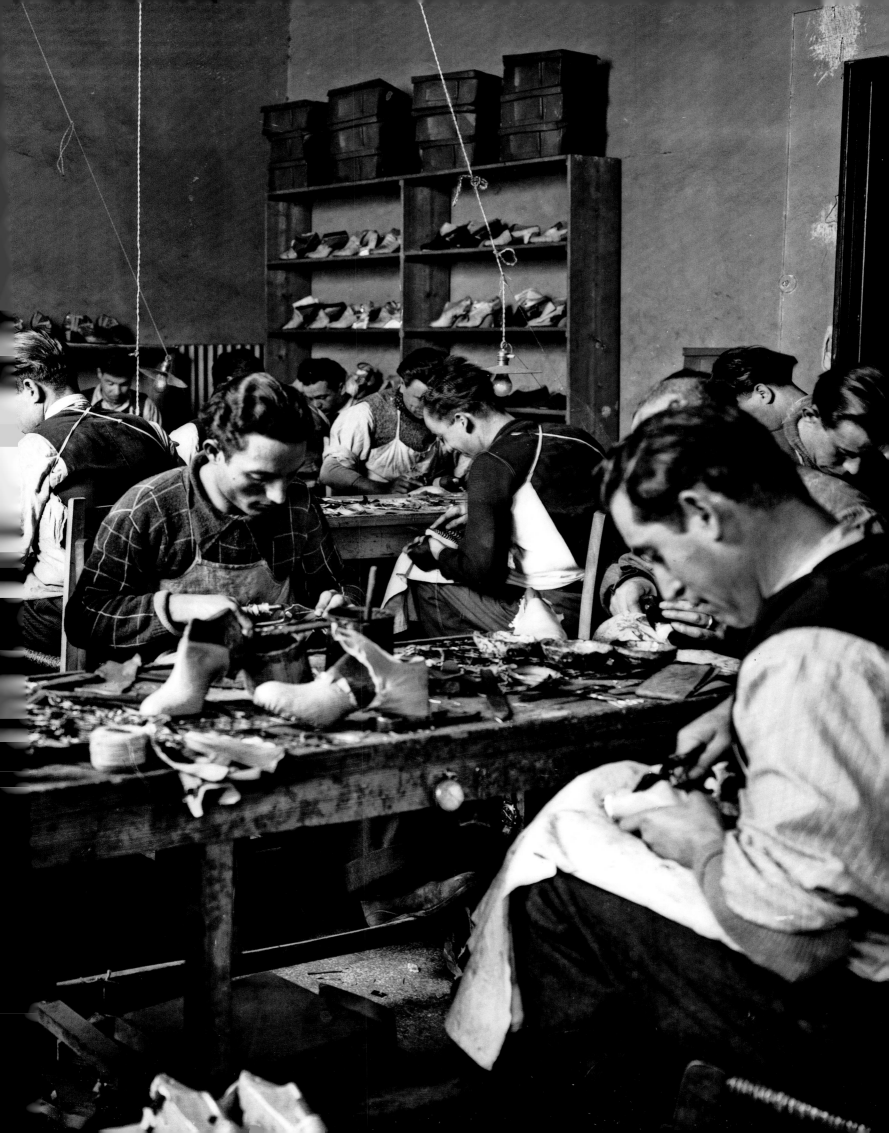

Prato: Between Tradition and the Future

Filippo Guarini and Laura Fiesoli

Prato belongs to the generation of districts that established themselves after the Second World War. It was founded on centuries of familiarity with the textile production process and its markets.[1]

Prato: The Historic Background

The geographical features of the plain surrounding Prato and the presence of the Bisenzio river favoured the birth and development of a textile industry here, with the construction of a network of workshops to prepare cloth (a process known as fulling) using water channelled from the river, linked with small shops in the town and outlying region. Prato's specialization in textile production dates back to the twelfth century, from the thirteenth the production of wool cloth was regulated by the *Corporazione della Lana*, one of Florence's seven major guilds of arts and trades. Between the thirteenth and fourteenth centuries, there was significant population growth in Prato, due both to the town's expansion and its status as a 'free commune', which involved a system of self-government that favoured the development of manufacturing activities in the textile sector.

The diffusion and articulation of this industry are embodied by the entrepreneurial model of Francesco di Marco Datini (1335–1410), a wool merchant. His production and distribution systems were extremely modern and included the acquisition of raw materials from Spain, England, France and Eastern Europe, where he had his own warehouses. Datini also entrusted the various production stages to specialist workers based in Prato or the surrounding area: spinning was done by women in the countryside, weaving in urban workshops and finishing processes were carried out in workshops in the valley. Finally, the cloth was sold across Europe by Datini's own agents.

During the Renaissance, the political and economic power of Florence also had consequences for textile production in Prato, as the city was forced to manufacture medium- to low-quality wool cloths that would not compete with the fine wools produced in the workshops of Florence. In the seventeenth century, Florentine control relaxed and Prato enjoyed a period of growth in the production of these types of cloth, which began to be sold in greater quantities in the local area and beyond. At the end of the century, the production of mixed-fibre textiles was established (linen and wool, cotton and wool, wool and hemp) as well as textiles woven from cotton and linen, called *mezzelane* (half-wools), representing the first attempts to mix wool with other fibres in Prato.[2]

From the Industrial Revolution to the 1980s

The industrialization of the production chain began in the second half of the nineteenth century with the use of steam and the introduction of new kinds of machinery, particularly for spinning, that dramatically

105 Opening up wool fibres
in a Pratese factory

speeded up the production process. These technical advances had a major impact on the structure of production: alongside the 'decentralized' medieval model, a new centralized one was implemented. As a result, many of the small workshops scattered across the region joined together to form larger establishments, overseeing the whole production cycle and increasing output by improving the organization of work.

At this time, a type of production invented in England in 1813 became common in Prato, using rags and old clothes to process recycled or regenerated wool. This made it possible to produce low-cost, warm textiles, which were exported to less industrialized countries with great success. Recycled wool production became the most widespread form of manufacture across the whole territory until the Second World War. In the first half of the twentieth century, the recycled wool industry in Prato focused on two different types of production. One was the manufacture of medium- to low-quality recycled wool cloth, used for military and domestic blankets as well as for shawls and throws aimed at the English and Dutch colonial markets and the countries around the Mediterranean basin. The other was women's wool clothing, a sector that grew significantly when military commissions ceased at the end of the Second World War. The shift in production towards womenswear meant that large textile factories began to disappear, replaced – once again, after centuries – by a network of small firms, mainly family-run and highly specialized in one or more phases of the textile cycle (for example the sale of fibres, spinning, weaving or finishing), paving the way for Italy's district system that still exists today.

Due to developments in the clothing industry, mechanized textile production became increasingly important from the mid-1950s onwards. To give a sense of the scale of the phenomenon, at the end of the Second World War almost all clothing worn by Italians was made to measure. Thirty years later this industry had almost entirely disappeared.

The 1960s and '70s represented a period of diversification in the textile industry. Spurred on by new market demand, Pratese companies set out to produce textiles of a higher quality than recycled wool. They introduced new materials, such as finer and more prestigious combed woollens, as well as products such as carpets, furnishing textiles, hosiery and knitwear. The major innovative aspect of this kind of diversification was the increasing focus on 'fantasy textiles' for womenswear, which were well suited to the flair and creativity of the Prato technicians. This important period of experimentation and innovation also saw the beginnings of research into the development of stretch fabrics and non-woven textiles.[3]

During the oil crisis of the 1970s,[4] businesses in Prato had to contend with another international scenario. Up until the middle of the decade, small companies developed, large factories completely disappeared and domestic work waned. At this time the economic-productive system in the district became standardized and began to form a model worth studying and imitating, thanks to its organization based on a network of small (and even smaller) firms, mostly specializing in different phases of the production process. The concentration in one area of thousands of companies involved in different parts of the cycle, such as woollen mills, planning and sales experts and third-party firms like spinning mills and weaving, dyeing and finishing specialists, as well as dedicated services such as distribution and import-export businesses, worked as a driver for the development of synergies, competition and innovation – all features that enabled the district to emerge as the model for Italian production.

Proof of the importance of the Prato textile district at this time was the launch in 1979 of Prato Expo, a trade fair promoting the district's industries.[5] Held in Prato and Florence for the first few years but later forming part of the Milanese circuit of the sector's major events, Prato Expo became not only the main forum for promoting Prato collections at an international level, it was also the event that would revolutionize working methods and lead to new ideas about relationships between firms. Because of this event, small- and medium-sized companies became more aware of the fact that in order to be competitive within a market that had become increasingly globalized since the second half of the 1970s, it was necessary to present a united front, but without losing their own specialisms. This need for a collective identity is illustrated in the unifying idea of a framework for firms to exhibit in as well as the creation of a space within the Prato Expo fair dedicated to research into fashion trends.[6] Prato Expo was the first attempt to publicize to the global market the identity of the district as a group of avant-garde companies, both in terms of taste and style as well as product innovation. Prato firms began to distance themselves from the standardized production of low-quality recycled wool in order to seek out new avenues of production, to move beyond low-cost competition and to ally themselves with the fashion cycle.

By the mid-1980s, Prato faced a significant crisis in the production of traditional, carded-wool textiles, which no longer corresponded with market demand. Instead, there was a prevailing trend for lighter, higher-quality wools, mixed with synthetic fibres that were more suited to lighter, easy-care clothes. The businesses that survived were those that changed their production. Wool ceased to be Prato's sole product and was instead gradually accompanied by cotton, linen, silk and synthetic fibres. Prato's relationship with the ready-to-wear clothing industry became increasingly significant and at the same time it became vital for companies to promote their products to both designers and consumers. The end of the decade brought experiments with microfibres and the latest kinds of synthetics, adding to the innovative and distinctive image of production in Prato. These new materials allowed Prato's textile manufacturers

Above
106 Shipping department in
the Campolmi factory, 1920

to approach specialist sectors, such as companies that produced sportswear and technical clothing. Some textile firms decided to specialize in these areas, foreseeing the general crisis of the fashion industry that began in the early 1990s as a consequence of globalization.

For Prato, this was a time of rich but fragmented local production: about a third of the region's textile products were made of summer fibres like linen, light wool and cotton, while the heavier, carded textiles, which had represented 90 per cent of production in the 1960s, now made up less than half of total production. Most fabrics were destined for womenswear (48 per cent), although the quotas for unisex and menswear articles increased (30 per cent), while sportswear was less significant (eight per cent). Luxury brands sold in ready-to-wear boutiques, retail units in shopping centres, franchises and foreign department stores accounted for 75 per cent of the textiles produced. Only five per cent was used in couture, while 20 per cent went to small, anonymous clothing companies.[7]

At this time, the dyeing and finishing industry became a strategic sector, endorsing the new variety in production as well as embellishing low-cost, ready-to-wear products. For clothing that was increasingly conceived within an international framework, the burden of seasonal fashions diminished and other factors, such as comfort and versatility, became more important. The woollen mills sought to interpret the needs of the consumer through direct contact with clothing companies and by offering personalized technical solutions.

To address these transformations within the industry and to quickly modify its own organizational models, Prato's textile producers, especially those involved in womenswear, had to adapt to three new levels of production. The first was programmed production, which takes place every six months and is based on clearly defined fashion trends that are developed well in advance of the seasonal collections. In recent years, these time frames have been shortened from 15 months to seven or eight months before sales. The quality of these collections is standardized and the textiles are promoted internationally at trade fairs, like Première Vision in Paris. The internal style offices of these textile producers are in constant contact with fashion designers. Even today, the strength of the Italian textile industry resides in its ability to second-guess these changes, maintaining its usual level of quality and creativity but combined with an increasingly flexible production model and the ability to manage both large and small batches.

The second level of production is that which directly links to Italian ready-to-wear.[8] These textile collections come out between eight and ten times a year and are sold to fashion companies as a package. The quality level is higher than that of fast fashion, but the production rates are still very quick. The third type of textile production is that destined for fast fashion. This type of textile is faster and cheaper to produce. In this production method, the textile may be imported in a semi-finished state from abroad and then dyed and finished in Italy. This reduces costs and maintains quick consignment times (for fast fashion, consignment is 15 days before sale). For the stylistic development of these textiles, Prato's woollen mills work with import-export companies and the large clothing companies such as Inditex (the Spanish owners of Zara and other brands) and the Gap. Ideas are adopted when broader trends from programmed production have already been established in the market; they are then simplified and brought into line with the taste of the wider public.

The Contemporary Panorama

Today, Prato's manufacturers produce clothing and knitwear as well as textiles. While knitwear became a feature of local manufacture in the 1960s, clothing is a relatively recent development that was born out of necessity in the late 1980s and early 1990s, taking it downstream of the supply chain. The development of this new supply chain has gone some way towards balancing the contraction of the entire textile sector. Changes in the industry throughout the last decade have led to firms being reduced by about 50 per cent over this period. The estimates for 2012 refer to 2,918 textile companies and 4,437 clothing and knitwear firms, with an overall turnover of about 4.4 billion euros. The export trade is one of the district's strong points, with a turnover of 2.4 billion euros.[9] Europe is the principal destination for Prato textiles (72 per cent in 2010), followed by a growing Asian market (18 per cent), the United States (five per cent) and Central America (five per cent).[10] Production is extremely varied and includes mainly medium- to high-quality womenswear, yarns used primarily for medium- to high-quality knitwear, furnishing textiles such as carpets, textiles for specialized uses (tufted textiles, laces, *passementerie* and embroidery), cotton padding, felts, cords, technical textiles (coated and oiled), fleeces and velvets. Research carried out in 2011 by Prato's Industrial Union showed that carded wool was still the most commonly produced product (36.6 per cent), although it had been dramatically reduced by the 'carded-wool crisis'.[11] After this came cottons and linens (18.5 per cent), elasticized textiles (10.2 per cent), knitted textiles (9.8 per cent) and finally synthetic fibres.

Prato's clothing industry owes much of its recent explosive growth to the development of Chinese enterprise. In 2011, out of more than 4,000 clothing and knitwear companies in the region, 3,402 were Chinese owned,[12] producing about one million garments a day. This 'parallel district' developed during the 1990s, becoming the largest Chinese community in Italy.[13] Nearly all the community's members came from only two Chinese provinces, Zhejiang and Fujian.[14] The Chinese immigrants in this area, of which there about 30,000 (including illegal immigrants), rarely work in Italian-owned companies. Instead, they have become entrepreneurs and have created a network of very small businesses in the ready-made knitwear and clothing sectors, the latter working for third-party brands, often Italian. The decision to establish themselves mainly in Prato, rather than other parts of Italy, was based on the fact that it is very easy to access raw materials there (yarns, fabrics and accessories) as well as semi-finished goods, and workspace is also readily available. Chinese entrepreneurs chose to produce ready-to-wear because it requires less initial investment and the necessary machinery is easier to transport and reassemble. The companies are run by young Chinese entrepreneurs, often women, and only operate for short periods of time, often because they are established illegally or they are staffed with clandestine workers.[15]

From the 1990s onwards, Prato's Chinese-owned textile businesses have shown a tendency towards a kind of 'ethnic vertical integration' by working with and employing Chinese immigrants. They will often begin by acquiring a third-party firm involved in clothing manufacture (dyeing and treatments) and supply (accessories, for example) or providing services for their businesses (consultancy, information technology) and their community (such as commerce and health care). This Chinese business activity is concentrated in specific areas of Prato, literally creating a town within a town. It is a system that is not integrated with the Italian one, and which is supplied by textiles made in China at a very low cost, due to the lower quality and price of the raw materials, as well as lower import taxes.[16] In the face of numerous challenges arising from this situation, today Prato's local administration and professional associations are working towards cultural mediation and diplomatic dialogue, trying to find the potential economic benefits that could lead to a greater integration between the

111 Quality control department
in a Pratese factory

Opposite
112 Wool and silk mohair (left),
mohair wool (right), Lanificio
Luigi Ricceri

productive capacity and receptiveness of the Chinese and the quality of Italian-made goods.

Between 2000 and 2010, Prato's textile exports experienced a drop of 50 per cent, due to a series of events that occurred from 2001 onwards, including the economic collapse linked to the 11 September attacks, China's entry into the World Trade Organization in November 2001 and the American financial crisis.[17] At the same time, China began to purchase more raw wool than Italy, becoming the biggest global importer of this important material. Concurrently, the Chinese government financed huge non-repayable contributions to develop the national textile industry. The global financial crisis of 2008 finally provoked a strong contraction in the economy and consumption at an international level.

As well as having to take on international competition and the stagnating global economy, at a domestic level the industries of Prato had to contend with the danger of the progressive disappearance of certain specialized manufacturing processes – carbonizing, for example, or the selection of rags, fundamental in the production of recycled wool textiles – due to the import of semi-finished textiles from abroad, which created significant gaps in the traditional production cycle. In order to tackle this problem, some woollen mills began to carry out certain processes in-house again, for example the refinishing of cloth. Their aim was to eliminate interruption in production and to avoid losing the technical skills that the area still possessed and which represented a unique and important level of quality.

Prato and the Future

Against a backdrop of an uncertain financial climate and internal integration problems, Prato's Industrial Union seeks to promote excellence in the local textile district in the field of fashion (both clothing and knitwear), wool producers and textile innovators, without forgetting the textile machinery and service sectors, which should demonstrate greater competitiveness in the field of technological innovation. Regarding the Chinese district, the Union aims to drive out illegal practices and to encourage the creation of one integrated production hub. The president of Prato's Industrial Union, Andrea Cavicchi, has said that the industrial politics of the district need to follow certain guidelines in order to survive the economic crisis and give a new impulse to the sector. These guidelines include pursuing 'excellence in global niche products, the close relationship with leader clients and the ability to supply complete services following their needs. Despite setbacks due to international competition and the ineffectiveness of European politics to support the textile and clothing manufacturing sectors, Italian fashion continues to attract global markets thanks to its design research, its quality and artisanal nature.'[18]

The image of 'Made in Italy' is fundamental to the country's fashion industry and this partly explains why the industry's recent crisis is due to dynamics of a political nature, rather than commerce or production. During the last few years, Europe has failed to sufficiently safeguard its own textiles and clothing manufacture. In order to guarantee a brand's quality, it will be increasingly necessary to make its origins and supply chain transparent. This is not easy, considering that in recent years it has been possible for a garment to be mostly made abroad but still be labelled 'Made in Italy'.[19]

The most recent European regulating proposals, foresee that by 2015 the traceability of a product's history of manufacture will be obligatory not only for labels on clothing and knitwear imported from countries outside the European Union but also for products made in the EU, for which up until now it has been optional. This should guarantee a widespread move to identify all the products circulating on the European market and to combat fakes and copies. In this scenario, the prestigious 'Made in Italy' brand could continue to be used for those goods whose final stage of production (for example clothes-making) takes place in Italy, according to the European Customs Code.

There are some encouraging signs for Prato's textile industry. Since 2011 there has been a growing tendency to source semi-finished goods within Italy, unlike previous years when the 'Made in Italy' brand depended to a greater degree on foreign products. Placing the emphasis on quality even if that inevitably means higher costs, this development challenges the current crisis in the sector.[20] In addition, during the last decade, the concept of eco-friendliness has grown more important in textile and clothing

products. As consumers have become increasingly concerned about pollution and the waste of natural resources, so fashion companies have begun to pay more attention to these issues, with strategies such as using environmentally friendly fibres, materials and dyes, and adopting new technologies to recycle waste and purify water. The Prato district became known as an ecologically sustainable model, the first in Europe to adopt a centralized purification system for the water used to dye, wash and refine textiles. Even the traditional recycled wool that typified the district's production until the 1970s is enjoying a renaissance due to its sustainable qualities. Given that it is produced from rags or scraps, regenerated wool enables the recuperation of waste products that would otherwise end up in landfill.[21]

The Prato Chamber of Commerce has become a flag bearer for these issues, instituting a series of coordinated proposals under the name of *Prato distretto verde* (Prato Green District) that are intended to reduce the environmental impact of industrial production processes.[22] One of these activities is called 'Regenerated Carded CO2 Neutral'. Launched in 2011, it aims to offset the pollution caused by the production of carded wool. The participating firms disclose details of their energy consumption and the levels of carbon dioxide emitted during the production of this textile in order to offset this with carbon credits, which involves planting new trees.

The clothing and textile sector still represents one of the successes of 'Made in Italy', as is shown not only by the numbers involved but above all by the reputation the industry enjoys at an international level.[23] Despite this, the system is dealing with a deep-seated crisis due to competition from international production hubs, the conquest of new markets, the advent of new technologies and the need to improve performance by reducing reaction times to the market and European politics. Sector workers are increasingly conscious of the fact that the 'Made in Italy' label can be a double-edged sword if it is not accompanied by traceability, quality controls and transparent communication with consumers. This is the principal challenge facing Italian fashion today: how to maintain its identity without renouncing competitive factors, such as an international supply chain (including producing and importing from abroad in order to keep down costs and speed up the process) and an ever-greater presence in international markets.

Some companies have managed to seize the opportunity to diversify their product range as a solution to the current challenging climate, such as Lanificio Luigi Ricceri (pls 112 and 113). One of Prato's oldest wool firms, it is one of the very few companies overseeing the complete cycle of production in the Prato district. The firm was founded in 1848 with a factory near the town's historic centre and is still owned by the same family today. In 1880 it received an award for the production of white woollen flannels. Over the years, the company grew, taking on all the production phases. Its current architecture shows the signs of this growth: next to the oldest building, dating back to the 1930s, stand more recent structures. The firm has not only grown in size but also in turnover. It was a strategic decision to continue producing clothing with high-quality raw materials and high standards of manufacture. This wool firm works with all kinds of fibres, including silk and refined yarns, it continually acquires new machinery, especially for refinishing and dyeing, and it invests in research and development. Its clients are major international designers, from Yves Saint Laurent and Burberry to Chloé and Yohji Yamamoto, and the company also produces couture textiles for individual outfits, including ones worn by the Duchess of Cambridge and Queen Elizabeth II.

Another example of Pratese innovation is Gruppo Furpile. Set up in 1972, the company concentrated on a newly developing market: fake fur. In the 1980s it started producing fleece, a fabric that soon become important in outdoor clothing and sportswear, and the company went on to become the sector leader.

113 'Mara', double wool crêpe
with satin squares, Faliero Sarti
& Figli, Spring/Summer 1968

114 'Selvaggia', cotton with silk
organza background, Faliero Sarti
& Figli, Spring/Summer 2014

Continued technical research led to such an expanded range that in the 1990s Gruppo Furpile became an industrial group with a vast array of products, from short fake furs and shuttle-woven textiles with a pile to knitwear. By continuing to develop textiles for specialized uses and also excelling at producing clothes, the company has maintained its strong position.

Lanificio Faliero Sarti & Figli provide further example of diversification. A family firm established in the 1940s and now in its fourth generation, it differs from the traditional Prato production model (pls 113 and 114). The woollen mill began by supplying textiles for the early Italian couture designs that appeared on the catwalk in Florence in 1952. With the birth of ready-to-wear, these textiles were offered to designers like Giorgio Armani, Nino Cerruti, Gianfranco Ferré, Romeo Gigli, Trussardi, Gianni Versace and Vivienne Westwood. In the early 1990s, the firm faced a changing commercial landscape by experimenting with a new product type: accessories. Based on a desire to meet the largest demand for finished goods, this choice enabled the firm to adapt its existing knowledge and technology to a new kind of production. Its line of scarves is made from refined fabrics for a high-level market. Although Faliero Sarti maintains its textiles line, the scarves now represent the firm's main focus.

The Role of the Prato Textile Museum in the Industrial District

The Prato Textile Museum was founded in 1975 with the aim of supporting professional training in the textile sector.[24] A form of textile archive that could be used as a teaching aid, the museum was housed within the city's technical college, the Istituto Industriale Tullio Buzzi. Eventually, the conservation requirements of a growing collection of historic materials as well as contemporary textiles,[25] and the desire to make this collection accessible to a wider public, meant that the school was no longer an appropriate place to house the museum. Furthermore, it was no longer possible to run the museum with only volunteer help. In 1997, the museum moved to a temporary home in the Piazza del Comune in Prato, where it remained until 2003 while awaiting the acquisition and restoration of its current and final home, previously a finishing mill, the Cimatoria Campolmi (pl.115).[26] The Textile Museum aims to attract not only specialists from the textile sector but everyone, from students and the local population to tourists. It is one of the few public spaces in Italy that regularly organizes initiatives on fashion and textiles and publicizes 'Made in Italy' goods.

The Textile Museum's key mission is to conserve the district's industrial heritage and at the same time to showcase Prato's contemporary textile industry and culture.[27] Within its galleries, there is a particular emphasis on the display of contemporary textiles (pls 107–108), which acts as the cultural interface with Prato's production district. Through its programme of exhibitions and events, the Textile Museum promotes the real face of textile production in Prato, today and into the future.

Filippo Guarini is the Director of the Prato Textile Museum
Laura Fiesoli is responsible for the contemporary textiles section at the
Prato Textile Museum

115 Internal courtyard (formerly the Cimatoria Campolmi), Prato Textile Museum

116 Gallery displaying historic textiles, Prato Textile Museum

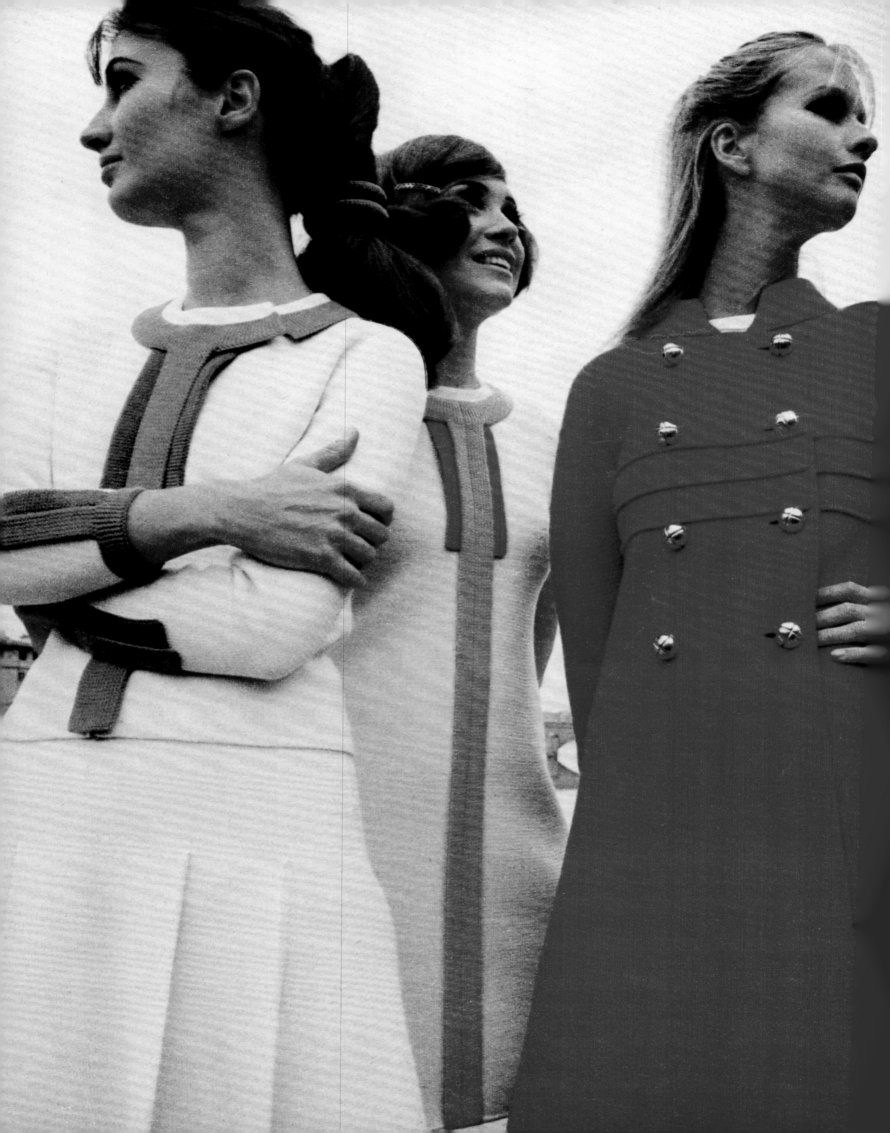

Elizabeth Currie

Knitwear

Designers worked to create increasingly innovative garments by experimenting with pattern and construction . . . combined with technological developments.

The remarkable success of Italian knitwear in the decades following the Second World War was rooted in long-standing historical traditions. For centuries, knitwear manufacture in Italy had been characterized by small-scale firms that relied heavily on subcontracting, making use of artisan skills and high-quality yarns. However, over the second half of the twentieth century, designers worked to create increasingly innovative garments, by experimenting with pattern and construction, fibres and yarns, combined with technological developments.

In the 1950s, Italian knitwear businesses began to secure contracts with prestigious department stores across Europe and, crucially, in the United States, including Bergdorf Goodman, Neiman Marcus and Saks Fifth Avenue.[1] Many of these garments were hand-finished and bordered on couture, particularly suited to the American market that had looked to Italy for this type of craft product since before the war.[2] One firm specializing in high-end fashion knitwear was Albertina (pl. 117). Founded in Rome in 1952, it soon attracted high-profile Hollywood clients such as Ava Gardner, Lana Turner and Gloria Swanson. In February 1955 an article in British *Vogue* showcased knitwear imports from Italy. To emphasize the sophistication of the designs, the pieces were photographed at the Milan studio of the painter and designer Piero Fornasetti, with the models posed in front of a series of his screens (pl.120). Available from London's Fortnum & Mason, the garments demonstrated knitwear's potential to cross over into more formal wear. As one caption read: 'Perhaps the most casual of them all, with its straight-to-the-hip line and push-up dolman sleeves; a sweater that stakes its claim to the adjective "evening" with opalescent paillettes threaded through the neck and cuffs. The matching fringed stole worn with a gipsy-like grace.'

Increasing demand for Italian knitwear led to a very rapid expansion in businesses in the principal manufacturing districts, including Biella, Treviso (the location of the high-street brand Benetton) and Carpi, a town situated 18 kilometres outside Modena. Previously Carpi had been the centre of the once-thriving straw-hat industry, but when demand for these products declined the small firms involved, many of them family-owned, reinvented themselves as knitwear manufacturers.[3] In the space of 20 years, between 1951 and 1971, Carpi more than tripled in size as it expanded into a significant manufacturing town. By 1981 there were 7,500 declared knitwear employees in Carpi, although this represented a small percentage of the actual numbers involved.[4] As in other areas of the textile industry, informal sector workers, often highly skilled women, make an important contribution to knitwear production.[5] Despite fierce competition from manufacturers in Asia, Carpi still has almost 2000 knitwear firms, with a staff of 10,000 and a turnover of one billion euros, half of which is accounted for by exports.[6]

Italian knitwear firms that developed in the post-war period were frequently based on decentralized organizational structures. Companies either created their own designs or realized those supplied by clients, utilizing a network of subcontractors who specialized in separate phases of the manufacturing process.[7] This kind of vertical system took its model from the 'putting-out system' that had epitomized many aspects of textile production in Italy since the Renaissance and still has the advantage of fostering a spirit of competition and cooperation. When it works well, it ensures greater flexibility and has the advantage of allowing firms to pool resources, helping them respond quickly to designers' needs. One striking success in terms of collaborative partnerships was Miss Deanna, founded in 1960 by Deanna Ferretti Veroni in Reggio Emilia. In 1971 she began a 20 year collaboration with Kenzo, in addition to working with many other designers including Giorgio Armani, Enrico

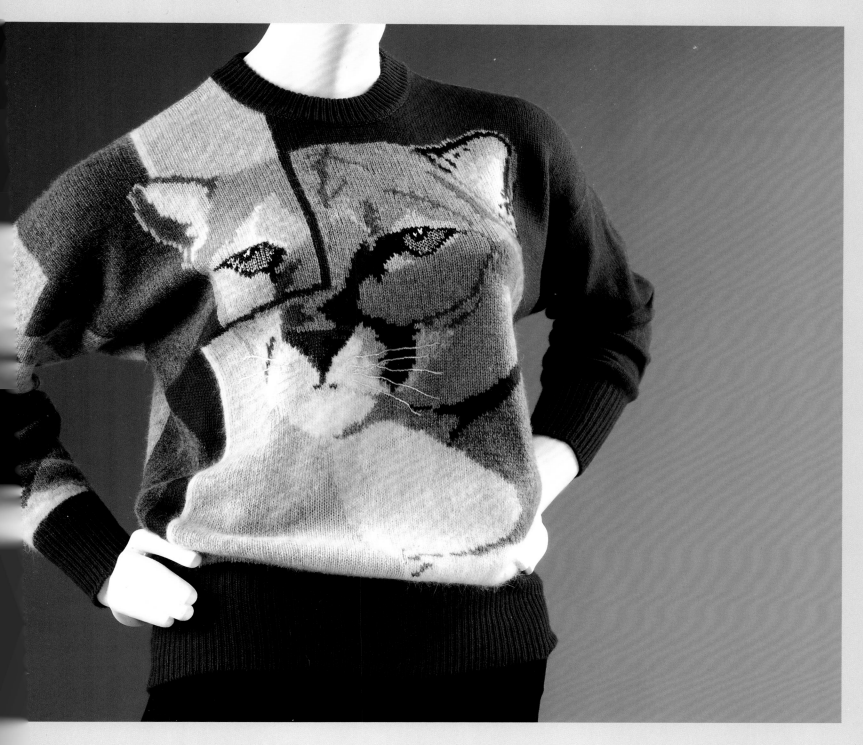

page 114
117 Albertina, fashion
photograph, 1960s

118 Krizia sweater, cashmere,
wool and angora mix, 1985
V&A: T.46–2007

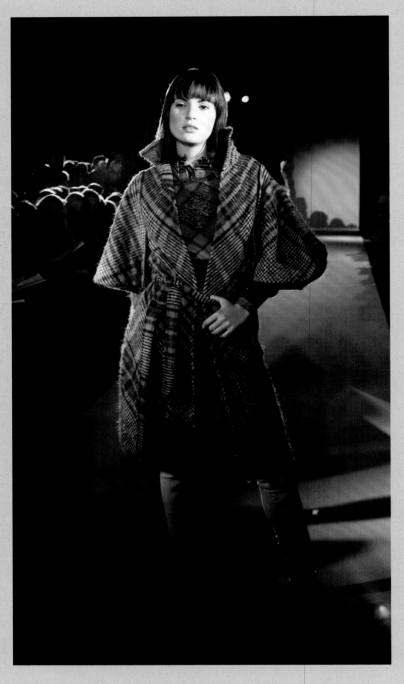

ers experimented with bold, graphic and sometimes surreal patterns. In 1967, Mariuccia Mandelli founded Krizia Maglia and the following year the label launched the first of its series of machine-knitted sweaters emblazoned with a different animal motif for every collection, often hand-finished with embroidered details. Fittingly, given Krizia's black panther logo, wild cats were a frequent theme, including a grey puma in 1985 (pl.118). During the same period, Gianni Versace explored a range of subjects, reinterpreting images by great twentieth-century artists such as Picasso and Kandinsky, which were then embellished with sequins, rhinestones and metal threads. His sweater emblazoned with two wrestlers returned to his favoured design inspiration: the art of ancient Greece. It was produced in 1983, the year that new breakthroughs in computer-programmed knitting machines were announced at the International Textile Machine Exhibition in Milan.[8] State-of-the-art technology meant that the garment could be completed just two days after the design was first sketched out.

The fusion between Italian knitwear and fashion is, however, most often associated with Missoni, the label founded in 1953 by Ottavio Missoni, who had started out making jersey tracksuits, and his wife Rosita Jelmini, whose family had a shawl-making company. Their backgrounds undoubtedly contributed to the flexible nature of their products, which underline knitwear's ability to combine elements of sportswear and more luxurious formalwear. Ottavio explained that their aim was to produce machine-made garments that nevertheless had a handmade look about them.[9] Missoni first rose to prominence in the early 1960s and achieved notable success between 1965 and 1970 with sweaters and ensembles in plain and patterned yarns, often dip-dyed at regular or irregular intervals to produce subtle gradations in tone that highlighted their trademark flames and stripes (pl.119). The company also became known for its experiments with mixed fibres, both natural and synthetic, combining wool, mohair, cashmere, silk, viscose, rayon and metallic threads.

Knitwear is enjoying a new wave of popularity in Italy, rediscovered by up-and-coming designers and big brands, as well as being the focus of recent museum exhibitions.[10] To differentiate themselves and maintain a leading position within today's global fashion system, Italian knitwear firms employ a range of strategies. Emphasis is often placed on quality, design and technical advances. Collaboration is still paramount and sometimes experimental, such as the recent partnership between knitwear company Maglificio Miles and Swedish designer Sandra Backlund. Many firms emphasize the calibre of their raw materials, a fundamental marketing strategy of cashmere brands such as Malo, Avon Celli or Annapurna, some of whom pride themselves on combining hand-finishing with cutting-edge computers.[11] A similar return to artisanal values can be found even in more contemporary brands, such as Aimo Richly, with its emphasis on touch and a sense of authenticity.

Elizabeth Currie is a lecturer and researcher specializing in fashion, art and design history

Coveri, Valentino and Martin Margiela. Ferretti Veroni's working philosophy was based on a determination to reinvent the possibilities of knitwear, by experimenting with yarns, prints, different kinds of finishes, washing processes and forms of wearability. The grey plasticized dress created for Margiela's Autumn/Winter 1998 collection was the first example of a mass-produced piece of knitwear that could be personalized. The dress was packaged and sold inside a transparent film of plastic, applied using an innovative heat-bonding technique. The plastic cover had to be pulled off before the dress could be worn. The act of removing it varied from person to person, leaving a permanent mark on the garment made by the owner. So although 100,000 identical garments were produced, once they were worn for the first time each one became unique.

From the 1960s onwards, as knitting machines became more sophisticated, the sweater became a blank canvas on which to reinterpret trademark motifs. Design-

Opposite
119 Missoni, 'Fashion in Motion'
show at the V&A, London,
November 2003

120 Orchid-pink wool sweater
and matching stole. Photograph
by Henry Clarke for 'Knitwear:
the Italian Way', British *Vogue*,
February 1955

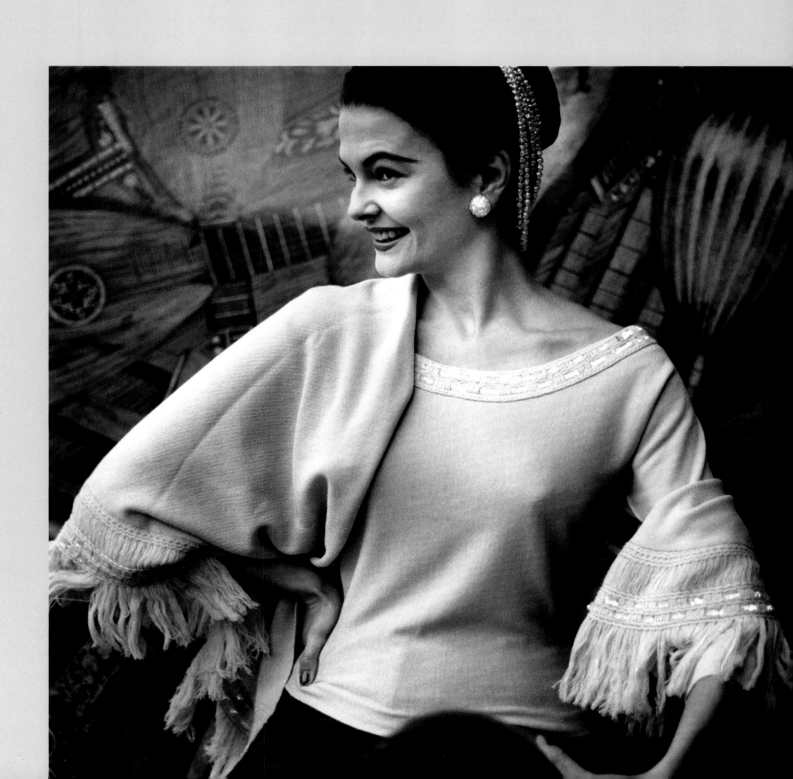

Oriole Cullen

Fur

Italian fashion was marketed on the dream of aristocratic elegance and nothing signified this luxurious lifestyle more than a fur.

Fur is closely linked to Italian codes of dress. In a country known for its innovative fashion, there are surprisingly traditional conventions of dress that persist. One such item is the fur coat. Fashion writer Judith Watt has suggested that in a society such as Italy, 'fur is inextricably linked with anxieties over status. It defines who you are.'[1] Traditionally, from the early twentieth century onwards, middle-class Italian parents bestowed a fur coat upon their daughters on their eighteenth birthday or as a wedding present. In 2005, fashion editor Anna Dello Russo explained to *The New York Times* that she received her own first fur, a long-haired Canadian wolf coat, from her parents when she turned 18 and rarely took it off, despite the roaring temperatures in her home town of Bari.[2] The fact that this tradition held sway even in the hot climes of southern Italy, where a fur coat is completely impractical, points to the significance of fur

within Italian society, not only as a luxurious status garment but also as a badge of a well-made and crafted item produced by skilled artisans, and thus part of an important industry. As such, while fur coats fell out of fashion in many countries in the late twentieth century, in Italy their popularity endured.

The emergence of the fur garment as a fashionable item in the mid-nineteenth century heralded the establishment of some of Italy's most successful furriers, such as Matti of Milan (founded 1847), Rivella of Turin (founded 1868) and Viscardi (founded 1908) of Rome and Turin, who provided luxurious furs to the Italian nobility and aristocracy. Throughout the 1920s and '30s, the use of fur in fashion increased, not just in the form of full fur coats but also for fur stoles, collars and cuffs, which became popular on outer garments from opera capes to tailored jackets, resulting in the unprecedented growth of the fur industry.

Furriers traditionally bought pelts such as sable, fox and mink at auction. Some furs were produced by the domestic market but many came from international trade centres such as Seattle, Copenhagen and St Petersburg, and were imported to Italy for processing and production. Italy was internationally recognized as an important centre for the preparation of skins and the subsequent making up into garments. During the Second World War, furriers were unable to obtain these luxury furs from abroad so indigenous furs such as rabbit, moleskin and lamb became the mainstay of the Italian fur industry, enabling it to survive these years. The Italian Fur Trade Association (AIP) was established in 1949 as an independent body representing all areas of the industry, with a focus on maintaining standards in craft skills and the artisan culture of the fur trade while also promoting its products.

In the 1950s, Italian fashion was marketed on the dream of aristocratic elegance and nothing signified this

luxurious lifestyle more than a fur. The Italy Today trade fair held in New York from 28 May to 12 June 1952 presented a series of shows focusing on the work of 15 of the top Italian fashion houses. Highlighting just how integral the fur industry was to the Italian fashion system at this time, four of these businesses – Matti, Pellegrini, Rivella and Viscardi – were exclusively furriers, while a fifth house, Veneziani, specialized in fur along with other garments. Back in Italy, *La Donna* magazine reported with much excitement on the trade fair's high-profile attendees and potential customers, which included Marlene Dietrich and Elizabeth Arden.[3] In 1956 the magazine *Pelicce Moda* was launched to meet the demand for a publication aimed specifically at the fur trade, but also to appeal to buyers both in Italy and abroad.

Sumptuous evening coats and stoles shown by designers and furriers were eagerly photographed by fashion magazines, and propagated by many Italian film stars as well as those visiting from Hollywood. Gina Lollobrigida and Sophia Loren were constantly photographed swathed in fur, Anita Ekberg famously frolicked by the Trevi fountain in a white ermine stole and Elizabeth Taylor was shot by paparazzi in a head-to-toe fur ensemble of a leopard print hat and coat (pl.123).

Fur was evolving from being the preserve of evening and occasion wear. One of the key names in Italian fur fashion in the post-war period was Jole Veneziani, who had worked as the manager of a fur house before establishing her own business in 1943. Veneziani combined fur with other fabrics to create not just coats but also suits and dresses with fur components (pl.125). Fur

page 120
121 Photograph by Gian Paolo Barbieri. *Vogue Italia*, December 1968

Opposite
122 Maquette for 'Inlaid Polychromies Collection' for Fendi, multi-coloured mink in a geometric pattern. Autumn/Winter 2000-1

123 Richard Burton and Elizabeth Taylor, February 1963

Following page
124 Fendi, Autumn/Winter 2013, Milan Fashion Week, 21 February 2013

was also being used in sportswear and leisurewear by designers such as Roberto Capucci, Irene Galitzine and Emilio Pucci, either for full garments such as jackets or as trim on items such as ski suits and palazzo pants.

As the 1960s heralded a new youth-led approach to fashion, many furriers diversified their product ranges, introducing furs that were suitable for daytime wear – brightly coloured furs, short fur jackets and even garments such as shorts, trousers and mini-skirts were the new focus. Experimental furriers like Soldano mixed and matched different furs in bands of colour and even teamed fur with unusual materials such as PVC. Leading the field was the Fendi family, whose business, established in 1925, was particularly active in pushing the boundaries of what could be achieved both on a technical and a design level (pl.122). Following several collaborations with fashion designers, in 1966 the Fendi sisters began a partnership with Karl Lagerfeld to design the label's first couture line. They created polychrome fur coats and trialled unusual and sometimes less expensive furs to give a variety in textures. The success of the partnership led to Fendi's introduction of ready-to-wear furs in 1969, with the idea of creating attractive, well-designed furs at accessible retail prices (pl.124). By this time, the company had moved into both the American and Japanese markets. As fashion writer Federica di Castro noted, the Fendis changed the approach to fur in Italy: for them, 'what really counted was the design: workmanship and choice of fur were secondary. Furs had to adapt themselves to the model and not the other way around'.[4]

The following decade saw increased experimentation in the treatment of fur with techniques such as shearing, pleating and dyeing. Linings and interlinings were discarded to make garments lighter. Piecing and printing were utilized to create patterned coats. Several of the couture furriers began to look to ready-to-wear and collaborations became popular, with furrier Rita Togno working with fashion designers Irene Galitzine and Mila Schön, and Matti partnering with the young Franco Moschino.

From the mid 1980s the international fashion market began to question the relevance of fur on both practical and moral grounds. With the growth of the animal rights movement and a worldwide recession that dampened interest in luxurious statement clothing, for the majority of the fashion world fur fell out of style. Yet in Italy, fur remained popular and visible to the extent that in 1985 the first exhibition of fashion to be shown in a national Italian museum celebrated the fur industry. Held at the Gallery of Modern Art in Rome, the exhibition was entitled *A Working Journey: Fendi-Lagerfeld* and showcased design drawings, production techniques and a range of garments designed by Karl Lagerfeld and produced by Fendi.[5] In 1987 the next generation of the Fendi family launched the Fendissime line, which included sportswear and accessories alongside fur. Aimed at a younger, more trend-driven market, the brand was an instant success.

In 1996 the Italian Fur Association established MIFUR, the annual International Fur and Leather Exhibition held in Milan. The industry was bolstered by new markets for Italian furs opening up in Russia and China. Norberto Albertalli, president of MIFUR, notes that in the time since the fair was launched, 'Italian fur producers have invested heavily to update their machinery for quirky finishes that allow them to provide designers with fur like mills supply silk or wool . . . that's why fur today is part of the fashion circuit, just as any other fabric or garment is.'[6] In 2010 a market report commissioned by the Italian Fur Trade Association showed that fur consumption in Italy had risen by 16 per cent on the previous year, with exports increasing by 34 per cent.[7]

Despite this increase in sales, the fur industry in Italy is being challenged by new competitors in the market. 'The boom of fur production in China has made sure that of the hundred traditional Milan furriers only some have survived,' says Dr Augusto Valsecchi, founder of fur company Conceria Milanese. 'The remaining tanneries are few and this is inevitable when another nation is producing with lower costs and apparently equal results.' China has very swiftly assumed this challenging position following the country's economic reforms of the 1990s. A US Department of Agriculture report from 2010 noted:

With only a decade of development, Chinese Fur Processing Industry became the largest in the world. According to European industry sources, 80 percent of world's pelts are processed and manufactured in China. China is the major buyer at most worldwide fur pelt auctions. In 2009, China's fur apparel exports reached US$ 998 million.[8]

The retail market and consumer habits are also rapidly changing: while winter in Italy still sees a proliferation of fur coats in the streets, the garment's popularity has waned, particularly with the rise of the down-filled puffa jacket, which has gone from sportswear to high-fashion item. 'Puffas are super-warm and super-light,' designer Giambattista Valli noted in 2009. 'They're something eventually everyone will have.'[9]

The future for fur in Italy appears to lie in the hands of the big-name fashion houses such as Gucci and Prada, as opposed to individual furriers. These brands are consistent in their use of fur, not just in full garments but also as trim and for accessories. One of the most photographed items of the Spring/Summer 2011 collections was a luridly coloured Prada fur stole in shades such as pink with black and white stripes. This move away from the traditional methods of wearing and buying fur has meant that Italian fur suppliers have had to move with the times. Valsecchi sees this as both a positive and a negative development: 'Large companies . . . like Prada and Marni have turned towards the fur industry, otherwise, perhaps, we would not even exist anymore. On the other hand this fact has put us in difficulty because the houses we work for look for a standard product while for us fur still has the mark of oneness and uniqueness.'[10]

Oriole Cullen is Acting Senior Curator of Fashion at the V&A. She specializes in twentieth- and twenty-first-century fashion and curates the V&A's 'Fashion in Motion' shows

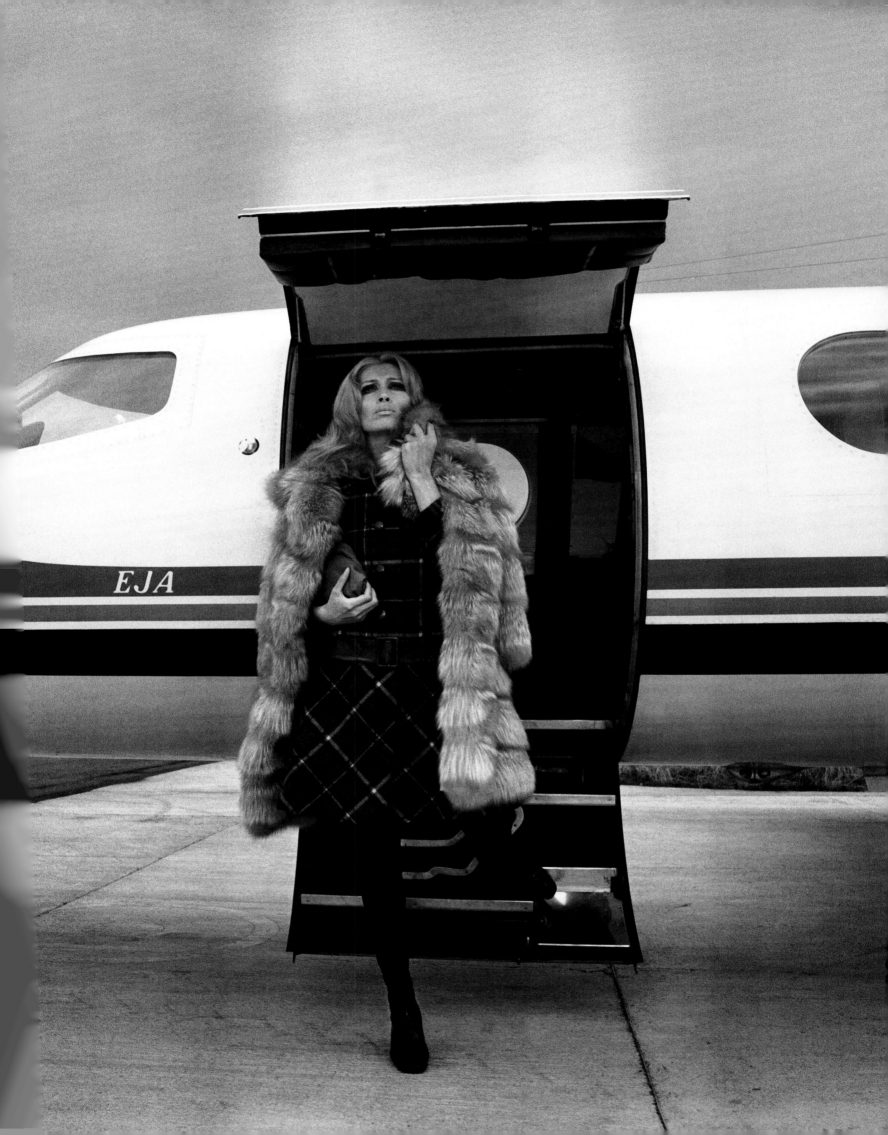

Helen Persson

Leather

Italy's leather craft traditions persisted from the medieval urban guilds through to the 1930s and '40s ... specialized skills were handed down from father to son...

Leather has become an increasingly important part of fashion design, and Italian fashion designers in particular are famous for their creative use of this material. The softest and thinnest leather can be dyed, printed and even engraved for use in a wide range of garments, from jackets to evening wear. Perhaps the most successful leather products have been the luxury bags and shoes that are made in Italy and exported worldwide. This success was due to the high quality products and their appealing design, backed up with influential advertising campaigns.

While Italy's innovative leather industry as we know it today began to expand after the Second World War, the making of leather goods is a centuries-old craft. Every element of the production chain, from tanning the skins to creating the finished product, has flourished there, although the raw materials are largely imported. Guilds for both tanners and shoemakers were first documented in Florence in the thirteenth century, and from the mid-fourteenth century the tanners clustered around Santa Croce basilica on the edge of the city. The Florentine production of leather goods such as shoes, gloves, bags and suitcases has long enjoyed a good reputation, and some leather goods for premium brands are still produced here. Other important tanneries, mainly specializing in sheepskin and glove leather, can be found around Solofra, near Naples, while the bovine tanners that largely supply the upholstery business are based in Arzignano, between Milan and Venice.[1] There are still many footwear manufacturers located in regions such as Tuscany, Veneto, the Marche, Umbria and Campania.[2]

Italy's leather craft traditions persisted from the medieval urban guilds through to the 1930s and '40s. Specialized skills were handed down from father to son and were often confined to regions. One example of a local leather specialist is Gucci. While today the company is known as a luxury goods empire, Gucci began modestly as a Florentine saddlery shop in 1906. In 1923, founder Guccio Gucci expanded the business, selling fine leather accessories with classic styling.[3] Gucci became internationally known in the 1950s and '60s for its handbags and other leather goods, distinguished by the company's signature double-G symbol combined with prominent red and green grosgrain bands. Their bucket bag and loafers became especially potent icons of success and are still highly desirable today. These small, elite, artisan businesses were led by quality rather than style and innovation, and before the Second World War, they were known only to a select clientele and a few international tourists with a taste for exclusivity.[4] French couture houses often employed these Italian artisans to create their shoes and handbags.

The success of the Italian footwear industry has relied on the combination of high-quality raw materials, elegant craftsmanship and the integrated businesses model, as perhaps best demonstrated by the example of Salvatore Ferragamo. More than anyone else, Ferragamo came to represent high-fashion footwear in Italy (see also pp.97–8). Having learned the shoemaking trade in Naples, he spent 13 years in the United States, where he studied mass-production techniques and attracted famous patrons, before returning to Florence and setting up his own shoe shop in 1929. He expanded his international trade during the interwar years, especially with the United States, and undoubtedly paved the way for the overseas success of Italian fashion in the years after the Second World War. Ferragamo cleverly combined craftsmanship and technological advances to create innovative but also functional and comfortable footwear of great beauty for the international elite.[5] From the mid-twentieth century, the company evolved into a global luxury goods empire (pl.129).

page 128

126 Dolce & Gabbana, ankle
boots, embroidered leather with
pastes and diamantés, *c.*2000
V&A: T.70:1,2–2012

127 Gianni Versace, fringed
leather ensemble with printed
silk blouse. Spring/Summer 1992
V&A: 209 to 211–1994

For some Italian fashion labels, leather garments and accessories were the key to help them break into high fashion after the war and ultimately to becoming some of the world's most successful fashion empires.[6] From the 1950s onwards, leather clothing featured in Italian casual- and sportswear. Although these garments were well made and stylish, the focus was on practicality rather than opulence, for example Veneziani-Sport's unfitted chamois leather jackets. The turning point came in the 1970s, when leather clothing began to be extremely fashionable, and the career of Roberto Cavalli in particular flourished. He experimented with printing and engraving on leather and suede, and also used leather in patchwork patterns. Cavalli's detailed and instantly recognizable exotic prints, applied even to leather, take the animal theme to the extreme. His flamboyant styles became popular with his rockstar clients such as Lenny Kravitz and Mary J. Blige.

Gianni Versace took the use of leather to a completely different level in the late 1980s and '90s. He introduced into high fashion certain stylistic elements hitherto associated with fetish, punk and biker clothing, such as spikes, studs and harnesses. His Autumn/Winter 1992 collection explored the theme of the Wild West and included garments featuring elaborately studded and fringed leather (pl.127). Furthermore, Versace used leather for glamorous eveningwear, which was not considered appropriate before. It is worth noting that Versace produced his leather fashions with the help of a high-end leather specialist called Ruffo, based in Tuscany.[7] Ruffo designs and produces leather goods for a large number of luxury brands, as does Rossimoda, the company behind many of today's global shoe brands. The expert leather production provided by these specialist firms helps many Italian fashion houses to create an entire branded look from head to toe. The list of successful Italian brands relying on the sales of leather garments and accessories is extensive, ranging from Bottega Veneta, best known for intricately woven leather bags, to established fashion labels such as Dolce & Gabbana (pl.126). Their success is based on a long tradition of craftsmanship of the highest quality married with innovative design and modern industrial technology, all presented within the framework of extremely clever branding to convey the luxury, status and sex appeal of their Italian products.

Helen Persson is Curator in Collections Management at the V&A, specializing in textiles and dress

128 Frida Giannini for Gucci, black leather bag with multicoloured patchwork, tassel and metal plate details, Spring/Summer 2007
V&A: T.67–2009

Opposite
129 Boots worn by a model in the fashion show for Salvatore Ferragamo's 2013 *Resort* collection, held at the Louvre, Paris, June 2012

3

Fashion and Image

Portrait/Self-portrait: The Image of Fashion

Maria Luisa Frisa

I called it On Italy because it seemed to me that it developed as an argument.
— Luciano Fabro, Vademecum, 1981

The photograph should perform two formally different actions. In the first place, and this seems to us the more important of them, it ought to create an alluring atmosphere of elegance and cultivated naturalness around the model through adroit attitudes of the subject, skilful construction of the setting and evocative staging. No particular attention to detail, no concern about capturing the whole of the design; it is simply a matter of getting across the impression of an elegant, graceful and interesting item of clothing. This will inevitably stir curiosity, at first vague and then more precise. At this point the other kind of photograph becomes more useful, more exact, more complete, more technical you could say. This is a difficult task, as it runs the risk of spoiling the allusive atmosphere that the vagueness of the first kind had deliberately cultivated.[1]

These reflections on photography and fashion, published in the magazine *Natura* in January 1937 and very likely written by the photographer, journalist and dandy Lucio Ridenti, show that fashion photography was already taking on a character of its own in Italy during the 1930s.[2] Later on, in 1941, Ridenti was one of the people behind the magazine *Bellezza*, the first 'monthly of high fashion and Italian life' and a publication capable of vying with *Harper's Bazaar* and *Vogue*. Through its mix of illustrations, photographs and articles, *Bellezza* outlined an Italian style of fashion, flying the flag of modernity. There were illustrations by Federico Pallavicini, Brunetta Mateldi and Edina Altara, along with photographs shot in outdoor locations, with views capturing the places and atmospheres of Italy. It contained, in embryonic form, all the words and themes that were to define the image of Italian fashion.

Italy: The New Domestic Landscape

Perhaps the uneven nature of our account makes it necessary to start with a precise image, a black-and-white photograph taken by Maria Vittoria Backhaus for Walter Albini's Autumn/Winter 1978 advertising campaign (pl.130). Published in the July–August 1978 issue of *Vogue Italia*, the double-page spread had the splendid 'WA' logo on one side and the words 'Lanificio Puma' on the other. In those years it was common practice for textile manufacturers or companies like Gruppo Finanziario Tessile (GFT) to fund campaigns promoting fashion (see also p.85): the Italian fashion system was taking shape through a series of creators of style who found in the country's system of production an extraordinary base that would underpin the strength and success of 'Made in Italy'.

Backhaus's photograph is a perfect synthesis of what we might call the story of an Italian style, one which does not speak solely of fashion, but also of an Italian lifestyle that will become the manifesto of a certain idea of beauty, capable of improving everyday life with objects of quality that express the spirit of their time. The picture has a horizontal format, alluding to the interior of a modern house. There is a large rectangular table, clearly the creation of a designer. Next to it, a smiling young woman, sitting in a very relaxed way on a metal chair. She's wearing loose trousers with a tight belt around the waist, accompanied by a short soft jacket, thick stockings and flat shoes. Her loose hair falls naturally on to her shoulders. With her left hand, she is picking up spaghetti from a plate on the table. It is this ill-mannered gesture, contrasting with the elegance of the overall effect but vital in an ancient, popular and neorealist way (although in the published photo the spaghetti have turned red), that gives the image its warmth, showing no qualms about mocking Italian stereotypes – and thereby acting as a seismograph for the complex upheavals taking place in Italian society.

page 134
Advertisement for Miu Miu featuring
actress Kirsten Dunst, Spring/
Summer 2008. Photograph by
Mert Alas and Marcus Piggott

130 Advertisement for Walter Albini,
Autumn/Winter 1978. Photograph
by Maria Vittoria Backhaus

It is clear that this picture marks a watershed in the series of images that, from a variety of perspectives, was progressively moulding the representation of Italian fashion. Backhaus's image is emblematic of the awareness that photography meets the need of fashion to mix with the world, to be part of the flow of life. Through photography fashion becomes a storytelling that, while it aims to impress and seduce, also wants to get its hands dirty in the present and express the spirit of the time. And so without any precise intention, fashion photography mixes up genres and languages and as result succeeds in composing a sequence that describes a democracy of vision: not just the succession of trends and styles, but also changes in culture and society.

Rome

It took the outsider's viewpoint of an important fashion magazine like *Harper's Bazaar*, stimulated by interest on the part of the American political world, to capture the creative vitality of a nation that had just emerged from defeat in war. Entitled 'The New Italy', the feature was at the heart of the July 1947 issue of the magazine. The photographs by Leslie Gill were of artists, film directors, actors and writers, including Angelo Savelli, Orfeo Tamburi, Alberto Savinio, Corrado Alvaro, Giuseppe Ungaretti, Roberto Rossellini, Anna Magnani and Alberto Moravia. Then there was Ferragamo, and the craftsmen of Capri and Rome. Four Roman noblewomen wore Gabriellasport, among them Marella Caracciolo di Castagneto, future wife of industrialist Gianni Agnelli.[3] Rome, in all its wounded beauty, was the magnificent backdrop for a fashion that was starting to attract attention but had not yet established itself as an independent style. In 1954, the fashion journalist Elsa Robiola wrote that in Italy fashion was being constructed on a solid base of prestige thanks to the international renown of some of its cities – Rome, Florence, Venice – to which, after the war, had been added some of the country's more or less famous islands:

> *To use a modern expression in vogue with the latest generations, we might say that is precisely the 'direction' of these Italian cities and islands that facilitates fashion presentations and sustains their tele-photo-cinema documentation around the world . . . The concept of a unique, unmistakable 'direction', as in cinema, is what sets the fashion of one country apart from the others, and we persevere in this so that Italian women can be the first to take advantage, to indulge themselves and, in a certain sense, become the players, in all circumstances.[4]*

Another magazine feature, published not long after 'The New Italy': in one of the photographs, two models are shown wearing creations by the Milanese atelier De Gasperi Zezza at the Baths of Diocletian (pl.131). The models look tiny against the imposing background of a massive, evocative monument. They occupy the lower part of the picture, while the Baths, a ruin of the past in silent dialogue with the rubble of the war, provide the setting for all the photographs in the feature entitled 'La moda nella città eterna' (Fashion in the Eternal City), published in 1948 in the magazine *I Tessili Nuovi*.[5] The images are by Pasquale De Antonis, a photographer who was interested in ethnography but also in the theatre, cinema and artists. It was this last aspect of his work that had brought him into contact with Irene Brin, through the Galleria l'Obelisco, run by her husband Gaspero Del Corso. Brin, who in 1952 became Rome editor of *Harper's Bazaar* and was one of the key figures involved in constructing and promoting the identity of Italian fashion, introduced De Antonis to fashion photography. 'La moda nella città eterna' was one of many magazine features that she organized and had shot by De Antonis, who never worked with anyone else in the fashion field: shoots in which the clothes provided an element of continuity with the locations of the Grand Tour, with the splendours of Italy's cities.

Reportage

A large limbo, the white background that plays such an important role in photographic studios, is hanging on the Spanish Steps in Rome (pl.132). The dazzling whiteness of that large rectangular piece of fabric occupies the left-hand side of the picture, in the foreground, and isolates the two models. Looking at each other, they ignore their surroundings, which in turn are thrown into strong contrasts of light and shade by the sunlight and by the use of the black-and-white film typical of photojournalism. Next to the limbo, a small crowd of children and adults seems distracted; they are playing with a dog, staring at the photographer, looking around. Everyone appears to be waiting to see how the show is going to end. The photograph is part of a feature that was published simultaneously in the Italian and American editions of *Harper's Bazaar* in 1970.[6] Oliviero Toscani's pictures are set in different parts of the city and the models are photographed against the limbo; onlookers are always present, especially children – children playing or observing the rituals of the fashion shoot, children that bring to mind the ones that throng the films of Italian neorealism, the ones that will grow up to become the protagonists of Pasolini's films. Toscani, born in 1942, was one of them, one of those kids who breathed the intoxicating scent of change and brought with them, along with rebellion, a new idea of beauty and desire. He wanted to photograph the vitality of the world, and this approach went down well: the early issues of *L'Uomo Vogue* (the first magazine of men's fashion in the world, launched in Italy in 1967) were illustrated almost entirely with his pictures, at the behest of Flavio Lucchini, the magazine's creator.[7] Interested in the street and street fashion, Toscani was able to capture a permanent revolution in taste through a highly personal style that was an offshoot of reportage.

'In fashion there is a line of narrative that seems closer to the way the reporter works than to the mannerisms of so many fashion photographers, more inclined to mythologizing the object, to the still-life, the portrait. And in reality the great fashion

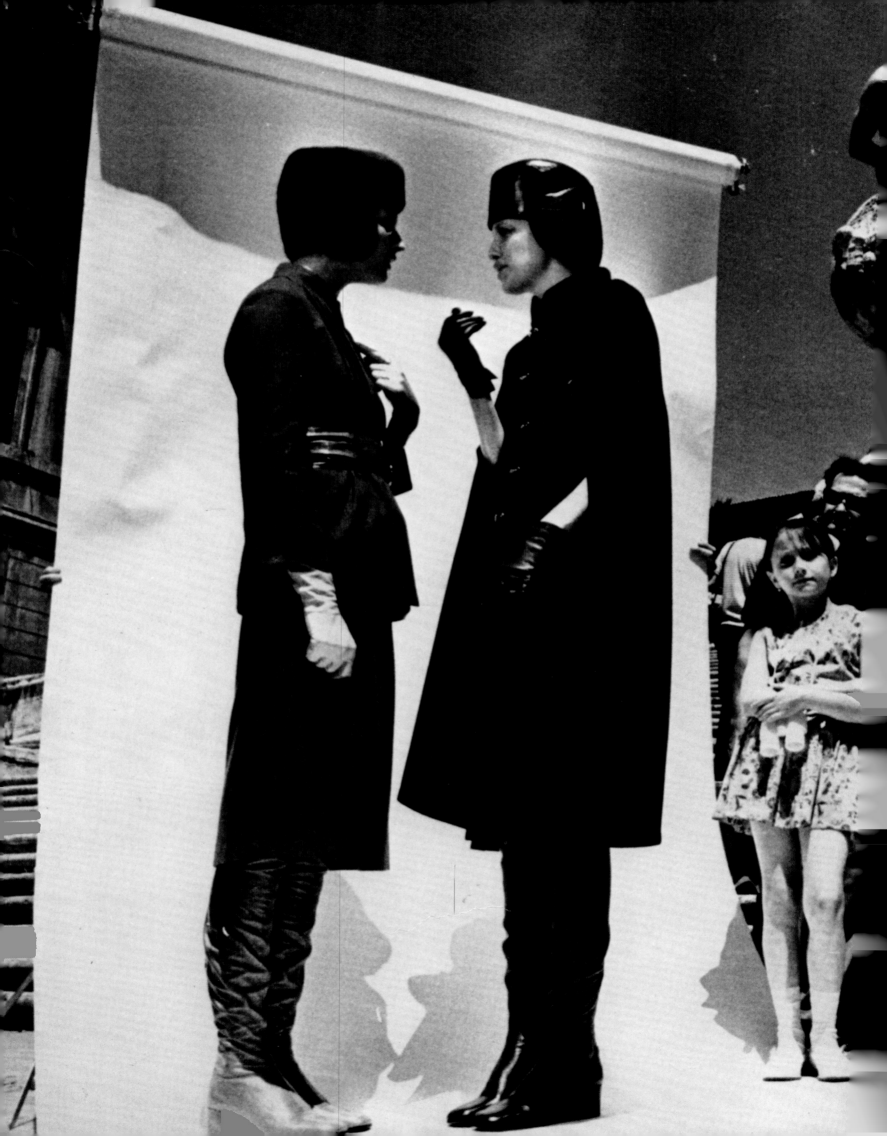

UNITED COLORS
OF BENETTON.

photo has always drawn energy, intelligence and persuasiveness from an incursion into reality,' wrote Ferdinando Scianna,[8] the photographer behind the Dolce & Gabbana Spring/Summer 1987 advertising campaign, which was rooted in the Sicilian landscape and imagery of their fashion (pl.134). It was the first time Scianna had worked in this field. The result was a series of black-and-white images that not only tell the story of a journey taken by the model Marpessa through the island, moving between noisy scenes of daily life and silent and magnificent antiquities, but also conjure up memories, atmospheres and impressions so strong and absorbing that photographer, designers and model have been caught forever in that dimension.

Powerful images that occupied the most conspicuous walls of the world's cities; images to which it was impossible to remain indifferent. Advertising increasingly put aside the goal of pure presentation and turned into something else: pacifist message, environmental proclamation, ethical manifesto, even going so far as to deny its purpose, although always with the aim of achieving visibility. It was the images born out of the strange and incredibly uninhibited partnership between Luciano Benetton and Oliviero Toscani that brought about this change. At the outset they were pictures of young people, representing the new tribes of the world. Benetton's first large advertising posters put the emphasis on ethnic, sexual, religious, cultural and aesthetic minorities. When the United Colors of Benetton had achieved recognition as the emblem of a brand in every corner of the planet, the campaigns turned more provocative, focusing on themes like AIDS, war, the Mafia, environmental sustainability and religion, illustrated by images that were shocking in their silent candour (pl.133). Toscani had learned the

lesson of appropriation from artists like Sherrie Levine. He took images created by other people and put them back into circulation. They were visual objects. There was no need for him to take new photographs. The ones that interested him already existed: images that captured the everyday moments that make up the personal and collective story of each and every one of us.

Family

In a society as strongly rooted in the institution of the family as Italy's, it was inevitable that the 'families' of fashion would put in an appearance in the early days of the 'Made in Italy' phenomenon. A feature entitled '*I clans degli italiani*' (Italian Clans) was published in the July–August issue of *Vogue Italia* in 1975. All the leading figures in the emerging field of ready-to-wear – Missoni, Krizia, Caumont, Armani, Basile, Albini, Ken Scott, Biagiotti, Valentino, Fendi and Versace for Callaghan – were portrayed in the settings of their choice, along with all the people who made up the variegated and colourful families that surrounded them, not only at work but in their everyday lives too. The pictures of the various 'families' harked back to the classical iconography of group portraits, but above all they were a representation of the extraordinarily tangled relationships of friendship, kinship, love and fascination that underpin all forms of creativity in which the individual relies on professional and emotional support to put his or her ideas into effect. In these photographs we find brothers, sisters, nephews, nieces and cousins, along with partners, muses, models, employees, journalists, photographers, illustrators, fashion show directors and PR specialists. It was an exploration of what was to become the geography of the new professions of fashion. Some chose their ateliers as the set for the shoot, others their homes, soon to be seen as status symbols, and yet others preferred to be photographed outdoors, perhaps with bicycles, with a small aeroplane or with a clapped-out Range Rover. Valentino is portrayed with his business partner Giancarlo Giammetti and the journalist Stella Pende (pl.135), while Ottavio and Rosita Missoni are accompanied by their three children and two models. Walter Albini is shown with his female friends, who are dressed like him, his brother and his life partner, the journalist Paolo Rinaldi. At this time Gianni Versace is still part of the Callaghan family and appears off to one side, looking very young. It is clear that they are all living through heroic times, the beginning of an adventure, and that they are fond of each other: in its early days, 'Made in Italy' derived its strength and its quality from a fantastic collaborative effort on the part of designers, art directors, manufacturers and advertising media. Over time the figure of the fashion designer and then the creative director would come to take up all the space, to the point of being identified with the brand.

Milan

The blank, nondescript and shabby wall of a building in Milan forms one side of a square, the name of

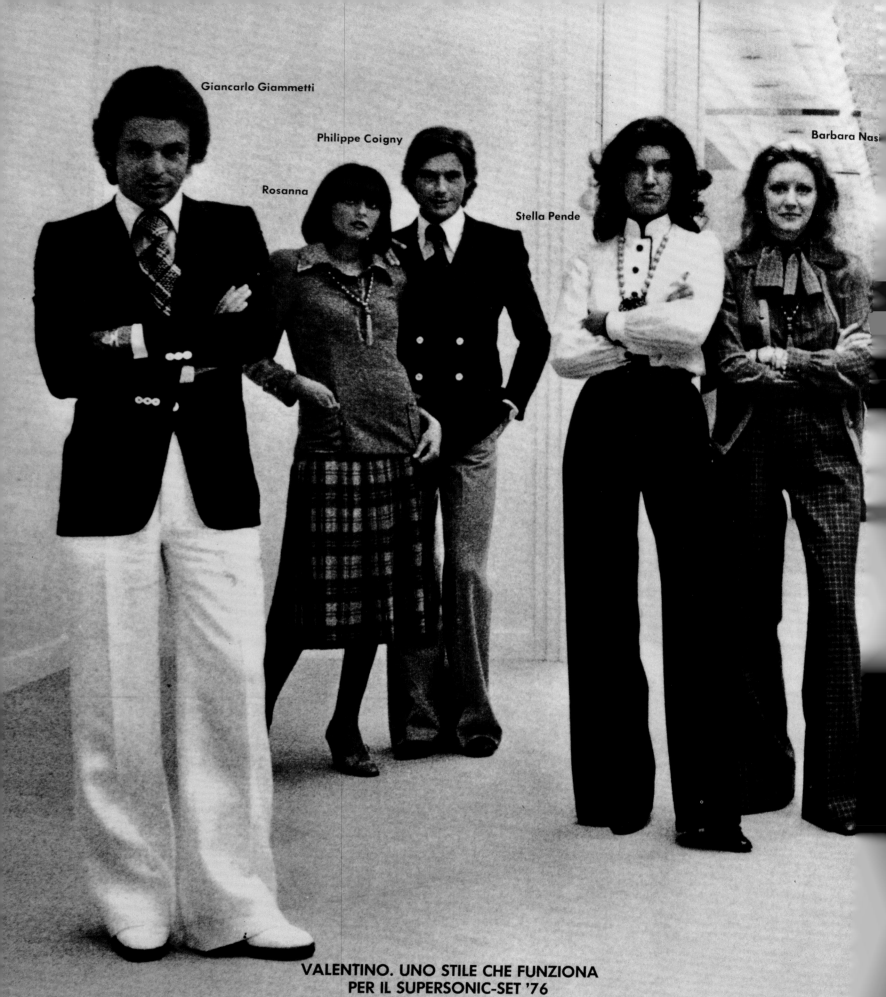

Giancarlo Giammetti

Philippe Coigny

Rosanna

Stella Pende

Barbara Nasi

VALENTINO. UNO STILE CHE FUNZIONA
PER IL SUPERSONIC-SET '76

Tra pochi mesi, con regolari aerei di linea, si potrà cambiare continente e emisfero alla velocità di 2200 km/ora. Valentino sembra aver studiato il suo nu
stile proprio per il ritmo di vita sempre più rapido e internazionale delle sue elegantissime. Se il supersonico «Concorde» è una sfida tecnologica, questo nu
prêt-à-porter è una sfida di raffinatezza e funzionalità combinate. Abiti esili e però anche docili ai movimenti, stratificazioni senza volume; e come particolar
semplici profili contrastanti, dei colletti alla cinese. C'è anche il vestito ventiquattrore, da indossare per una colazione a Parigi e un pranzo a New York nella st
giornata: un duepezzi nero sempre col colletto cinese. Qui, su quella che è la celebre pista di lancio di Valentino, la passerella della sua sala bianca a R
una foto di gruppo con lui in primo piano, alcune sue modelle, fra le quali Francesca Zambelli divenuta collaboratrice, poi due delle sue celebri fans, S
Pende e Barbara Nasi. All'altro capo, Giancarlo Giammetti, vicepresidente e manager, con Philippe Coigny suo assistente. Quanto a piste di lancio, notare
Valentino ne ha da poco inaugurata una anche a Parigi: qui ha presentato per la prima volta la sua moda e ha aperto una boutique in faubourg St. Ho

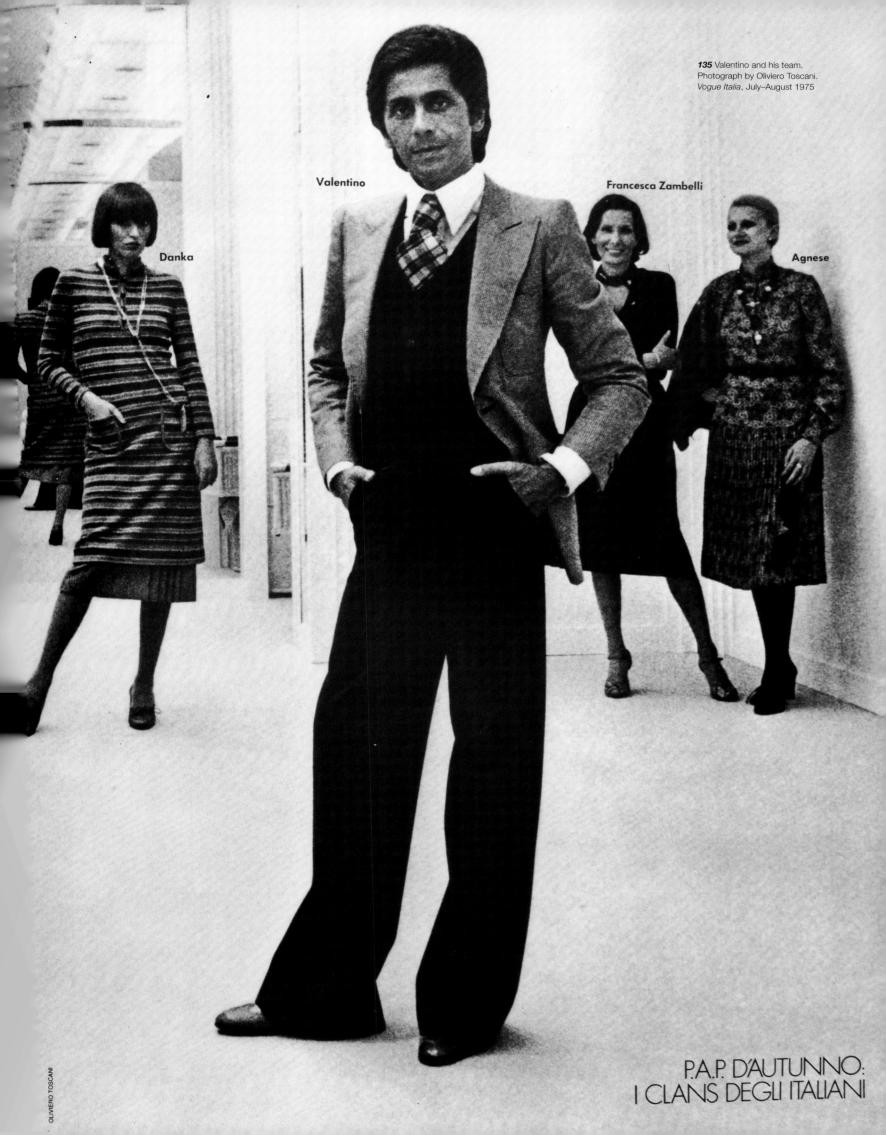

135 Valentino and his team.
Photograph by Oliviero Toscani.
Vogue Italia, July–August 1975

Danka

Valentino

Francesca Zambelli

Agnese

P.A.P. D'AUTUNNO:
I CLANS DEGLI ITALIANI

OLIVIERO TOSCANI

Opposite
136 Advertisement for Giorgio
Armani, Autumn/Winter 1984.
Photograph by Aldo Fallai

137 Advertisement for Emporio
Armani, Spring/Summer 1984.
Photograph by Aldo Fallai

which few recall. A square traversed by heavy flows of
traffic that are chiefly concerned only with what can
be seen through the windscreen. One morning, on that
anything but glamorous wall, an image appeared in the
format of a mural. That image, which was to change
the name of the junction at which it was located, spoke
to the new generation, the young people born around
1968 and who had grown up during the 1970s, the
dark decade of terrorism known as the 'years of lead'.[9]
The technique was still that of painting, practiced by a
highly skilled poster artist who copied the photographs
of the campaign shot by Aldo Fallai in 1984 for
Emporio Armani, a new line that aimed to break out
of the cage of an elitist style and fulfil the great desire
for fashion shared by all strata of society (pl.137).

The protagonists of Emporio Armani's little
seasonal tales were young men: a group of them all
dressed in the same bourgeois uniform, sitting in the
Metro station on their way from one place to the next,
made an immediate impression on the map drawn
by the new flows of the city of fashion. In another
photograph by Fallai, again for Armani, the (female)
model is wearing a perfect jacket and clutching
newspapers (pl.136). It is a contemporary portrait that
shows how fashion had been able to create a uniform
for a new generation of women as well, women
capable of looking men straight in the eye. Women
who did not want to dress like men, but who knew full
well that if they wanted to escape the role of secretary,
assistant and employee, they were going to have to
find a mode of dress that would protect them and give
them confidence. Giorgio Armani recalls:

> *In the beginning I worked a long time with Aldo Fallai,
> trying to fully define the Armani style in photography as*

*well. I wanted it to be modern and intense, passionate
and at the same time casual, like a scene out of the best
of all possible lives. Antonia Dell'Atte with a newspaper
under her arm, kids sitting in the subway, the young man
of Emporio Armani inspired by the statues of the Stadio
dei Marmi in Rome. Thinking back on this today I notice
they had a strong Italian tone, probably due to similar
background and life experience, shared by Fallai and
myself. In a certain sense, Fallai was my eyes, the gaze
that observed my fashion.[10]*

Postmodernism

The covers that the photographer Occhiomagico
created between 1982 and 1984 for *Domus*, the
design and architecture magazine edited at the
time by Alessandro Mendini, evoked the new ways
of living conceived under the dictatorship of
postmodern design:

> *When he dresses in the morning every individual is like a
> great painter. The best portraitist of himself. This hyper-
> sensitivity that each person has to the need to invent his own
> figure can be extended to design and to architecture, in a
> hypothesis of continuity from the landscape of the body to
> that of the territory.[11]*

It was the first Venice Architecture Biennale,
directed by Paolo Portoghesi in 1980, that, with the
now legendary promenade through the Corderie
dell'Arsenale known as the 'Strada Novissima', a mix
of memory and imagination, of *genius loci* and melting
pot, brought the visions of generations of industrial
designers, architects, artists and fashion designers
into focus, with Italy in the front rank. The same
year also saw the publication of the first issue of the

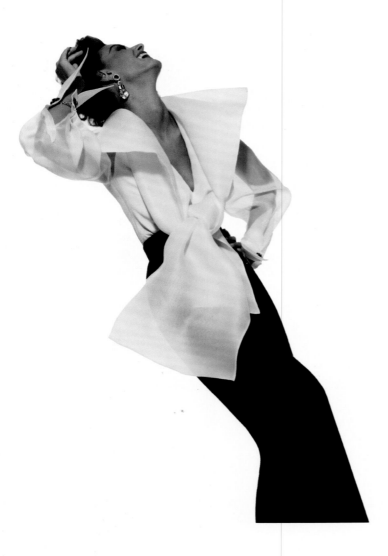

definition of this imagery. The headlines on the cover, positioned without fear of clashing with the image, were uncompromising slogans: 'Women change their look', 'This is how we will dress'. In the magazine, the decade that followed the 1980s opened emblematically with an image that reinterpreted Italian fashion design: it was the Autumn/Winter 1991 campaign for Gianfranco Ferré's collection of women's ready-to-wear. Gian Paolo Barbieri's photograph transformed one of Ferré's variations on the theme of the white blouse, symbolic of all the sophisticated architectures for the body created by the designer, into a glamorous play of diagonal lines that seem to trace (and emphasize) the structure of the outfit (pl.138). The 'taking apart' and 'readjusting' that Ferré himself defined as 'the dynamics of the design process'[12] were reinterpreted through a photographic eye that expressed a precise Italian idea of glamour: essential, syncopated, subtle, almost stripped to the bone.

Drawing

Moschino's 1990 advertising campaign makes very clear the relationship that the label's designer had always had with the world in which he operated: *Stop the Fashion System!* is a drawing that he made himself, representing fashion as a vampire, beautiful but thirsty for blood (pl.142). Franco Moschino, who had studied art at the Accademia di Brera in Milan, took the forms of fashion, Italian stereotypes and the languages and practices of art and used them to create an extraordinary montage in which his collections became more than a simple sequence of garments. He claimed the freedom to criticize the system from within, pointing out its defects. Drawings, typographic symbols, provocative words or pop icons like the 'smiley face' were all means that he used to express himself and to communicate, both in the clothes he designed, which often became surfaces on which he wrote or drew, and in his publicity images, which even then were based around environmental themes and the defence of the weak and the different.

In *Vanity* magazine, fashion became a visionary and surrealist cartoon. The magazine was edited by Anna Piaggi, who was careful to avoid the photo catalogue effect, instead resorting to old-fashioned drawings and showing the phases by which a face, a dress or an accessory turns into an image.[13] The muted atmospheres created by the grainy pastels of graphic artist Lorenzo Mattotti transformed the photographic features into dreamlike journeys that emphasized the imaginative character of Italian fashion and opened a window on the parallel worlds in which the ideas destined to turn into clothes and collections took on form and colour. The succinct woodcuts of François Berthoud, which combined graphic design and a style of painting somewhere between Pop art and expressionism, became ideograms that incisively and obsessively captured the details of the designs, their superimpositions, transparencies and silhouettes.

magazine *Donna*, conceived by that exceptional creator of fashion magazines Flavio Lucchini and edited by Gisella Borioli. Quoting the critic and painter Gillo Dorfles, she wrote in the first editorial:

> *Fashion has never been as relevant as it is in 1980; and the magazine has been created to understand our times and bear witness to them. It has been launched . . . in the first year of a couple of decades that are going to turn the world upside down, of a period in which technology, intelligence and difficulties will change humanity and its way of life . . .* Donna *will speak of fashion, but not of that alone: clothes and cultural trends, design and economics, beauty and politics, health and modes of behaviour, entertainment and sociology, music and literature.*

The covers of *Donna* offered a series of freeze-frames of the shape of fashion in the 1980s (pl.139). Geometry, a triangle on a white ground, underlined the form and construction of the garments of the protagonists of that *prêt-à-porter* at which Italian designers excelled. There were no reservations about photographing the model from behind, as happened in the first issue with a picture by Oliviero Toscani, breaking every rule of communication in order to place the emphasis on the new super-body: broad shoulders, narrow waist and trim legs. Along with Toscani, photographers like Fabrizio Ferri and Giovanni Gastel played a fundamental role in the

DONNA

INTERNATIONAL FASHION MAGAZINE

N. 20 - FEBBRAIO 1982 - LIRE 4000

100 PAGINE
PER CAPIRE TUTTO
E SAPER SCEGLIERE
IL MEGLIO
**NUOVA
MODA '82**

Giacca con
revers asimmetrico
di Versace

Opposite
138 Advertisement for the
Gianfranco Ferré ready-to-wear
collection, Autumn/Winter 1991.
Photograph by Gian Paolo Barbieri
V&A: E.406–2013

139 Gianni Versace ensemble.
Photograph by Oliviero Toscani.
Donna, February 1982

140 and 141
Missoni advertising image,
Autumn/Winter 1983. Illustrations
by Antonio Lopez

Opposite
142 Franco Moschino advertising
image, Spring/Summer 1990

Fashion and Image Portrait/Self-portrait: The Image of Fashion

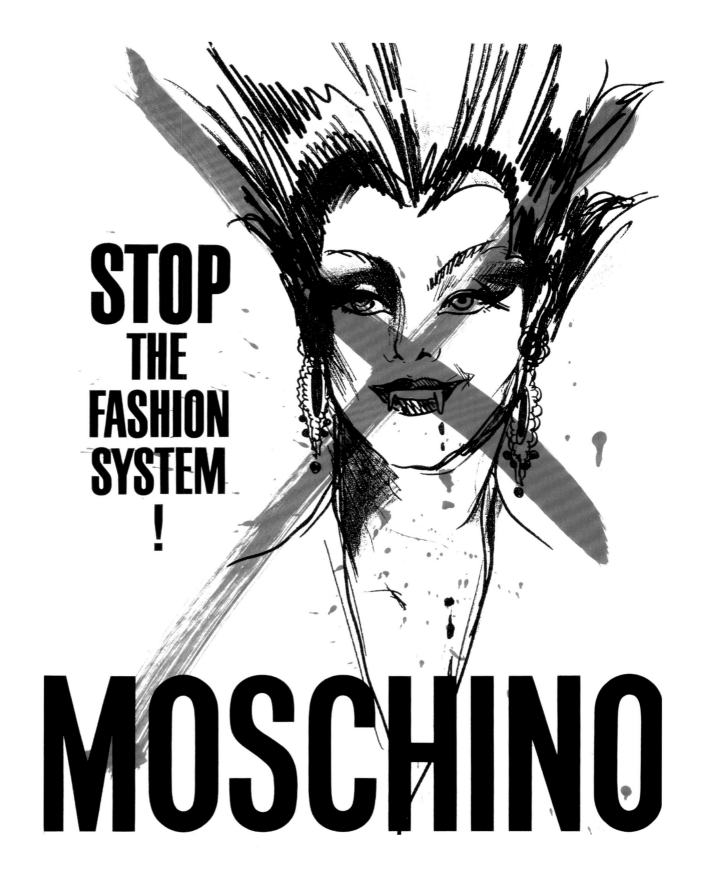

STOP
THE
FASHION
SYSTEM
!

MOSCHINO

Opposite
143 Romeo Gigli ensemble,
December 1987. Illustration
by Mats Gustafson

144 Self-Portrait with Vera
Lehndorff as Veruschka, 2001.
Photograph by Francesco Vezzoli
in collaboration with Vera Lehndorff
and Gian Paolo Barbieri

The complexity and quality of some designs were best expressed through the combination of a terse and essential graphic line and richness of colour. The men that Antonio Lopez drew to illustrate Missoni's garments are powerfully realistic, appearing to jump out of the page (pls 140 and 141).[14] The precision of the drawing was better than any photograph at conveying not just the infinite gradations of colour that run through the knitwear, but also the new life of a company that would become a dominant force in contemporary clothing.

With the same precision, but using an ethereal, soft, blurred and washed-out line, Mats Gustafson's illustrations proved the perfect vehicle for the revolution that Romeo Gigli represented in Italian fashion when, between the late 1980s and the early '90s, he delicately insinuated himself between the combative images of hyper-structured women of early Italian ready-to-wear with a new idea of a woman, a rarefied, soft and nostalgic look that brought the decade of yuppies to a close and heralded new scenarios that would dance to the fragile, sometimes sombre rhythm of the intimist and minimalist subtraction that would characterize the 1990s (pl.143).

Bellezza

Veruschka Was Here is the title of the work that Francesco Vezzoli presented at the Venice Biennale in 2001. The artist's starting point was the photograph by Franco Rubartelli that appeared on the cover of the German weekly *Stern* in March 1969. It portrayed Veruschka, an icon of those years, wearing a sort of fringed red poncho designed by Valentino. The artist was able to persuade the model to put on the same clothes and, seated on a banquette, embroider her own portrait in needlepoint for the first three days of the exhibition. He then asked Gian Paolo Barbieri, another master of fashion photography, to take a picture of Veruschka as she worked on her tapestry, again citing Rubartelli's image, and another in which the artist and the model, dressed alike, are seated back to back (pl.144).

Veruschka's hypnotic beauty[15] would often be used by her partner Franco Rubartelli in a hieratic way to interpret the perfect forms of Italian fashion. In another piece of exemplary reciprocity, Benedetta Barzini's strange and irregular Mediterranean beauty, along with her personality and origins, made her one of the key faces of American *Vogue* under the editorship of Diana Vreeland. She and Mirella Petteni, another of the great Italian models and a favourite of Helmut Newton's, epitomized a certain ideal of Italian beauty based on faces rather than bodies. I am thinking too of Isabella Rossellini, or of Monica Bellucci and Mariacarla Boscono. These models interpreted fashion with their gazes. Before the 1960s there had been Elsa Martinelli, and then, together with Petteni and Barzini, came Isa Stoppi, Elsa Peretti, Alberta Tiburzi and Marina Schiano, further examples of an Italian type of beauty, so magnetic and magically imperfect that in the 1960s and '70s it became the preferred mirror in which to look at international fashion. And it was Alberta Tiburzi, who had become a photographer herself, who discovered one of the Italian faces of the 1980s, Simonetta Gianfelici.

145 Alice Furnari with a dress
from the first Prada catwalk
show. Photograph by Manuela
Pavesi. *Dazed and Confused*,
December 2003

Opposite
146 Ken Scott, *Il Circo* collection,
1968. Photograph by Alfa Castaldi

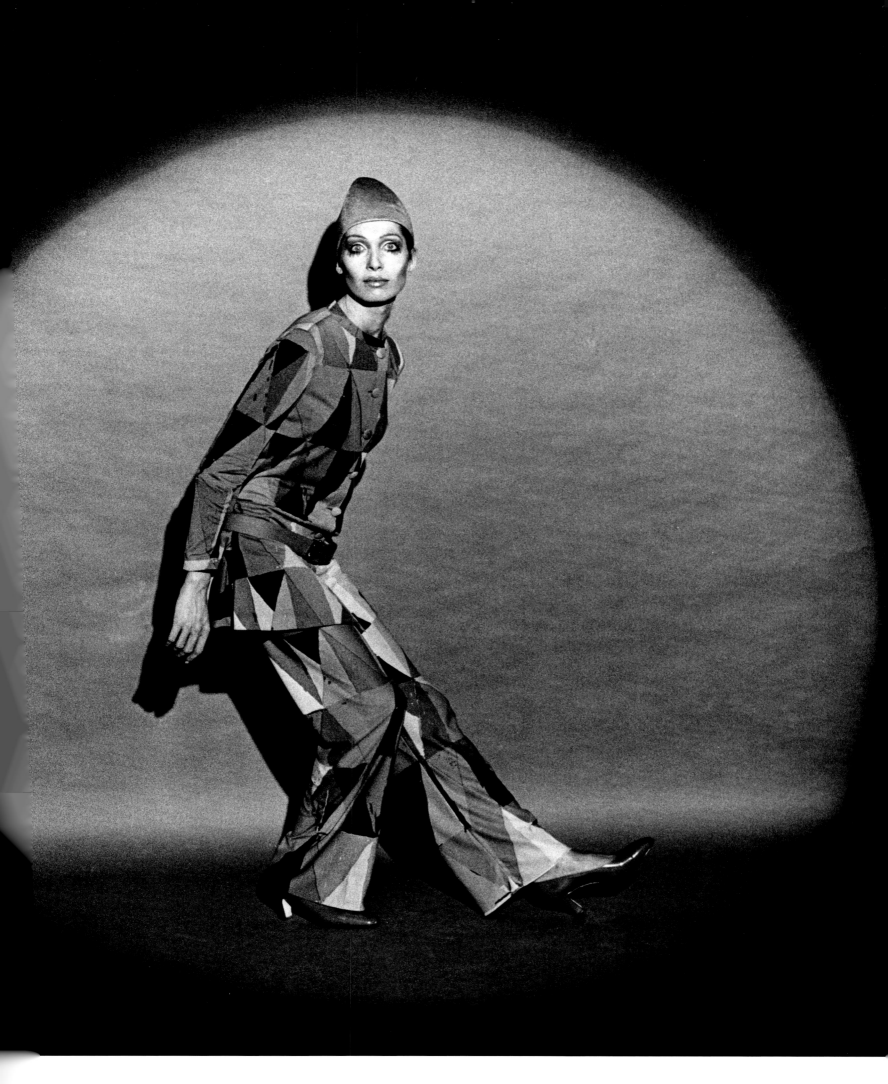

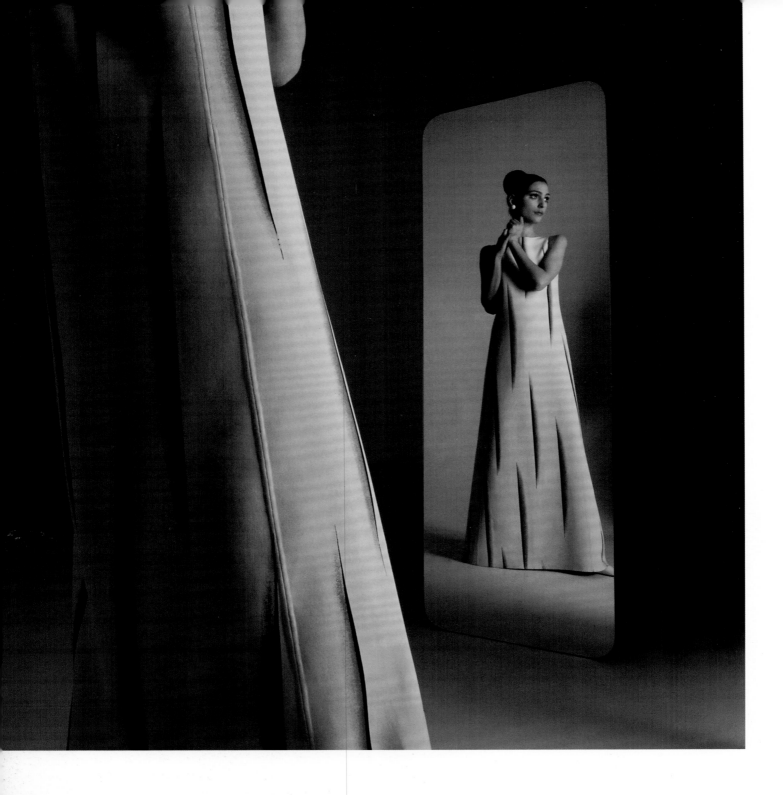

147 Advertisement for Mila Schön, Spring/Summer 1969. Photograph by Ugo Mulas

Opposite
148 Advertisement for Miu Miu featuring actress Kirsten Dunst, Spring/Summer 2008. Photograph by Mert Alas and Marcus Piggott

I think it is the intensity of these faces, veiled with melancholy, that is so striking. In them we see mother, wife, daughter and lover, desire and renunciation, reticence and boldness, care and neglect. A photograph by Manuela Pavesi comes to mind in which she uses her daughter Alice Furnari as a model (pl.145). It's something she does often, because fashion for Pavesi transcends the body over which it is draped. It does not need to fit well or look beautiful. In her daughter's face she finds the obsessions of her imagination, such as the intense Claudia Cardinale of Luchino Visconti's 1965 film *Vaghe stelle dell'Orsa* (released in the UK as *Of These Thousand Pleasures*). In this photograph Alice's face is the centre around which the rest revolves. The middle-class affluence suggested by the room is contradicted by Alice's pose, her bare feet resting on a suitcase that has just been closed, staring into the lens with a cup in her hand, a lock of hair dangling over her face. Italian beauty is not the charming kind, which delights in frivolity. It is hard and troubling.

Ugo Mulas
Ugo Mulas is the most important photographer Italy has produced. Working in fashion out of economic necessity, he created images that are still striking today, not just for the beauty of the end product, but also for the research that they represented on that tricky terrain. On the subject of fashion photography, Mulas said:

It is not only pointless, but also very dangerous to try to hint at an ideology or a message under this theme, which is in itself so insubstantial. The most that a fashion photographer can do is produce a fresh, modern image, an image that figuratively has been deeply analysed at least from the viewpoint of form, even if it implies nothing else, but you can't play around with the grand themes of life. In my view the best thing that you can do when taking fashion photographs is to focus attention on the product that is being photographed, to make sure that the cut of the garment, its construction, is clearly visible.[16]

And yet over the course of his short career (he died aged 44), Mulas succeeded in leaving a deep mark on fashion photography. His 'fairly explicit' images, as he described them, tending to the essential, display a perfect balance between the model and the dress and their relationship with the backdrop. While his early fashion photographs made use of popular events like bicycle races or the scenery offered by Italian cities like Venice, Rome or Florence as settings for the clothing, over the years, spurred on in part by the example of his artist friends and in particular Lucio Fontana, Mulas's work grew increasingly spare, allowing him to place the emphasis entirely on the fashion.

The encounter with fashion designer Mila Schön was fundamental for both. On the one hand he introduced her to Fontana, whose works were

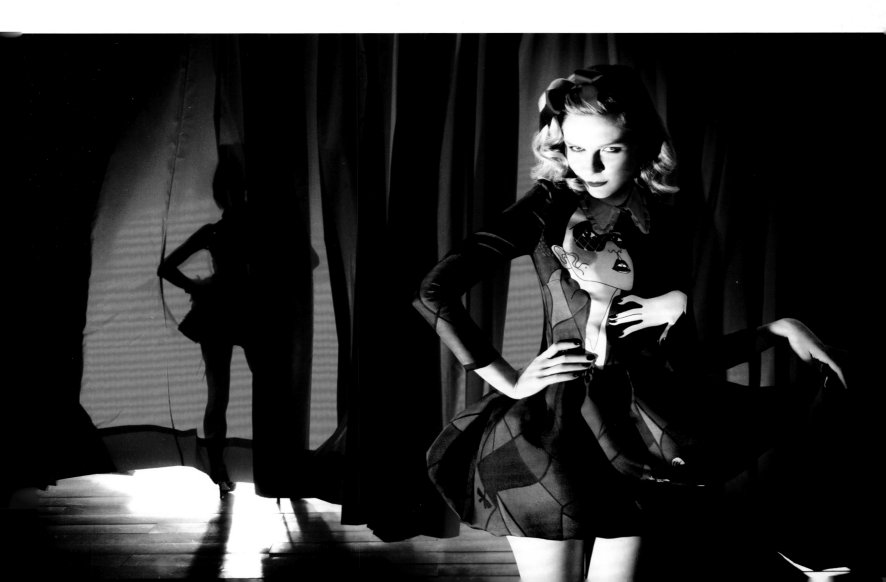

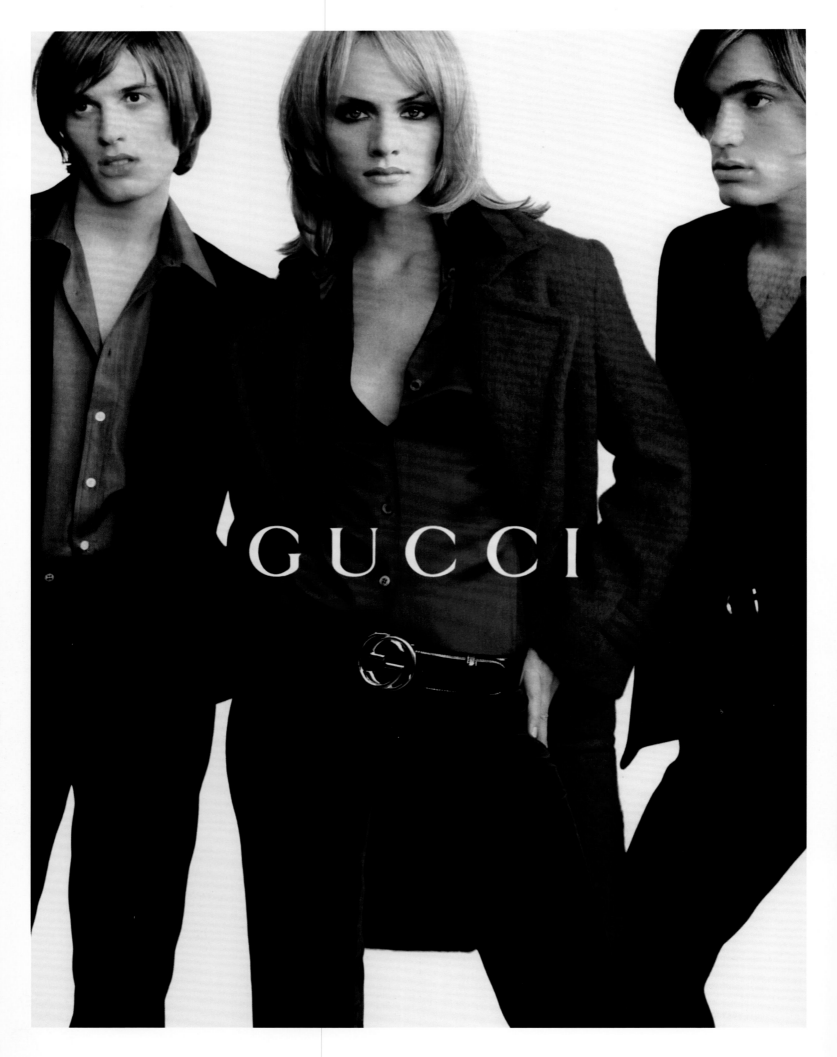

Opposite

149 Advertisement for Gucci
featuring actress Amber Valletta,
Autumn/Winter 1995. Photograph
by Mario Testino

150 Prada, Spring/Summer 1998.
Photograph by Glen Luchford
V&A: E.50–1997

to provide her with the inspiration for a collection (Spring/Summer 1969) that Mulas later photographed using Benedetta Barzini as the model; on the other Schön gave him complete freedom to carry on with his pursuit of an impossible absolute (pl.147). Mulas came close to it in his last pictures, published in *Vogue Italia* in 1973, the year of his death. The full-page advertisement consisted solely of a sequence of contact prints showing the empty set awaiting the arrival of the model.

Commedia dell'Arte

'Smart may have the brains,' ran the Diesel advertising campaign, 'but stupid has the balls.' 'Smart has the plans, stupid has the stories.' 'Smart had one good idea and that idea was stupid.' The Diesel 'Be Stupid' campaign for Spring/Summer 2010 by that genius of communication Renzo Rosso, who succeeded in creating a demand for Italian jeans all over the world, was a tribute to the kind of creative edginess that ignores the rules.[17] Rooted in the heart, not the head, the campaign swept the world with an energy that was transformed into mocking, liberating laughter, following the example set by the contemporary Italian artist who has achieved the greatest international fame, Maurizio Cattelan. Rosso reminds me of the feigned naivety of the characters of the *commedia dell'arte*, able to prick the balloon of situations and stories and bring them back to the simplicity of life.

The Harlequin photographed by Alfa Castaldi in 1968 to capture Ken Scott's colourful fashion in a black-and-white image pertains instead to the more melancholic side of the masked types of the *commedia dell'arte*. The lithe figure of Isa Stoppi is silhouetted against the closed curtain, a Pinocchio-style hat on her head, evoking the sad sense of loneliness that can overtake us at carnival time (pl.146).

There is a fascinating dialogue between this image and an extraordinary picture that was used to present the Miu Miu Spring/Summer 2008 collection. Miuccia Prada has always chosen young actresses as the models for this line's advertising campaigns. In this case it was Kirsten Dunst, photographed in Los Angeles by Mert & Marcus (pl.148). The inspiration for this collection came once again from the stock characters of the *commedia dell'arte*, which provided the elements, decorations and forms of the garments. Prada is adept at the game of disorientation, at reconciling her anti-graceful poetics with the emotions that can be conveyed by the beautiful faces of disquieting young women. Here the actress has been photographed against the backdrop of a curtain, but half-open this time, and the intense, deep colour of the picture sets off perfectly the attitude and outlines of this diminutive figure with very white skin and lips as red as a wound, who looks like a puppet operated by strings.

International Style

There are images that appear out of the blue and change everything. Afterwards it seems as if nothing can be the same as before. In most cases it is not

the complexity of the composition that makes them different from the others: it is the consciousness of the time in which they are set and in which they are steeped that is striking. Tom Ford, the Texan brought to Florence to act as creative director for the Gucci brand, reinvented and redesigned a model of femininity that at once became an icon, taken up by Madonna and often to be seen on the red carpet of Hollywood. A certain 'American' simplicity, with clinging blouses and the soft drapery of silk jersey presented against the backdrop of Pierre Koenig's Case Study Houses in Los Angeles for the Autumn/Winter 1996 campaign, was grafted on to an Italian landscape that turned into a postcard to be sold to tourists. Brands are global and want to adopt an international style that can convey a powerful and clear message everywhere. Amber Valletta, as shown flanked by two boys/men in Mario Testino's photograph for the Autumn/Winter 1995 campaign, which was devised by fashion editor Carine Roitfeld, was to provide a benchmark for thousands of women all over the world, who still dress the same way: tight hipster trousers, close-fitting blouse unbuttoned to expose the cleavage and a belt (pl.149).

This kind of imagery conjured up fusion lifestyles, an international style that was supposed to capture people's imagination, diverting them from the banality of everyday existence. Thus we no longer find figures set against a background but icons caught in their natural habitat, as in Steven Meisel's photographs for Versace's Autumn/Winter 2000 campaign, where Amber Valletta again and Georgina Grenville, shot in classic poses, look perfectly at ease in the spectacular suite of bourgeois rooms that we see behind them.

The hypnotic images of the Prada Spring/Summer 1997 campaign, photographed by Glen Luchford, bring us back to a suspenseful, labyrinthine tale, one whose allusions serve to take us somewhere else. Amber Valletta is there once more, but the whole advertising campaign is based on atmospheres that evoke the bewilderment of David Lynch's *Twin Peaks*, and Prada's clothes become almost as iconic as the plastic in which Laura Palmer was wrapped, a ravished Ophelia of the 1990s (pl.150). The photographer's lens captures the mystery that shrouds the solitary figure drifting in the current aboard a small boat: a shape cut off from its own reality. Miuccia Prada knows a lot about contemporary art and experimental film, and turned to architect Rem Koolhaas for a reflection on shopping that has led to the revolution of the Prada Epicentres. The images of her campaigns, like the sets of her shows, changing every season to follow her obsessions, are a paradigmatic example of what the language of fashion has now become: the place where visions of the contemporary world disintegrate.

Today, the Italian landscape has been transformed once and for all into the context of global entertainment, the definitive picture postcard. Its cities are destinations for shopping and gastronomic invasions. The image of the Italy of fashion is shaped

151 'The Waiting Game', *Spoon,* 2003. Photograph by Andrea Spotorno

by objects that continue to be sought after and desired all over the world, for the quality of their materials and the refinement of their production, hard to replicate elsewhere.

In order to convey this new sentiment of vision, that of those who look, are looked at and would like to be able to recognize themselves in the other person's gaze, a number of independent magazines have emerged in Italy that work to bring together the different versions of contemporary existence – publications like *Drome*, *Grey*, *Hunter*, *Kaleidoscope*, *Mousse*, *Pizza*, *Studio* and *unFLOP*. The founders of these magazines play around with their own obsessions in a daring way, and this produces a vision of fashion that is more on the edge, shaped by a particular attention to experimental art united with the capacity to bring up subjects that may even be quirky and bizarre, but are always in tune with what is going on around them. They are magazines that use fashion, and know how to adapt it through graphics and layouts more receptive to lo-fi aesthetics to create a short-circuit with a wide variety of themes and subjects, following routes of their own through the multiple geographies of globalized fashion.

One of the most interesting traits shared by these magazines is the web of empathy they weave between designers, photographers, stylists and journalists, allowing them to take an alternative approach to the methods of bringing the image of Italian fashion into focus. They are run by editors who have decided to put themselves on the line in order to carry out a personal project, aware that fashion can be an incredible driving force of curiosity and change. These publications are platforms from which to relaunch, through the visionary work of wardrobe stylists and photographers, a new season in Italian fashion. Among these figures, who live and work between Italy and the rest of the world, are the stylists Anna Carraro, Tanya Jones and Rossana Passalacqua and the photographers Silvia Camporesi, Diego Fuga, Stefano Galuzzi, Carlotta Manaigo, Marco Pietracupa and Andrea Spotorno (pl.151).

In this account, I have chosen to focus on single images, presenting them in a sequence that mixes up genres, occasions and languages and that remains open to future adjustments and additions. An atlas that emphasizes common characteristics and a number of recurrent refrains, which have disappeared and then resurfaced over the decades, from the post-war period to the present day, as peculiar and congenital constants of aesthetics and identity. It is the images themselves that have led me between the diverse souls of the photography of Italian fashion, between their distinctive characteristics, between *topoi* and prejudices, commonplaces and clichés. In fashion's pulsating memory it is the images that sustain the rhythm of the narrative and rearrange themselves into new connections and trajectories; in a construction that is always shifting, as it is subject to continual changes, in the reconstruction of a story that is also my own. Out of this free-ranging and meandering collection has emerged a curious and intrinsic unity, which on the one hand has something to do with the subjects covered, and on the other with the life of the person who has explored them.

Maria Luisa Frisa, fashion critic and curator, is Director of the Degree Programme in Fashion Design and Multimedia Arts (BA) at University IUAV, Venice

Italian Fashion Designers in Hollywood

Stella Bruzzi

152 Anita Ekberg in the Trevi fountain, Rome, in a scene from Federico Fellini's film *La Dolce Vita*, 1960

When asked about the relationship between Italian fashion and Hollywood, many people are likely to come up with images of a youthful, bare-chested Richard Gere getting ready to go out in Paul Schrader's *American Gigolo* (1980). The opening bars of 'The Love I Saw in You was Just a Mirage' by Smokey Robinson and the Miracles play as Julian (Gere) wipes the last traces of cocaine from a pocket mirror. He goes over to his wardrobe (neatly and amply stocked for a heterosexual man in 1980) and selects four unstructured Armani jackets in different light shades, all in the designer's trademark glossy, mixed-fibre fabrics. He then bends down and opens three drawers in turn, the first filled with meticulously arranged ties, the second and third containing well-folded shirts. Particularly interesting in cinematic terms is that in this shot, the focus is definitely on the clothes and not on Julian. We are meant to notice them.

Julian picks out four silky shirts and lays one on top of each jacket. This time the low-angle shot draws our attention to him and his bare chest as he briefly but thoughtfully peruses his options, before he returns to the drawer of ties and takes out four of them, moving to the music as he proceeds to likewise drop them on to the bed. After a quick close-up of Julian, the image switches to a tight tracking shot along the potential outfits: sensuously lit folds of neutral, earth-toned fabric. Gere looks down as he rearranges the ensembles slightly, smiles with satisfaction at his final selection and walks away, after which there is a sharp cut (although the song continues uninterrupted) to a shot of him fully dressed, tying his shoelaces. The camera then starts to pan up Gere's body as he buckles his belt and turns to look at his reflection in a full-length mirror, knotting his tie as he practises a bit of Swedish in preparation for his appointment that evening. The phone rings, but Julian doesn't respond

immediately; instead he walks past the bed and in one smooth, nonchalant move picks up one of the jackets and continues on towards the phone while slipping it on. He switches off the music, as there's a knock at his apartment door.

Why did this moment of casual narcissism become one of the iconic sequences in the history of the relationship between fashion and film? The most significant thing about this scene in *American Gigolo* is that it is constructed around Julian's Armani clothes; they are not incidental to it, as the majority of Hollywood costumes are, they do not play second fiddle to character, they are to be looked *at* rather than *through*. Giorgio Armani's involvement in film costume design is complex. Gere in *American Gigolo*, with his coordinated sets of unstructured suits, silk shirts and matching ties, essentially puts on display the Armani capsule wardrobe of the era (pl.155). In this instance, Armani's designs are being used in the film *as fashion*, as bought-in items of covetable menswear. Conversely, for Brian de Palma's *The Untouchables* (1987), Armani worked with Marilyn Vance-Straker, the film's costume designer, to design unique period costumes for the characters, albeit costumes that nevertheless exhibited the traits of contemporary Armani designs.[1] This essay is largely about the film work of Italian fashion designers who have been heavily involved in the design of a film's costumes or who have actively *designed* costume items, as opposed to those whose clothes have been bought by costume designers off the peg. Armani's involvement in *American Gigolo* heralded a new era of collaboration between film and fashion, specifically Italian fashion, although it was by no means the first instance of an Italian designer being involved in a Hollywood production.

In the early 1920s, footwear designer Salvatore Ferragamo moved to Hollywood, having already

opened a shop in Santa Barbara a few years previously. He was hired to make boots for Westerns produced by the American Film Company, in addition to working on D.W. Griffith's *Way Down East* (1920) and contributing designs to other major productions, such as Cecil B. DeMille's *The Ten Commandments* (1923), James Cruze's *The Covered Wagon* (1923) and Raoul Walsh's *The Thief of Bagdad* (1924), starring Douglas Fairbanks. Soon, many of the famous screen stars of the 1920s – Pola Negri, Mary Pickford, Gloria Swanson, Joan Crawford and Rudolph Valentino among them – began ordering made-to-measure shoes from his small Santa Barbara shop, and he acquired the nickname 'shoemaker to the stars'. In 1923, buoyed by his success in Hollywood, Ferragamo was

able to open the Hollywood Boot Shop on Hollywood Boulevard, before returning to Italy in 1927 to settle in Florence. He continued to design shoes for the rich and famous, among them Marilyn Monroe.

Another Italian atelier associated with making some notable incidental or one-off items for Hollywood was Sorelle Fontana. The three Fontana sisters, Zoe, Micol and Giovanna, opened their first atelier in Rome in 1944. As with Ferragamo, the sisters' influence on Hollywood was more specific than far-reaching, and revolved around individual stars as opposed to full movie productions. Having created Linda Christian's extravagant fairy-tale wedding dress for her marriage to fellow actor Tyrone Power, held in the basilica of Santa Francesca Romana in Rome

Opposite

153 Ava Gardner with designer Zoe Fontana on the set of *The Barefoot Contessa*, 1954

154 Sorelle Fontana, fashion sketch for a gown worn by Ava Gardner in the film *The Barefoot Contessa*, 1954

155 Richard Gere wearing Giorgio Armani in *American Gigolo*, 1980

in 1949, the sisters participated in Giovanni Battista Giorgini's first fashion show in Florence in 1951. That same year, Micol left for Hollywood, arriving in the United States as a personal friend of Power and Christian, who introduced other Hollywood people to the designs of the Fontana sisters. Subsequently, their sumptuous, New Look-inspired gowns adorned Audrey Hepburn, arguably Hollywood's leading clothes horse at the time, Ingrid Bergman, Kim Novak, Grace Kelly, Anita Ekberg, Elizabeth Taylor and Sofia Loren, although the designers are best known for their lasting relationship with Ava Gardner (see pl.32).

The Fontana sisters designed several off-screen dresses for Gardner as well as her costumes for *The Barefoot Contessa* (1954), *The Sun Also Rises* (1957) and *On the Beach* (1959). *The Barefoot Contessa* showcased the Fontana style perfectly and Gardner's luxurious gowns epitomized the strong feminine appeal of their work, with their wasp-waisted and full-skirted dresses in bright silks encrusted with contrasting embroidery and diamanté (pls 153 and 154). Quintessentially 1950s in that they designed more regularly for Gardner's more voluptuous hourglass figure as opposed to the gamine shape of Audrey Hepburn, the Fontana sisters were known for their formalwear and their exquisitely crafted designs, which recalled the excessive French fashions of the eighteenth century. However, their prominence and fame, as several critics have observed, could be directly attributed to their links with the Hollywood glitterati, especially Gardner, without whose patronage 'it is unlikely they would have been able to achieve such fame'.[2] One of the Fontana sisters' most famous gowns was the sensuous and voluptuous black dress Anita Ekberg wore while cavorting in the Trevi fountain in Federico Fellini's *La Dolce Vita* (1960), although even this can be traced back to Ava Gardner, who was not only the sisters' ideal muse and mannequin but also the prototype for the film's visiting Hollywood star (pl.152).[3]

This close relationship between couture house and individual star has proved an enduring and essential component of the history of fashion's association with cinema. To this category one could add, in terms of examples from the golden age of Hollywood, the outfits Elsa Schiaparelli made for the outrageous and witty Mae West in *Every Day's a Holiday* (1937; pl.156). Schiaparelli famously constructed the costumes on a mannequin made to West's measurements, which later went on to inspire the torso-shaped bottle for her perfume Shocking (which in turn inspired the Jean Paul Gaultier perfume bottle in the shape of a woman's torso, still available today, which is said to be

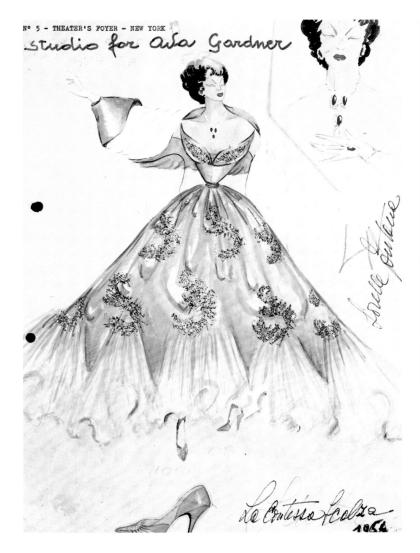

an homage to Madonna). There is a qualitative – as well as a quantitative – difference, however, between Schiaparelli's loud designs for Mae West and Armani's dressing of Richard Gere in *American Gigolo*. I have already argued that, for all their muted, natural tones, Armani's clothes for *American Gigolo* demand to be looked at as opposed to through. When compared to Schiaparelli's oversized, jauntily angled and feathered hats for *Every Day's a Holiday*, the intrusive quality attributed to Gere's costumes might appear unlikely. However, the spectacular impact of some fashions on a film's character and narrative is not inevitably in direct proportion to their ostentatiousness, for Schiaparelli's costumes for Mae West are as much about Mae West as they are about fashion, principally serving to augment and embellish the star's already well-defined larger-than-life character. Armani's relative lack of flamboyance (but then not many couturiers could ever compete on the flamboyancy front with the designer of the lobster dress, the shoe hat or the monkey-fur shoes) does not mean that his costumes necessarily become invisible. As one critic legitimately observed, '*American Gigolo* is not even about its protagonist; it is about what he wears. *American Gigolo* is about Armani.'[4] In part, this holds true in relation to *American Gigolo* specifically because of Armani's dominance of menswear design at the time of the film's release and throughout the 1980s, so people who went to the film potentially saw in Gere's suave yet casual elegance the epitome of who they would like to be or be with. Armani's astute abolition of stiff lining and padding to make the man's suit emulate the woman's in the way it moved with the contours of the body led to the emergence of a softer, androgynous or sexually ambivalent masculinity to overtly challenge the square traditionalism of the classic male silhouette.

Arguably the most significant characteristic of Italian fashion as showcased by Hollywood is easy elegance, as exemplified by the classic style of Nino Cerruti, with whom Giorgio Armani worked as a menswear designer between 1964 and 1970. Cerruti, who opened his first Cerruti 1881 boutique (the date refers to the year the family textile firm was founded) in Paris in 1967, started his film costume career in the same year with Arthur Penn's iconic *Bonnie and Clyde* (1967), for which he designed Faye Dunaway's retro hats (pl.157). In spite of this beginning, when it comes to his Hollywood work, Cerruti has traditionally been associated with designing formal and smart casual wear for male protagonists in films such as *The Witches of Eastwick* (1987), *Pretty Woman* (1990), *Philadelphia* (1993), *Die Hard: With a Vengeance* (1995), *As Good as it Gets* (1997) and *Air Force One* (1997). Cerruti's fashions are classic, mellow and controlled; they are rarely controversial or radical, although his influence has proved extensive, especially on the unstructured tailoring of men's suits. Cerruti's suits, like Armani's, while neither feminine nor androgynous, lack the anonymity of the stiffly tailored suit, that 'practical (if historically uncomfortable) uniform of respectability'.[5] As worn by male stars as diverse as Richard Gere, Jack Nicholson, Harrison Ford, Michael Douglas or Tom Hanks, they have also come to denote elegant, traditional masculinity. Although it is undoubtedly the case that designers such as Cerruti or Armani, who both worked extensively on big-budget, mainstream Hollywood projects during the 1980s and '90s, used films to 'show off their clothes, just as Ferragamo had done with his shoes',[6] Cerruti's approach to his film work echoes that of full-time costume designers. Nino Cerruti maintains that he is not concerned with making a personal statement but rather sees his role as 'working for a character', because

'when you work for a film you need to help the actor or actress to emphasize the role they're playing'.[7]

The manner in which Cerruti's designs work in tune with a character is illustrated by the way wealthy asset-stripper Edward Lewis (Richard Gere) is dressed in Garry Marshall's *Pretty Woman*. During the extended title sequence, two male colleagues are talking about Edward before he even appears on screen, one remarking to the other that he is 'probably off in a corner somewhere charming a *very* pretty woman'. Sure enough, there is a cut to Richard Gere, not talking in person with a 'very pretty woman' but on the telephone to a girlfriend with whom he is breaking up, wearing a black suit and tie with a contrasting white shirt and pocket handkerchief, an outfit that perfectly complements the actor's salt-and-pepper hair. When, a while later, he has met and started to fall for hooker Vivian (Julia Roberts), Edward accompanies her to Wilshire Boulevard to buy enough expensive clothes to fill a wardrobe. Vivian, still in her short, stretchy hooker-dress, is concerned that, as had happened the previous day, the stores will not prove very welcoming, but Edward reassures her, explaining that 'stores are never nice to people; they're nice to credit cards'. Swathed in the sophisticated, subtle elegance of his double-breasted suit, which is grey tinged with mauve and again put with a white shirt, white handkerchief and black tie, Edward is the walking embodiment of the wealthy man with a limitless credit card (pl.158). As the couple enter their chosen boutique, Edward enlists the services of its cartoonishly oleaginous manager by announcing that their intention is to spend not only a 'profane' but a 'really offensive' amount of money, a statement of

ostentatious intent that contradicts the understated nature of his Cerruti suit but is nevertheless also compatible with its exclusivity.

Gere's suits in *Pretty Woman* do not deviate significantly from the business-like black–grey colour spectrum, although they do get paler and less formal as Edward 'lightens up', falls further for Vivian's charms and becomes more emotionally receptive and expressive. He arrives at a polo match, for instance, in a comfortable cloudy-grey single-breasted suit jacket worn over loose peg-top trousers, a cream shirt and patterned tie. Although he does not abandon his darker, sharper suits (for the trip to see *La Traviata* at the Met, for example), there is a definite sense in *Pretty Woman* that Edward's costumes, just as much as Vivian's, reflect character development. Which means that for their last morning together at the Beverly Wilshire, when he has yet to realize that he wants to stay with Vivian forever, Edward sits down for breakfast in his most buttoned-up, conformist suit yet – a midnight blue three-piece with a tight waistcoat, white shirt and grey patterned tie. Like many of the Hollywood characters Cerruti has costumed, Edward is a classic, traditionalist, unreconstructed man.

Coco Chanel is reputed to have said that 'if a woman walks into a room and people say, "Oh, what a marvellous dress", then she is badly dressed. If they say, "What a beautiful woman", then she is well dressed.'[8] A similar remark could be made about the menswear of either Nino Cerruti or Giorgio Armani: that these clothes project and enhance their wearer's masculinity, which is no doubt the prime motivation for so many male stars also becoming the Italian designers' loyal clients off-screen as well as on. In direct contradistinction to Chanel's ethos sits the extrovert Gianni Versace, who before his death in 1997 provided, and in some cases specially designed, conspicuously glamorous items for a number of non-classic, gay- and drag-oriented movies, both within and beyond Hollywood. Besides creating women's costumes, alongside fellow fashion showman Jean Paul Gaultier, for Pedro Almodóvar's *Kika* (1993) and drag outfits for Wesley Snipes and Patrick Swayze in Beeban Kidron's *To Wong Foo, Thanks for Everything, Julie Newmar* (1994), a flat reprise of *The Adventures of Priscilla, Queen of the Desert* (1994), Versace also worked in Hollywood and, like virtually every one of his couture compatriots, it seems, on the television series *Miami Vice*.[9] In 1995, for example, Versace contributed costumes to Paul Verhoeven's ill-judged lap- and pole-dancer movie *Showgirls*, including Elizabeth Berkley's black dress – although Versace's most infamous little black dress has to be the safety-pinned example Elizabeth Hurley wore for the 1994 London premiere of *Four Weddings and a Funeral*. As Stephen Gundle writes, the exposure this dress received 'increased the curvaceous Hurley's profile and made Versace into a byword for show-stopping sexy clothes'.[10]

Dressing attention-seeking actresses in glitzy clothes, however, was not all Versace achieved when it came to film costume. He worked on Mike Nichols's

The Birdcage, for instance, the 1996 remake of the classic French cross-dressing comedy *La Cage Aux Folles* (Eduardo Molinaro, 1978). Set in South Beach, Florida and featuring a middle-aged gay couple who own a drag club, the film resonated with Versace's own life: he owned a house in Miami Beach, Casa Casuarina, outside which he was murdered on 15 July 1997. Nichols's movie features loud, camp clothes – Robin Williams's brightly patterned, voluminous shirts and wide-legged trousers; Nathan Lane's floaty safari tops and silk scarves. The film and its costumes celebrate homosexuality and poke fun at the 'straight' suits and staid drag the pair have to endure when they meet the ultra-conservative, homophobic parents of their son's fiancée for the first time. Straightjacketed in his sombre dark suit and tie, Williams performs a passable impression of Cerruti man. However, not all Versace's work for film was well respected and the release of *Dredd* in 2012 saw the appearance of a number of articles on the internet that poked fun at Versace's rejected or modified designs for *Judge Dredd*, the 1995 film starring Sylvester Stallone as the titular comic-book character.

Early 2013 saw the unveiling of Miuccia Prada's costume sketches for the eagerly anticipated remake of *The Great Gatsby*, directed by Baz Luhrmann (with whom she had also collaborated on *Romeo + Juliet* in 1996) and starring Leonardo DiCaprio and Carey Mulligan. The memorable Ralph Lauren costumes for the 1974 version directed by Jack Clayton, with Robert Redford as Gatsby and Mia Farrow as Daisy Buchanan, set the fashion bar fairly high and part of Prada's task would be to displace those classic, privileged looks. Menswear items for the film were designed by Brooks Brothers, and Gatsby embodies a timeless, hard-fought elegance, from his black party suit to the more ostentatiously *nouveau-riche* off-white ensemble he wears for his crucial reunion with Daisy. The affinity between Daisy's Prada-designed dresses, however, and Prada's own collections are unmistakeable, as illustrated by the fur collars worn over glistening metallic dresses that strode down the catwalk in Autumn 2011. In an interview with *Vogue News*, Catherine Martin, the film's overall costume designer, explains what she wanted from the Italian designer:

> *Our collaboration with Prada recalls the European flair that was emerging amongst the aristocratic East Coast crowds in the Twenties . . . The fashions of the time saw the development of a dichotomy between those who aspired to the privileged, Ivy League look of wealthy Long Island and those who aspired to European glamour, sophistication and decadence. Our collaborations with Prada reflect that collision of these two aesthetics.*[11]

The film, like its fashions, is nostalgic as well as contemporary. So how much has changed in the relationship between fashion and film over the decades? Italian fashion still represents aspirational elegance as intimated here, but not all fashion designers (apart from arguably Armani and Cerruti)

are as yet easily or seamlessly integrated into a movie's fabric, with directors and costume designers predominantly having elected to cherry-pick from the work of Italian designers, selecting one or two crucial items, rather than giving over a film's whole aesthetic to them (as, for example, Luc Besson did with Gaultier on his 1997 film *The Fifth Element*).

In another interview about *The Great Gatsby*, Martin is more explicit about who did what on the film. She reopens the tussle between costume and fashion designers for ownership of a movie's look, differentiating between her contribution to *The Great Gatsby* and Prada's. 'Daisy's costumes were made in-house in Australia and designed by me', she says. 'I designed and had made all the principal women's costumes within [my] workshop, and a lot of the incidental male costumes.'[12] Having established some parameters, Martin then becomes more relaxed and effusive about the impact a couturier can have on a movie, remarking that 'Prada didn't just donate clothes, she also helped shape the new *Gatsby* aesthetic' through amalgamating contemporaneity and vintage and by adding 'texture' to the characterizations.[13] However, it is evident where – despite the pre-release fashion magazine interest in Prada's involvement – the balance of power lies. (Indeed, unlike Armani, Prada does not get a top costume billing, and one has to wait until the very end of the credits to catch her name at all.) This *Great Gatsby* is a costume movie as opposed to a fashion movie, for apart from the odd item, such as Daisy's fur-trimmed gold party dress (pl.159), the characters' clothes are to be looked through rather than at; they strive for period authenticity and, for all their superficial 1920s glitziness, they remain subservient to character, class and narrative. And in this, Luhrmann's adaptation sits in contradistinction to the 1974 version starring Redford and Farrow, which visually was dominated by Lauren's quintessentially 1970s pastiche jazz-era clothes – clothes that, in turn, went on to influence catwalk fashions in the months to come.

The involvement of Italian ateliers in Hollywood over nearly a century is characterized by the extremely refined tug of war that is the working relationship between film and fashion: on the one hand, there is the commercially-oriented pull of the designers towards wanting to showcase their clothes and in effect use popular movies as window displays, while on the other, there is the genuine desire to give themselves over to narratives and characters, to view costuming as a different craft altogether. Italian designers continue to be so successful in Hollywood because they have perfected the essential art of maintaining this balance between art and craft.

Stella Bruzzi is Professor of Film and Television Studies at Warwick University and a Fellow of the British Academy

Judith Clark

Anna Piaggi

She was anti-explanation, anti-intellectualization.

Anna Piaggi died in August 2012 at the age of 81 at her home in Milan. Since the late 1950s she had worked for the Italian fashion industry as an editor, a journalist and a stylist. She contributed to the '*Il vivere moderno*' (modern life) section of *La Settimana Incom* and to *Linea Italiana*, as well as writing columns for *L'Espresso* from 1987 to 1989 and for *Panorama* from 1993 to 1997. She was fashion editor at *Annabella* and *Arianna* magazines during the 1960s; she was editor-in-chief of *Vanity* from 1980 to 1983; she was fashion editor at *Vogue Italia* from 1969 to 1971 and a trend reporter through her 'Box' column from 1974 to 1979. And from 1988 until the time of her death, Anna Piaggi contributed her *Doppie Pagine di Piaggi* (double pages of Piaggi) to the magazine. These double-page spreads were the subject of a book published in 1998 to celebrate the tenth anniversary of the project.[1]

A set of *Doppie Pagine* was published in every issue of *Vogue Italia*. As with Piaggi's earlier 'Box' reports (which can be considered precursors to the *Doppie Pagine*), their subject matter always sprung from the current catwalk collections, on season, re-described and themed, although the pages existed outside the magazine's explicit commercial remit. The *Doppie Pagine di Piaggi* were originally commissioned by Franca Sozzani, the magazine's editor-in-chief since 1988, to 'disrupt every issue and all expectations'. In the early years of Sozzani's editorship, the pages (undoubtedly a homage to Alexey Brodovitch's use of the double-page spread at *Harper's Bazaar* during the 1940s and '50s) were developed with art directors Fabien Baron and Juan Gatti. Their most confident idiom was developed from 1992 onwards with Luca Stoppini, the magazine's current designer. The pages always consisted of a very precise collage of cropped catwalk images, 'references' (associated images) and text. Happy to choose words for their graphic or onomatopoeic effect, Piaggi was uninterested in spelling out her associations – these pages were finally, she felt, her most efficient expression. They were contemporary gestures.

In the early 1980s, when she was editor of *Vanity*, Piaggi told her readers: 'Each edition of *Vanity* will have, as *Vogue* has, its point of view, its concept . . .concentrated ideas, an assembly of images, and few words.' She went on to list in the inside cover of the inaugural issue what to look out for: '1. Label, 2. Description, 3. Expression, 4. Mystery, 5. Detail, 6. What is contemporary? 7. Atmospheres that return, 8. A book to read, 9. Accessories, 10. The other versions/drawings.' In doing so, Piaggi was giving us a fundamental clue to her own preoccupations.

Piaggi always thought of herself as a reporter and was preoccupied by what she described as 'in real time' or the urgency of fashion. Her attitude was formed with her husband and long-term collaborator, Alfa Castaldi, whom she married in 1962 (pl.62). Castaldi had come to fashion from photo-reportage, and as early as 1971 he had created a collage-like style that created a choral impression of a trend. Her first suggestion for the title of an exhibition at the Victoria and Albert Museum dedicated to her was *Anna Piaggi: Instant Fashion*; she was anti-explanation, anti-intellectualization. Her word for her thoughts was instinct, but they appeared like Walter Benjamin's critical constellations.

Fashion was never timeless for her. Although historical dress was both essential to her pages and to her own famous self-styling, it was at the service of the moment, recruited through collage to illustrate the present, to animate it as well as interrupt it with anachronisms. Piaggi visited London regularly from the 1960s onwards. It was in London that she began collecting vintage couture and where her approach to the histories of dress, fictional and real, and its kaleidoscopic details was formed. Her attitude to anachronistic styling – the mixing of 'high' and 'low' dress, couture and street styles that we see in the thousands of images taken of Piaggi – was largely due to her long-standing friendship with Vern Lambert, an Australian dress historian whom she met in London at his vintage dress stall at Chelsea Antiques Market.

Like Diana Vreeland, Piaggi hated nostalgia. In her home, which was also her archive of clothing and images, no one object was held up as more valuable than any other. She did have preferences: Punk, Futurism, the Ballets Russes and the Bauhaus came up a lot in conversation (themes that could be accompanied by a narrative of rupture), as well as her enduring affection for the Anglo-Saxon capacity for immense bad taste. Her fashion stories were never about a progressive or prescriptive account of beauty, which held little interest for her. She was drawn to extremes, to ideas that would

conventionally be described as ugly for their being out of place, excessive, uncontained. It was these elements of the historical avant-gardes that held such appeal for her. While Miuccia Prada was developing what is now described as her 'ugly chic' of the 1990s, Anna Piaggi was writing Prada's press releases, her 'words in freedom', as she called them.

For Piaggi's pages every word had to count; for the sake of efficiency she often had to make up new words or splice them together: Chic-Triadique, Pink-Ink – you either got it or you didn't. Like the titles of Karl Lagerfeld's affectionate drawings of Piaggi in the 1970s and '80s, they read like a joke: 'The Triadique Balenciaga' of 1978, referring to the padding in a suit that presumably reminded both of them of Oskar Schlemmer's voluminous *Triadic Ballet* figures. Or 'Fortune Punk', a reference to Anna's knack for reinventing one style as another, in this case her distressed Fortuny, found in Porta Portese flea market in Rome. History is treated with a distinctive lightness of touch and dates and facts are always omitted.

'A little message; in order to adopt a new style, you have to know how to get thoroughly into the part and understand and allow others to understand – show others – what you have on . . . oh philosophical box.'
Anna Piaggi's last 'Box' report, *Vogue Italia*, March 1979.

Judith Clark is Professor of Fashion and Museology at the London College of Fashion, UAL, where she teaches on the MA Fashion Curation course

page 170
160 Anna at home, 1986.
Photograph by Alfa Castaldi
V&A: E.436–2013

161 Doppia Pagina for the V&A exhibition, *Anna Piaggi Fashion-ology*, commissioned by Judith Clark, 2006. The 'V' and 'A' of Victoria and Albert, of Alfa and Anna, of Anna and *Vogue*, and Anna and *Vanity* were used throughout the exhibition. Luca Stoppini found every instance of a word beginning with a V or an A appearing in the Doppia Pagine and from them made a hypothetical one

D.P.
di Anna Piaggi

COMME DES GARÇONS
S/S 2006.
Photo by
BARDO FABIANI

Victoria & Albert-ology

The letters V and A have been a constant part of the Double Pages on Italian Vogue and 2 important initials in my work and in my life. With my Very Art Director Luca Stoppini I have followed a chronological Vocabulary-with-variations from 1988 to 2006 for a new special Double Page! A.P.

Sonnet Stanfill

Paolo Roversi: An Interview

I am deeply Italian, as soon as something comes through from Italy, for sure my heart is beating...

I am very proud to be Italian. I love my country, of course. I was born in Italy and grew up in Italy, so my culture is Italian and my roots are very, very deep in Italy, even if I came to Paris in 1972. Last summer I did some work in my house by the sea in Ravenna and just under the kitchen floor they found some roots of the pine trees outside. And I said, 'Don't touch them! These are my roots!' Because this was the house where I was born. When my parents died I could not sell the house. I am a very nostalgic person. I was born in Ravenna, then I studied in Bologna, then I went to Venice for a year before coming to Paris. I had a very beautiful childhood and youth in Italy.

In the 1980s I met Martin Harrison, who was already writing about photography, and he told me, 'You know, your photographs look a lot like the images of the Madonna by Dante Gabriel Rossetti.' I said, 'You think so? You see something religious in my pictures?' He said, 'Absolutely'. And then a few weeks later I went back to my mother's house and I looked all around, and there were images of the Madonna all over the house! All the churches in Ravenna have that central figure. I said to myself, 'Oh, he's right. My pictures are coming from this iconography of my childhood.' So I am very Italian, I am deeply Italian, even if I have been here in Paris for 40 years. Every time I go back to my country, the language, the food, the scents, the colour of the sky – all this is very moving and very touching.

I came to Paris because I met Peter Knapp [the art director of French *Elle*] at a dinner. I went to dinner and brought a little box of my pictures. I won't forget the way that he took the pictures out of the box and put them on the floor, and on his knees he moved one here, another there, all around. I'd never seen anyone touch and move pictures like that before: suddenly, two pictures together became something else, and I would see something else in them. I was completely shocked – I'd never seen an art director move like that. He told me, 'Come to Paris, and you can assist me for a week.' So I came. That was 1972, and I'm still here.

The first Condé Nast magazine I worked for was *Lei*. I worked with Franca Sozzani, because at this time she was fashion editor of *Lei*. Flavio Lucchini was the director of Italian Condé Nast, and he created *L'Uomo Vogue* with Oliviero Toscani, who was working very closely with him at this time. Together they laid down the first stones for this first very important men's fashion magazine. And so I started with *Lei* and *L'Uomo Vogue*, and I arrived at *Vogue Italia* later.

Franca is very loyal and faithful, because we're still working together. We have a lot of respect for each other and a real friendship. Our careers have been in parallel, especially at *Vogue Italia*. All the Condé Nast magazines work with the same rules, the same formula and attitudes, but the spirit is very different, of course. Because I am deeply Italian, as soon as something comes through from Italy, for sure my heart is beating, even due to the fact that we speak the same language! I don't say *coiffure*, I say *la pettinature* and *facciamo i cappelli*; it's different. Certain words are different, and then the spirit is different.

The faithful ones to me have been British and Italian *Vogue* (see also pp.281–3); the others come and go, like everything in fashion. One day you are the best photographer, another day you are not the best. And then you are the best again. They kiss you, and then they don't kiss you, and then kiss you again . . . That's fashion, I know this very well. In Hollywood, they say that the value of the man is the value of his last movie. In fashion, you are the value of your last picture in a magazine. For a designer, it's his last collection. If a fashion designer makes two or three collections that are so-so, well . . . it's a *monde sans pitié* for everyone, in all these worlds that depend on the crowd, the taste of the critics. If a singer's last album is wrong, he has to do a much better album the next time.

We [photographers] are interpreters in a way; we are not writing the music, we play the music. So if I play with the Berlin Philharmonic it's not the same as playing with the orchestra of La Scala or the London Symphony. The sound is different, the theatre is different, everything is different. I never take the same pictures for every magazine for which I work. It's inspiring for me in a certain way, it pushes me in a certain direction, it's stimulating. *Vogue Italia*, for me, is inspiring. It's not even a question of freedom, because freedom, when you're talking about creativity, doesn't mean so much. It's a question of the right stimulation. Fashion is a world full of nuances. It's a mixture of mood, of look, of elegance, of faces – because the faces of the models change all the time, and you know why this season a model is a little bit out and a new one is arriving – and they bring something fresh and all the rest is less fresh. This is the same for the designer collections: there are a lot of nuances and you have to be *in it* to feel those nuances. If not, looking from outside, everything is the same. With fashion, it's better to stay home if you don't understand these nuances, the right mood, the right way.

With *Vogue*, we know already that we are at a certain level. We know the music. They know the music well. You are sure, when you work for *Vogue Italia*, that you are working with the top of the class.

And if you make a mistake, they correct you immediately. You trust them because you know you're in good hands, because they work with the best photographers, they have good taste and they have a lot of experience.

It's hard for me to say that I have favourite designers, because when I work for them they *are* my favourite. When you work directly for a designer, there is a very strong exchange, because the designer writes the music and then I have to play it. In the designer's mind is a certain woman, a dream of a woman, an ideal woman, and I have to create the image of this woman and not another one. It's difficult, the woman of Romeo Gigli is not the woman of Armani, the woman of Armani is not the woman of Versace. If I agree to work with him it's because I like him, I like his work and I think I can help him to find this woman, to make this dream become a reality, in a way. Well, it's not reality because it's a page in a magazine, but it's more concrete than just a dress on a hanger. It's like being an interpreter, so that everybody can hear the music.

4

Italian Menswear

The Return of the Courtier: Men and Menswear

Christopher Breward

page 178
Man in a grey suit on a bicycle, Milan. Photograph by Scott Schuman. *The Sartorialist,* 2011

Opposite
165 Marcello Mastroianni in *La Dolce Vita,* 1960

It has become something of a cliché in writing about Italian style to suggest that the cultivation of elegance is a national trait with roots stretching back to antiquity, but clichés are often representations of underlying truths. The assertion that men of Italian ancestry have held a special and highly exportable claim on the art of fine dressing has been made by succeeding authors and social commentators since the publication of Baldassare Castiglione's influential *Book of the Courtier* in 1528 (if not before), and continues to be reiterated with authority into the present. Castiglione's famous insistence on the importance of noblemen adopting a graceful nonchalance (*sprezzatura*) in all forms of public behavior, but most importantly in terms of speech, gesture and dress, is a dictum with as much relevance in the democratic, globalized Europe of the twenty-first century as in the competitive Italian courts of the fifteenth (pl.166). Ornella Kyra Pistilli affirmed this in her recent critique of the Italian fashion industry and the perception of its fall from grace:

> *Style makes an invisible grace visible. Style is a magic act. This is why it is so powerful. And this is why it is taken so seriously. 'Made in Italy' needs to rethink its style and to respond to the challenges of changes with research, creativity and innovation. It is time to come out of the superficial views of the dominant economic model, of the marketing offices, the logo obsession, and to return to the street – the source of sociality, lifestyle, taste . . . It is time to return to the street to listen to the deafening noise of codes and translate everything into design. Soon!* [1]

Street Style

The theatre of the street was certainly the space in which the tenets of a distinctive post-war Italian dandyism were first played out in the 1950s, when the modern Italian fashion industry was taking shape. As discussed in earlier chapters of this book, American financial support administered through the Marshall Plan of the late 1940s ensured that the struggling textile factories of the north had access to adequate capital and raw materials. As this process of political and economic reconstruction continued, Italian manufacturers and consumers also embraced an American idea of modernity, filtered through film, television and magazines, which promoted the positive aspects of a consumer lifestyle. A popular appetite for accessible luxury and new employment opportunities in the regions around Milan drew peasant workers from the south, and this movement of labour, expanding aspirations and sudden revolution in taste joined forces with the distinctively glamorous, sometimes decadent, values of elite Italian society to transform the cultural landscape of the country. It was a shift that affected both the macroeconomics of the fashion industry and the more intimate discourse of the fashionable male body.

Those small family firms of the Veneto and Emilia-Romagna, which made up a significant element of the Italian manufacturing sector (known as the Third Italy) alongside luxury tailoring and accessories companies including Brioni, Gucci, Gruppo Finanziario Tessile (GTF) and Ermenegildo Zegna, found themselves in a prime position. Their traditional promotion of exquisite craftsmanship, together with a willingness to adapt to the new context of mass marketing and innovation, meant they were well placed to meet the challenges of rapidly shifting consumer demands. An ensuing domestic boom coincided with the highly favourable reception of Italian goods, images and ideas in the rest of Europe and the United States. Alongside textiles and clothing, Italian-made food and drink, domestic utensils, office

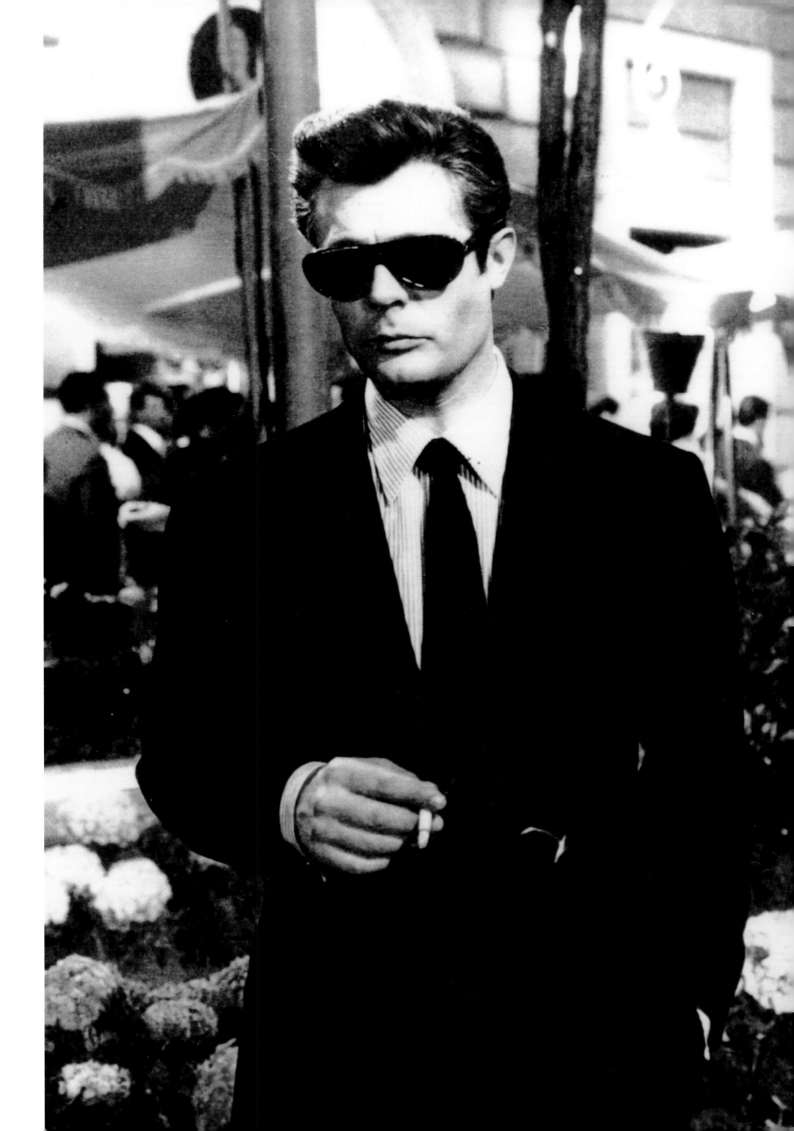

equipment, furniture and automobiles were universally celebrated for their sharp styling, high quality, beautiful materials and urbanity. This was a virtual domination of the world of fine things that, aside from a blip caused by the international oil crisis of the mid-1970s, would continue through to the 1990s, when competition from China and successive political and economic crises would push the 'Made in Italy' miracle into crisis. Underpinning all of it, at least as far as the development of menswear was concerned, was a sophisticated understanding by designers and consumers of the fluxive social meaning of fashion, its relationship to shifting questions of distinction and identity and its progressive ability to perform change. Curator and critic Germano Celant suggests as much in his perceptive essay on Giorgio Armani:

> *Fashion could not continue to affirm a social and economic split that at that time appeared quite visibly in its absolutizing differentiation, as witnessed in the films of that decade, from the garments of Roberto Capucci and Emilio Schuberth worn by the clerical and papal nobility in . . . Fellini's* La Dolce Vita *(1960), to the monochrome black of the upper bourgeoisie of Michelangelo Antonioni's* L'Avventura *(1960), to the motley and haphazard look of the proletarian class in Pasolini's* Accattone *(1961). Rather, fashion had to dissolve the distinctions, to reinvent clothing with a signic function that would become a surrogate identity.[2]*

The film director Pier Paolo Pasolini's literary and cinematic work, most particularly his tender observations of the look and attitude of those displaced and hungry southern youths who had come seeking work in the northern cities in the 1950s and early 1960s, is especially evocative in its description

of the fractious evolution of new, distinctive and influential forms of fashionable masculinity in the streetscapes of a modernizing Italy (pls 171–2). Literary theorist Paola Colaiacomo is precise in her description of Pasolini's creative method, where 'the attention goes to the grain of the garment, its material and cut: a whole garment-world where levels of memory and desire hide and merge. On the one hand the body is seen to strain the garment outwards, and stretch it almost to an extreme . . . On the other there is all the irrepressible flaunting of alterity in the new fetishes applied obsessively to the body in every possible way.'[3] In stories published between 1953 and 1975, Pasolini constantly returned to the electrifying modernity and underlying violence of the proletarian Italian wardrobe. His words and images marked the emergence of an antithetical courtly style, where a constant tension between American novelty and traditional values produced a bold and eroticized version of glamour that hovered between vulgarity and elegance, honed in a pointed shoe, a tight, bright white shirt, experimental hues and the ubiquitous blue jeans or flashy ready-made two-piece suit:

> *And then those clothes: those sickening clothes, tied to the financial possibilities of the famous Fifties, bought according to taste, a little plebeian, exactly the style of those years: a sportscoat found in a ready-to-wear shop. Of a strange little colour, a little rust and a little orange, the shirt collar open, it too bought ready made, in a little shop in the centre of town; the trousers sagging slightly . . . worn and a little short; the shoes eaten up on the outside by the heels, like one who walks a little ape-like; and especially those short, horrible socks, with those little red dots, stretched by elastic a little over his ankles.[4]*

The V&A's collections hold a number of items from the 1960s and early 1970s by tailors including Carlo Palazzi and Bruno Piattelli, which although produced for a bourgeois market display some of the stylistic verve that Pasolini describes in his homage to proletarian narcissism: a suit where the loud herringbone tweed pattern is a printed simulacrum in cotton and a boxy sports jacket in burnt umber tones (pls 169 and 170). Their brash confidence would continue to exist as a characteristic trait of mainstream Italian menswear for the remainder of the twentieth century, evoking both the new opportunities of modernity and more traditional memories of Latinate ostentation and machismo. But by the mid-1970s other, more radical interpretations of fashionable masculinities were beginning to emerge.

North and South

The emerging iconography of post-war Italian menswear developed within, and was synonymous with, the context of a radical restructuring of Italian society. The fruits of pan-European political activism in the late 1960s, a loosening of the tight hold on social mores traditionally enjoyed by the Catholic Church, widening access to education and

employment as well as rising standards of living caused by the 'second economic miracle' had pushed Italy beyond its agrarian, feudal past to a present that found its meaning in a collective lifestyle dream. Nowhere were the effects of this new modernity more evident than in the cosmopolitan shopping streets, exhibition halls and design studios of Milan, the boutiques, restaurants and clubs of Rome, the beach playgrounds and villas of the Amalfi coast and Sicily, and the glossily voyeuristic pages of paparazzi-fuelled celebrity magazines including *Oggi*, *Epoca* and latterly *L'Uomo Vogue*. Through all of them the graceful figure of the new Italian courtier carved an elegant arc, but the ghosts of older versions remained present.

As fashion historian Valerie Steele has remarked in her characterization of the resulting Italian 'look', a tension has persisted between two opposing stylistic paradigms. The first favours an overblown, operatic celebration of life's pleasures and tragedies. It is a fiery, carnivalesque tradition, infused with a kitsch nostalgia, rooted in the emotional psyche of the south and redolent of Pasolini's vagabonds and gigolos. The second takes refuge in the cooler refinement of an almost monastic simplicity. It favours the more abstract, anti-historicist pursuit of luxury for its own sake, restricts its influences to a philosophically informed, minimalist aesthetic and draws its antecedents from the craft traditions of the northern tailor.[5] Intriguingly, Colaiacomo posits the idea of rags as the textile metaphor that links both paradigms and points towards the conceptualization of Italian fashion idioms in the 1980s:

As a type of clothing, rags belong to the world of the outlying borgate . . . In these districts, rags not only come into their own, but are forced to take sides. They mark both the final point of the evolution of textiles, and the steps in a very precise hierarchy. [As Pasolini notes:] 'The smell of

168 An Italian café terrace.
Photograph by Jean-Philippe
Charbonnier, c.1950

Opposite left
169 Bruno Piattelli, tan wool jacket
and white trousers with cotton shirt
and green woven silk tie, c.1968
V&A: T.222, A, B, C, D, E–1984

Opposite right
170 Carlo Palazzi, houndstooth
printed cotton jacket (detail), 1970
V&A: T.110–1985

tobacco, of clothes not changed for months (the same hard, caked trousers, which have taken on the shape of knees and the crotch, where they are worn and whiteish; they contain warmth, but at the same time a chill) . . .' Ten more years will pass, while evolution prepares its next move. It will then be fashion which sends cast-offs, ethnic and exotic clothing from heaven: a cloud of 'soft, gentle rags', openly desirable and desired by all.[6]

Giorgio Armani's career has clearly followed the 'northern' route, and he has perhaps done most to refine and disseminate a reconfigured understanding of the modern Italian courtier in an international context (pl.175). Crossing disciplines from an education in medicine, Armani first worked in the fashion industry as a menswear buyer for the Milanese department store La Rinascente, housed in an austerely authoritarian Novecento-style building of the late 1920s in the Piazza del Duomo. The store's enlightened retailing policy embraced the new spirit of Italian design, reflecting the increasing affluence and discerning attitudes of its customers. In 1953, just before Armani started working there, the store had hosted the exhibition *The Aesthetic of the Product*, showcasing innovation in domestic goods.

This was followed by the store sponsoring an annual prize, the *Compasso d'Oro*, for the best Italian design of the year. Clearly inspired by the progressive strategies of his employer, Armani branched out from buying, working as a designer for the Cerruti group in the 1960s before establishing his own label in 1974.

Highly conscious of the commercial need to accommodate as broad a segment of the consuming public as possible, Armani developed a quietly unobtrusive sartorial register that sat well in terms of a courtly insistence on a graceful persona. It also allowed him to market his brand internationally on a scale undreamt of by his predecessors. It entered the United States in 1980 and later that decade diversified to a younger, unisex clientele via the jeans and sportswear-based Emporio Armani line. But to emphasize the business acumen of Armani at the expense of his impact on the development of the aesthetics of male dress would be distorting. His disarming practicality belied an attention to function, form and finish that revolutionized the direction of fashion from the mid-1980s onwards. He famously eviscerated the structure of the formal business suit, sloping the shoulders, freeing the stiffened lining in the jacket's interior,

lowering the buttons and lapels and adopting fabrics that were lighter in weight, texture and colour. It was as if the traces of modernity present in the American Ivy league sack suit of the late 1950s and the rags of a common memory of post-war deprivation and aspiration in Italy had blurred, producing a new, more timely elegance, deftly identified by Celant:

> *Armani understood that clothing was . . . part of the everyday management of one's appearance, a tool of personal symbology: 'When I began to design, men all dressed in the same way. American industry called the shots, with its technicians scattered all over the world . . . all impeccably equal, equally impeccable . . . They had no defects. But I liked defect. I wanted to personalize the jacket, to make it more closely attuned to its wearer. How? By removing the structure. Making it into a sort of second skin.'*[7]

Armani's invention of a second skin signalled the introduction of a new sense of femininity in the presentation of Italian men's clothing that was profoundly radicalizing; an abandonment, in the spirit of *sprezzatura*, to its tactile qualities, its soft, caressing feel on the body. At the same time the puritanical hold on a subtly differentiated framework of restrained tones, textures and shades, and a deliberate contrast with the hard surfaces of the muscular 1980s torso produced a frisson that Armani had begun to explore in his designs for Julian, the lead character played by Richard Gere in Paul Schrader's film *American Gigolo* at the opening of the decade. In the famous dressing scene (also described by Stella Bruzzi in this book, see p.162), Julian's playful toilette anticipates a new male narcissism that was to become the signature of Italianate fashionability by the decade's close:

> *He avails himself of a form of expression and a mask capable of mimicking – like his clothes and outer layer – the desire and pleasure of the other person. He thus avoids vulgarity and spectacle, dissolving the impetus and perfection of his limitlessly available body in the suppleness of the materials and colours that liberate its sensual form, but grant him, in their uniformity and measure, a triumphant innocence.*[8]

Such innocent triumphalism should not, however, be taken as evidence that a more overtly theatrical engagement with the bacchanalian spirit of 'southern' sensibilities had been stifled. Other designers of Armani's generation produced ideas and collections that made very different play with the figure of the modern Italian courtier, creating versions that were in turn more libidinous, sensual and brashly glamorous. Walter Albini was one: steeped in the cinematic traditions of 1930s and '40s Hollywood that had informed his childhood dreams, he excelled in fashion illustration, textile and interior design and began producing exotically themed womenswear for a number of Italian companies and boutiques in 1964. From then until the early 1980s (Albini died in 1983, at the age of 42), his technically brilliant experiments with sinuous unisex and cartoon-like menswear collections were highpoints of the Milanese fashion season, sharing much in common with the exuberantly camp but always chic aesthetic employed by contemporaries elsewhere in Europe, among them Yves Saint Laurent and Ossie Clark (pl.173). Albini's heyday was perhaps the mid-1970s, when his deliberately nostalgic take on the 'Latin Lover' Riviera style of the 1920s was the quintessence of international good taste. As *Time* magazine recorded in the spring of 1973:

171 Pier Paolo Pasolini, Rome, 1970

172 Poster for Pier Paolo Pasolini's
film *Accattone*, 1961

Opposite
173 Walter Albini. Photograph
by Barry McKinley. *Linea Italiana*,
Autumn/Winter 1972

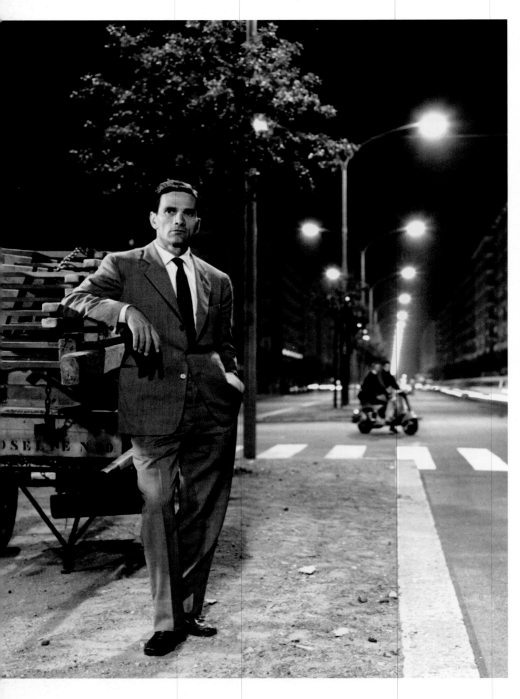

Opposite
174 British actor and comedian Peter Sellers arrives at London's Heathrow Airport accompanied by Australian model Miranda Quarry, carrying Gucci bags, 1970

175 Giorgio Armani, Spring/Summer 2009, Photograph by Mert Alas and Marcus Piggott

Opposite
176 Gianni Versace, Spring/Summer 1993. Photograph by Doug Ordway

Below left
177 Gianni Versace, *L'Uomo Vogue* promotional supplement, Spring/Summer 1985

Below right
178 Gianni Versace, men's day ensemble, Spring/Summer 1985
V&A: T.317, A, B, C, E–1985

For many designers and their customers, the 'In' echo is of the '20s . . . French magazines are calling it le style tennis *or the Deauville look. But it might just as easily be described as the Newport-to-Palm Beach mood . . . Polo, tennis and golf – not as they were played but as they were watched – are central to the sporting-set concept . . . The idea is elegance – a calculatedly casual, languid elegance, suggesting an evanescent Fitzgerald memory of the summer of '22. 'To want to walk out on the lawn wearing a white silk shirt and white flannels presents a very rich dream-like atmosphere,' says New York designer Ralph Lauren . . . Milan's Walter Albini, who might be called the Godfather of the Italian Gatsby look, has drawn on the Fitzgerald era since he first started designing ten years ago. 'It was a cultural high-water mark in fashion, decorating, literature, painting,' he contends. 'Actually, nobody has done anything new since. . .' [9]*

Alongside Armani, Gianni Versace would prove the exception to Albini's claims of creative stasis, offering an exciting and entirely innovative contribution to the evolution of Italian menswear in the last quarter of the twentieth century. His unique skill lay in his ability to translate the material outcomes of Italy's cultural and economic transformation so that they met the more diffuse desires of an international market, but in an idiom radically different to Armani's transcendental modernism. Trained as an architect in his native southern Italy but raised as a tailor in the

domestic context of his mother's dressmaking business, Versace developed an early and useful knowledge of broader European fashion trends through his role as a buyer for the family firm in Paris and London in the late 1960s. Before establishing his own eponymous business in 1978, Versace worked as a designer for several of the small Milanese companies whose rising fortunes were also changing the profile of the city.[10] His own journey from an artisanal background in the south to the sophisticated ambience of the north was one that had been shared by many of his compatriots, and there is something autobiographical in his mature work that paid passionate homage both to the idea of traditional roots in the sensual primitivism of an older way of life and the promise of worldly success inherent in the consumerist, market-driven tenets of the modern world; a luxurious materialism that was entirely unapologetic and owed much to courtly traditions of 'magnificence'.[11]

Through the 1980s and '90s Versace pioneered a distinctively voluptuous signature style for men and women, which utilized extraordinarily rich fabrics and often aimed to emphasize the sexuality or social power of the wearer (pls 176–8). Running alongside commissions for opera and ballet costumes from La Scala and director/choreographer Maurice Béjart, his designs embraced a vivid theatricality and sense of occasion and were readily adopted by those in the film, sport and culture industries whose professional

responsibilities demanded prominent public exposure (Sir Roy Strong, director of the V&A from 1973 until 1987, was an enthusiastic patron of Versace's work). From the clinging sinuosity of the metallic fabrics and sculpted leather employed in his collections in the early 1980s to the opulent Mannerist prints and glittering accessories that signalled glamour and expense in the 1990s, Versace's output made deliberate play with the overlapping categories of beauty and vulgarity. Under the aggressive business control of Gianni's brother Santo, the brand also functioned on two complementary levels. It came to be regarded as the chosen uniform of the new super-rich, retailed at prohibitive prices in spectacular boutiques at the world's most exclusive locations; while through the wider marketing of fragrances, diffusion lines and, from 1993 onwards, home furnishings, Versace also formed the paradoxical symbol of a more popular celebration of success, crystallized in the emergence of the ubiquitous celebrity culture.

In the trademark of the Medusa's head, which Gianni Versace adopted as his crest, the designer signalled his understanding of the sublime propensity of fashion to shock and horrify, but most importantly to awe the consumer into submission. The careful orchestration of his own life and product offered a perfect template of uncontested distinction. Versace's personal tastes and desires were photographed for a succession of promotional books and advertising campaigns that hymned the lush surfaces of his several palaces as though they were sets for a Visconti movie,

and lovingly described the bronzed bodies of his princely coterie (often depicted naked, but for the coy draping of a Versace towel or tie). The imagery was deliberately intoxicating in its all-enveloping, sensual appeal, and left little room for subversion or alternative choices on the part of his intended audiences.

The commercial clout of an organization that was enjoying a phenomenal turnover of £600 million and profits of £60 million in 1996 also had the effect of stifling dissent in the fashion media, ensuring maximum press coverage and adulation. But Versace's vision was, according to some critics, ultimately empty of any deeper meaning and quite terrifying in its aesthetic predictability – a veritable pornography of fashion, whose values seemed to bring it too close to that other cliché of Italian masculinity, the Mafiosi. The mythic status of the brand was only strengthened in 1997, when a celebrity-obsessed psychopath murdered the designer on the steps of his Miami mansion. True to the family traditions in which the brand had been built, his legacy was taken up by his sister and muse Donatella, who continued to purvey the compelling Versace version of courtly glamour to twenty-first century consumers with characteristic verve.

Playboys and Courtiers
Something of the ebullient spirit of Versace can also be found persisting in the present decade through the enduring stereotype of the Italian playboy and his taste for the good things. It has certainly been a continuing and defining characteristic of more

Opposite left
179 Tom Ford for Gucci, silk velvet
evening suit, Autumn/Winter 2004
V&A: T.7.1-13–2005

Opposite right
180 Dolce & Gabbana, men's
ensemble of cotton velvet
waistcoat and trousers with
wool overcoat, *c.*1991
V&A: T.52:1–4–2011

established brands, including the luxury sportswear
and accessories retailer Gucci from 1945 until today
(pl.174). As journalist Karin Nelson recalls:

> *Celebrities and aristocrats, in the spirit of post-war
> liberation, filled Gucci's shop on via Condotti . . . gentlemen
> like the actor Gigi Rizzi, whose most enduring legacy was
> the women he wooed (Brigitte Bardot, Veruschka), and
> Walter Chiari, who had an affair with Ava Gardner while
> she was still married to Frank Sinatra. Handsome, well
> travelled, sexually irresistible and impeccably turned out,
> these sorts of fellows would come to represent not just a
> masculine ideal, but an archetype of the Gucci male . . .
> The beauty of playboys is that they never get old; rather
> they are perpetually seductive.[12]*

The ageless and seductive beauty of the Italian
playboy was perhaps a guiding inspiration for
American designer Tom Ford, who was taken on by
Gucci as a womenswear designer in 1990. At this
point, the company was struggling financially and
beset with scandal, but Ford rose swiftly through its
ranks, becoming design director in 1992 and creative
director in 1994, with ultimate responsibility for the
entire product range and public image of the company.
From then until his departure in 2004, Ford 'was
able to return the brand to the worldly prominence
of its golden age, evoking memories of luxury and
the jet-set lifestyle'.[13] The signature components of
the Ford/Gucci look, culled from the experiences
of a youth misspent in Studio 54 and a libidinous
catalogue of sharp tailoring, lizard-skin loafers, velvet
smoking jackets, tightly caressing knitwear, silk-
jacquard ascots and amber-tinted aviator sunglasses
that directly referenced a half-century of *sprezzatura*,
mark something close to the apotheosis of an Italianate
masculine style that has become truly global (pl.179).

Similar appropriations of courtliness can be
found in the trademark stylistic signatures of other
Italian mega-brands that came to prominence in the
1990s, including Miuccia Prada's reinvention of the
luxury leather-goods factory founded in Milan by her
grandfather in 1913. From 1989, the introduction of
ready-to-wear and sportswear lines brought Prada to
the attention of a wealthy, metropolitan international
market whose interest in art/fashion collaborations,
experimentalism and intellectual purity was well suited
to Miuccia Prada's interest in promoting her vision in
the context of an aesthetic and philosophical avant-
gardism that was distinctly Italian in its subtlety. The
work of Domenico Dolce and Stefano Gabbana, who
produced their first womenswear collection in 1986,
with menswear following in 1990, has been closer in
spirit perhaps to that visceral but almost elegiac quality
of Sicilian passion (captured in Luchino Visconti's
1963 film of Lampedusa's novel *The Leopard*) that also
inspired Versace. Tight white vests, gigolo suits, peasant
caps and the brazen celebration of lusty homoeroticism
that characterizes their infamous perfume and
underwear campaigns could never be described as
'subtle', but Dolce & Gabbana's nostalgia for a long-

lost Italian idyll is undoubtedly imbued with a powerful
sense of pride in a romantic national heritage (pl.180).

A younger generation of Italian menswear
designers, in common with their peers in Antwerp,
Berlin and east London, have perhaps been less ready to
accept the inheritance of their commercially successful
forbears, opting instead for a more collaborative,
connected, interdisciplinary and socially responsive
version of creativity, which is antithetical to the
lifestyle concepts that were dominant in the 1990s. For
example, Fabio Quaranta, who was born in Rome in
1977, presents his vision in a more challenging and
oppositional idiom than that employed by his elders. His
collections are marked by an enjoyment in textural and
stylistic juxtaposition that is also evident in his profile on
the Fondazione Pitti Discovery website:

> *Astigmatic and left-handed, Fabio Quaranta had his first
> encounter with fashion when he planned a vinyl covering for
> an all-star sneaker. At the same time he created his own label,
> FQR for men's ready to wear and developed artistic projects
> for Motel Salieri, a workshop where he invites creatives from
> all over the world to promote their work. Mr Quaranta's
> concept of fashion is linked to the idea of feeling good and at
> ease inside the clothes you wear. He loves uniforms in general
> and Enzo Cucchi's style. His icons include Syd Barrett,
> Daniel Johnston, Gianni Colosimo, Will Oldham, Aleister
> Crowley and Carlo Benvenuto.[14]*

As impossible to pin down as Castiglione's recipe
for courtliness and clearly at a moment of redefinition
if Quaranta's refreshing reassessment means anything,
the evolving nature of Italian menswear over the
previous 65 years has nevertheless left its distinctive
imprint on the self-presentation of sartorially aware
men everywhere. The final word on the matter is
perhaps best left to an Italian, although it seems that,
as far as masculine style is concerned, according to
Luigi Settembrini we are all Italians now:

> *But instead of Italian creativity, what if we were to speak
> of flair and eclecticism? That is, of the capacity to link
> and integrate different combinations in an original approach
> (this being a fundamental component of Italy, of Italian
> culture, Italian art, and Italian history. . .)? What if we
> were to talk about something inherent that predisposes Italy
> and the Italians to the harmony of many voices, the art of
> juxtaposition, great mental flexibility and curiosity about
> what is new, and a certain intellectual restlessness united
> with a healthy scepticism toward excessively complete systems.
> Something therefore that is very close to the post-everything and
> pre-nothing sensibility of this turn of the millennium, and to
> the words with which Italo Calvino concludes the last of his
> Six Memos . . . 'Who are we, who is each of us, if not a
> combination of experiences, information, books we have read,
> things imagined? Each life is an encyclopedia, a library, an
> inventory of objects, a series of styles, and everything can be
> constantly shuffled and reordered in every way conceivable.[15]*

Christopher Breward is Principal, Edinburgh College of Art and Vice Principal,
Creative Industries & Performing Arts, University of Edinburgh

'In the Things That Go Over Other Things'

Alistair O'Neill

The first appearance of Italian menswear in a promotional fashion show is in the unlikely guise of a male escort. Organized by Giovanni Battista Giorgini at his home, the Villa Torrigiani in Florence in February 1951, Italy's first internationally attended fashion show was staged over three days. The first day offered a static display of women's daywear, including sportswear and accessories; the second was a day of rest; and the third involved a cocktail party and a grand ball, with a fashion show of women's eveningwear programmed between the two.

For the second show of 1951, which took place at Florence's Grand Hotel, Giorgini decided that the models presenting the women's evening wear would be accompanied by men, so that the staging of the fashion show would mirror the guests gathered in anticipation of the ball. For the third show, held in January 1952, Giorgini invited the Roman tailoring firm Brioni to dress the men escorting the models in their latest evening wear designs. To the invited audience, this was the first sighting of Italian fashion for men, promoted as a regional craft and, in part, an exportable product. But for the show, these clothes still functioned as an accompaniment to the *alta moda* womenswear designs.

While Italian fashion for women was promoted in acknowledgement of the resurrection of haute couture in Paris, Italian tailoring for men remained indebted to the traditions and style of English bespoke suits. Brioni sought to challenge this deference through the use of unexpected fabrics. In menswear, silk is traditionally used as a lining fabric for suits or for ties, but Brioni introduced a tuxedo with black shantung silk used as the outer fabric. The tailors thought the shantung's slubby weave and irregular, slightly matt surface conveyed an appropriate sense of masculinity. This is one of the earliest examples of a garment exported for sale as an off-the-peg item in American department stores (offered with a further alterations service) or advertised as 'Made to order from Rome'.

American *Vogue* reported on these new Italian imports in May 1953 as 'Sports Clothes (m. and f.) Designed in Italy', maintaining the idea of showing designs for men and women side by side, but in this instance stressing their casual and sportif nature (pl.182). Staff photographer Henry Clarke shot the clothes in Esposizione Universale Roma, the area of south-west Rome that was developed for the World's Fair of 1942 but abandoned due to the war. In the pages of the magazine, the fascist architecture is reconfigured as a backdrop for leisure time, where young men and women wear clothes that speak of a different kind of confidence: 'It was Italy that made popular the silk suit for men; the Roman sandal, black for the beach, sweaters more tonic than basic.'[1]

The pages feature a Brioni sports jacket made to order 'of that wonderful lightweight Italian raw silk, in Prince of Wales plaid in varied tones of grey' and a sports shirt 'as intensively tailored as a tunic – in a new silk fabric called Shantung-Fiammato'.[2] While clearly citing Brioni's innovative use of silk, the *Vogue* article concentrates on the fabric's deployment in casual clothing. Indeed, it is arguable that the enduring features of Italian menswear lie not in the list of achievements at the start of the article, but in the clothes the magazine chose to feature: noticeably tailored separates made from lightweight fabrics of natural fibres, often reinterpreting classic English cloths with a softer handle.

Many tailors felt the need to question and value what Italian menswear stood for in the post-war era; they believed that clothing was a means of shaping

181 Brioni suit modelled by
Angelo Vitucci, 1950s

182 'Sports Clothes (m. and f),
Designed in Italy', American *Vogue*,
May 1953

Opposite
183 Italian Trade Commission
promotion in the trade journal
Men's Wear, 25 September 1954

a modern identity for men in post-fascist Italy, while maintaining a national design style distinct from European competitors. Although Italy's *Risorgimento* took place in 1861, the country still remained proud of its regional traditions. The Roman style of tailoring is the most formal of styles, but it is also recognized for its invention. This style is typified by the work of Agostino Caraceni, who traded in Rome and Paris, and Nazareno Fonticoli, master cutter at Brioni. Fonticoli was also a founder member of the revived *Accademia nazionale dei Sartori* (Italian Academy of Tailors), originally established in Rome in 1575 by Pope Gregorius XIII and re-established in 1948. Neapolitan tailoring offers a jacket with a high-cut armhole and a wide sleeve for ease of movement, with a form constructed with minimal padding. The firms of Mariano Rubinacci and Cesare Attolini are central to this soft style of suit, described by Attolini as being 'like cardigan sweaters, not armour'.[3] (For a case study on tailoring by Glenn Adamson, see p. 218–19.) There is also a Milanese tradition, sober in form and similar to the English model.

However, many of these regional variations of Italian tailoring were less clearly perceived at the international level. In 1952, the World Federation of Master Tailors, founded in 1910, decided to stage their first international men's fashion show as part of their International Tailoring Congress in Scheveningen, in the Netherlands. 'An Italian dinner suit made up in black shantung was enthusiastically

applauded,' a reporter for the British tailoring trade journal, *Tailor and Cutter*, wrote. 'This was again very well modelled by the wearer – although the appearance was distinctly American in its loose effect.'[4] While stating that the suit was Italian in origin, this comment is symptomatic of British and American reporting on tailoring from western Europe at this time, tending to measure garments against their own styles and often labelling their difference as 'Continental' (pl.183).

To counter this tendency, that same year Italian tailors established the Maestrelli Foundation, which met annually to decide the basic principles of style to which its members would adhere. Although it was eventually wound up in the 1970s, The Foundation offered a broader platform for the promotion of Italian tailoring, less focused on Roman principles, as advocated by the Academy of Tailors. In 1954, the Maestrelli Foundation organized a festival in San Remo, where we find evidence of the shorter length of straight jacket and tapered, cuffless trouser that would establish the Italian style. The festival followed on from the 1954 International Tailoring Congress held in Rome, where delegates were specially invited for an audience with Pope Pius XII, who argued that the tailor's craft must escape mechanisation to maintain its 'aesthetic nature' and 'spiritual value':

*No doubt it is also essential to ensure an intensive
production to comply with the daily requirements of the*

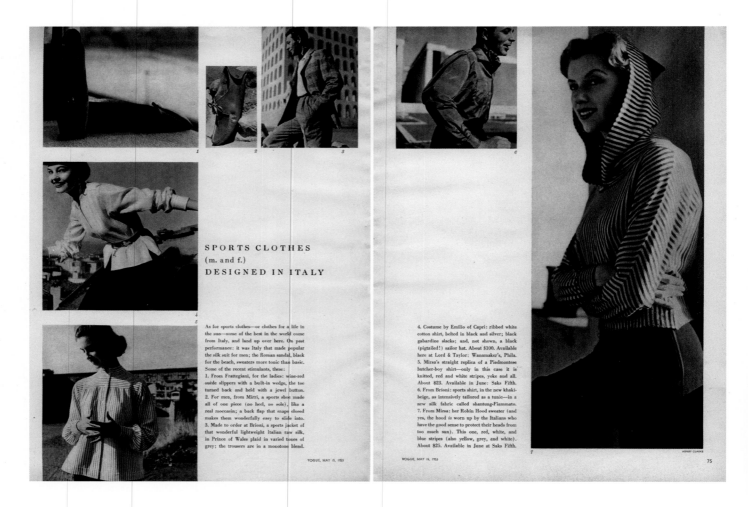

SPORTS CLOTHES
(m. and f.)
DESIGNED IN ITALY

masses, but the place of honour will always be for the individual production, that in which the craftsman takes the maximum advantage of the quality of the cloth used and employs all his resources to materialize the model which his mind had conceived.[5]

For a country in the midst of economic reconstruction, this message must have seemed contrary, but it unwittingly offered a model for informing intensive clothing production with the knowledge of individual production, as the observance of religious doctrine in an increasingly secular society. The kinds of clothes made as a result of this approach, especially in the papal city, conveyed the essence of what would later be termed *La Dolce Vita*.

By September 1955, *The New York Times* ran an article entitled 'A Designer Out of Italy Offers New Look to Men', confirming the arrival of men's fashion shown on the same seasonal basis as womenswear. The article showcased the arrival of Fonticoli's business partner Gaetano Savini in New York, on the first leg of a trunk show around the United States to promote Brioni's 'Columnar Look':

The Italian's new cut might be considered a post-graduate version of the 'Ivy Leaguer' because it is still tall and slim in concept. However, it adds width to the shoulders, breadth to the chest and length to the jacket – all in moderate proportions. Trousers are still narrow, tapered and cuffless.[6]

In this collection, Brioni unveiled much of what would come to define the Italian look in tailoring, with the exception of the length of the jacket. What distinguished the look from its American counterpart was the tactile handle and luxurious drape of the cloth, articulating a softened structure and a trim silhouette that followed the body to delineate a clean, modern line. Dress historian Farid Chenoune has noted that this style of tailoring 'constituted a refined distillation of American easygoingness',[7] particularly noticeable in the way the tailored trouser, when worn without a jacket, conveyed the swagger of the blue jean. Reflecting at the turn of the 1960s on the influence of Italian tailoring on men's clothing, Savini identified three principles:

First, the deliberate elimination of anything unnecessary to the true line of the garment. The shoulder padding, and the dreadful dust-collecting turn-up on the trouser! Secondly, the discovery that lightweight fabrics can have the same body as heavy, bulky materials. Thirdly, that men have realized how important it is for them to dress well. Dressing properly in a classic, simple style can affect their whole life; the impression they make in their job, on their girl friends![8]

Savini's principles were not innovated by Brioni alone, but by a collective sense of tailoring emerging from the districts of Italy specializing in textile and clothing production. Between 1958 and 1963, Italy's economic miracle rose to new levels of productivity

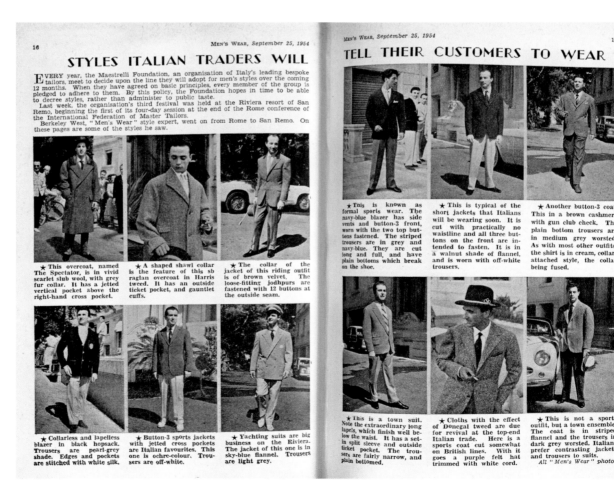

184 Italian Trade Commission promotion in the trade journal *Men's Wear*, 1964

Opposite above
185 Missoni, wool and acrylic machine-knitted cardigan, Autumn/Winter 1971
V&A: T.1087–2000

Opposite below
186 Walter Albini, total look for *Milano Moda* supplement to *Vogue Italia*, 1975

in manufacturing, creating a form of disposable wealth for the nation that prompted the advent of mass consumerism. Over these years, Italians not only promoted themselves as progressive modern subjects, but also sold this idea in commodified form through exports. In men's clothing, the archetypal garment that signalled this sense of modernity was knitwear.

As early as the 1920s, the knitwear company Avon Celli in Milan had produced an undershirt with a knitted collar – a proto-garment of what we recognize today as a three-button knit polo shirt. Knitted in either wool or cotton, it was soft and easy to wear but crucially, it maintained the formal appearance of a woven shirt. Avon Celli started exporting these garments to the United States and Europe in the late 1950s.

In 1960s London, the Italian Trade Centre on Old Burlington Street was responsible for staging a number of exhibitions of Italian knitwear manufacturers keen to expand into the British market. By 1963, Italy's total exports of knitwear had exceeded £52 million, of which roughly a quarter was for the American market.[9] In broader terms, in the first half of the 1960s the Italian ready-to-wear industry was growing at an average rate of 20 per cent, which was matched by the rate of increase in export. By 1965 Italian knitwear exports totalled £280 million, accounting for roughly one third of the country's total textile industry output.[10]

In 1964 the Italian Institute of Foreign Trade organized a special supplement in the British tailoring and ready-to-wear trade journal *Men's Wear* (pl.184). The photographs were shot in Portmeirion, the tourist village built in North Wales by Sir Clough Williams-Ellis, inspired by the architecture of southern Italy.

Examples of imported Italian menswear, such as a fedora hat by Borsalino, a tab-collared shirt by Pancaldi, a Prince of Wales check suit by d'Avenzaor, a knit polo shirt from Caravel, produce the kind of sartorial attitude that in a few years' time would feature in the British television programme *The Prisoner* (1967), filmed in the same location.

The *Men's Wear* supplement includes a useful account of perceptions of Italian manufacture and standards of workmanship at the time. According to the magazine, 'the cleanness of finish, coupled with the Italians' capacity to marry adventurous design and conservative, classic line, guarantee them an increasing popularity in Britain.'[11] It notes that the Italians favour high-quality natural fibres, such as botany wool, over synthetic yarns and pay close attention to the consistency of finishing in fully-fashioned garments. The article makes a virtue of the close connection in Italy between the know-how of machine knitting and the implementation of automated production, effecting a reduction in price point but not in quality: 'These aptitudes are aided by the structure of the domestic knitwear industry, which, consisting primarily of small, family concerns, with perhaps 30 to 50 employees, is well equipped to tackle short, high fashion runs uneconomical for the larger type of concern which we are familiar with here.'

This production model offers a high degree of flexibility in responding to limited and varied orders, ideally suited to the novelty of the fashion market, and it remains an important part of the Italian knitwear industry even today. The success of Missoni, based near Milan, is predicated on this model of production.

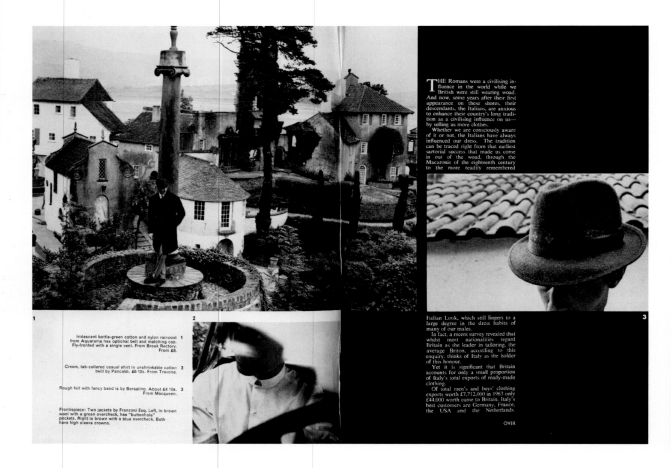

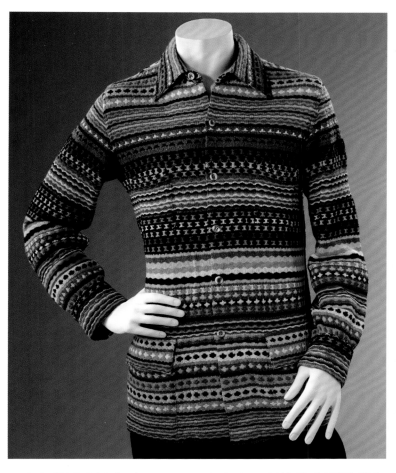

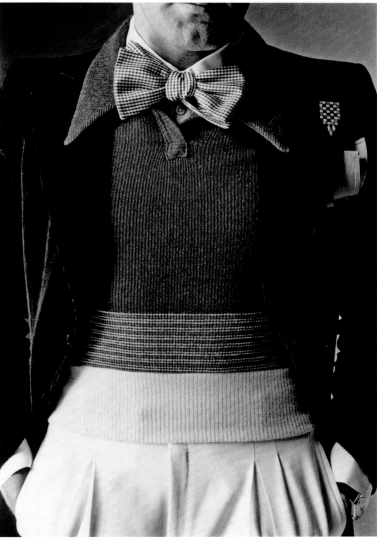

Ottavio and Rosita Missoni applied Bauhaus-informed ideas and an unrestrained sense of colour to complex knitwear designs, translated for industrial production but retaining the look and feel of hand-knitted garments. With their casual shapes, the sweaters and cardigans offered a look of refined sportswear for men that was widely influential in the 1970s (pl.185). In 1973, the Venetian countess Anna Bozza Camerana spoke to *Women's Wear Daily* about her Missoni wardrobe: 'Recently, I especially like men's shirts and sweaters which I wear with my blue jeans. I used to wear more evening dresses from Missoni; now I prefer the men's wool shirts.'[12]

By the 1970s, the emphasis placed on Florence and Rome as centres of fashion retracted from the pull of the industrial north. Already established as a centre for product design and the home of the Triennale trade fair, Milan was also the home of Italian publishing (*Vogue Italia* was launched there in 1963) and a broad range of media-based industries. The city's proximity to the textile mills of northern Italy made it advantageous for them to sponsor clothing manufacturers who chose to showcase their collections in Milan, which quickly established a local culture of ready-to-wear rather than *alta moda* or bespoke, defined by an industrial aesthetic.

The individual who typifies this transformation, as has already been mentioned by other authors in this book, is Walter Albini. For a *Milano Moda* supplement to *Vogue Italia* published in 1975, Albini was photographed as both designer and model of his total menswear look, sporting wide double-pleated white trousers with a matching shirt, fine gingham bow tie and a colourful rib jumper with extended collars worn over an accessorized needlecord jacket (pl.186). Once again, the look stresses the centrality of knitwear in men's fashion – in this instance the reference is in relation to knitted sporting costumes of the 1930s, the period to which Albini owed the greatest debt; although it is soon eclipsed by the next style of Milanese menswear, principally attributed to the designs of Giorgio Armani.

After designing for Nino Cerruti's ready-to-wear label Hitman in the late 1960s, Armani freelanced for the likes of Ungaro and Ermenegildo Zegna before setting up his own company with his partner Sergio Galeotti in 1974. Armani first became known for offering an unconstructed jacket, with no padding and sometimes without even a lining. The label's style was characterized by a relaxed silhouette and a layered look with an emphasis on woollen fabrics, knitted as much as woven (pl.189). The ease of wear and the tactility of the fabrics established a style set somewhere between formal and casual dress, a refined and luxurious interpretation of peasant workwear. The traditional economies found in these kinds of clothes, such as patch pockets on an unlined jacket without a lining fabric, offered a point of difference from formal tailoring, and the colours --tending towards browns and beiges, greys and greens -- retained a country feel.

American *Vogue* described this new model for
Italian menswear, spearheaded by Armani, as being
formed from a cultural framework surrounding,
'everyday life . . . a rediscovered interest in European
tradition, including folk culture and the importance of
ecology, which makes the choice of natural handmade
fabrics, used today in as the same way as in the past,
a vital part of this whole look.'[13]

Armani's early success was due to appearances
in *L'Uomo Vogue*, on both advertising and editorial
pages (pl.190). An offshoot of *Vogue Italia*, the men's
magazine had been published biannually since 1968,
but in 1975 it went monthly and from 1977 it was
published bilingually, in Italian and English (see
p.245). Editor Flavio Lucchini was instrumental not
only in spearheading the international promotion of
menswear designers such as Armani, Versace and
Cerruti, but also in providing a set of references for
this new approach to dressing.

The August 1976 issue of *L'Uomo Vogue* was
devoted to exploring the influence of country dress on
fashion, in response to Yves Saint Laurent's Russian-
inspired haute couture collection. The magazine
showcased photo studies of Sardinian farmers, Breton
workers and Bulgarian peasants (pls 187 and 188).
In one feature, a documentary photograph of an
unidentified working man is captioned 'The Country
Look: as in the collections of Armani or Basile', while
another caption highlights a 'pointed cap, very similar

to those at Cerruti'. While tongue-in-cheek, the issue
as a whole set out to establish a framework for this
new style of Italian menswear, rooted not in city
tailoring or resort wear but in the simple, functional
qualities of country clothing. By 1978, Lucchini was
championing this look in the pages of American *Vogue*
as one of 'updated ease', its newsworthy elements
being 'overshirts, jackets, in the things that go over
other things'.[14] In the pages of his own magazine,
he described the influence of Armani's signature
unstructured garment, 'The Jacket Non Jacket':

> *Jackets are like smocks. Sometimes even the most
> sophisticated ones resemble cardigans and are better still if
> they seem well worn. Revers are small, shoulders sag and
> pockets are expandable. They are roomy, comfortable and so
> wide that they seem to be at least two sizes too large. They
> are completely unlined, soft, shapeless and so loose that
> when the cuff buttons are undone the sleeves can be easily
> rolled up. In fact they are untailored or unstructured.*[15]

If we compare this to the three principles of
the Italian Look defined by Gaetano Savini in the
early 1960s, we can appreciate how a decade later
Italian menswear had evolved a style of dress still in
accordance with these principles, but produced from
the specificity of country clothing designed to be worn
for city life. The other element reprised in this era
is the resort wear of the 1950s, now injected with a

Il look '77, pull chiné e giacca morbida, con berrettaccio folk.

Montone « nature »: come in tutte le collezioni-pelle attuali.

Il rustico insegna: come nelle collezioni Armani o Basile.

La testa del contadino come l'ultimo Fiorucci

La divisa da lavoro: potrebbe essere un'idea di Robert Bruno.

La salopette, come tutti i giovani avant-garde, adesso

ALLA RICERCA DELLA TRADIZIONE

IN FRANCIA UNGHERIA ROMANIA ALLE FONTI DEL COUNTRY – LOOK

Dall'Ungheria alla Romania alla campagna attorno a Parigi, Uli Rose ha ritrovato le fonti spontanee del « country-look » tanto amato dagli stilisti. Nelle campagne dell'Ungheria e della Romania i contadini vivono secondo un ritmo particolare, coltivano la terra con metodi tradizionali, si muovono ancora sui carretti a cavallo. Vestono con tessuti robusti, solidi tweed che

portano per vent'anni; il vestito è una parte di sé. Ma anche a pochi chilometri da Parigi (Uli Rose ha realizzato il suo reportage a 30 chilometri dalla capitale) si possono trovare nei villaggi gli stessi costumi di un tempo, una non-moda antica ed attuale: si direbbe che, da George Rech a Jap, gli stilisti abbiano percorso questo cammino alla ricerca delle loro ultime ispirazioni.

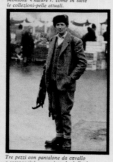

Giubbetto e sovrapantaloni antipioggia: un'idea ripresa da Cerruti.

Tre pezzi con pantalone da cavallo e scarponcini: un perfetto look Rech.

Sempre sul country-look: potrebbero essere dei Jap.

Berretto a punta, molto simile a quelli di Cerruti.

East-look-gilet: è anche una tendenza dell'inverno.

Anche in Romania ci si veste a strati.

Giacca e tunica stile Jap, con sciarpa-borsa stile Albini.

Sempre il matelassé, con berretto alla Jack Nicholson.

Imper per acquazzoni improvvisi. Proprio come quelli di Castelbajac.

Borghese «alla moda»: con gli stivali in vista.

97

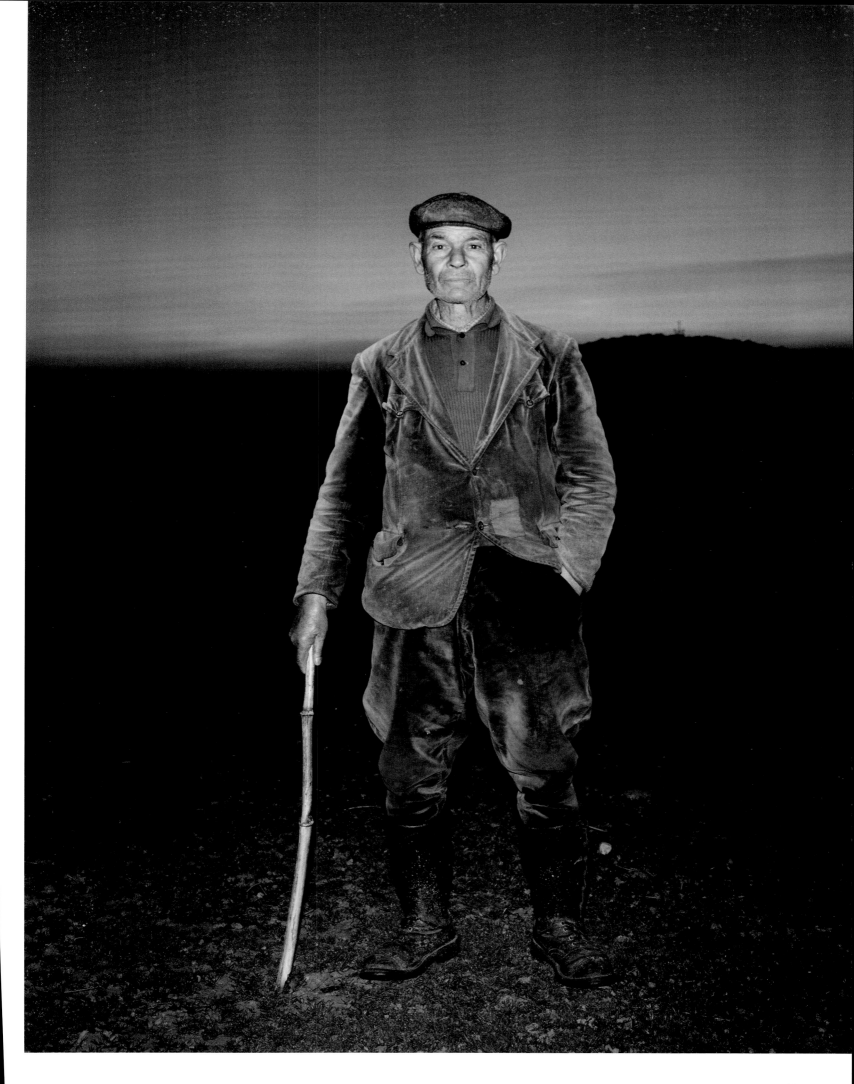

189 Giorgio Armani, linen and
cotton men's ensemble, Spring/
Summer 1994
V&A: T.106:1–4–2011

Below right
190 Giorgio Armani, menswear
collection, Autumn/Winter 1978.
L'Uomo Vogue, September 1978

Opposite
191 Gianni Versace, menswear
collection, Spring/Summer 1978.
Photograph by Oliviero Toscani.
L'Uomo Vogue, May 1978

knowing and strident sexuality, typified by the designs
of Gianni Versace for Complice and Callaghan in the
1970s, brilliantly articulated in the pages of *L'Uomo
Vogue* by photographer Oliviero Toscani (pl.191).

Much of the work of Armani and Versace
would reach maturation in the 1980s, when it was
rationalized within a decorative frieze of postmodern
Italian symbols. Anthropologist and writer Ted
Polhemus described this era as set between
'Catholicism and stripping housewives, between
classicism and futurism, between the good taste of
Armani and the vulgar excess of Versace'.[16] In his
essay on postmodern menswear, dress curator Richard
Martin described the expression of this ideology in
clothing as suggestive of 'looseness, a détente in values
and a release from stricture'.[17]

The ways in which concepts and ideas ascribable
to culture could be inspired by the manifestations of
an increasingly branded world of Italian goods were
addressed in the 1990s by a style of fashion journalism
invested with irony. In the third issue of *Arena Homme
Plus*, the biannual British men's fashion magazine
launched in 1994, Editor Iain R. Webb reported on
the menswear revolution in Milan. In his article, he
recounts a joke that had circulated at the men's shows
the previous October, at the presentations of the
Spring/Summer 1995 collections:

Q: How many fashion editors does it take to
change a lightbulb?
A: I didn't know Prada and Gucci did lightbulbs

Webb was writing about the revival of two Italian
companies with established histories in leather goods
that were now being fêted for their ready-to-wear

fashions. The return of Gucci was secured by
the appointment of the American designer Tom Ford
as creative director, which involved him 'scaling things
up and down in size and adding blissful colour and
sheen to everything'; while Prada in the hands of
Miuccia Prada, the founder's granddaughter, offered
a discreet style of darkly coloured dress that spoke of
uniform rather than peacockery (pl.194): 'You would
think that those guys in their black nylon parkas,
matching trousers and rucksacks were *Carabinieri* if it
wasn't for that triangular logo.'[18]

While Webb acknowledges both ends of the
spectrum of Italian menswear, as well as the desire
among fashion cognoscenti for their consumables,
there is no mention of the astonishing rise of the
middle ground. In 1996, economist Marco Fortis
published a study that highlighted the strong
performance of Italian exports in the consumer
products sector, notably textiles and apparel as well
as footwear and leather goods.[19] Although Italy only
accounted for a nine per cent share of G7 exports
in total, this proportion was not reflected in fashion-
related goods such as footwear (66 per cent), menswear
(38 per cent), womenswear (34 per cent), women's
knitwear (27 per cent) and men's knitwear (20 per
cent). The report offered a definition of Italian
identity for design and manufacture closely bound to
the unique manifestation of its industrial districts.

More recently, Italian companies such as Bottega
Veneta, Marni and Etro exploit fabric technology
to redefine the use of manufactured materials
in menswear (pl.193). They benefit from a local
manufacturing base that offers the vertical integration
of production, from fibre to finished garment. The
further assimilation of design and production means

UNA CERTA CAMICIA ED E' SUBITO SERA

that thread, yarn and fabric innovation is often woven into the design of the final product. In addition, the tradition of trade fairs, typified by those organized in Florence by Pitti Immagine, offers 'sites of recurring exchanges of ideas and innovation, essential engines for industries with a seasonal character'.[20] The Pitti Uomo fair, held in January and June of each year, is now recognized as much for the sartorial appearance of its audience as by the product ranges displayed on its stands.

In 2011, Italy still ranked second in global exports of clothing, leather goods and footwear, although since the financial crisis in Europe, its market position is in stagnation and in some areas in decline.[21] A sensible response to this situation would be to go back to basics, as Miuccia Prada did in her men's collection for Spring/Summer 2013, where male and female models strode out on the catwalk in an interchangeable wardrobe of resort-infused city clothing (pl.195). It was a return to many Italian details once considered innovations, now classics: knitted polo shirts, wide-sleeved straight jackets, cuffless trousers, pointed-toe shoes. Reviewing the show for Style.com, Tim Blanks revealed that Miuccia Prada 'had taken three days to get the border on the collar of a polo shirt just right. On the other hand, she also claimed that the collection had come together faster than anything she'd ever done.' This can be taken as a fitting commentary on contemporary Italian menswear: aware of the time that must be taken to uphold its sartorial traditions, but realizing them in an era of accelerated supply and demand. When asked about the collection, the art critic and curator Germano Celant (who has also been the artistic director of the Prada Foundation in Milan since 1993) said it could be taken as a combination of 'the post-war and the contemporary'.

In the space of 60 years, Italian menswear has grown into a significant industry, comparable to Italian womenswear. While presentations of *alta moda* and bespoke tailoring are now less common than the omnipresence of ready-to-wear fashion shows – or *confezione*, as it is called in Italian – to a global fashion audience, the male model striding the catwalk in Italian clothing no longer plays the part of the escort.

Alistair O'Neill is Reader in Fashion History and Theory at Central Saint Martins College of Art and Design, London

192 Romeo Gigli, velvet and wool men's ensemble, Autumn/Winter 1997
V&A: T.30:1–4–2011

193 Etro knitwear, Spring/Summer 2007. Photograph by Daniel Riera.
Fantastic Man, 2007

Opposite
194 Prada Men advertising campaign featuring John Malkovich, 1995. Photograph by Peter Lindbergh

PRADA

Italian Menswear 'In the Things That Go Over Other Things'

195 Prada menswear collection,
Spring/Summer 2013

From Tennis Court to Football Terrace: Italian Sportswear and British Male Style

Jonathan Faiers

Sportswear develops on the basis of the equation: technology, life, fashion. In the last six or seven years everything has been revised, and as a result of sports practically everything has been sold to everybody.[1] — *Pier Luigi Rolando*

Possibly what Italy has contributed of the most universal fashion value is their sportswear.[2]
— *Bettina Ballard*

The 1980 Wimbledon men's singles final between defending champion Björn Borg and volatile young pretender John McEnroe has gone down in the annals of sporting history as one of the great tennis matches of all time. This would be Borg's fifth and final victory at Wimbledon, completing an unmatched run of five successive Wimbledon titles, leaving the centre court vacant for McEnroe's decisive victory in 1981. To reach the final, McEnroe had defeated Jimmy Connors, the older American firebrand, and during the semi-final match McEnroe had established his reputation as the irascible, foul-mouthed, brash young superstar riding roughshod over the polite conventions of Wimbledon. During the tournament Borg wore Fila, McEnroe Sergio Tacchini and Connors Cerruti 1881 tennis wear, and the global coverage of these historic matches meant that 'Made in Italy' – and in particular Italian sportswear for men – had never seemed quite so universally desirable.

Having three tennis champions act as brand ambassadors serves as a prime example of Italy's highly successful marriage of manufacturing expertise, reputation for producing popular and fashionable men's casual wear and unique understanding of the symbiotic relationship between sport and fashion, but their two-week Italianization of Wimbledon is also symptomatic of the importance of Italian sportswear to British male style during the 1970s and '80s. In Britain, the Italian brands the tennis stars wore during this tournament are now most commonly associated with the casuals, the football subculture that adopted European casual men's clothing, 'acquired' while attending their club's away matches, as their uniform.[3] Indelibly linked to football hooliganism, the European brands favoured by casuals, it has been suggested, were first worn as an attempt to deflect the attention of the police: in the later 1970s, the police would typically continue to target easily identifiable skinheads, leaving the smartly dressed casuals free to infiltrate rival clubs and initiate violence. Iconic garments such as the Fila 'Matchday' and 'Terrinda' track tops, the 'Settanta Mk 1' polo shirt immortalized by Borg and Tacchini's

196 Fila, 'Settanta' tracksuit top

197 Fila, 'Terrinda' tracksuit

198 Björn Borg wearing Fila tennis
ensemble, 1977

'Dallas' tracksuit represented for the label-obsessed casual the irresistible combination of Italian styling, textile innovation and celebrity endorsement (pl.196). The popularity of the tennis or polo shirt, typically three-buttoned, short-sleeved and made from fine knitted cotton, brought together for British consumers fundamental elements of Italian style with an acknowledged pre-eminence in the field of innovative knitwear production. Between them, the major labels worn at Wimbledon in the late 1970s and early 1980s encapsulated the relaxed look, masculinity, exclusivity and stylistic experimentation that appealed to the casuals, who can be seen as positioned at the end of a trajectory of fashionable British subcultures that looked to the continent for their sartorial inspiration.

From its earliest days, male British subcultural dress has favoured tennis above all other sports as a source of casual wear. The polo shirt in particular can be worn either dressed up or down, making it a quintessential example of the easy chic so often regarded as characteristic of Italian womenswear. Italian menswear, or at least a popular conception of 'Italian Style', first found fertile ground in Britain in the late 1950s and early 1960s, and was a crucial element in the development of mod style. As a reaction to post-war sartorial austerity, the conservative styling of the older generation and the vestimentary nostalgia of the Teddy boys, the mods took their inspiration from both the sound and the look of the American modern jazz movement (hence 'mods') and from Italian and French men's fashion. Italian men's tailoring was perceived as being less structured, lighter and more directional in terms of its detailing than standard British men's tailoring, and Italian accessories such as casual men's knitwear and shoes became key components of mod styling. Just how Italian the 'Italian' suits worn by the majority of mods were is doubtful, and it is more likely that the Italian look desired by the style-conscious young British male had been filtered through the lens of Italian-American actors and entertainers – the 'Perry Como' haircut, for example, was much in demand from barbers in the mid-1960s.[4] Italian and French cinema also offered vital guidance for the aspiring mod: 'There was something different about foreign films . . . they looked differently, dressed differently and they had a different body language.'[5]

'Italian' suits featured shorter, boxier jackets, narrow trousers and lighter, more colourful cloths, as well as all-important and ever-changing details such as covered buttons, longer side vents and slanted or stepped trouser hems. These suits were available from the new men's retailers specializing in imported European fashions, such as John Stephen's highly successful string of fast turnover and affordable fashion outlets in the Carnaby Street area of London.[6] As well as continental-inspired tailoring, Italian knits featured prominently in Stephen's shops alongside other imported desirables chosen to satisfy the needs of an expanding British male fashion market. Elsewhere traditional, made-to-measure tailors such as Bilgorri of Bishopsgate identified a new

fashion-conscious market and established themselves as specialists in cutting 'Italian' suits.

Together with drinking in coffee bars and riding Italian-made scooters, wearing imported knitwear and an Italian suit were essential constituents in the Italianization of the fashionable young British male. While the sartorial subtleties of the mod look were relatively short-lived, disappearing under successive waves of decidedly less smart subcultural styles (skinheads with their obsessively and aggressively pressed Ben Sherman shirts and polished Dr Martens boots being a possible exception), a lasting legacy of the mod era was Italian knitted casual wear. Typically three-buttoned, collared, plain or with stripes in a contrasting colour, these shirts knitted either in fine wool or synthetic fibres remained a staple of British men's outfitters from their first appearance in the 1950s onwards, migrating from the fashionable backs of mods to the wardrobes of older British men, where they became a permanent fixture. Predating Italian knitted cotton tennis shirts, the British Fred Perry shirt was also required wear for the trendsetting mods and subsequently became the alternative to the Ben Sherman shirt for skinheads. Although the Fred Perry shirt was also adopted by the casuals, it was the Italian branded polo shirt that held pride of place in their wardrobes. The brands worn by Borg, McEnroe and Connors provide a suitable sartorial key to understanding the influence of Italian labels on popular British men's fashion of this period. While representing a different aspect of Italian innovation, each brand also offers insights into the broader socio-cultural implications of the subcultural adoption of Italian style in the UK.

'This way, even if his own skill does not attain the same heights, he can at least expect to achieve some of the effect.'[7]
Niccolò Machiavelli

'As much as it pains us, we Brits have to admit that when it comes to football, cars and fashion the Italians seem to do it better than most.'[8]

Founded by two brothers in the town of Biella in 1911, Fila originally produced Alpine clothing suitable for this part of northern Italy. The Piedmont region's high mountain pastures and plentiful water supply make it an ideal location for the rearing of sheep and the production of wool, and the textile mills of Biella have been an important centre of wool processing and innovation in textile manufacturing since the medieval period. With the purchase of a textile mill in Biella, Antonio Cerruti and his two brothers had established the family business in the town in 1881 (hence the brand name Cerruti 1881) and went on to keep abreast of the latest spinning and weaving technology. Apart from Fila and Cerruti, other companies with factories in Biella include Piacenza, Loro Piana, Barbera and Zegna, which serves as an indication of the area's importance to the Italian textile and garment industries. Cloth from Biella is regularly

199 Film still from *The Firm*, 2009

Opposite left
200 John McEnroe wearing
Tacchini tennis ensemble, 1980

Opposite right
201 Jimmy Connors wearing
Cerruti 1881 tennis ensemble
at Wimbledon, 1980

sourced by the most illustrious of houses, from Brioni to Armani. In 1966 Sergio Tacchini, a professional tennis player, established his own textile company some 50 kilometres east of Biella, in the town of Bellinzago Novarese in the Novara region. A much younger company than either Cerruti or Fila, Tacchini immediately set about experimenting with new fabrics and colourways that would change forever the traditional all-white sporting uniform of tennis.

Both Fila and Tacchini were at the forefront of celebrity endorsement and understood its power as a marketing tool, as is evidenced by a comment about sport's ability to sell everything to everybody once made by Pier Luigi Rolando, Fila's most successful creative director. Fila's partnership with Björn Borg, which commenced in 1975, swiftly established the brand's reputation as a manufacturer of directional tennis wear. In 1976 Rolando worked with Alessandro Galliano, Fila's engineering director, to develop a four-needle sewing machine that would allow technical innovations in stitching and reversible embroidery on sportswear. He also began designing a range of tennis wear endorsed by Borg, including the iconic pinstriped polo shirt and the Borg BJ line, with its distinctive logo (pl.198).[9] The Fila 'Terrinda' track top was to be the last of the Rolando Borg garments and was an instant hit with British casuals (pls 197 and 199). With its directional biker styling and padded shoulders, the jacket was ahead of its time and became the most desirable of all Italian track tops.[10] Endorsed by tennis 'superbrat' John McEnroe, Tacchini also produced a number of garments that swiftly became indelibly associated with the casual style (pl.200). Perhaps the most recognizable was the 'Dallas' tracksuit, featuring a collar that could be zipped up to form a roll neck (pl.202). It would become one of the most ubiquitous of all casual garments during the mid-1980s, making

the journey from tennis court to football terrace.

Established in the late nineteenth century, Cerruti diversified into developing and supplying cloth to the military in the First World War and then continued to expand its textile business worldwide. But when Nino Cerruti took over in 1951, he guided the family firm in what would be a decisive new direction both for the international recognition of the Cerruti brand itself and for luxury Italian menswear in general. Combining the fine cloths produced by the family firm with an innovative approach to menswear that brought together the best of Neapolitan and English tailoring traditions, Cerruti opened a flagship store in Paris in 1967 selling luxury men's ready-to-wear clothing. Cerruti would be an important component in the dissemination and popularization of a more relaxed yet ultimately stylish approach to modern men's tailoring that would be forever associated with Italy. If brands like Fila and Tacchini courted celebrity endorsements as a way of promoting their sportswear, Cerruti also understood the role that celebrity and the media would increasingly play in brand identification, and was one of the first of a wave of Italian menswear designers to work in film.[11] The company's most notable foray into sportswear was its partnership with Jimmy Connors, which began in 1980, the year he was famously defeated by McEnroe in the semi-finals at Wimbledon (pl.201). But over the next four years of his contract as a brand ambassador for Cerruti's sporting line, Connors would regain his position of sporting glory, winning his second Wimbledon title in 1982 while wearing the subtle Cerruti 1881 logo. In its day, the Cerruti tennis line was one of the most exclusive and expensive brands available, and the company has retained its legendary status by not reissuing its classic 1980s sportswear lines, unlike many other Italian labels.

The three brands' varying methods of production, marketing and diversification provide a distillation of many of the elements that made Italian sportswear so attractive to the British male. Its association with sporting success, its incorporation of cutting-edge textile manufacturing, its wearability and its cachet of continental exclusivity made Italian sportswear irresistible to the casuals, who could identify with its inherent athleticism and 'achieve some of the effect'.[12] Ironically, these garments associated with the reserved, courteous (at least until the emergence of Connors and McEnroe) and traditionally middle-class sport of tennis were then worn by casuals at football matches, historically positioned as working class, and which during the 1970s and '80s increasingly became characterized in the British press as much in terms of the violence on the terraces as for displays of skill on the pitch. Connors and McEnroe's iconoclasm and lack of sportsmanship on court and Borg's icy ruthlessness no doubt also played a part in the popularity with the casuals of the brands under discussion here. Their adoption of these Italian sportswear labels went largely unnoticed until the association with football violence was made explicit. Much as had happened with the mods and their highly publicized confrontations with rockers at British seaside resorts in the 1960s, it was violence that brought their sartorial individuality to public attention:

> [D]eviant or 'anti-social' acts – vandalism, swearing, fighting, 'animal behaviour' – are 'discovered' by the police, the judiciary, the press; and these acts are used to 'explain' the subculture's original transgression of sartorial codes . . . the mods, perhaps because of the muted character of their style, were not identified as a group until the Bank Holiday clashes of 1964, although the subculture was, by then, fully developed, at least in London.[13]

So it was with the casuals, who had remained largely unrecognized compared with the more noticeable football-following skinheads. However, once associated with systematized and sartorially indeterminate hooliganism, the casuals' admiration for continental menswear would become indelibly associated with violent rail trips to European fixtures and clashes with rival fans and police, accompanied by raids on European clothing retailers.

One of the more perceptive articles charting the rise of the casual phenomenon appeared in the July 1983 edition of *The Face* (pl.203). Thanks to the magazine's wide readership among the 1980s British style circuit, this piece would do much to consolidate the association of brands such as Fila and Tacchini with Anglo-Saxon aggression by the tabloid press. Entitled 'The Ins and Outs of High Street Fashion', the article features a report from Liverpool by Kevin Sampson in which he describes how the casual look originated in post-punk, Bowie-influenced styling – in particular the ubiquitous wedge haircut, which was adopted by Liverpool fans during the 1979 football season. The casuals would subsequently retain the distinctive hairstyle, but strip away the original 'do-it-yourself' attitude to clothing and replace it with a succession of domestic and European sportswear brands. Sampson goes on to note that while sports clothes were coveted, the style was not about high fashion. Although names like Armani and Versace would eventually be incorporated by some of the more fashion- and brand-obsessed casuals, it was the less exclusive, although still expensive, sportswear labels that were most highly prized: '[I]nspiration, though, comes not from the expensive Italian boutiques but from the local football ground. Here the traditional cycle of experiment–adopt–abandon whirls round as fast as you can play. This is young, urban, male Britain

— modern as hell, and how.'[14]

The companion piece to Sampson's article comes from Dave Rimmer, who reports on the casual phenomenon from London and describes its increasingly younger following. His text is accompanied by a photograph of a group of boys aged 14 and 15 wearing a variety of sportswear brands, including Fila, Ellesse, Lacoste, Pringle and Lyle & Scott. Rimmer provides a useful checklist of key casual elements, as well as naming some of the places where the most desirable brands could be obtained in Britain. Many of these were traditional sporting goods shops, golfing suppliers and outdoor or camping specialists that already stocked many of the brands the casuals wanted, but on becoming aware of the sudden emergence of a new clientele, were keen to satisfy the demand for more exclusive imported designs. Increasingly, these shops became known for stocking the latest European brands, fuelling the casuals' desire for the latest edition of a particular shirt or track top.

While higher-end department stores were quick to realize the commercial desirability of Italian sporting brands, the seasonal, bulk-buying patterns of larger outlets meant that the constant and often relatively minor style and colourway modifications produced by

Italian sportswear companies that were most desired by the dedicated casual were not profitable enough for major retailers to stock. It was the smaller specialist shops with a dedicated and guaranteed clientele of casuals who were able to turn over the never-ending stream of sportswear variants profitably, at least at the height of the casuals phenomenon from the late 1970s to the mid-1980s. As the label obsession gathered momentum throughout the 1980s, department stores would stock the more mainstream Italian menswear brands adopted by the casuals, such as Versace and Armani, which had guaranteed commercial appeal in addition to the niche market of casuals. Of course many of these items were beyond the reach of the average casual, who emulated 'the trendsetting cockneys in their Fila tracksuits, Ellesse T-shirts and Tacchini everything', but if they could not be obtained when attending away matches abroad, they had to be acquired nevertheless.[15] For some casuals this led to practices such as 'steaming' – running through shops grabbing as many items from the display as possible and exiting again just as swiftly – or 'taxing', which involved preying on more vulnerable casuals outside clubs or when they were leaving shops with their latest purchases and demanding the brand-name clothes off their backs.

The casuals' obsession with Italian sportswear brands can be seen as a last outburst of sartorial rebellion, centred somewhat ironically on the acquisition and display of the brand and its logo, a practice that would ultimately ring the death knell on subcultural style. In the face of the escalating prices of the more exclusive Italian sportswear lines, Rimmer asks which brand will be the next to be adopted by the casuals: 'Word is it'll be Dior, Saint Laurent and Aquascutum.' By the time his article appeared in 1983, this prediction had already come true for some of the more dedicated casuals, who had been wearing Armani sweaters and Versace shirts for some time. What had originally been a subversion of Italian sportswear labels worn as subcultural high fashion descended into today's designer label brandscape, where subculture can be marketed as successfully as any other 'look'. The rise or in some cases reinvention of Italian superbrands such as Versace, Armani and Dolce & Gabbana, followed later by Prada and Gucci, would come to dominate British men's style, signalling the end of a sartorial rebellion that can be traced back to the original adoption of Italian style by the mods as an antidote to the blandness of post-war British male clothing. It is doubly ironic that these Italian superbrands are a contributing factor to the uniform blandness of contemporary popular male British style, in many cases worn by grown-up casuals with the kind of money and lifestyle that necessitates the abandonment of their former edgier and more working-class sportswear.

Tennis wear worn on the terraces, sartorial one-upmanship masquerading in the livery of sportsmanship and relaxed Italian chic translated as casual British aggression synthesize what perhaps has always been the irony accompanying British men's love affair with Italian style. As the mods recognized the impossibility of living *la dolce vita* in decidedly un-continental 1960s Britain, so too did the casuals (without the benefit of cinematic referents) realize that in economically divided 1980s Britain, Italian sportswear brands promised the illusion of attainable sartorial subjectivity. What both the mods and the casuals also came to recognize was that this adoption of a carapace of continental sophistication, whether in the form of Italian suits or sportswear, must always be tempered with a decidedly British iconoclasm and worn with the guidance offered by a Tacchini-wearing McEnroe: 'Man, you cannot be serious!'

Jonathan Faiers is Reader at Winchester School of Art

ELLESSE *PRINGLE* FILA

BY KEVIN SAMPSON

● **Fashion has always been a city thing.** The adoption of certain labels and garments is geared towards other people knowing what's what. The important factors are quality, colour, a certain visual *rightness* and, of course, price – why pay less? This merry-go-round can't properly exist outside of the conurbations for the same reasons that you don't have the Grand Prix at Leominster. No, the wasted youth of, say, Barrow are going to opt for a far more outrageous individual stance because their market forces **demand** it.

This, in 1983, is popularly labelled **style**. The media emphasis for the past year has been on individualism, resulting in a nationwide army of Buffalo boys and gal Georges. Good old self-expression rears its pretty head once more, and *style is in fashion*. Can this be all that is happening in rag-crazy Britain? You can bet your **Fila** tracksuit that it isn't, as any paid-up football fancier will tell you. Times are tight, but, for those actually affected by the national disgrace, their reaction has been well in tune with history.

Image before belly is The Message, and the young city dweller of today is more concerned with fashion than ever. His inspiration, though, comes not from the expensive Italian boutiques but from the local football ground. Here the traditional cycle of experiment-adopt-abandon whirls round as fast as you can play. This is young, urban, male Britain - modern as hell, and how. And how?

Let's rewind to the summer of 1977. Remember it? The Buzzcocks? "White Riot"? "Low"? That Berlin-phase Bowie LP may not have seemed important at the time, but in the breaking down doors for the world of youth culture. Scotland Road is a puzzle for Housing Dept officials – the clanism of its people legendary. Why does no-one work? Why do they all have videos? Why won't they move to a nice overspill estate? This clanism became especially evident in the children of Scotland Road, the first "Scallies" to emerge in 1977.

Taking the cover of Bowie's "Low" as a point of reference, they mixed the bohemian cool of Buffalo with punk's snazzier trappings. The resulting image was at once ugly, effeminate and extremely attractive. Mohairs worn with straights and plastic sandles, complemented by camel duffel coats. But it was the distinctive hairstyle that stamped SCAL-LY all over them, the unique and wonderful lopsided wedge – a haircut popular in the last great depression, ridiculously 'claimed' by hair stylist Trevor Sorbie at Vidal Sassoon.

The start of the 1977 football season saw this look spreading, slowly at first, while a vibrant club scene began to take shape. Centred on two New Wave clubs, Checkmate and The Swinging Apple, a Punk-Scally cross-over was noticeable for some months. Yet as electronic music began to predominate in early 1978, Checkmate became more fringe, less spike. Lots of punks adopted the cyclops wedge as a weird hairstyle, resulting in a miazma of dyed flicks flopping around to "Sound And Vision" in Checkmate. It was here, incidentally, that Richard Jobson's bespoke "Into The Valley" kick-dance originated. So there.

It was around February of 1978 that this fledgeling fashion shook off its punk influences and became more of a cult, a football-orientated lifestyle. Suddenly *everyone* at the match was sporting a drooping fringe, straights and **Pod** shoes. Like all good cults, the metamorphosis was very swift and very widespread. Though drinking, stealing, claiming and clubbing were all important, obsession with clothes gripped young Merseyside something murderous.

Between spring 1978 and winter 1979 the city's rag-trade was turned upside down. The emphasis went on detail. First it was drainies rather than just straights. Then it had to be **Lois** drainies. Then, come 1979, it was a new label every month. **Inega, Fiorucci Lacoste. FU's** all had their moments, but never very long ones. Now *this* was fashion. No sooner was a new brand or colour established than it was cast off, replaced and ridiculed.

The shops became wise to the movement and capitalised on the joke aspect of it. Stickers claiming "In For One Day Only!!!" were attached to gold jumbo cords, while a shop in Lime Street displayed an array of three-star jumpers with the invitation "Why go cold?" This was a reference to the thin baggy shirts being worn – top button done up, no jacket – in January.

As 1979 wore on, though, inspiration fell thin on the ground. The style leaders of Scotland Road simply went more ridiculous, by wearing no underpants, walking with their hands behind their backs and using Staffordshire Bull Terriers as a fashion accessory. At the same time there was a great deal of hatplay. All manner of headgear came and went – baseball caps, deerstalkers, trappers hats, flat caps. By this time the cult was well established.

The beginning of the 1979 football season saw the Liverpool look popularised to a national level. Manchester with its Perries' and London's 'Chaps' quickly imitated and emulated their Scouse rivals, by the sheer range of selection and the class of their clothing. Calibre was still as vital as before, with nightclubs maintaining their importance in the way of life.

Towards the end of 1979 the Liverpool clubscene shifted to The Harrington Bar, where Joy Division could be heard next to The Crusaders, and it was this leaning towards jazz-disco that prompted a renewed interest in quality. However, the Londoners could not be beaten at their own game and the Chaps came up with a luxurious image unlike anything touched upon before. This was an incongruous mixture of **Nike** trainers, frayed **Lois** jeans and **Lacoste** shirts, worn with cashmere scarves and jumpers, topped with long **Burberry** raincoats. The age of Football Chic was upon us.

1980 saw a change in direction. Long fringes were ousted in favour of huge, bowl-type mushroom wedges, instantly doubling the width of the head. At the same time the clothing was much more sports-image conscious, rather than club orientated. Tennis shoes were worn with faded jeans and **Adidas** ski-anoraks, and, while the footwear was regularly altered, anoraks and faded jeans became a Scouse fixture. The Londoners displayed a variety of leatherware and **Lacoste** gadgetry before knuckling down to the serious business of out-sporting the world. Meanwhile Manchester's Perries seemed anxious to make 1980 a happy year for Adi Dassler (sic), apparently exhausting the entire catalogue within six months.

By 1981 just about every team in the country was able to boast a collection of match-dudes, each trying to outdo the next city in terms of terrace cool. In point of fact, there was very little variation from city to city. The cockneys wore diamond **Pringles** and the scousers had green **Peter Storms**, but the status-quo was **Slazenger** jumpers, **Lee** jeans, **Adidas** trainers. The fashion was not limited to clothing either. Travelling to aways by Inter-City (NEVER by coach), sitting at the match rather than standing, blowing instead of drinking and, more worryingly, carrying Stanley scalpels were all integrated into the football youth culture. People who talk of all-seater stadia know nothing. The undesirables know nothing. Observe West Ham's Inter City Firm travel to a northern

Tacchini etc. Farahs: school only.
● Nike (*red flash, not blue*) or Diadora trainers. Kickers too. Adidas went out with Fred Perrys. Sta-prest, Ben Shermans and anything sold by Dickie Dirts. That is to say: with the ark.

And that is what's currently worn by London's version of Liverpool's Scallies or Manchester's Perries – concentrated mainly in the East, South East and bits of the West, Ealing for example. They haven't got a name, though some call themselves Casuals.

There are variations – especially according to age as the word gradually seeps down from older to younger – but generally it's pretty rigid. Style don't mean a thing, the brand-name's the game. Get it wrong and you're an object of derision. Get it right and you're ... *right*. Detail of course is what counts. If you aren't looking for it, you won't notice it. And detail – to wit: the label on breast, back pocket, collar; Lacoste's crocodile, Fiorucci's triangle, Pringle's lion – is damned expensive.

Roughly, the cheapest you can get the complete outfit is around £170 (tennis shirt £25; jumper £40; trainers £25) and, let's face it, our lemon Lacoste isn't going to last till laundry day. What's more, as the pace-setters move on, it isn't getting cheaper.

What to do? Nag your parents. If that doesn't work? Get a Saturday job. The alternative is ridicule. Cheaper counterfeits, mainly of Lacoste, are easy to come by; loose crocodile labels can be bought at markets like East St or Walthamstow. But anyone who knows anything can spot a fake a mile off. *That's not a Lacoste, you buskie! Look at it!* The crocodile's far too light, the material's too thin and the washing instructions aren't sewn into the seam of the left arm, *like they're supposed to be* . .

And so, both shoplifting and the odd smash 'n' grab are on the increase; the former mostly Up West, the latter wherever the right kind of window display is left foolishly unprotected by iron grill. (Also, less dramatic but just as telling, a lot of labels are sliced off in shops – tags from Kickers particularly, tend to be stuck in rows on one pair.)

And then there's "taxing". If you walk into Lords disco in Ilford on a Tuesday night wearing your brand new Ellesse, or down East Ham High Street in your Burberry any hour of the day or night, there's always a chance that you might get taxed. This means someone bigger and probably older persuading you to part company with that natty garment at knife-point. Why, you're liable to get chased right across the park just because you're carrying a Temple's of Walthamstow carrier bag. They'll tax you of *anything*. Your jacket, your shirt, even your trousers. So maybe you save your best stuff for special occasions, or wear an old, innocuous coat over the top of it all.

And if taxing weren't hazard enough, there's also "egging". Older types with cars do this, jealous (so the theory goes) because they've spent all their cash on the motor and can only afford the despised Gabiccis or the Fox or Coyote Lacoste imitations. You could be walking down the road, feeling sharp in your sky-blue Fila, when suddenly – WALLOP – an egg hurled from a passing Escort hits you square in the back, ruining it. You get to know which cars to look out for. Some of them have rows of little eggs – each denoting a successful hit – painted on the side . . .

Apart from down to the local disco, off to the next away match, or into the odd fight with Mods (there was one recently in Romford), it's difficult to see where all this is heading, or even how much more expensive the gear can get. The incoming Ellesse range is wide and dear enough to last for a while. After that? Word is it'll be Dior, St Laurent and Aquascutum. By then, Lacoste, where it all started, will be more or less forgotten.

If that's true, then no-one will be more pleased about it than Lacoste's UK distributors.

Lacoste is a French firm, founded 50 years ago by tennis champion René Lacoste (he was nick-named *Le Crocodile*, hence the logo). They see themselves as a reputable, traditional firm, concerned above all with quality. They manufacture only in France – a factory in Troyes – and began distributing to "top menswear and quality sports shops" in Britain about eight years ago.

Their production can't keep up with current demand, their distribution is still based around that original group of "quality" retailers (Simpsons, Harrods, Lillywhite etc), and what remains of the UK company's quota is only allocated elsewhere once those shops have been stocked. At the moment they "aren't in a position to open any new accounts", and are attempting to control demand by stocking individual shops only with certain sizes. White Hall Clothiers, for example, are allowed to stock only the children's range.

Mr Terrence, a spokesperson for the company, confessed that they'd "prefer to lose 10-15% sales" than have the present situation continue. Why, not only do they have to track down counterfeiters and loose label merchants, they're also getting complaints from their "more classy" retailers who've suddenly found shoplifting skyrocketing, lumps of concrete regularly being hurled through the windows, and are frankly wondering whether to carry on stocking Lacoste at all.

"It is a problem this, ah, football element," explained Mr Terrence. "They get everywhere, even to Harrods and Simpson. And it's not just stealing, they even cut the crocodiles off with razor blades, tearing *great holes* in the shirts." This seemed to horrify him more than anything.

"From our point of view, the sooner this dies out, the better."

Dior won't know what's hit them. ◆

adidas
Lyle & Scott
NIKE

◆ Photos here and previous page DAVID CORIO. Photos Opposite page SHEILA ROCK

● Postscript to Kevin Sampson's piece on the previous page: Liverpool fanzine The End is well up on all things Scally. Contact c/o Phil Jones, 16 Steerscroft, Cantril Farm, Liverpool. Enclose SAE.

Glenn Adamson

Tailoring and Craft

The Neapolitan jacket makes a vivid contrast with a traditional Savile Row jacket

When Gennaro Rubinacci opened his bespoke menswear shop in Naples in 1932, he chose to call it London House. In fact he had never visited London (and never would), but there was little doubt in his mind that British suits were the apex of gentlemanly elegance.[1] In those days, Italian tailoring was largely made up of family enterprises, aimed primarily at a local clientele. There was nothing in Naples or anywhere else in Italy that matched the reputation of London's Savile Row. British tailoring was a standard to which Italians could only aspire.

Fast-forward to the year 2000. In that year, Italy exported £28 million worth of suits to the UK and imported less than £1 million worth of British suits in return. Similarly, in the overall global marketplace, Italy was exporting six times the value of men's suits as Britain, and their product was concentrated at a higher-quality end of the market.[2] This dramatic turnaround is one of the great success stories of twentieth-century Italian fashion. For the most part, men's suits and jackets today are made using computer-assisted rendering and cutting. They are assembled by relatively low-waged workers (disproportionately female), whose skill levels tend to be graded according to speed rather than quality.[3] That state of affairs, often decried as a sweatshop system, is relatively rare in Italy. It is true that some Italian companies, including luxury brands, outsource their production to other parts of the world. But the firms that have performed most strongly in recent years are those that focus on domestic production at the upper end of the quality scale, where Italy has a clear competitive advantage.[4]

The dynamism of the Italian menswear sector is due to a number of factors, including the strength of Italy's textile mills, the innovations of a few key fashion houses and of course the country's overall high standing as a centre of style. But perhaps the greatest factor has been the craftspeople themselves, who continue to form the backbone of the Italian menswear industry. The contrast with Britain is stark. In the UK, the interwar period saw hand tailoring decline precipitously as ready-to-wear came to dominate the market.[5] The menswear emporium lost its role as a locus of male sociability, along with other typically Victorian and Edwardian institutions such as members' clubs and military officer corps.[6] In Italy, by contrast, it remained customary for men to consult their local tailor well into the post-war years, and the tailor's shop itself remained a fixture of city and village life. As a result, just as in the textile trade, Italy retains a deep wellspring of small artisan firms. This workforce is trained through a combination of specialist secondary schools and workshop-based apprenticeships.

Even in the ready-to-wear sector, a surprising amount of hand tailoring still takes place: it is common for jackets to be made in an 'open' style, where the shape is roughed out sculpturally using basting stitches that will be removed before final finishing, rather than being cut, stitched and fused by machine (as is more usual in the UK).[7] But of course the real repository of tailoring skills lies in the making of bespoke garments. There is a great deal of lore and local pride in this trade, and also a good deal of regional variation.

The aforementioned firm of Rubinacci, for example, despite its founder's idealization of the British gentleman, was instrumental in developing a specifically Neapolitan jacket shape. Typically made from lightweight fabrics, without padding or lining, this garment is ideal for wearing in the hot southern climate of Naples. Other details are less pragmatic, but together they communicate an air of relaxed elegance: a rounded pouch-shaped pocket known as a *pignata*; a lapel that rolls up in a swelling conical taper from the top button; and most noticeably, a ruched sleeve top that rises airily above the shoulder. The overall lightness of the jacket belies its exacting construction. The garment is anchored to the torso at the armhole, which is pulled tight through the use of many small darts. In this way the sleeve can be left remarkably wide, and the interior volume of the jacket relatively capacious, without losing that sense of specific crafting to the body that is so crucial to bespoke tailoring.[8]

The Neapolitan jacket makes a vivid contrast with a traditional Savile Row jacket, which has a higher waist and a canvas-padded breast in order to create the classic 'hourglass' shape so associated with British style. Though the features pioneered in Naples are

not observed in other parts of Italy, the overall pattern is clear. In general, British tailoring is more structured and sculptural, literally 'buttoned up', and aims at an effect of overall balance. Italian suits are more relaxed while also being fitted and sleek and, in comparison to British tailoring, do less to correct the wearer's natural shape and stance. Textiles differ, too. Both climate and style lead Italian tailors to opt for lighter, glossier fabrics while the British tend to go for heavier cloth with a matte finish (pl.205).[9]

Of course, these stereotypes are just that and tailors in both nations frequently depart from them, working against type. Rubinacci's fabulous collection of vintage fabrics includes many choice British samples, and many superb Italian cloths are on offer at Savile Row tailors (pl.207). It is also worth noting that Italian tailors have been a mainstay in London since the immediate postwar period, when a dire economy drove many to emigrate. If you walk into a Savile Row workshop today, you will meet artisans from all over the world, and many of the most skilled and long-serving are likely to be Italian. While these craftsmen have accommodated themselves to the British style, their skills are no less the product of their upbringing and of course a certain amount of hybridization has taken place.

Quite apart from the movements of the artisans themselves, Italian tailoring today is a global business, which circulates by physical, digital and financial means. The blogosphere thrills to images of Luca Rubinacci (pl.210), the dandyish scion of the Naples firm, snowboarding in a bespoke suit;[10] or to tales of master tailor Enzo D'Oris, who will fly anywhere on earth to measure a wealthy client for a 'K-50' suit by Kiton, made of ultralight merino wool and costing a cool $50,000.[11] Some of Italy's top luxury menswear brands, moreover, are owned by international conglomerates. A conspicuous example is the Rome-based company Brioni. Founded at the end of the Second World War, the firm has been just as innovative in its way as Rubinacci, being the first to put male models on the catwalk and introducing strong colours and patterns to bespoke menswear in the late 1960s, perhaps in reply to styles coming from Swinging London.[12] In 2011 Brioni was acquired by the French magnate François Pinault for his luxury group PPR, (now known as Kering) which also includes brands such as Gucci, Yves Saint Laurent and Bottega Veneta, as well as a half interest in Alexander McQueen and Stella McCartney. Given consolidations like these, it is clear that national styles of tailoring are increasingly strategic branding opportunities rather than dyed-in-the-wool traditions.

Glenn Adamson is Director of the Museum of Arts and Design in New York and formerly Head of Research at the V&A

page 216
204 Henry Poole, Savile Row, London, interior of bespoke jacket (detail), 2012

From above
205 Henry Poole, Savile Row, London, bespoke jacket (detail), 2012

206 Rubinacci, Mayfair, London, bespoke jacket (pocket detail), 2012

207 Rubinacci, Mayfair, London, cloth samples 2012

Gianluca Longo

The Man in the Street

The elegant man is the man in a well-cut suit.

There is something about Italians that makes them recognizable all around the world: their style. In particular, the way Italian men wear their suits. If a woman can never have enough handbags, no man can ever have enough suits, from formal ones for the office to relaxed styles for the weekend. Then there are the fabrics: wool, linen, cotton . . . We Italians love a good suit and we love playing with colourful accessories – mixing and matching ties and pocket squares is a favourite sport for my countrymen. I'm proud to say that whether you're in a piazza in Rome, a villa in Puglia or a Venice *enoteca*, the native man will stand out for his natural elegance.

The tradition of Italian tailoring goes back to the early 1900s, when the first clothiers started to open up to the public. The demand for suiting and shirting was increasing, and the making of garments was no longer a private affair between a tailor and his wealthy customers, something that took place behind closed doors. From Lombardy to Naples, via Piedmont, Rome and Palermo, the man in the street wanted to look smarter. And Italians have always loved to show off.

By the 1930s, Italian suit makers were gaining respect. Among them, the house of Canali, established in 1934 near Milan, became renowned for its cutting precision and the canvas-supported construction of its jackets, with their hand-rolled collars and sleeves set in by hand. In Naples, Vincenzo Attolini invented the 'rag' jacket, the 'boat' pocket and the closed sleeve (where buttons are sewn on, with 'fake' button holes), while in the same city, Gennaro Rubinacci was experimenting with a different style. And with the addition of Corneliani

and Caraceni not long after, the Italian suit was about to rule supreme.

Ermenegildo Zegna entered the suit-making market after the Second World War and Brioni revolutionized the world of suits by putting men's fashion on the catwalk in 1952. Kiton opened in 1956 with impeccable tailoring and high-quality sartorial standards. In Italy, suit tailors were flourishing, more so than in France or Britain, with the economic boom of the 1950s and 1960s also working in their favour. Italian tailors all have their own secrets for achieving the highest quality, and they guard them to this day.

In terms of accent, culture and lifestyle, there are many differences between the north and south of Italy, and the same is true of sartorial traditions. The jacket is the man's garment *par excellence* and each school of Italian tailoring has its own style: constructed or soft, with a concave or egg-shaped shoulder. As the business capital of Italy, Milan is a serious place and the Milanese are known for being very serious about everything. Walking around the city centre, you can't miss the sleek elegance of men in their pinstripes and their bird's eye suits, either in grey or dark navy (pl.209). Here the jackets are stiffer than they are further south, featuring a constructed shoulder, a more defined breast and waist, with medium-size lapels. An immaculately pressed white shirt and a pair of shiny black shoes complete this austere and powerful look.

'The elegant man is the man in a well-cut suit,' Nicoletta Caraceni, of the 90-year-old Milanese tailoring house that bears her family's name, points out. 'There is

a kind of secret language and reciprocal respect when men do business, and all wear a good suit. A tailor is the architect of the body, and they must make a man feel at ease when wearing their creations.' Italian suitmakers are in fact wizards of cutting. They try to hide any flaws in a man's physique and make him look slim, tall and elegant. So the armholes are higher, the shape is more streamlined and the garment is carefully proportioned. From the placement of the waist to the width of the lapels and the cut of the collar, every aspect of the Italian suit is tailored to flatter and conceal at the same time. 'At Caraceni, for example, our lapels are softer, more like a shawl on the breast, and they give a slimmer line to the jacket,' Nicoletta adds.

Men in Florence and Rome have very similar tastes in fashion, and they definitely have a more relaxed look than the Milanese (pl.208). In these cities, you will probably see more men wearing a *spezzato* suit, that is to say a jacket and trousers that don't match (a classic of which is the navy blazer/grey trousers combination), while strolling in the streets, riding a Vespa or just lounging in a bar. Here the cut of the jacket is also more relaxed, just like the lifestyle. In particular, the jacket features the 'concave' shoulder, designed without supports: starting at the neck, the first part is straight, then it softens in the second stretch before curving up with a dart. In Italy this style is known as *sellata,* which means 'saddled', and it sits on the man's shoulder like a saddle. A very fashionable Florentine friend of mine loves wearing a 'saddle-cut' jacket 'because it's flattering, and helps even the man who has not done sports for a long time. . .'. That is very Italian reasoning. A precious patterned pocket square, a contrasting tie and a pair of smart brown shoes, and the relaxed, elegant look is done (pl.211).

Moving further south, Naples has its own strong sartorial tradition. Men here love to wear colours and to experiment with new combinations of patterns, and in their own way they always look smart. The Neapolitan tradition of suit jackets relies on the school of the Rubinacci family. They were the first to try the 'egg-shaped' shoulder: droopy, without edges, rounded off and with side darts to make it even softer. Then the jacket itself is often unlined, with patch pockets. 'In Italy, men's style changes according to the weather. The Milanese like dark tones, because its rains a lot. In Naples, we love colours because most of the time it's sunny,' notes Luca Rubinacci, who is the young ambassador of Neapolitan suit makers (and much loved by street-style photographers for his looks; pl.210). 'Then if you still want to look good in a jacket, a heavy structured one is not comfortable. My grandfather was the first one to realize that and created the relaxed "egg-shaped" jacket, in order to be so soft around the body, almost like wearing a shirt.' And therefore perfect for warmer climates. Neapolitans love to mix and match their suits, and with their colourful trousers, vibrant scarves and extravagant ties, their suede loafers on their always sockless feet, they have created a style all of its own: the Neapolitan taste.

Gianluca Longo is a journalist and fashion observer

page 220
208 Valentino Ricci, Florence. Photograph by Scott Schuman, *The Sartorialist,* 2009

Opposite
209 Man in a grey suit on a bicycle, Milan. Photograph by Scott Schuman, *The Sartorialist,* 2009

Above
210 Luca Rubinacci, Naples. Photograph by Scott Schuman, *The Sartorialist,* 2009

Left
211 Pocket detail, Florence. Photograph by Scott Schuman, *The Sartorialist,* 2009

5

The Fashion Business

The Business of Fashion

Emanuela Scarpellini

page 224
212 Valentino, photograph by
David Bailey, British *Vogue*,
November 1987

Opposite
213 Emilio Pucci and
models. Photograph by
Sergio del Grande, 1964

The Geography of Fashion

Creativity, flair, research, innovation, originality –
so many words come to mind when attempting to
define the traits of Italian fashion. There is perhaps
one fundamental aspect that is not as immediately
apparent, despite it being one of the key features that
sets Italian fashion apart: namely, the business side. The
real heart of Italian fashion lies in its relationship with
industry – and the resulting ability to translate ideas
and intuitions into high-quality, mass-produced models.

From an industrial point of view, Italian fashion
has a long history, its roots embedded in a textile
manufacturing industry that goes back centuries if one
includes handmade traditions. The modern fashion
industry can be said to date from the late nineteenth
century, with the establishment of a network of large
and small firms in the business of producing cotton,
wool and, above all, silk fabrics. What was lacking
back then was a sizeable market and the ability to
produce 'fashionable' models, a monopoly held by
Paris's haute couture houses on the womenswear front,
while London had cornered the market for men's suits
and sportswear.

An initial bid to launch a distinctive Italian
fashion was made in the fascist period, when the
regime endeavoured to develop the industry by
setting up public institutions to coordinate various
initiatives, including the creation of a national fashion
authority, the *Ente Nazionale della Moda,* in 1932 and
the promotion of shows and events showcasing Italian
products. This undertaking clearly had a dual purpose:
on the one hand, it was a question of ideology, namely
the shaping of a separate national identity from France
and the establishment of gender models to which
Italians were expected to conform.[1] On the other
hand, significant economic interests were pushing for
the development of textile and clothing firms, riding

the tide of economic self-sufficiency and campaigns
championing national industry. Italy already had
a wealth of large cotton manufacturers, including
Cantoni and Crespi, and wool mills such as Marzotto,
Rossi, Rivetti and Zegna, especially in the northern
regions of the country, along with a multitude of small
semi-artisanal businesses (pl.214). As well as promoting
these manufacturers of traditional materials, the
regime's nationalist policy also fostered the revival of
humbler textile fibres such as linen, jute and hemp
(the production of which was, for the most part,
controlled by Linificio e Canapificio Nazionale). In
addition, there were promising developments in the
field of artificial fibres, with entrepreneur Riccardo
Gualino specializing in the manufacture of rayon from
cellulose. Through his company Snia Viscosa, rayon
production exploded, earning Italy second place in
the global rankings by production quantity in 1925.[2]
Meanwhile, clothing was still very much the realm of
artisans and tailors, with shirts, ready-made suits for
men and underwear being the exceptions, especially
around Turin and Milan. Without taking into account
the thousands of tailors and dressmakers working
from home, 27,000 businesses were recorded in this
highly labour-intensive field in 1911. It was a similar
story in the tanning industry, which in the same year
numbered 30,000 firms nationwide and was strongly
linked to the development of the first large-scale shoe
factories, in addition to the manufacture of traditional
leather goods, including bags and luggage.[3]

The efforts of the fascist regime to control
national production proved to be wishful thinking and
failed to fully harness the inherent potential of an
economic system that showed aspects of innovation
and industrial concentration alongside craftsmanship
and production on an artisanal level. A milestone
in the development of Italian fashion came in the

period after the Second World War and was centred around two major cities: Florence and Rome. In 1951, Florence was the venue of the first internationally attended Italian fashion show, which proved to be epoch-making. The show's considerable success prompted the creation of a regular event held at the Palazzo Pitti in the coming years.[4] Where better than aristocratic Florence for Italy to launch its new clothing collections? With its Renaissance buildings and local wealth and culture, the city provided an extraordinary historical backdrop, suggesting an ideal continuity between the luxury of the past and the aesthetic models of the present.

At the same time, Rome was working on its reputation as an alternative fashion hub. Specializing in high fashion, the Italian capital was home to some of the country's most famous fashion houses, such as Sorelle Fontana and Emilio Schuberth. Above all, it managed to forge a special relationship with Hollywood, with many films being shot in Rome during this period. With a list of regular clients including such celebrity names as Jaqueline Kennedy and Elizabeth Taylor, Rome wanted to be recognized as an alternative to Paris on the fashion and media front.[5]

Throughout the 1950s and '60s, 'creative tailors and dressmakers' grew in number, their businesses booming. Clothing companies offering quality mass-produced garments also flourished, sometimes turning to these talented new professionals for advice, as was the case with Gruppo Finanziario Tessile (GFT), owned by the Rivetti brothers, who enlisted the services of the dressmaker Biki (pl.215). The next step came in the early 1970s, with the advent of a new profession: the fashion designer. It was no coincidence that the first veritable ready-to-wear fashion show, featuring collections by Albini, Caumont, Missoni, Krizia, Ken Scott and Trell, was held in 1972 in Milan, a city that not only offered specialist fashion trade shows such as MilanoVendeModa, which was soon followed by Modit, but was also located close to the textile manufacturers and connected to a rich web of high-quality clothing companies and artisans. This was the foundation on which a 'democratic' fashion

214 Lanificio Ermenegildo Zegna
advertisement, 1940

Opposite
215 Biki, coat, hat and gloves.
Grazia, 1951

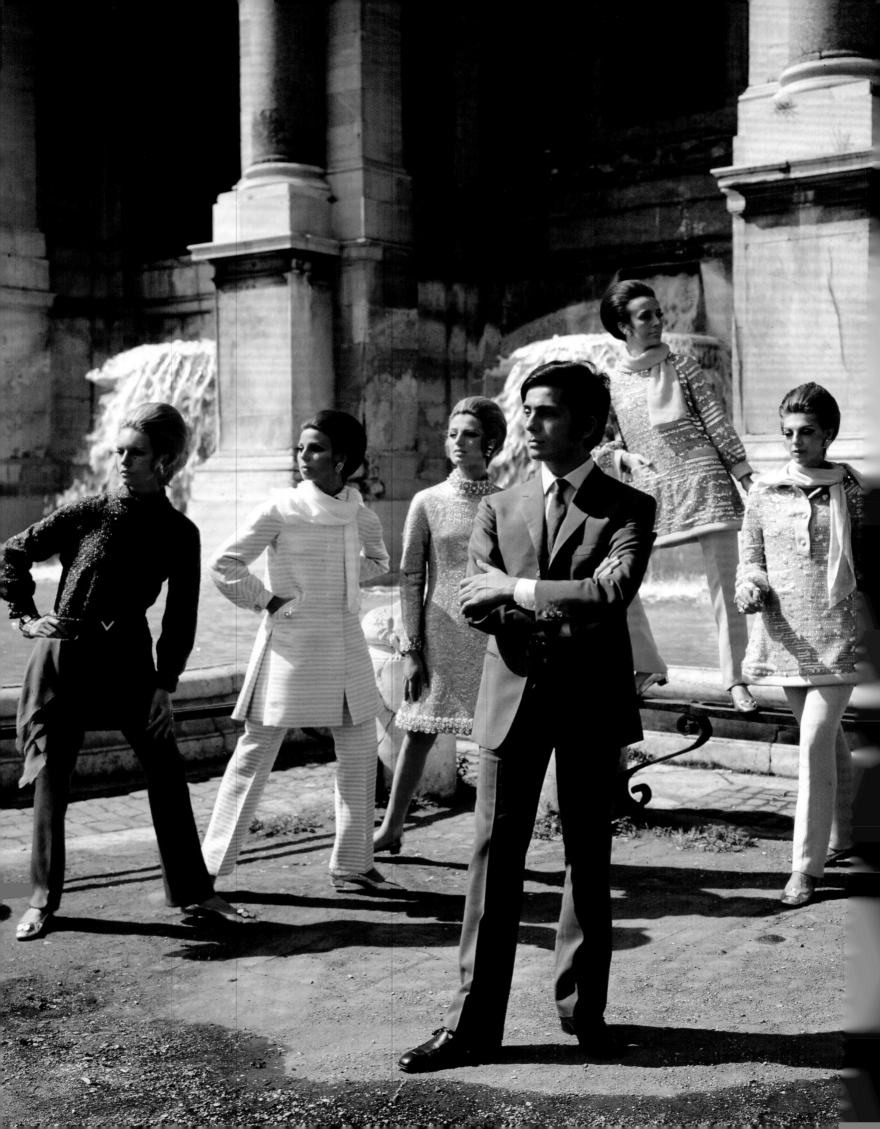

Opposite

216 Valentino and models, Rome, July, 1967

217 Map of Italy's textile and fashion production districts, in collaboration with *Osservatorio Nazionale dei Distretti Italiani*

was built, open to a wider public than the high fashion of the elite few. Milan's promotion to the status of the new fashion hub thus reflects an organizational and economic transformation as well as a cultural metamorphosis that mirrored the changes in 1970s society, with new social groups taking centre stage. One such group – the youth demographic – turned its attention to London: not to the traditionalist city of old, but to the new Swinging London of Carnaby Street and the King's Road. This group also included young women, who were joining the workforce in greater numbers and wanted to assert their own independent style and personalities. Fashion became flexible and communicative.[6]

This environment fostered the development of a 'fashion system', that is to say a system connecting production, designers, marketing and media, and early brands such as Armani, Versace and Valentino, among others, established an international reputation. Giorgio Armani, above all, was a true pioneer, not just in terms of style and designs. In 1978, together with his business partner Sergio Galeotti, Armani signed an agreement with GFT that would mark a turning point: the collections were conceived by the designer and then produced entirely on the factory floor under his supervision. This was the advent of industrially produced ready-to-wear clothing, bolstered by the recognition of young people as potential customers, served by diffusion lines and purpose-built brands, like Emporio Armani. Equally significant was the importance Armani attached to the media world as a means of promotion – consider, for example, Richard Gere's Armani wardrobe in the film *American Gigolo* (1980; pl.155). In the same way, Gianni Versace sensed that fashion models had an important role to play and was instrumental in developing their status as new beauty icons and advertising vessels, while Valentino maintained a close link between the refinement typically associated with Parisian haute couture and his ready-to-wear garments (pl.216).[7]

It is interesting to note how this process leading to the profession of the fashion designer in a sense parallels that which first saw the designer emerge in the furniture world. This development also clearly stemmed from the period between the two world wars, with architect/designers such as Giuseppe Terragni and Giò Ponti becoming established in the following years thanks to the close collaboration between creative minds designing simple, essential objects and large and small firms. This was the birth of Italian design, which saw designers such as Ignazio Gardella, Franco Albini, the Castiglioni brothers, Ettore Sottsass and various others become household names. The message that emerges from both cases is clear: even everyday objects like clothes and furniture can have aesthetic meaning and enhance the interior landscape of our homes. Beauty is not limited to the exclusive worlds of museum art or high culture, and can instead grace our day-to-day lives: no longer a privilege exclusive to a select few, we can all enjoy its value.

The Manufacturing Structure: Industrial Districts

One of the keys to understanding the success of fashion designers from the 1970s onwards is their ability to work in synergy with a manufacturing landscape of small and medium-sized businesses, whose flexibility and adaptability made them particularly well suited to catering to the demands of the fashion market.

As far back as the nineteenth century, economist Alfred Marshall had noted how evolution towards a well-structured large firm was not the only feasible path to successful manufacturing. Observing the textile manufacturers based in Lancashire and Sheffield, he coined the term 'districts' to describe an area specializing in a specific production activity, marked by a certain social uniformity and home to both collaborative and competitive relationships. In Italy, in the years after the Second World War, various industrial areas began to approach this definition. In a country where large-scale enterprise had never been of vital importance – except in sectors such as engineering, energy and the chemical industry – manufacturing districts developed in many regions of northern and central Italy, specializing in 'traditional' sectors, especially consumer goods, most notably textiles, clothing, footwear and accessories (pl.217). The distinguishing traits of these industrial districts were a horizontal division of work, namely between different firms, rather than vertical, that is to say within the same firm; strong links with the local area; the presence of external economies and support structures, such as small local banks; and, lastly, a strong reference to family ties that often united the various firms/families, creating a relationship of trust and cooperation that was first and foremost personal rather than exclusively commercial. All this

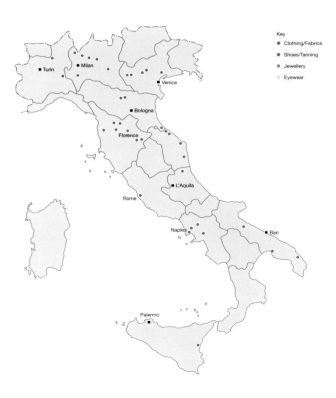

Key
- ● Clothing/Fabrics
- ● Shoes/Tanning
- ● Jewellery
- ● Eyewear

was grounded in an age-old tradition of technical know-how and craftsmanship, with some production processes even being associated with certain areas for centuries: Florence was known for its straw products (pl.218) and Como for its silk, there were the tanneries of Tuscany and the tailor's shops of Naples.

The role played by these industrial districts in the development of the textile and fashion industries was not apparent from the very beginning. Like the public, scholars were still generally of the opinion that large firms would always deliver industrially produced items of superior quality, being the only entities capable of combining innovation, economies of scale, far-reaching business relationships and efficient organization, and hence playing the leading role in driving development. It wasn't until the 1980s that economists comprehended the manufacturing and employment potential of the districts and a wealth of research was initiated.[8] In 1991 this culminated in a law that defined and identified Italy's industrial districts, even giving them legal status as integrated and specialized production areas marked by the presence of small- and medium-scale industry.[9]

A broad census based on these new definitions conducted in 2001 led to the first complete picture of the districts. According to this survey, out of the total number of 156 industrial districts recorded, no fewer than 45 specialized in textiles and clothing (the highest single number), with 63,954 manufacturing units and 537,435 employees. We could add to this a further 20 districts specializing in leather, hides and footwear, with 23,441 manufacturing units and 186,680 employees. Overall, the fashion sector employed around 700,000 people.[10] It is worth noting that in some places a large chunk of the population was employed in manufacturing: in certain districts, the percentage of people employed in the dominant sector was well in excess of 40 per cent of the population.[11]

From a geographical point of view, Lombardy, the Veneto, Tuscany and Piedmont were the regions that stood out in the textile and clothing sector, while the dominant regions in the leather sector were the Marche and the Veneto.[12] Going into further detail, the following areas proved to be particularly important in the textile sector: Biella (with 22,742 employees), Carpi (11,647), Como (21,991), Busto Arsizio (29,113), Prato (41,449) and also Castel Goffredo and Vicenza, which represented highly specialized fields, such as hosiery. The outstanding districts when it came to leather were Santa Croce sull'Arno (with 16,203 employees), Civitanova Marche (15,822), Arzignano (11,333 employees) and Montebelluna (6,161).[13]

Overall, the fashion sector was backed by a highly diversified manufacturing structure featuring large firms built on long-standing traditions, especially in textiles, along with thousands of small integrated manufacturing units that were highly skilled in manufacture, swift to change and adapt designs, techniques and products to meet any demand, and capable of offering competitive production costs relative to quality.

The Distinguishing Traits of Small Firms

Numerous studies from the 1980s onwards analysed the distinguishing traits of the small firms that made up the fabric of Italy's manufacturing districts, in search of the secret of their success. What set small firms (officially defined as having fewer than 50 employees, even though they were often little more than family businesses) apart from their larger counterparts? To start with, it was easy to see the disadvantages: smaller economies of scale, unfavourable conditions when it came to purchasing and storing goods, limited resources to devote to marketing and advertising. Small firms were particularly vulnerable to changes in the economy and were more dependent on services and public organizations, especially banks and credit institutions, not to mention the fact that they basically had no political representation.[14]

However the districts' small firms were able to focus more on the pursuit of quality rather than quantity, since achieving continuous growth and expansion was not usually their aim. In addition, because they were better equipped to adapt to the market and were ultimately more flexible, these companies were attractive to designers, with their often fickle demands. Then there were those all-important reasons that had nothing to do with economics: numerous studies pointed to the fact that profit was just one of the factors motivating the owners of small firms. Just as important were the pursuit of social status; the identification with the place of work and the local area; the will to succeed and seek a sense of personal achievement; and the desire to put the family on a solid financial footing, perhaps founding a small dynasty. The presence of family members in the workplace – which, according to some theories, would be expected to create problems and tension given that different values inevitably came into play – instead served as a positive cohesive factor, somehow shielding the family psychologically from the external environment and helping them through rough patches. At the same time, though, this close connection between family and business had negative repercussions, such as low capitalization of the firm due to the family's determination never to resort to external financing in order to maintain control; and the fact that there was a tendency to fill company positions with family members, even if external candidates had better technical and professional qualifications. Various analyses also underlined how this structure could foster a certain tendency towards authoritarian paternalism, which led to children being treated as subordinates, relegating them to a lesser role within the family as well as at work. It comes as no surprise, therefore, to find that the most difficult stage in the history of these small firms arrived when it was time for the children to take over, due to the blurred lines between entrepreneur and company. In many cases, this transition could even result in the company being sold or closing down, despite very healthy balance sheets. Only if this crisis could be overcome without trauma were the foundations laid for the business to flourish in the long term. [15]

Lastly, the predominant role played by small companies in the Italian fashion industry can be attributed to more general dynamics. In a mature and fiercely competitive industrial market, residual spaces or niches are created that are not suitable for large-scale firms, either because they do not promise enough profit or because they call for overly rapid changes or because they target a limited consumer base. In this case, which is typical of certain luxury products, small-scale companies operate more easily and produce good financial results.

Financial as well as deep-rooted social and cultural factors therefore explain the unique qualities of the districts' businesses, which offered traits particularly well suited to designers' demands. They were able to produce their models all in one place, possibly after ordering fabrics in special colours and patterns elsewhere. In the district, different businesses would cut the fabrics, sew the pieces, add or even make the required accessories, package the product and send the finished item to the fashion house. A perfect manufacturing organization, with the difference that it was spread across a large area rather than being contained inside one big factory.

The Role of Women

There seems to be a significant pattern of male dominance among entrepreneurs within the fashion industry, given the traits of the manufacturing firms. So what is the role played by women in these small manufacturing units and, more generally speaking, in the wider field of fashion? Studies conducted on the role of women, especially research into the business history of Italy and elsewhere, have already highlighted some basic elements. To start with, they reflect on how women are historically less present in businesses as a result of well-known socio-cultural factors, which are more apparent the further back in time we go. However, recent studies have shown that, in many cases, it is more a matter of women being 'invisible', due to a variety of factors, rather than actually being absent from management positions within companies.[16]

Firstly, women very often work (and have done for decades) in sectors that are deemed marginal and have therefore been less closely analysed by historians or are less frequently the subject of public discussion. This is certainly the case with businesses involved in the manufacture of clothing, accessories or leather goods, perhaps a little less so with textile companies.

Consequently, these are fields that lack the research or knowledge base that would make it possible for them to be compared with major branches of industry such as engineering, farming and finance, for example.

Secondly, as mentioned earlier, women in the fashion industry mainly work in very small firms, not in large companies. These leave behind fewer traces and documents than major corporations, making it difficult to procure accurate data on the actual internal workings of family-run businesses.

Thirdly, women often work in roles that are not officially recognized. The public and legal documents produced by a company, such as those recording legal and financial transactions, company positions and contracts, almost always feature the names of the men running the business. These documents do not attest to the informal side of company life and hence the roles played by women who, unlike those men, often provide informal services and do informal jobs, without pay. A typical case would be the entrepreneur's wife, who does not hold an official position but is always in the wings and so closely involved in her husband's business as to be able to take his place at a moment's notice should the need arise; or the woman acting as

'informal financier', procuring the capital the business needs but without being appointed to an actual job. The economist Federico Caffè once made a light-hearted comment on this paradox, which results in distorted official statistics, saying that if he had married his housemaid, he would have brought down the country's GDP, given that her previously paid-for services would have become free and consequently would have 'disappeared' from the official tally. For this reason, especially in an industry like fashion, it is important to use a broader and more flexible concept of 'entrepreneur' that takes into account both formal and informal aspects and the variability of historical and geographical situations.

From the very beginning, there has certainly been no shortage of leading female designers and entrepreneurs, starting with Simonetta Colonna di Cesarò (see pl.46).[17] Involved in the high-fashion business from the early post-war years, she was highly regarded in the United States and later in Paris, a city she moved to in the 1960s, following the path taken some decades earlier by Elsa Schiaparelli. Perhaps a more typical case of a female entrepreneur might be Mariuccia Mandelli, better known as Krizia, one of the pioneers of ready-to-wear clothing (pls 219 and 220). Her beginnings can be traced back to a small artisan business run with a handful of workers in Milan. The company was founded in 1954, and in the early days, Krizia took part in industrial fashion fairs, like the clothing show in Turin in 1957, and later in prestigious events like the Palazzo Pitti show in Florence in 1964 and the Milan shows from the 1970s onwards. Krizia expanded fairly quickly, opening a factory near Milan where garments are produced from fabrics made with original materials and exploiting new developments in knitwear production. Here, then, we have an example that shows the market's openness to new names, including those of women.

Typically, women are perceived as playing the role of the entrepreneur's wife within the firm, sharing the husband's business completely but generally holding a more low-profile public position, as mentioned earlier. One counter-example is of Ottavio and Rosita Missoni, a couple who always shared the production and creative workload (pl.221). From the beginning, Ottavio Missoni had a particular passion for sportswear, thanks to his own successful athletic career, which saw him take part in the final of the 400 metres at the London Olympics in 1948, while his wife Rosita Jelmini boasted a family background in the clothing business. Focusing on knitwear in bright colours, they managed to interpret the transformations of a fashion for less formal, more relaxed clothes. Within the space of a few years, their original small business on the outskirts of Milan, which they had opened in 1954 next door to their home, had grown into a large company with premises on the outskirts of Varese, where they were gradually joined by their children. Illustrating the importance of their marital collaboration was Ottavio Missoni's reaction to being awarded the *Cavaliere del Lavoro*, the Order of Merit

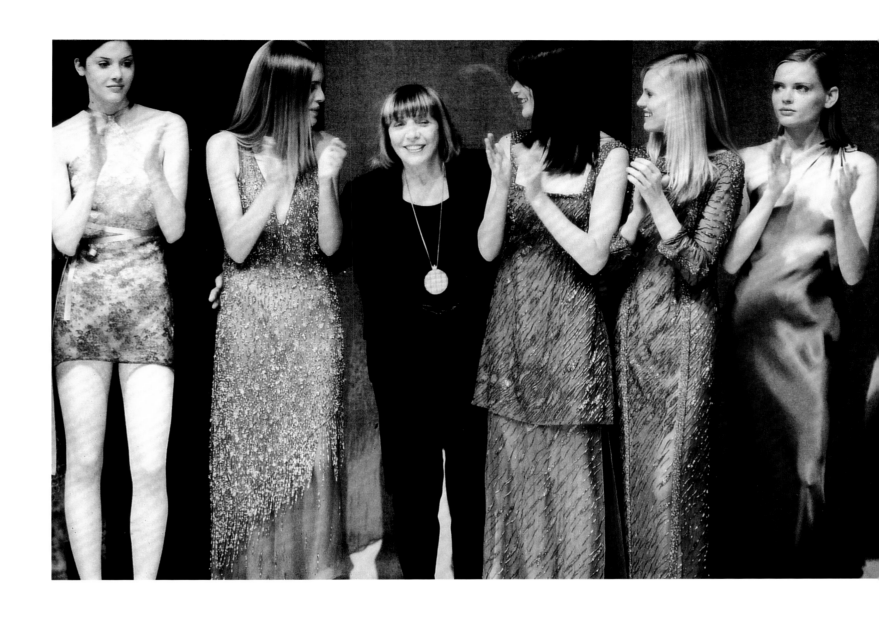

221 Rosita and Ottavio
Missoni, *c*.1990

Opposite
222 Ferragamo clients'
shoe lasts, 1952

223 Wanda Ferragamo
and her children, 1997

for Labour, for his services to industry in 1993. He was angry that his wife Rosita was not included in the honour, thus publicly acknowledging the importance of their working relationship.[18]

Just as interesting is the case of another couple, the Ferragamos, who were in the footwear field. Born in 1898, Salvatore Ferragamo emigrated to the United States at a very young age and his creations proved particularly popular in Hollywood, where his list of important clients included movie stars of the time (pl.222). On returning to Italy in 1927, he opened a small family business in Florence, which continued to flourish even through the trying period of fascism and war. In 1940 he married Wanda Miletti. Ferragamo died in 1960, leaving behind an internationally successful business, and his wife took up the company reins, aged 38 and with six children in tow. The business went on to enjoy another major international growth spurt, not only successfully cementing its position in the very lucrative footwear and leather goods industries, but even branching out into perfumes and clothing, to the point of becoming one of the most highly regarded companies in the field. All this at the hands of Wanda Ferragamo, who very much played the leading role in forging the destiny of her family's business, despite the brand bearing only her husband's name (pl.223).

The handover of businesses from their 'founding fathers' to new female management becomes perhaps even more evident if we take a look at generational transformations. One of the biggest names in Italian fashion today has its roots in the work of Mario Prada, a craftsman who began producing bags and luxury leather goods in the centre of Milan in 1913 (pl.224). On his death in 1958, his daughter Luisa took control

of the company and 20 years later her own daughter, Miuccia Prada, stepped up to the top job (see pl.69). The Prada brand expanded in the 1980s, growing on both the design and the business front, partly with the aid of Miuccia's entrepreneur husband Patrizio Bertelli. Together, the couple launched innovative accessories, including bags made from unusual materials, and held their first fashion show in 1988, which would be followed by men's and sportswear collections as well as a diffusion line, Miu Miu. In this case, therefore, it was with the arrival of the young female generation that the typical roles of the couple were partially reversed, to better interpret a modern image of luxury and elegance – a result in some way attributable to a complex production system that has key factories in Milan and Tuscany, while also employing the services of many independent producers.

The Globalization of Fashion

The world of fashion, by its very nature, has always been international. Nevertheless, since the end of the twentieth century, the globalization of markets has had a particularly strong effect on the Italian fashion system. The first consequence was the rapid growth of outsourcing, whereby certain stages of production, and sometimes even the manufacture of entire products, were moved to factories far from Italy in order to seek out new markets and, above all, to cut production costs. It is hard to put a figure on this phenomenon, which is partly concealed by the fact that products are finished in Italy so that they can still be labelled 'Made in Italy', but the key players were undoubtedly countries such as Turkey for the production of leather goods and various Asian countries, including India and China, for the production of textiles and clothing.

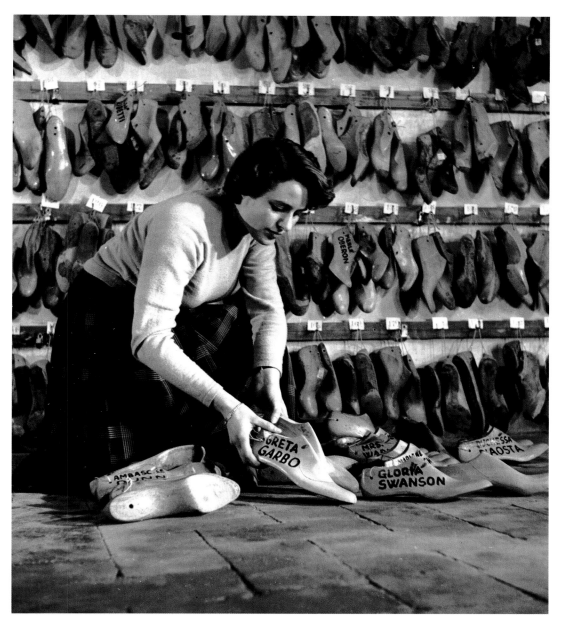

224 Advertisement for Fratelli Prada, *Illustrazione Italia*, September 1937

Opposite left
225 Pucci catwalk show, Spring/Summer 2013

Opposite right
226 Gucci catwalk show, Spring/Summer 2013

It is also worth mentioning that this practice has been the subject of controversy; it has led to proposed European Union regulations to accurately identify the place of manufacture and fuelled many union protests given the loss of jobs. However, market dynamics are still steering these developments.

The second consequence has been a considerable interpenetration of Italian and foreign capital. Fashion businesses, which were becoming more and more multinational, with complex creative, manufacturing and administrative structures in dozens of different countries, began adopting the same approach as large corporations in other industries. This resulted in many international takeovers. In several cases, the leading players were large Italian corporations buying companies abroad: consider, for example, the emblematic case of the English footwear manufacturer Church's being taken over by the Prada group in 1999, or the takeover of one of America's oldest fashion houses, Brooks Brothers, by the Retail Brand Alliance, in turn controlled by the Del Vecchio family, owners of Luxottica eyewear. Similarly, many Italian businesses now have foreign owners. Bernard Arnault's luxury goods conglomerate LVMH (Moët Hennessy-Louis Vuitton) owns Pucci (pl.225), Acqua di Parma, Fendi, Bulgari and Loro Piana; another French group, François-Henri Pinault's Kering, controls Gucci, a landmark Italian brand (pl.226), in addition to Bottega Veneta, Brioni and Sergio Rossi. Other prominent Italian fashion brands have been bought with capital from the Middle East. The Dubai-based Paris Group has taken over Gianfranco Ferré and Qatar-based Mayhoola for Investments has bought Valentino (pl.212). On the one hand, therefore, we have seen the

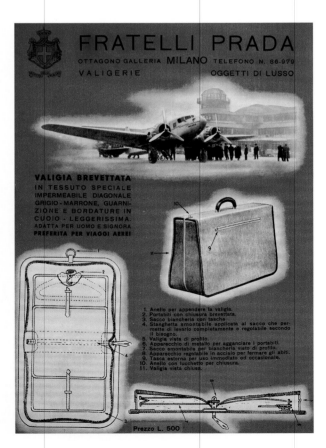

strengthening of multinational centres of luxury; on the other, the growing attractiveness of Italian fashion brands as an investment for financial funds. Whatever the case, the internationalization of manufacturing and, dare we say, of the values associated with Italian fashion, is a *fait accompli*.

Another aspect that characterizes the fashion system in the twenty-first century is the focus on distribution. Having channelled considerable efforts into the creative side of the business as well as into manufacturing and advertising, companies now focus to a large extent on distribution channels, especially retail outlets. Until a few decades ago, and certainly at the dawn of Italian fashion, most sales were conducted over the counters of department stores or luxury boutiques that offered customers numerous labels. Over the last 20 years, the major fashion brands have opened a large number of directly operated stores. These have proved essential to the strategy of foreign distribution, especially in the emerging markets of Brazil, Russia, India, China and South Africa, which lead the recovery following the financial crisis that began in 2008. By avoiding intermediaries, these stores also ensure wider profit margins. Finally, fashion companies also communicate the values of their brand and its positioning through their stores, thus strengthening the image of a brand that is no longer linked to individual products. The Prada group, as of 31 July 2012, had 414 of its own stores, accounting for over 80 per cent of total sales.[19] A younger but internationally very important company – the one created in 1985 by Domenico Dolce and Stefano Gabbana, who have always been very careful in their choice of brand communication, employing endorsements and 'concept stores' – currently has 251 directly operated stores in 40 countries.[20]

In light of recent developments, what picture does the Italian fashion system present today from a manufacturing point of view? The answer is inevitably complex since we are faced with a composite world, capable of bringing together artisan micro-enterprises, businesses based in industrial districts (which have dropped in number but are still highly efficient), large modern companies and outsourced manufacturing, often with finishing carried out in Italy. In 2011, the Italian textile and fashion sector alone recorded 52,768 million euros in total sales (up 6.3 per cent from 2010), with a strong export bias, 51,873 companies (down 2.3 per cent) and 446,900 employees (down 2.6 per cent); it accounted for 29.5 per cent of sales and 35.5 per cent of the total number of companies in this sector across the 27 member states of the European Union.[21] These figures attest to the creative and manufacturing vitality of an industry that has grown globally within the space of a few decades, an industry that successfully projects its message of making aesthetics and luxury accessible to the whole world.

Emanuela Scarpellini is Full Professor of Modern History at the State University, Milan, and director of the MIC Center for Fashion Studies

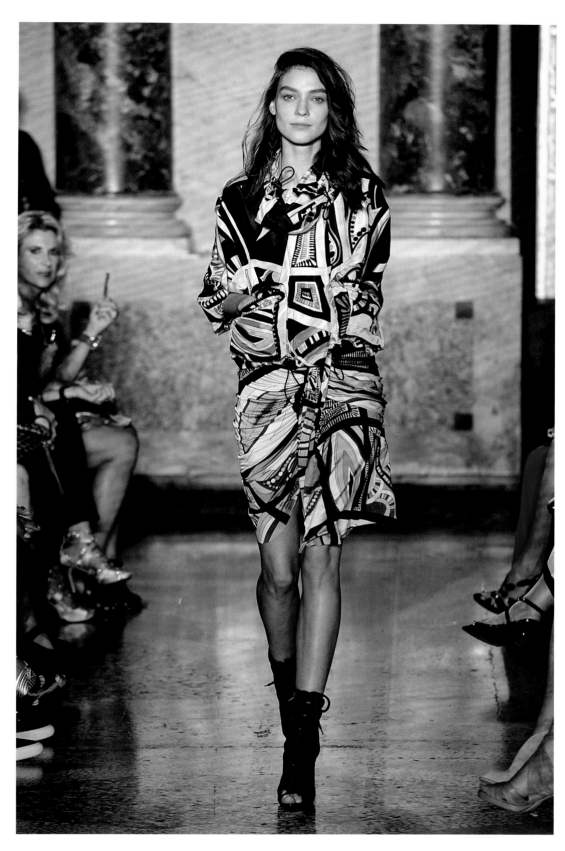

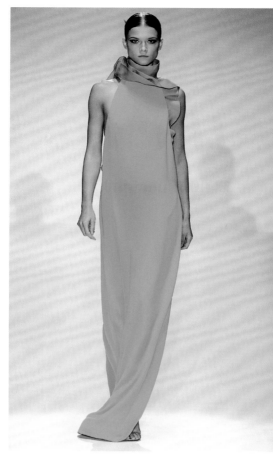

Communication in the Fashion System

Elena Puccinelli

In the 1970s Milan emerged as Italy's fashion capital. There were many reasons for this supremacy, including the city's location at the heart of a region that was home to many small- and medium-sized textile companies, garment manufacturers and leather specialists; a well-developed credit system and a widespread network of services and infrastructures. Italy's principal fashion and women's magazines were also based in Milan, as were prestigious communication and advertising agencies. The birth of *Milano Collezioni* in 1978 – the Milan fashion shows as we know them today – was the result of a complex historical process.[1] The boom years of the 1960s saw Italy undergo profound social, cultural and economic changes. Models of life arising from Italy's class-based divisions or associated with its agrarian past were undermined or made obsolete. Women and above all young people emerged as the new subjects of consumerism, as they demanded from the fashion industry products they could relate to, that could give a measure of their social prestige and an indication of their newfound rank and status.[2] Indelibly linked as it was to an elite and traditional model, couture was no longer in a position to respond to those needs, nor could such demands be met by a clothing industry that had developed in the previous decade through a straightforward quest for quality combined with continued growth, but which was facing a production crisis at this time.[3]

The answer came in the form of shops selling British, French, and Italian ready-to-wear as well as used clothes or traditional dress, which went on to become the drivers of the Italian manufacturing system and its qualitative leap forward. A number of these boutiques started designing pieces they sold under their own labels or gradually transformed themselves into small enterprises specializing in ready-to-wear garments (see pp.51–7). It was at this time that the figure of the fashion designer started to emerge. The role of the fashion designer should not be confused with that of the couturier, or a manager of a clothing business. The fashion designer is charged with running a system that controls the conception, development, production and ultimate consumption of the product. His or her role is to facilitate the passage to a planned production, and ready-to-wear was thus the outcome of the union between designers – initially Paris-based like Karl Lagerfeld, Emmanuelle Khanh and Christiane Bailly and then later Italian designers like Walter Albini, Luciano Soprani and Gianni Versace – with textile manufacturers such as Basile, Girombelli, Papini, Missoni, Maramotti, Zanini, Billy Ballo and Cose.

Before long, the need to identify the people who would buy the item of clothing being conceived, with their specific needs and psychological and cultural traits, made clothing manufacturers ever more aware of marketing processes, from merchandizing and promotion to advertising and image creation. The designer was called upon to create a strong image, and the elements he or she leveraged to that end were drawn from show business, the visual arts, music, graphic design and photography.

It soon became apparent that the fashion shows held at the *Sala Bianca* in Florence, originally conceived to provide an overview of Italian fashion, were not suited to representing the complexity of the message projected by an entire ready-to-wear collection. In 1972, Walter Albini, who two years earlier had shown the standard 16 dresses in Florence – eight of which were black and entitled *le vedove* (the widows) and eight flesh-coloured and entitled *le spose* (the brides), all inspired by the 1920s – organized a mammoth show, presenting 177 combined looks at the Giardino

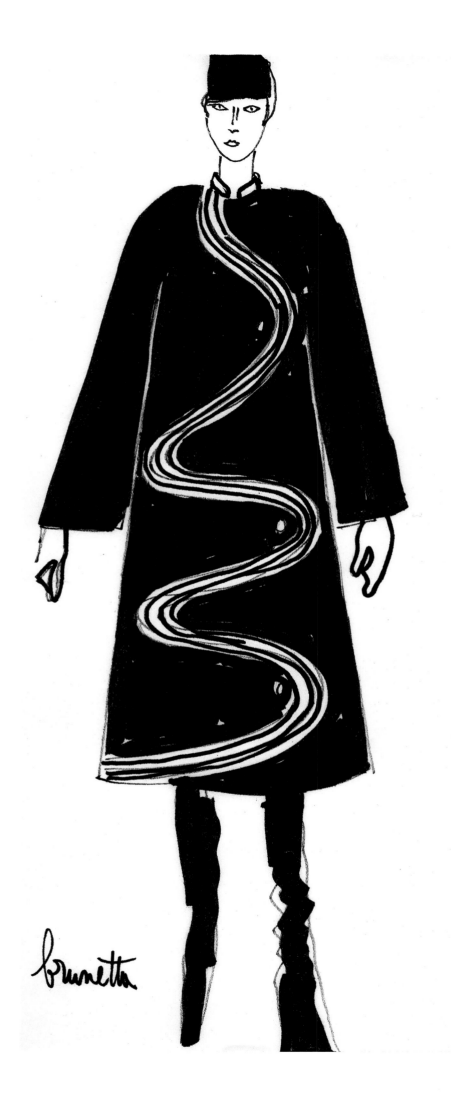

Brunetta

Alta Moda

versione elegante
della pelliccia con
tracciato di "muraglia
della Cina", innesto
a righine bianche e
nere

(Pelliccia moda)

di Milano club. This grand event marked the end of the old format of fashion presentations, held inside couture houses and intended for a restricted group of clients. Albini's spectacle helped establish the importance of the fashion show within ready-to-wear's complex communication system. Many fashion brands were being launched at this time and presented themselves to the public with a completely different language from that of the past. Hotels, cafés and restaurants became the preferred locations in which to showcase fashion in combination with an element of spectacle, conceived in such a way as to make an impression on clients and influence their choices. Each catwalk show constituted a proposition as well as a choice in terms of image and style through which the fashion house addressed its public.

By the time *Milano Collezioni* was launched in 1978, the principal fashion brands were established and the ready-to-wear sector clearly defined. The clothing employers' union, the *Associazione Industriali dell'Abbigliamento* (Industrial Clothing Association), had made the decision to move in favour of the Milan fashion shows, entrusting Beppe Modenese, a Milanese businessman, with the task of facilitating relations between clothing manufacturers and designers (see pl.54). After an initial failure, an agreement was reached with some of the more forward-looking entrepreneurs, such as Monti, the Missonis and Mariuccia Mandelli (Krizia). The shows were to be held at the home of the Milan Fair, a truly inspired choice of venue as it focused on an image of Milan as a place where fashion and industry come together. The *Fiera Campionaria di Milano* is a trade fair that has its origins in the *Esposizione nazionale* held in the city in 1881 and the World's Fair of 1906. Set up in 1920, *Fiera Milano* was allocated its definitive location at Nuova Piazza d'Armi in 1923. Dozens of annual events are held there, emphasizing the relationship between Italian creativity, design and light industry. The most important of these events is the *Salone internazionale del mobile*, colloquially known as the Milan Furniture Fair. From the second half of the 1970s, *Fiera Milano* became Italian fashion's most important international showcase, promoting everything from leather goods, footwear and fur to ready-to-wear and textiles. The success of *Milano Collezioni* was confirmed in October 1979, when participants included Versace, Fendi, Basile, Missoni, Caumont, La Viola, Ken Scott, Biagiotti, Complice, Armani, Krizia, Ferré, Albini, Massei, Genny, Sanlorenzo, Callaghan, Geoffrey Beene and Miyake.

In the 1980s and '90s, the collaboration between designers and manufacturers continued to develop, further changing the fashion industry as a result. These decades saw the rise of the big brands; the power of the brand became greater and designer labels started to dominate the fashion business. Those were the 'total look' years, when designers achieved god-like status, emerging as cult personalities who imposed lifestyles and trends with the help of the media. The fashion label suggested exclusivity and prestige, it contained an aesthetic ideal that allowed consumers to opt for the lifestyle they wanted. Fashion companies created new worlds, each with their own set of aesthetic values, emerging as phenomena of communication, even more so than of the actual product. Designer brands sought a defining image and advertising became a key instrument in constructing the meaning of fashion.

Against this background, the field of communication became crucial. Thus, the progression of the Italian fashion industry saw the parallel development of related skills and professions.[4] Barbara Vitti (pl.228),[5] the undisputed champion of Italian public relations whose clients included Giorgio Armani, Valentino and Versace (pl.229), said in 1988 that the success of Italian fashion was 'a boom of

ideas, professional skills, industrial capacity, and the humbleness to realize that talent, creativity, had to be tempered to entrepreneurial requirements. The main character was the product. Followed closely by the personalities involved, which would have been silly not to capitalize on in order to attract greater media attention.' According to Vitti, the press played a key role in the 'miracle' of Italian fashion and the way it ultimately took off: 'There cannot be a market without communication, without information.'[6]

Alongside Franco Savorelli di Lauriano[7] and the previously mentioned Beppe Modenese, Barbara Vitti was a pioneer in turning public and press relations for fashion houses into a full-time career. Not fully developed as a profession until the 1980s, the public relations representative (PR) was still a completely new professional figure in the 1960s. In the realm of professions related to the fashion industry, non-exclusive PR experts had for years been performing a role that was not unlike that of the in-house PR and press officers at various brands, such as Rita Airaghi at Ferré; Emanuela Schmeidler at Versace; Rossella Mauri at Krizia; Giovanna Sioli at Missoni; Daniela Giardina at Valentino; Karla Otto, Carla Buzzi and Antonella Zunino at Dolce & Gabbana and Marina Fenghi at Curiel, to name but a few. Feared, courted, and much in demand, these fashion communications experts elected Milan as their headquarters. As the

image creators, theirs is a difficult and ambiguous role, requiring innate gifts such as grace and understanding combined with rigorous professional skills. A good PR and an effective press office can both create and maintain their clients' fame.[8]

Over time, fashion communication came to be dominated by the visual elements: samples, showrooms, photographs and videos, in addition to presentations and catwalk shows. Characteristic of the industry, the latter are the culmination of the work of all those involved in the fashion business, especially the PR people, who bring the fashion designer, the buyers and the specialist press together. Targeting originality and distinctiveness, the dominant element of catwalk shows at present is spectacle, with today's fashion shows including concerts, ballets, choreography, videos and art installations. These shows are then supported by an impressive array of print publications, including books and catalogues that contribute to transforming fashion into culture, into something of ever-growing importance – not to mention the internet, where catwalk shows are broadcast almost simultaneously or exclusively.

In advertising, the message put out by the big labels differs from that of the smaller fashion houses, whose ads will usually show the item of clothing worn by models, depicted next to the company's logo. Rather than staging the product, big labels display atmospheres, scenarios, lifestyles, ways of life and behaviour. As forms evolve, advertising abandons the field of seduction to seek surprise. The paradoxical creates incongruities by stepping out of the accepted norm, capturing our attention and interest by catching us off guard. In this area, Barbara Vitti was a pioneer. Consider for example Giorgio Armani's decision to announce the opening of his Emporio Armani stores in 1984 through huge billboards, such as the one put up at via dell'Orso in Milan, of a type that had never been used before in the fashion industry (see p.147). To promote Emporio Armani, his second line, Armani used a communication tool traditionally favoured for advertising household appliances. He had sought an alternative language to advertise a range that targeted a wider, younger audience. The location he chose was strategic: highly visible and in a central, elegant street. The success of this experiment led to it being repeated in other cities.

The privileged interlocutors of the PR people are the media – daily newspapers, magazines, television and cinema.[9] In the 1960s, lifestyle or women's magazines increased the information and advertising tools available to fashion-related industries, which provided promotional material firmly believing in the strategic benefit of appearing on the printed page. Thanks to their ability to connect the different players involved, magazines actively participated in establishing the Italian fashion system. Magazines in Italy can claim a long-standing function in changing the course of fashion consumption, going back indirectly to the eighteenth-century gazettes of French derivation and more directly to the gossipy women's

Opposite
230 *Time*, 5 April 1982

231 *Amica*, 24 September 1968

magazines founded in Milan in the 1930s. The latter included *Lei*, a magazine published by Rizzoli that was later renamed *Annabella*, then *Anna* and is today simply called *A*. Reflecting the changes taking place in society and especially in the role of women, numerous new magazines were established after the end of the Second World War. Having gained the right to vote after the First World War, Italian women now had greater access to higher education and to more professions. They also became the protagonists of a newly consumerist society. In the pages of women's magazines and fashion periodicals readers sought not only escape but also practical advice on fashion, beauty, health, cooking and relationships.

Milan emerged as the capital of Italy's periodical press; it was also home to the country's principal publishing houses. These houses gradually started a process of concentration that over the years saw the establishment of the large publishing conglomerates we have today, namely RCS Mediagroup, Mondadori, Condé Nast and Hearst (the current owner of magazines originally founded by Rusconi and later Hachette). The 1960s saw the birth of titles such as *Vogue Italia* and *L'Uomo Vogue*, *Amica* and *Linea Italiana*. In this wide field, the monthly with the greatest authority was no doubt *Vogue Italia*, heir of *Novità*, the magazine conceived by Emilia Rosselli Kuster in 1950.[10] *Vogue Italia* stood out not only because

of its international outlook and the quality of its printing and photography, but because of its articles, which focused above all on the style and design aspects of fashion (see pp.249–54).

Mainly interested in fashion's artistic paradigm, *Vogue Italia* addressed the refined and cultured classes, a readership that was also involved in the complex goings-on of the magazine itself by virtue of organizing charity events, exhibitions and holidays in the most exclusive spots, which were then covered in the magazine's pages. For example, several women belonging to the aristocracy or *haute bourgeoisie* opened their houses to *Vogue* reporters, agreeing to model clothes on an exclusive basis. And if they worked, these women would give readers a tour of their ateliers, presenting their latest collections. The magazine also showcased the best of *Vogue*'s international editions. Advertisements for less expensive products disappeared from its pages, as did those that were not fashion-related. Dressmaking patterns, too, were scrapped in order to give more space to ads for prominent textile, leather and cosmetics companies, for the magazine's aim was to position itself as an irreplaceable source of specialist information. Only on these pages was fashion considered as a manufactured or commercial product: in the rest of the magazine, fashion was treated as a record of the costume and culture of the period. Fashion was regarded as a work of art, a concept expressed through the magazine's photography, language and graphic layout. As for the creation of fashion, emphasis was placed on its formal aspect, its design and the impact it had on people's taste and way of dressing.

A similar philosophy was shared by *L'Uomo Vogue*, which was first published in 1967 as a supplement of *Vogue Italia* before emerging as an independent magazine. With Franco Sartori as its editor-in-chief, the magazine's editorial board included the likes of designer Chino Bert and art director Flavio Lucchini, while the photographers Ugo Mulas and Oliviero Toscani were responsible for the magazine's image. *L'Uomo Vogue* set out to give menswear personality, a goal that fashion houses were also attempting to achieve in those years. To this end and to overcome prejudice, the magazine initially opted for non-professional models, chosen from among the big names of show business, politics and art, or by going back to characters of the past. The success of *L'Uomo Vogue* reflected that of 'Made in Italy' to the extent that by the 1980s, under the direction of Cristina Brigidini, the monthly magazine had established itself as the undisputed point of reference for menswear at an international level.

Another influential publication was *Amica*, a weekly magazine belonging to *Corriere della Sera* that was launched in 1962 (pl.231). Under the direction of Enrico Gramigna, the magazine could rely on collaborators like Flavio Lucchini, the illustrator Brunetta Mateldi (pl.227) and writer Dino Buzzati. Initially focusing on fashion that was simple, practical and easy to wear, before long *Amica* was required to

transform itself into an information and advertising vehicle for fashion-related industries. While articles dedicated to couture provided glossiness, *Amica* nevertheless continued to uphold the new ready-to-wear philosophy, a memorable example of which was a famous campaign orchestrated by five PR experts representing five different labels. The so-called 'Group of Five', formed by Barbara Vitti, who was working for Hettemarks, Sergio Levi at Turin's Gruppo Finanziario Tessile, Gianfranco Bussola at Marzotto, Francesco Balduzzi at Ruggeri and Achille Maramotti, the founder of Max Mara, met regularly in Milan to discuss communication strategies, relationships with publishing houses and which trends to introduce in order to cross-fertilize their promotions. Out of one of these meetings came the decision to launch the fashion for red coats on the pages of *Amica*: five different looks, one for each fashion house. The promotional campaign was intensive and shop windows everywhere displayed the coats, which became that year's must-have garments.

In 1965, *Linea Italiana* was founded by the small Milanese publishing house Aracne, then aquired a year later by Mondadori, one of Italy's most important publishing groups (pl.232).[11] *Linea Italiana* is remembered as the real manifesto of both Italian high fashion production and textiles (see p.85). Initially

a half-yearly publication, *Linea Italiana* was gradually transformed, becoming a monthly magazine in 1973. The Italian state saw *Linea Italiana* as an important communication vehicle and promoted it through the Ministry of Foreign Commerce and the Institute for Foreign Commerce (ICE), which distributed it internationally. The first issue's editorial, entitled 'High fashion and Italian textiles', outlined the magazine's objectives to 'illustrate the typical trends of high fashion, support the textile of national production'.[12] Colours and textiles are defined by *Linea Italiana* as the unquestionable strengths of Italian taste. The magazine's constant concern is to endorse the entire textile sector through specialized coverage, which includes a 'duty of technical information of fabrics and models'.[13] Catering principally to a professional readership, *Linea Italiana* aimed to facilitate contact between the two sectors, defined as the two engines of the industry. The two sectors needed to sustain each other, with a view to establishing a coordinated effort between creativity and manufacturing to stimulate the development of an Italian fashion system. The success of this approach, which culminated in the international triumph of Italian designers and the elevation of Milan to the status of fashion capital, was confirmed in the 1980s by the revitalized publishing industry with the launch of magazines such as *Donna*, *Donna più*,

Opposite
232 *Linea Italiana*, Autumn/
Winter 1968

233 *D* magazine, 27 May 1996

234 *Elle*, September 1989.
Photograph by Oliviero Toscani

Max, Italian editions of *Elle* and *Marie Claire*, as well as more specialist titles such as *Fur* and *Vogue Sposa*, a bridal magazine.

Donna, a magazine created by Flavio Lucchini, art director at the Rizzoli publishing group and founder of Edimoda, a new publishing house specializing in fashion, represented a manifesto for the era (see pl.139). Under editor-in-chief Gisella Borioli, the magazine's originality lay in its analysis of fashion as a social phenomenon bordering the world of design, while it was given a strong international outlook by the images of truly outstanding photographers such as Fabrizio Ferri, Giovanni Gastel and Oliviero Toscani. At the height of its success, *Donna* was the standard-bearer of Italian creativity. It is regarded today by fashion industry insiders as the institutional showcase of ready-to-wear, thanks to its international fashion coverage and interviews with influential designers such as Giorgio Armani, the Missonis and Krizia in Milan; Claude Montana, Thierry Mugler and Yves Saint Laurent in Paris and Norma Kamali, Calvin Klein and Ralph Lauren in New York, as well as major names such as Karl Lagerfeld and Vivienne Westwood. Although its scope was international, the magazine's main interest lay in Italian fashion, and thanks to its interview-based format, it succeeded in featuring the key figures of the industry. In addition

to those mentioned earlier, Walter Albini, Laura Biagiotti, Enrico Coveri, Gianfranco Ferré, Franco Moschino, Luciano Soprani, Valentino, Gian Marco Venturi and Gianni Versace also appeared in the magazine.

The year 1987 saw the launch of Italian editions of *Marie Claire* and *Elle*, founded in France in 1937 and 1945 respectively. Published monthly and edited by Vera Montanari, *Marie Claire* addressed women who were actively involved in the changes that Italian society was undergoing. Co-published in Italy by Hachette and RCS, *Elle* was first edited by Carla Sozzani and later by Daniela Giussani (pl.234). A highly sophisticated magazine in terms of content and images, it addressed a young, cultured, metropolitan woman interested in fashion and beauty. Thanks to the synergies achieved through collaborating with their international sister editions, the two magazines have been notable for their ability to anticipate the development of fashion at an international level.

The 1990s marked a watershed in the history of fashion and women's magazines with the launch in 1996 of *Io Donna* and *D – La Repubblica delle donne* (pl.233), weekly supplements of *Corriere della Sera* and *La Repubblica*, Italy's two major daily newspapers. Benefiting from the authority and prestige of the publications to which they belong, as well as sharing some of the newspapers' prominent journalists, both weeklies reflect the profound cultural transformation women have experienced since the 1960s. The size of the fashion sections in these magazines, the numerous pages of large brand advertisements, the glossy layouts and the slick photography are clear indications of the public's continued interest in fashion – an interest that is intercepted, through periodical publications as well as daily papers, by the advertising of the large international fashion and luxury groups that invest heavily in this form of communication.

Since the early 2000s all fashion and women's magazines have developed their online presence, either through the creation of websites, portals, apps or downloadable versions of their publications to be read on a tablet. Condé Nast publishes Style.it, a magazine that is available exclusively online, as well as the Vogue.it website. The blog of *Vogue Italia* editor, Franca Sozzani, is a leader of the genre (see p.265). RCS Mediagroup not only has the Leiweb.it internet portal, but also the *Lei* television channel. Similarly, numerous companies are now focusing their attention on e-commerce. Multimedia platforms have multiplied the communication options available, and today's readers, users and consumers enter a world where they themselves are protagonists: following the live stream of a catwalk show, sharing images on social networks and writing comments on issues that interest them.

Elena Puccinelli is an historian and archivist at MIC Centre for Fashion Studies, Milan

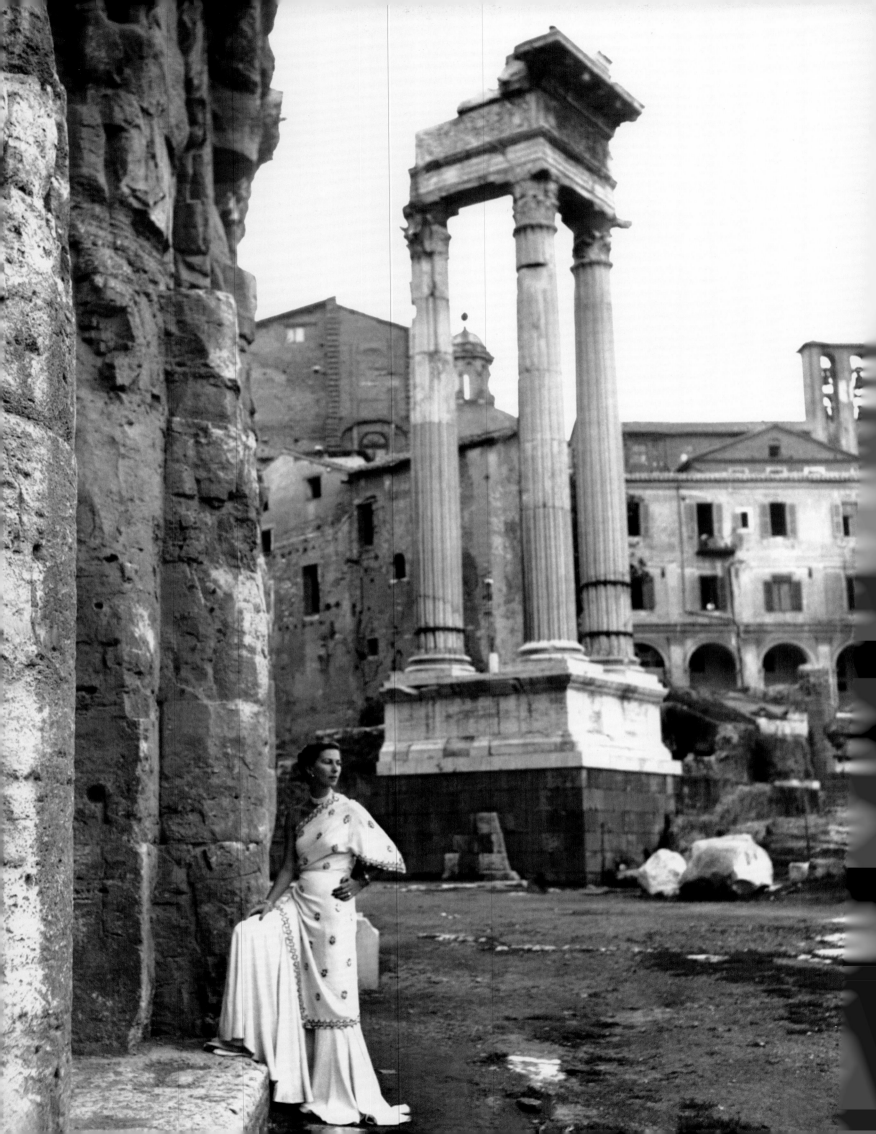

Lucia Savi

La Moda in Vogue

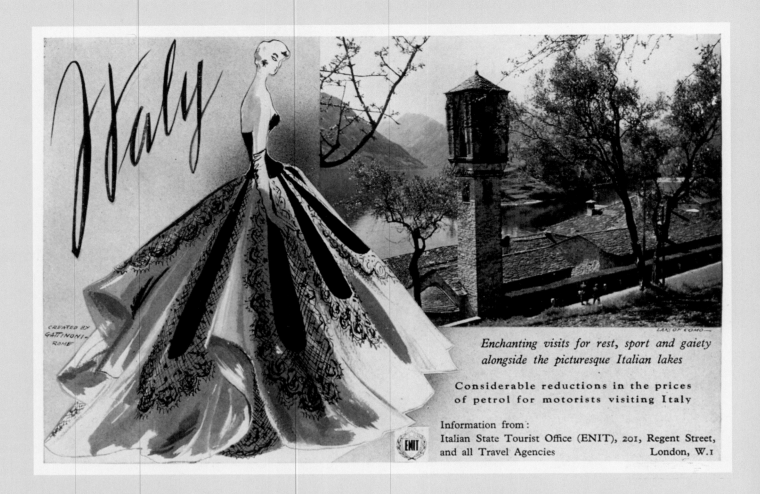

Enchanting visits for rest, sport and gaiety
alongside the picturesque Italian lakes

Considerable reductions in the prices
of petrol for motorists visiting Italy

Information from:
Italian State Tourist Office (ENIT), 201, Regent Street,
and all Travel Agencies London, W.1

Italian clothes are inclined to be as extrovert as the people who wear them, gay, charming, sometimes dramatic...

The pages of British *Vogue* offer a unique perspective on the rise of the Italian fashion phenomenon. This rich source documents the increasing foreign interest in Italian fashion in the decade from 1945 to 1955, a pivotal period that laid the groundwork for the development of an independent Italian fashion system.[1] The articles published in *Vogue* during these years illustrate the shift in Italy's fashion identity, from a post-war agrarian country that specialized in a few highly crafted products to the new European fashion capital, on a par with Paris and London.

In September 1946, *Vogue* published a seven-page article by Marya Mannes entitled 'The Fine Italian Hand'. This piece covered the most popular Italian designers of the time and was illustrated with photographic portraits of the designers and examples of their garments, most of them modelled by aristocratic women.[2] Mannes encapsulates the status of Italian fashion after the Second World

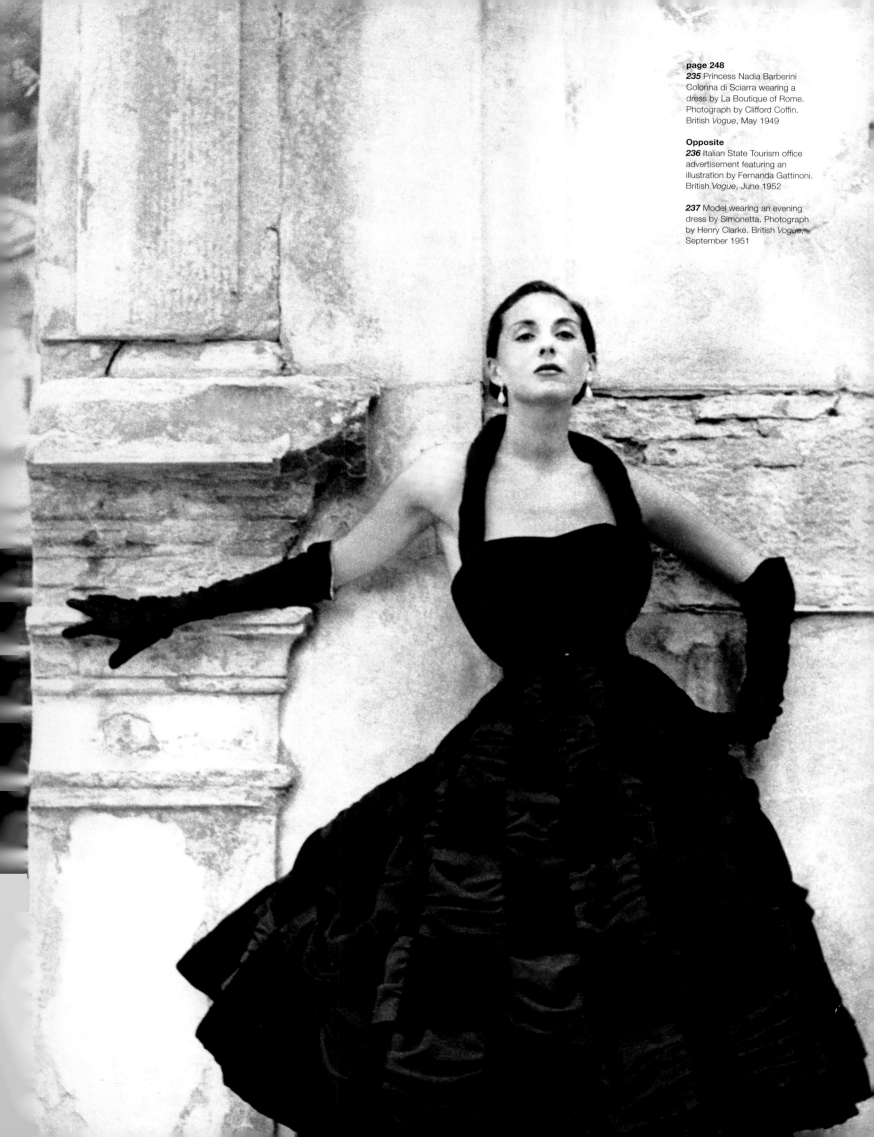

page 248
235 Princess Nadia Barberini Colonna di Sciarra wearing a dress by La Boutique of Rome. Photograph by Clifford Coffin. British *Vogue*, May 1949

Opposite
236 Italian State Tourism office advertisement featuring an illustration by Fernanda Gattinoni. British *Vogue*, June 1952

237 Model wearing an evening dress by Simonetta. Photograph by Henry Clarke. British *Vogue*, September 1951

238 Lauren Bacall in an Isetta microcar, Rome. Photograph by Paul Himmel. British *Vogue*, April 1954

War: 'Italian clothes are inclined to be as extrovert as the people who wear them, gay, charming, sometimes dramatic, but seldom highly imaginative or arresting.'[3] She writes that Italian fashion was still heavily influenced by Parisian models, with some exceptions: examples of strong Italian innovations included 'washable evening gowns of great elegance' and beach clothes.[4] The outlook for the Italian fashion industry was positive, the author concludes.[5]

Vogue's interest in Italy during the late 1940s was not limited to fashion, and the magazine published several articles on Italian cities and regions.[6] Mannes wrote a further article in which she explored Italian talent in the fields of literature, painting, sculpture and cinema. Her enthusiasm for this young country is tangible, and she writes that 'if Italy is allowed a period of peace and freedom, she might contribute to Europe and to us an extraordinary creative vitality.'[7]

In the early post-war years, Vogue portrayed Italy as a country eager to return to her past splendour after decades of dictatorship. Il bel paese became known for high-quality craftmanship at a lower price,[8] as well as its souvenir silk prints, practical sportswear and 'breathtaking workmanship in the details, such as embroidery'.[9] Beautiful landscapes, good food and a 'favourable rate of exchange' made Italy a desirable holiday destination, immortalized on the pages of Vogue as a series of stunning locations for fashion shoots.[10] The fashion photography featured in these articles is staged and theatrical, and the clothes are mostly worn by elegant, aristocratic women (pl.235). Set against sumptuous natural and artistic backdrops, the garments appear less relevant then the surroundings. Countess Spalletti leans casually against the stone architecture of a lavish garden in bloom, Baroness Reutern almost disappears next to an impressive column and the period furnishings of a sumptuously decorated Roman house while Princess Marcello del Drago looks impeccable on the Spanish Steps. In these photographs, Italy becomes synonymous with artistic beauty.[11]

The first Florentine fashion shows had the merit of encouraging Italian fashion houses to present original creations and the rest of the world to look closely at these Italian innovations. Vogue articles such as 'Italy Shows a New Strength in her Fashion Trade', published as early as September 1951, also brought further international attention.[12] The change of perspective on Italy as a fashion force is subtle but at the same time radical. The clothes, now worn by professional models, became the main focus of photographs shot with a much closer view (pl.237). The captions are less mundane; they describe the specific and unique characteristics of the garments shown, providing the names of the designers and the fabrics rather then emphasizing the lineage of the wearers or the historical backdrop.

From the early 1950s, Vogue published several articles devoted to Italy's fashion artistry, with evocative titles such as 'Italy's Casual Genius'.[13] The rebirth of the country through its fashion output became such a crucial subject that in December 1951 the Italian State Tourist Office created the first of a series of advertise-ments featuring fashion sketches by Fernanda Gattinoni (pl.236), who was based in Rome.[14] Designers such as Salvatore Ferragamo, already internationally famous before the war, increased their visibility by being featured in full-page advertisements for English department stores such as Harvey Nichols and Fortnum & Mason.[15] Italy's new status in the fashion world became evident in March 1953, when Vogue named it as one of Europe's four fashion capitals, alongside Paris, London and Spain.[16] Vogue dedicated three pages to a celebratory report on the latest trends in coat and suit lines from Italy, including descriptions of the details of construction and the use of elegant and innovative fabrics by designers such as Milan-based Veneziani and Vanna or Simonetta and Fabiani from Rome.

Veneziani and Simonetta in particular capitalized on this early international attention and became pivotal figures in promoting Italian fashion around the world. As early as February 1952, Veneziani was singled out by Time magazine as the best designer in the fashion show organized by Giovanni Battista Giorgini that year, while British and American Vogue both featured a full-page colour portrait of Simonetta (see pl.47).[17] In these post-war years, international recognition of entrepreneurial Italian design talent was crucial in developing Italy's identity as a producer of high quality fashion.

By 1954 Vogue began to portray Italy as a modern country. Rather than being photographed against a backdrop of classical art and architecture, models are now shown walking into freshly built apartment blocks designed by contemporary architects, in front of neon lights and billboards or lounging on sleek sofas.[18] Rome also changed her skin, her ancient ruins and famous Colosseum now used as the settings for Hollywood movies. Vogue chronicles this shift by reporting on the presence of celebrities in the Italian capital, such as actress Lauren Bacall, who is photographed sitting in an unusual Italian car, the tiny Isetta (pl.238).[19]

In 1955, Vogue announced that imported Italian products, specifically knitwear, were finally available in British shops such as Simpsons, Harvey Nichols and Fortnum & Mason. To mark the occasion, these designs were photographed in the Milan studio of the 'brilliant designer Fornasetti', shown against his original and contemporary screens (see pl.120).[20]

In the span of a decade, Italy left behind its former epithet as the Cinderella of fashion, known only for its sportswear. The skilful promotion of the country's landscapes, artistic heritage and culinary delicacies served as a boost to its fortunes, while the inventiveness of Italy's designers charmed foreign buyers into crossing her borders. The innovation and creativity these designers displayed in all branches of fashion paved the way for what would become the global success of Italian fashion in the decades to come.

Lucia Savi is Assistant Curator of the V&A's exhibition The Glamour of Italian Fashion 1945–2014

Margherita Rosina and Lucia Savi

Nattier: Textile Innovators

Nattier and our fabrics were so successful because they were the most concentrated expression of the times

The story of textile company Nattier exemplifies 1960s Italian entrepreneurship: in the span of three or four years, the owners went from managing a small family business producing medium-quality menswear fabrics to becoming leading textile producers in womenswear, with more than 200 models a season in the Paris haute couture shows.[1]

In the early 1950s Vittorio Azario started working at Litex (Lanificio Italiano Export) his family's textile mill, in Strambino, near Turin (pl.240). Established in the 1920s this mill initially produced only average-quality fabrics for the nascent Italian men's ready-to-wear industry. In 1959 Azario and his English fiancé, Brenda, began

producing women's fabrics and in 1960, the year they married, they decided to specialize in wool fabrics for womenswear.

At that time it was unusual for textile manufacturers to be in direct contact with fashion houses, as the couture market was dominated by fabric distributors or wholesalers known as *carnettisti*. Brenda and Vittorio Azario tried selling their fabrics to the leading Italian *carnettisti* such as Satam, Sassi, Gandini and Bises, but without success. The wholesalers refused to buy from them because they were not yet selling to the French haute couture houses. It soon became clear to the couple that if they wanted recognition and to sell worldwide,

they had to sell to Paris first. In the early 1960s, they decided to set up their own *carnet* with a French name that would only distribute the fabrics of their Italian manufacturing company. The Azarios called their new venture Nattier, after the French Rococo painter Jean-Marc Nattier. Now they had Nattier to sell the bold, inventive fabrics for which they would become famous to the couture houses of Italy and France, while Litex manufactured both these luxury fabrics and less expensive textiles for a less specialized market.

According to Brenda Azario, Nattier became one of Italy's most successful textile names in the 1960s because of two important factors: 'We had no tradition behind us in womenswear, so we had no limitations and nothing to lose. Also we had inherited very old machinery.'[2] When Rodier, a leading French fabric company, closed down in the early 1960s, the Azarios bought part of the Rodier archive and hired Roger Dietsch as a consultant. He in turn helped bring on board other experts, and these so-called 'loom fixers' were able to modify the old looms to produce complex structure and special design elements.

Brenda and her husband started buying the archives of other French textile companies that were closing down – some of these dated back to the 1870s. Vittorio, with his technicians, studied the structure of the oldest fabrics, yarn and special effects of the 1920s and tried to emulate them. Achieving that kind of quality and finesse in the 1960s was almost impossible (pl.244). 'Vittorio, a very skilled technician, wouldn't take no for an answer,' Brenda recalls. 'He would demand the impossible from the machine. I remember him standing next to the machine, saying "*vai, vai, vai*" [go, go, go].'

Reviving the past wasn't the only inspiration. 'We learned to make beautiful things by emulating others,' Brenda explains. 'We would go to Galeries Lafayette in Paris to buy pieces of French fabric in order to copy them at home. You learn by copying, that's where you start, until you find your own voice.' Vittorio's risk-taking, technical knowledge and ability to exploit the potential of the old machinery allowed Nattier to revolutionize the construction of fashion fabrics. Customer demand also encouraged Nattier to invest in research and experimentation. 'Quality at that time was made to measure and made to last,' Brenda says. 'No customer ever asked us to make the fabric cheaper; they just wanted it better. Above all in fashion, the product was king.'

At the same time Nattier also collaborated with producers of synthetic fibres, such as DuPont (see pl.71) and Snia Viscosa. The company was criticized by some for not exclusively using pure, natural fibres, but the young Azarios were thinking mainly of the finished product. They embraced the novelties the new fibres had to offer, such as cross-dyeing and bright colours: 'In different times luxury means different things. At that time the luxury we brought to Italian fashion was courageous innovation. Innovation at all costs; to liberate us from the very conservative mentality of the times.'

Very quickly, Litex became one of the major textile suppliers for French haute couture, first through the Parisian distributor Pierre Besson and later by opening its own Nattier office in the city, at 220 rue de Rivoli. The company also had offices in New York and representatives as far afield as Beirut and Japan. Nattier expanded its market share in the United States, where the presence of major luxury manufacturers increased the demand for high-quality products. The company was able to sell directly to the most important American manufacturers of the time, such as Ben Zuckerman and Originala, and a few years later to designers such as Geoffrey Beene and Oscar de la Renta. In the early 1960s Neiman Marcus also became a client. 'Stanley Marcus was the first to ask us to take advertising pages in *Vogue*,' Brenda

page 254
239 Advertisement featuring Nattier fabrics, American *Vogue*, March 1968

Opposite
240 Litex Factory, *c.*1962

241 Vittorio Azario at his desk, *c.*1966

242 Nattier stand at the MITAM textile fair, Milan, *c.*1967

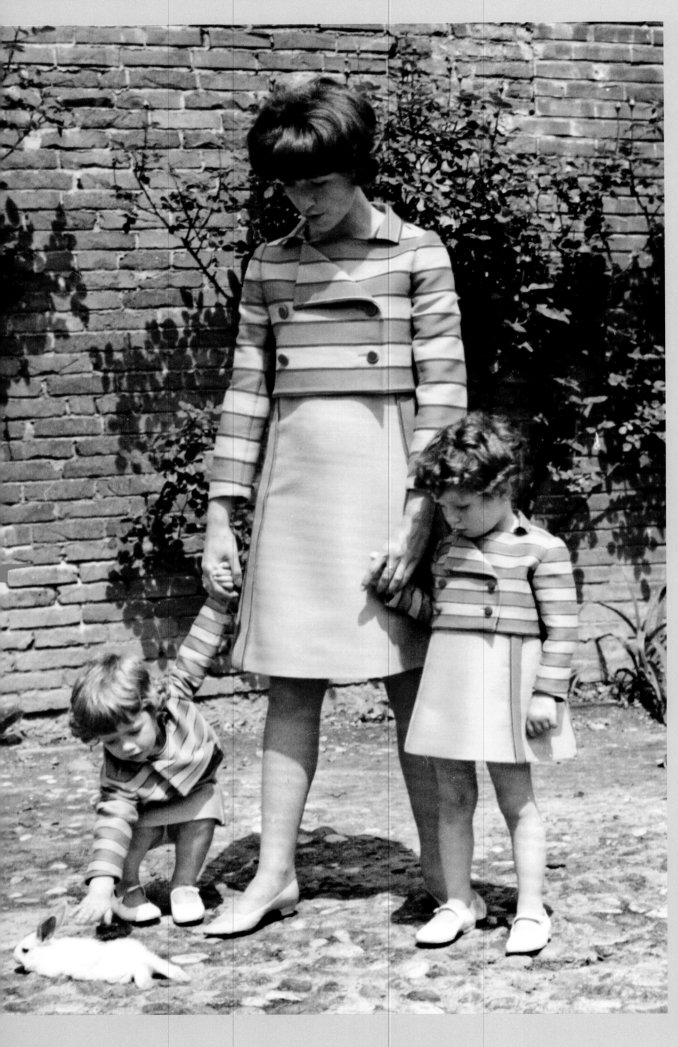

243 Brenda Azario and her two
daughters, wearing matching
Ungaro outfits, 1966

Opposite
244 Vittorio Azario at the loom,
*c.*1962

245 Brenda Azario with Nattier
fabrics, 1965

Azario recalls. 'In America this was necessary, because the marketing process was more advanced, otherwise we didn't advertise. Our fabrics were photogenic and stood out, you couldn't miss them. During some seasons we would have more then 70 pages of editorial in a single magazine.'

A consummate technician, Vittorio Azario was responsible for the manufacturing (at the height of their success, Litex and Nattier had up to 200 employees) while his wife was the face of the business (pl.245). In charge of sales, Brenda Azario always wore couture garments made out of Nattier fabrics (pl.243). Her main role was to open new markets. She recalls how she would target a new city such as Berlin, Barcelona or Tokyo: 'From the magazines I knew the names of some of the clients I should visit, but often I would walk down the main shopping street and say, "We will sell here, here and here" on the basis of what they had in their windows [in the 1960s, fabric shops were still a regular feature of the main shopping streets, since local dressmakers were important producers of clothing]. I would walk in and ask to see the owner or manager. When they asked what I was selling, my answer was always the same: "What I am wearing." No one ever refused to see me. In fashion you have to look the part.' Her schedule was relentless: 'I used to take a plane on Monday morning, come back Friday night, and I visited literally every market that could possibly buy our fabrics. From Finland to Australia, I knew them all.'[3]

Brenda Azario has said of Nattier: 'Our place in textile history was based on two cycles of innovation: one was partial innovation, the other was far more radical.' The first 'partial innovation' was the use of a brushed mohair bouclé yarn, which was very common in knitted textiles at the time but rarely used for woven fabric. Vittorio Azario took this unusual yarn and made a tweed that was used by Chanel and by Dior, among many others.[4] A more radical development was Vittorio's inven-

tion of a triple gabardine, which revolutionized the way garments were made. Weighing up to 800 grams per metre, this new type of fabric enabled designers such as Courrèges and Ungaro to create mini dresses in textiles that 'could be sculpted', as André Courrèges described it. Once Nattier mastered this innovative way of constructing plain fabrics, the company started experimenting with colours and patterns, by weaving, embroidering or printing them. Their printed textiles included high-impact geometric designs in fluorescent colours.[5]

This period of innovation and success came to an end in 1969. The company was put into receivership in 1972 and went out of business the following year. 'We failed to pace our success. We got carried away with our success, we didn't understand as well as we should have done that you have to finance your sales growth,' Brenda Azario explained in 1982.[6] In 1969 Vittorio had borrowed heavily to modernize some of the production, buying new machines at an interest rate of seven per cent, but this soon went up to 15 per cent and the business suffered as a result. The company's fragile financial situation was made worse by personal circumstances, especially an accident in 1969 that caused Brenda to be hospitalized for two years. As she was responsible for much of the company's sales, her absence had an instant, negative impact.

The 1960s had been the years of youth and change; Italy had experienced an 'economic boom' and the country was full of optimism. Looking back at that decade, Brenda Azario says: 'Nattier and our fabrics were so successful because they were the most concentrated expression of the times. You can't be successful unless you express the times you live in.'

Margherita Rosina is the director of the Museo Studio del Tessuto at Fondazione Antonio Ratti, Como

Lucia Savi is Assistant Curator of the V&A's exhibition *The Glamour of Italian Fashion 1945–2014*

Oriole Cullen

The Sozzani Sisters

... the dream is to have lots of Italian talents to grow and to show

Carla and Franca Sozzani have played key roles in the evolution and promotion of both Italian and international fashion over the past 40 years. As the owner of Milan's noted 10 Corso Como gallery and concept store (pl.247) and the influential editor of *Vogue Italia* respectively, the sisters have developed and revolutionized the Italian approach to fashion publishing and retail, continuously presenting new ways of viewing and consuming fashion while often challenging their audiences in the process.

Born in Mantua, the Sozzani sisters had a wide-ranging appreciation of art and design instilled in them from an early age. 'Our father took Franca and me every Sunday to see Milan's beautiful churches,' Carla recalls, 'but we were not going for the religion, we were going for the paintings and the architecture.'[1] This early visual training transcended all eras, as Franca notes: 'At one point my father developed a love for everything ultra-modern, for Swedish design. When we moved to Milan we lived in a skyscraper, which was considered strange at the time.'[2] Their love of fashion also developed early, thanks to exposure to one of Italy's celebrated design houses. 'I always loved fashion and I remember my father got upset with me because I bought a Pucci outfit.

I was only 15,' Carla explains. 'At the time Pucci was like a dream, because you have to remember there was no *prêt-à-porter* . . . it was haute couture dresses or you had a dressmaker making your dresses. So when all of the ready-to-wear started, Pucci for example, and Yves Saint Laurent in Paris, you could go in a shop and buy a pair of pants with a shirt or an outfit, it was so great! Pucci used to have a beautiful little shop in Milan. I remember my sister and me used to buy little pyjama suits. It was the first experience of ready-to-wear that we had.'[3]

Amid a wave of student protests in Italy in 1968, Carla Sozzani took the opportunity to leave Milan and take a break from her studies at the city's Bocconi University. Not long afterwards she received a stern telegram from her father, stating that a long holiday was not a serious option and that she must either resume her studies or find a job. Fortunately for the world of Italian fashion, Carla chose to take up employment at a magazine owned by a friend of her mother's.

Cheri Moda was a general interest women's magazine, which featured a diverse range of topics from food to dressmaking patterns, and from children's clothing to high fashion. The latter element allowed Carla the privilege of attending the great couture shows in Rome and Florence, but at the same time she had to deal with other, less glamorous aspects of the magazine, so that fashion was always situated within a wider context. She recalls the thrill of going to Rome and seeing the work of Galitzine, Sorelle Fontana and Schuberth at the Palazzo d'Espagna while also dealing with the magazine's knitting pages: 'For me there was no stigma, [no] boundaries between food and shoes or art or design, everything was mixed. So in a way my early years were [a very good way] to understand lots of things.'[4]

Carla Sozzani's interest in fashion soon led her to *Vogue Italia*, where in 1976 she was joined by her sister Franca, who began working at *Vogue Bambini* after completing a degree in philosophy, literature and German. This was an exciting time in Italian fashion; everything changed when Walter Albini and others decided to show their collections in Milan. While fashion designers had previously all shown their collections in one loca-

tion, with one presentation following another, the shows now became performances, spectacles that lasted for 30 or 40 minutes. This period would see the rise of a new generation of Italian designers on the international stage. By the mid-1980s, Carla Sozzani was also working with one of these designers, Romeo Gigli, to help develop his label. In 1987 she left *Vogue Italia* to become editor of Italian *Elle*, with radical plans to overhaul the publication and create an inspirational magazine as opposed to something overtly commercial. '*Vogue* at the time was really "fashion, advertising and fashion, advertising and fashion", not as it is now. There was no relationship with the readers,' Carla explains. 'So I really wanted to do something that could bring together all [elements of fashion] . . . it's beautiful and it's part of the social environment, it's part of our evolution, it expresses what we are. It's not only a dress.'[5]

At *Elle,* Carla Sozzani enlisted the services of the young art director Robin Derrick, who had worked at cutting-edge publications such as *i-D* and *The Face*, and together they collaborated with photographers including Bruce Weber, Steven Meisel, Paolo Roversi and Nick Knight to create a radically different magazine. Within publishing circles, this is regarded as a key moment, establishing the direction magazines would take in the coming decades. In 2005, Cathy Horyn, the fashion critic of *The New York Times,* wrote that Sozzani's *Elle* represented 'an aesthetic break in magazine publishing that was . . . rare in its beauty and influence'.[6] Unfortunately advertisers rebelled at the proliferation of non-Italian designers in the pages of *Elle* and Sozzani produced only three issues before the magazine's publishers decided to change tack and called for her resignation. She refused, insisting that they fire her, as legendary editor Diana Vreeland had been fired from American *Vogue*.

Following her exit from *Elle*, Carla Sozzani decided to open a photography gallery in an old converted car garage in Milan. 'I wanted to make books and do a gallery and concentrate on images,' she explains,[7] going on to point out that photography was not perceived as an art form at the time and that the gallery's location was not considered to be on the right side of town. 'At the beginning, people didn't understand. Everything in Milan was in the centre – windows, marble and wood, slick – and this was in a courtyard, no windows, cement floors, cars and plants . . . it still had electric wires everywhere!'[8] After a year, Carla opened a bookshop to support the gallery and then decided to expand the space to include fashion. 'I was missing fashion,' she says, 'so that's where the whole idea came [from] to do my magazine in a different way. Like expressing the same thing I was doing in magazines but . . . alive.'[9] At the time, the idea of a very eclectic and personally edited selection of clothes, books and objects was highly unusual and somewhat alien to general retail practice. Made up of black circles, the logo created by American artist Kris Ruhs, Sozzani's partner, had a unique hand-worked aesthetic that was completely unlike the polished corporate identities of most fashion stores at the time. In 1991 the Italian sociologist Francesco Morace coined

the phrase 'concept store' to describe this new kind of retail space which offered the visitor an intelligent, uplifting and cultural experience.[10] Sozzani sees 10 Corso Como as somewhere that offers 'slow shopping', where the visitor is invited to meander through different spaces, to stop and eat, to linger and to let their eye be drawn here and there by interesting things. The success of the store has resulted in the opening of branches in Tokyo, Seoul and Shanghai to date.

After several successful years at *Vogue Bambini*, Franca Sozzani became editor of *Lei*, the dynamic magazine for young women, in 1980. She then went on to edit men's magazine *Per Lui* before being appointed editor of *Vogue Italia*. *Vogue* had first entered the Italian market in 1965 in partnership with *Novità*, an existing Italian magazine. *Vogue & Novità* was relaunched

page 260
246 Franca and Carla Sozzani, 2011

Opposite
247 Interior of 10 Corso
Como, Milan

248 Designer Azzedine Alaïa with
Franca Sozzani, Paris. Photograph
by Foc Kan, 2009

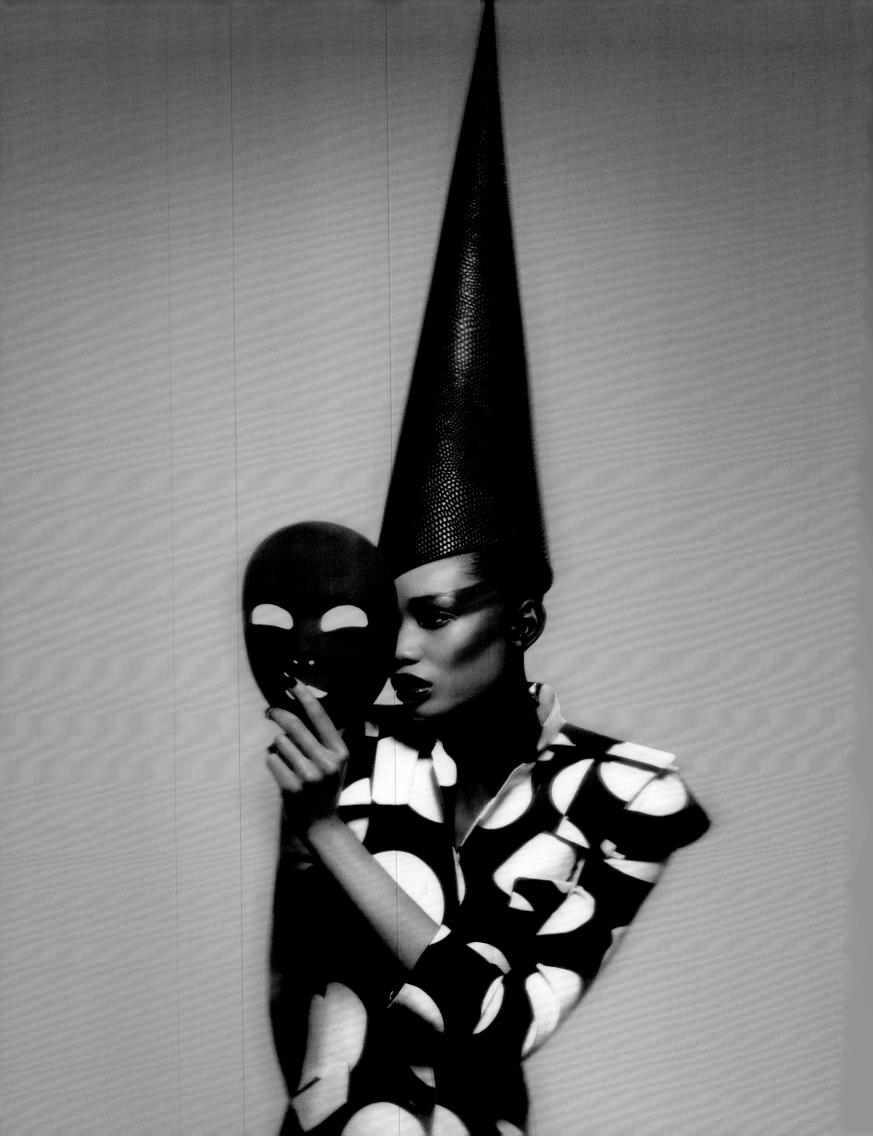

the following year as *Vogue Italia* under the editorship of Franco Sartori, who remained at the helm until his death in 1987. Writing about the early years of Sartori's *Vogue,* Stefania Ricci noted that 'the underlying attitude, conveyed through the magazine's photography, text and typeface, is that fashion is a work of art. Emphasis tends to be laid on the formal aspect, design and the effects of style and dress on history.'[11] This artistic approach waned somewhat and over the years, the magazine became locked into a particular formula. Sozzani describes the publication she inherited in 1988 as 'a trade-only magazine where everything was decided in a very structured way: one Krizia outfit, one Armani outfit, one Versace outfit, one Ferré outfit'.[12] Fearlessly, she turned this structure on its head. Her first cover featured an outfit by French designer Yves Saint Laurent, which caused an outcry among Italian designers. She established a key relationship with American photographer Steven Meisel, appointing him to shoot every cover image in order to create a strong visual identity: 'Italian is only spoken in Italy, so our images have to be very strong to attract attention.'[13] Alongside Meisel she recruited other photographers including Peter Lindbergh, Bruce Weber, Paolo Roversi (see pp.176–7) and Craig McDean.

Franca Sozzani's new vision for the magazine emphasized lavish editorial content, with features frequently running up to 20 pages or more, and she dared to move away from conventional storylines and push the boundaries of what might be expected in a glossy magazine. For the first few years, Sozzani struggled with unhappy advertisers and fashion designers who preferred the old order, but she pinpoints the turnaround to the excitement generated by the February 1990 cover featuring Madonna.[14] From this moment onwards, the magazine began to be recognized as the most avant-garde and creative of all of the international editions of *Vogue*. 'She created a new visual language and refined how fashion and style was portrayed and communicated,' Jonathan Newhouse, chairman of Condé Nast, says of Sozzani's work at the magazine. 'She closely collaborated with photographers and stylists, giving them the freedom and scope to produce dramatic, provocative and beautiful images. Italian *Vogue* under Franca's direction pushed the limits . . . it became the point of reference, the magazine every designer wanted to appear in and every photographer and stylist wanted to work for.'[15]

Franca Sozzani's choice of topic is often challenging to the reader and frequently reflects current affairs: subjects such as the oil spill in the Mexican Gulf, terrorism, plastic surgery and celebrity rehab have all provided inspiration for fashion editorials. Sozzani has voiced unpopular opinions and covered unorthodox subjects. 'If you want to feel safe you don't take risks,' she says. 'But if you don't want to be safe and want to make different work, then you may make more mistakes.'[16] In 2008 she produced the 'Black Issue' of *Vogue Italia*, featuring solely black models (pl.249). The issue sold out across the international market and was reprinted several times over in Britain, Germany and the United States, causing many to ask why this had never been done before, particularly in America, which has such a diverse fashion audience. In Sozzani's words, 'a fashion magazine today can also deal with other themes than just clothes and shoes, and portray through its pictures life occurrences and also events that may change the evolution of things.'[17]

The growth of the internet has changed fashion publishing and Franca Sozzani has been quick to recognize the potential for her magazine to communicate directly with its readers. In early 2010 *Vogue Italia* launched its website, which includes destination pages such as 'Vogue Black', 'Vogue Curvy' and 'Vogue Talents' for young designers, along with Sozzani's own personal daily editor's blog. In 2011 the site introduced 'Vogue-encyclo', a fashion and design encyclopaedia that operates like Wikipedia: readers can add their own contributions, which are monitored by the *Vogue* team. Again addressing topics that others shy away from, Sozzani has added an anti-anorexia page and a petition gathering signatures to support the closure of pro-anorexia websites. She has described the *Vogue Italia* website as a 'process of democratization that has affected many people who would probably have never bought the magazine.'[18]

Although their outlook is international, both Carla and Franca Sozzani have always been firm supporters of Italian fashion. 'Mine is not a patriotic attitude,' Franca says, 'but the strong belief, as a professional, that here people create, invent and produce, [based] on a background of culture, tradition, craftsmanship and inventiveness'.[19] Carla also praises the country's richness of talent, highlighting the unique element of craftsmanship: 'In Italy we have these amazing artisans, it would be nice to help them . . . maybe to sell some limited editions all over the world. There is so much we can do.'[20] Both sisters are strong supporters of young design talent, with one of the most important initiatives being the 'Who Is On Next' programme sponsored by *Vogue Italia*, a search for a new wave of young Italian designers. 'For me the dream is to have lots of Italian talents to grow and to show,' says Carla Sozzani. 'It's not only in fashion, it's everywhere. They say the [mark of a] good teacher is when the one who comes after you is better than you. We should all, Italians of our generation, try to be good teachers.'[21]

Oriole Cullen is Acting Senior Curator of Fashion at the V&A. She specializes in twentieth- and twenty-first-century fashion and curates the V&A's Fashion in Motion shows

Opposite
249 Beauty supplement of 'Black Issue', *Vogue Italia*, July 2008. Photograph by Dusan Reljin

Notes

Introduction — Sonnet Stanfill

1 Archivio G.B. Giorgini, Alb. 5/19, press release for 1952 fashion show
2 John Foot, *Modern Italy* (New York, 2003), chapter 1
3 Italy's former colonies included Ethiopia, Libya, Eritrea and Somalia. At the war's end Albania became a sovereign nation and Italy ceded the Julian March to Yugoslavia and the Dodecanese Islands to Greece. Other disputed territories included the city of Trieste, which rejoined Italy in 1954.
4 Paul Ginsborg, *A History of Contemporary Italy: Society and Politics 1943–1988* (London, 2009), p.122
5 Nicola White, *Reconstructing Italian Fashion: America and the Development of the Fashion Industry* (Oxford, 2000), pp.12–13
6 Mario Lupano and Alessandra Vaccari (eds), *Fashion at the Time of Fascism* (Milan, 2009), pp.279–87
7 Eugenia Paulicelli, *Fashion Under Fascism: Beyond the Black Shirt* (Oxford, 2004), pp.75–97
8 Sofia Gnoli, *La Donna l'Eleganza Il Fascismo: La Moda Italiana dalle origini all'Ente Nazionale della Moda* (Catania, 2000), pp.106–13
9 John Foot, *Modern Italy* (New York, 2003), p.31
10 Nicholas Crafts and Gianni Toniolo, *Economic Growth in Europe Since 1945* (Cambridge, 1996), p.438
11 Emanuela Scarpellini, *Material Nation: A Consumer's History of Modern Italy* (Oxford, 2008), p.129
12 Nicola White, *Reconstructing Italian Fashion: America and the Development of the Fashion Industry* (Oxford, 2000), see chapter 1
13 Archivio G.B. Giorgini, ALB4/5-5G. Memorandum from the *Ufficio Commerciale del Consolato Generale d'Italia*, 26 October 1951
14 Rosalind Pepall, 'Good Design is Good Business': Promoting Postwar Italian Design in America' in Giampiero Bosoni (ed.), *Il Modo Italiano: Italian Design and the Avant-garde in the 20th Century* (Milan, 2006), p.77
15 Archivio G.B. Giorgini, ALB 2/8 On 25 September 1950, Rogers wrote to Giorgini about the proposed fashion show: 'May I say at once that I think this is a splendid idea. It seems to me that this show should cover various aspects of fashion such as sportswear, afternoon wear, evening wear, etc. . . it should be held here at the Brooklyn Museum early in January.'
16 Archivio G.B. Giorgini, ALB 2/36
17 Ibid., ALB 2/52
18 The designers who presented collections at the July 1951 showings were Antonelli, Carosa, Fabiani, Fontana, Schuberth, Visconti, Fabvro, Marucelli, Noberasco, Vanna and Veneziani, along with sportswear from Veneziani Sport, Mirsa, Avolio, Emilio Pucci, Simonetta Visconti and Baroness Gallotti.
19 *St Petersburg Independent,* 18 January 1952
20 *Harper's Bazaar* fashion editor Carmel Snow wrote in a special report for the *New York Journal-American,* published on 16 February 1953, that 'a frock in Italy costs about a third of the French prices'.
21 Archivio G.B. Giorgini, ALB 3/100.1
22 Archivio G.B. Giorgini, ALB 5/110, *Los Angeles Times*, 4 August 1952
23 Archivio G.B. Giorgini, ALB 15/4
24 The correspondence relating to Mrs Abegg's donation of her clothing indicates various spellings of the dressmaker's name, including Grimaud, Grimaudi and Grimaldi. Thanks to research conducted by Dr Anna Jolly of the Abegg-Stiftung at the Biblioteca Nazionale in Turin, we believe that the correct spelling is Maria Grimaldi.
25 Letter from Mrs Werner Abegg to Keeper of Textiles, Mr Donald King, 29 May 1976. Museum acquisition file no. MA/1/A33
26 *Women's Wear Daily*, 26 January 1956
27 Archivio G.B. Giorgini, ALB 19/123
28 *The New York Times*, 25 July 1955
29 *American Vogue*, 15 January 1967, p.50
30 *New York Journal-American*, 16 February 1953
31 See Maria Luisa Frisa and Stefano Tonchi, *Walter Albini and His Times* (Venice, 2010) and Gloria Bianchino (ed.), *Walter Albini* (Parma, 1988), for discussions on Albini's collaboration with Etro.
32 Author interview with Roberto Sarti, Prato, 20 November 2012
33 Michael Porter, 'Clusters and the New Economy', *Harvard Business Review* 76, (November–December 1998), no.6
34 John Colapinto, *The New Yorker,* 3 January 2011
35 Report published by Sistema Moda Italiana, Il Tessile-Moda italiano (2012), p.7
36 Ibid., pp.2–3
37 Edoardo Nesi, *Story of My People* (Milan, 2010), p.137
38 Pamela Golbin, *Madeleine Vionnet* (New York, 2009), p.30
39 'Prada Sales Climb 29% in a Year', *The Financial Times*, 19 February 2013
40 Maria Giuseppina Muzzarelli, 'The Future is Looking at China', *Zona Moda Journal* (Bologna, 2011), p.10
41 *The New York Times,* 8 October 2010
42 Bernstein Research, *European Luxury Goods* (New York, 2013), p.4
43 Author interview with Miuccia Prada, 8 December 2011
44 *Wall Street Journal,* 11 September 2001
45 LVHM press release, 8 July 2013
46 'PPR Acquires Italian Maker Brioni', http://dealbook.nytimes.com/2011/11/08/ppr-acquires-italian-suit-maker-brioni [accessed 18 September 2013]
47 LVHM press release, 24 November 2001
48 Italy's unemployment rate for 2011 was 11 per cent and its public debt in 2012 topped 126 per cent of GDP. These figures secured from economics website Index Mundi, www.indexmundi.com/italy/economy_profile.html [accessed 30 August 2013]
49 Archivio G.B. Giorgini, ALB Jan 18-22,1952/122, *New York Journal-American,* 16 February 1953

Great Dressmakers of Italian Fashion — Sofia Gnoli

1 Bonizza Giordani Aragno, *900 Il Secolo alla moda. 1900–2001* (Rome, 2001), p.20
2 An Italian fashion house founded in 1815 in Milan, Ventura became known for its ability to replicate French designs. At the height of its success it was named the official supplier to the Royal Household and in 1924 it opened a branch in Rome. It closed in the 1940s.
3 Madame Grès was the pseudonym of Germaine Emilie Krebs (1903–93), a French dressmaker. In 1934, in partnership with Julie Barton, she founded the fashion house Alix Barton. In 1941 she opened her own atelier. Her designs, inspired by classical Grecian draperies, influenced many designers in addition to Gattinoni, from Valentino to Issey Miyake, and earned her international fame as the 'queen of drapery'.
4 A brilliant exponent of fashion journalism, Irene Brin was the pen name of Maria Vittoria Rossi (1911–69). She started out in 1932, writing articles on clothing for the Genoese *Il Lavoro* newspaper. In 1937, she began to contribute to *Omnibus*, a periodical edited by Leo Longanesi. It was Longanesi who suggested the name Irene Brin. Later she worked for *Bellezza* and *Harper's Bazaar*. She also published a number of books, including *Usi e costumi* and *Dizionario del successo dell'insuccesso e dei luoghi comuni.*
5 While she was visiting Rome in 1947, Eva Peron ordered garments from Fernanda Gattinoni.
6 Irene Brin, 'Da lei si vestono attrici e ambasciatrici', *La Settimana Incom Illustrata*, 9 June 1951
7 Eugenia Sheppard, 'Fashion Report From Europe', *New York Herald Tribune*, 20 July 1956
8 Her collaborators included Chino Bert, Patrick de Barentzen, Giulio Coltellacci, Silvano Malta and Antonio Pascali and André Laug. See Bonizza Giordani Aragno, *Il disegno dell'alta moda italiana 1940–1970* (Rome, 1982), p.40
9 M. Minnini, Maria Antonelli, *La moda Italiana: Le origini dell'alta moda e la magliera* (Milan, 1987), p.254
10 Quoted in Arturo Calzano and Vanja Strukely, 'Moda, grafica e pubblicità', in *La moda italiana: Le origini dell'alta moda e la maglieria* (Milan, 1987), p.154
11 Ibid., p.173
12 A knitwear brand specializing in womenswear founded in 1936 by Olga di Gresy in Galliate (Novara). Fame arrived in 1950, when Odette Tedesco, a buyer for the American department store I. Magnin placed a large order for Mirsa clothing. This was the beginning of a relationship that continued for 25 years. In the 1950s, Mirsa took part in the catwalk shows organized by Giorgini in the *Sala Bianca* at Palazzo Pitti. The company closed in 1984.
13 A fashion house founded in Capri by Clarette Gallotti, one of those who took part in Giorgini's first group show in February 1951.
14 In 1929, Gabriella di Robilant accompanied Elsa Schiaparelli to the United States, working as her assistant and model, when Schiaparelli presented her last collection of sportswear at Stewart & Company; see Dilys E. Blum, *Shocking! The Art and Fashion of Elsa Schiaparelli* (Philadelphia, 2003), pp.15, 293. It is interesting to note that although Schiaparelli mentions Gabriella di Robilant several times in her autobiography and describes her as a great friend, Robilant does not refer to Schiaparelli in hers.

See Gabriella di Giardinelli, *Una gran bella vita* (Milan, 1988).

15 Quoted in Emanuela Audisio, 'Super-donna Simonetta', in *Velvet* (January 2008), p.165

16 Bettina Ballard, *In My Fashion* (New York, 1960), p.256

17 Angelo Tarlazzi, Italian designer (b.1945). After having worked for Carosa from 1972 to 1976, he became artistic director at Jean Patou. Afterwards, returning briefly to Italy, he worked for Laura Biagiotti and Basile. In 1977 he set up his own atelier. In 1989, he became the artistic director of the fashion house Guy Laroche. Quoted in Pia Soli, *Il genio antipatico* (Milan, 1984), p.67

18 A great sense of intuition enabled her to work with collaborators who could contribute in an innovative way, such as Patrick de Barentzen, Quirino Conti, Ibi Farkas, Pino Lancetti, Angelo Tarlazzi and Mario Vigolo.

19 Bonizza Giordani Aragno, *Irene Galitzine: La principessa della moda* (Bergamo, 2006), p.44

20 Irene Galitzine, *Dalla Russia alla Russia* (Milan, 1996), p.136

21 Galitzine Archive, Rome. The three women Jacqueline Kennedy refers to are her sister Lee Radziwill, the socialite Jayne Wrightsman and Marella Agnelli.

22 Cited in Gloria Bianchino and Arturo Carlo Quintavalle, *Moda Italia 1951–1989 dalla fiaba al design* (Novara, 1989), p.80

23 Guido Vergani (ed.), *Maria Pezzi: Una vita dentro la moda* (Milan, 1998), p.136

24 Ibid., p.103

25 Silvana Bernasconi, in Pia Soli, *Il genio antipatico* (Milan, 1984), p.37

26 Fernanda Pivano, *Le favole del ferro da stiro* (Milan, 1964), p.10

27 Guido Vergani *Dizionario della moda* (Milan, 2009), p.755

28 In 1950 she took over Ventura's Milanese headquarters at 18 Corso Venezia and in 1957 she opened a branch in Rome, in Rampa Mignanelli.

29 Pivano (cited note 26), p.21

30 Directed by William A. Seiter

31 Roberta di Camerino explained that she gave the bag this name 'because its small, fat shape and rigid handle reminded me of the famous Italian circus dwarf, *Bagonghi*', quoted in Sofia Gnoli and Gianni Rizzoni (eds), *Agenda della moda* 2002 (Milan, 2001), p.96

32 Princess Grace of Monaco was photographed on the front cover of *L'Europeo* (10 November 1959) with a *Bagonghi* bag on her arm.

33 Roberta di Camerino Archive, Venice

34 Various authors, 1947–1997, *The art of elegance: Roberta di Camerino* (Milan, 1998)

35 Following the example of early pioneers of Italian style, such as the Lombard dressmaker Rosa Genoni (1867–1954) and the Roman Maria Gallenga (1880–1944).

36 *Schiaparelli and Prada: Impossible Conversation,* exh. cat, The Metropolitan Museum of Art, New York (New York, 2012), p.58

Reorienting Fashion: Italy's Wayfinding after the Second World War — Vittoria Caterina Caratozzolo

1 Bettina Ballard, *In My Fashion* (New York, 1960), p.250

2 Fred Davis, *Fashion, Culture and Identity* (Chicago, 1992), p.112

3 Simona Segre Reinach, 'National Identities and International Recognition', *Fashion Theory* (June 2011), vol.15, issue 2, p.268

4 Peppino Ortoleva, 'Buying Italian: Fashion, Identities, Stereotypes' (1999), quoted in Eugenia Paulicelli, *Fashion Under Fascism: Beyond the Black Shirt* (New York, 2004), p.27

5 Simona Segre Reinach, *Un mondo di mode: Il vestire globalizzato* (Rome, 2011)

6 Michelangelo Testa was the editor-in-chief of *Bellezza,* a high-fashion magazine that was launched in November 1945.

7 Michelangelo Testa, 'Italia internazionale', *Bellezza* (1947), issue 20–21

8 Mario Lupano and Alessandra Vaccari (eds), *Fashion at the Time of Fascism: Italian Modernist Lifestyle 1922–1943* (Bologna, 2009), p.11

9 Ibid., p.226

10 Richard Martin, *Fashion and Surrealism* (London, 1988), p.107

11 Ibid., p.49

12 Marya Mannes, 'Italian Fashion', *Vogue* (January 1947), p.119

13 Ibid.

14 Penelope Rowlands, *A Dash of Daring: Carmel Snow and Her Life in Fashion, Art, and Letters* (New York, 2005), p.429

15 Nicola White, *Reconstructing Italian Fashion: America and the Development of the Italian Fashion Industry* (Oxford, 2000), p.35

16 Vera Rossi, 'La moda francese e la nostra', in *I Tessili Nuovi* (January–March 1949), p.58

17 Irene Brin, 'Obiettivi puntati sull'Italia', *Bellezza* (May 1950), pp.72–4

18 Luigi Settembrini, 'From Haute Couture to Prêt-à-Porter', in Germano Celant (ed.), *The Italian Metamorphosis 1943–1968* (New York, 1994), p.487

19 Alessandro Pasquali, 'L'Italia è di moda', *Novità* (June 1953), pp.21–2

20 White (cited note 15), p.48

21 Elsa Robiola, 'America insegna', *Bellezza* (November 1956), p.14

22 Paula Rabinovitz, 'Walking the Walk: Circulation and Exchange', in Cristina Giorcelli and Paula Rabinovitz, *Exchanging Clothes: Habits of Being 2* (Minneapolis, 2012), p.4

23 White (cited note 15), p.38

24 Reka Buckley and Stephen Gundle, 'Flash Trash: Gianni Versace and the Theory and Practice of Glamour', in Stella Bruzzi and Pamela Church Gibson, *Fashion Cultures* (London, 2000), pp.334–5

25 Irene Brin, 'Moda Italia Giramondo', *Bellezza* (June 1956), p.124

26 Gianna Manzini, 'La moda tende a un linguaggio universale', in Nicoletta Campanella (ed.), *La moda di Vanessa* (Palermo, 2004), p.212

27 Roland Barthes, 'Le dandysme et la mode' in *The Language of Fashion*, (Oxford, 2006), p.68

The Fashion Revolution in Milan — Simona Segre Reinach

1 Quoted in John Potvin, 'From Gigolo to New Man: Armani, America and the Textures of Narratives', *Fashion Theory* (September 2011), vol.15, no.3, p.281

2 Anne O' Connor, 'L'Italia: La Terra dei Morti?', *Italian Culture* (2005), vol.23, pp.31–50

3 *Domus* online, 17 May 2011 [accessed 8 December 2012]

4 See Nicola White, *Reconstructing Italian Fashion: America and the Development of the Fashion Industry* (Oxford, 2000)

5 Maria Giuseppina Muzzarelli, *Breve storia della moda in Italia* (Bologna, 2011)

6 See Eugenia Paulicelli, *Fashion Under Fascism: Beyond the Black Shirt* (Oxford and New York, 2004)

7 See Mario Lupano and Alessandra Vaccari (eds), *Fashion at the Time of Fascism: Italian Modernist Lifestyle 1922–1943* (Bologna, 2009)

8 See the essay by Vittoria Caterina Caratozzolo in this book

9 John B. Fairchild in Guido Vergani, *La Sala Bianca* (Milan, 1992), p.17

10 See Adriana Mulassano, *The Who's Who of Italian Fashion,* with photographs by Alfa Castaldi and a foreword by Anna Piaggi (Florence, 1979)

11 Simona Segre Reinach, 'Putting It Together', in Maria Luisa Frisa and Stefano Tonchi (eds), *Walter Albini and His Times: All Power to the Imagination* (Venice, 2010), pp.18–20

12 Potvin (cited note 1), p.294

13 Mulassano (cited note 10)

14 Maria Vittoria Carloni in Guido Vergani, *Dizionario della moda 2004* (Milan, 2003), pp.425–6

15 Simona Segre Reinach, 'Milan the city of prêt-à-porter', in Christopher Breward and David Gilbert (eds), *Fashion's World Cities* (Oxford, 2006), pp.123–34

16 Natalia Aspesi, *La Repubblica*, 23 March 1976, quoted in Mulassano (cited note 10)

17 Mulassano (cited note 10), pp.3–4

18 Anna Piaggi in Mulassano (cited note 10)

19 Paola Colaiacomo and Vittoria C. Caratozzolo, 'The Impact of Traditional Indian Clothing on Italian Fashion Design from Germana Marucelli to Gianni Versace', *Fashion Theory* (June 2010), vol.14, no.2, pp.183–214

20 Paolo Volonté, 'Social and Cultural Features of Fashion Design in Milan', *Fashion Theory* (December 2012), vol.16, no.4, pp.408–14

21 Anna Piaggi in Mulassano (cited note 10)

22 See Maria Luisa Frisa and Stefano Tonchi (eds), *Excess: Fashion and Underground in the 80s* (Milan, 2004)

23 Paola Colaiacomo, *Fatto in Italia: La cultura del made in Italy* (Rome, 2006)

24 Stefania Saviolo and Salvo Testa, *Le imprese del sistema moda: Il management al servizio della creatività* (Milan, 2000), p.38

25 Elisabetta Merlo, *Moda italiana: Storia di un'industria dall'Ottocento a oggi* (Venice, 2003) and C.M. Belfanti,'Introduzione', in C.M. Belfanti and F. Giusberti (eds), *La moda, Annali della Storia d'Italia* (Turin, 2003), vol. 19

26 see Merlo (cited note 25)

27 Ivan Paris, *Oggetti cuciti: L'abbigliamento pronto in Italia dal primo dopoguerra agli anni Settanta* (Milan, 2006), p.104

28 *Schiaparelli and Prada: Impossible Conversations*, The Metropolitan Museum of Art, New York, 10 May – 19 August 2012

29 Valerie Steele, *Fashion Italian Style* (New Haven, 2003)

30 Simona Segre Reinach, 'If You Speak Fashion You Speak Italian', *Critical Studies in Fashion & Beauty* (2010), vol.1, pp.203–1

31 Enrico Cietta and Marco Ricchetti, *Il valore della moda* (Milan, 2006), p.25

32 Maria Luisa Frisa, *Una nuova moda italiana* (Venice, 2011)

33 Paola Bottelli, 'Punto tutto sulla qualità made in Italy: Ma che fatica la start up nella moda', www.moda24ilsole24ore.com, 19 October 2010, [accessed 24 December 2012]

34 Enrico Cietta and Marco Ricchetti, *Il valore della moda,* (Milan, 2006)

35 Yunika Kawamura, *The Japanese Revolution in Paris Fashion* (Oxford, 2004)

36 Mulassano (cited note 10), p.1

Textiles: The Foundation of Italian Couture — Margherita Rosina

1 'Gli stranieri ci guardano e dicono . . .', *Linea Italiana*, Spring/Summer 1974, no.45

2 Ibid.

3 Amalia Bottero, *Nostra Signora la Moda* (Milan, 1979), p.23

4 Nicola White, *Reconstructing Italian Fashion: America and the Development of the Fashion Industry* (Oxford, 2000), pp.9–31

5 Ivan Paris, *Oggetti cuciti: L'abbigliamento pronto in Italia dal primo dopoguerra agli anni Settanta* (Milan, 2006), pp.86–7

6 Guido Vergani, *La Sala Bianca* (Milan, 1992)

7 Elsa Robiola, 'I primi dieci anni di vita di *Bellezza*', *Bellezza*, (September 1951), no.9

8 For an overview of the important silk industries in the Como area, see Francina Chiara, 'Indice documentario delle aziende', in Chiara Buss (ed.), *Seta il Novecento a Como*, exh. cat. (Milan, 2001), pp.332–41

9 Margherita Rosina and Francina Chiara (eds), *Carla Badiali disegnare il tessuto*, exh. cat. (Como, 2007)

10 Margherita Rosina and Francina Chiara (eds), *L'età dell'eleganza. Le filande e tessiture Costa nella Como degli anni Cinquanta*, exh. cat. (Como, 2010)

11 Emilia Kuster Rosselli, 'Tessuti nuovi, colori inattesi', *Novità* (April 1952), p.56

12 Margherita Rosina,'Tessuti italiani anni Cinquanta: tradizione e fantasia', in *Annicinquanta. La nascita della creatività italiana*, exh. cat. (Milan, 2005) and Margherita Rosina, 'Una passione per i bei tessuti', in Enrica Morini and Margherita Rosina (eds), *La moda come passione e come professione. La donazione Silvana Bernasconi*, exh. cat. (Milan, 2005)

13 Dario Binda, *Chiné* (Como, 1991), pp.53–60

14 Francina Chiara, 'Indice documentario delle aziende', in Chiara Buss (ed.), *Seta il Novecento a Como*, exh. cat. (Milan, 2001), p.339 and Margherita Rosina and Francina Chiara (eds), *Guido Ravasi il signore della seta*, exh. cat. (Como, 2008)

15 Shirley Kennedy, *Pucci. A Renaissance in Fashion* (New York, 1991); Alessandra Arezzi Boza and Margherita Anselmi Zondadari (eds), *Emilio Pucci 1957: la collezione Palio* (Colle Val d'Elsa, 2007); Francina Chiara,'The Foulard (scarf) that did the trick: Emilio Pucci and Giuseppe Ravasi, a partnership between a tailor and a silk maker', in *Moda. Made in Italy*, exh. cat. (Tielt, 2013), pp.55–83

16 Examples of this kind of work are conserved in the Fondazione Archivio Emilio Pucci in Florence, which holds an immense collection of textile and photographic material, and at the Museo Studio del Tessuto of the Fondazione Antonio Ratti in Como, the custodian of the Ravasi Archives.

17 Valditevere was an Italian firm launched in 1951 by three Florentine noblewomen – Vittoria Pacini Battaglia, Piretta Rocco di Torrepadula and Donina Cicogna. The name was inspired by the upper valley of the Tevere, and the company was set up with the intention of preserving and developing the hand-weaving traditions of that area. For printed silk garments, Valditevere collaborated with Ravasi into the 1970s, as shown by the registers of the Como firm held at the Museo Studio del Tessuto of the Fondazione Antonio Ratti in Como. Valditevere is still in business today (see *www.valditevere.it*).

18 Terital was also the commercial brand used by Rhodiatoce to commercialize its own polyester fibres, both as staple fibres and continuous filament yarns. For many years the company promoted Terital as a quality textile, marking the selvedge to distinguish it from other polyesters.

19 The Lanerossi Archives at Schio (Vicenza) hold a large number of photographs of garments made by Italian tailors using Lanerossi Terital and wool textiles, which were used for publicity purposes. The backs of the photographs are inscribed 'please reference Terital'.

20 Vergani (cited note 6), pp.78–82

21 *Linea Italiana*, Spring/Summer 1966, no.3. In a Confezioni Marzotto Italian style publicity image, the model is shown in a pink wool suit with violet trim on the collar, cuffs and small pockets, inspired by the Chanel suit worn by Jacqueline Kennedy in Dallas on the day President Kennedy was assassinated, 22 November 1963.

22 'Colori Tessuti Modelli una parata perfetta', *Linea Italiana*, Autumn/Winter 1966, no.4

23 Ibid.

24 Isabel Koellreuter and Martin Widmer, *Soie Pirate: The History and Fabric Designs of Abraham Ltd* (Zurich, 2010), p.41

25 Ibid., pp.82–3

26 See Guido Vergani, *Mantero 100 anni di storia e di seta* (Florence, 2002)

27 Margherita Rosina,'Una passione per i bei tessuti', in Enrica Morini and Margherita Rosina (eds), *La moda come passione e come professione. La donazione Silvana Bernasconi*, exh. cat. (Milan, 2005), pp.38–40 and Ivan Paris, *Oggetti cuciti. L'abbigliamento pronto in Italia dal primo dopoguerra agli anni Settanta* (Milan, 2006), pp.293–301. Interstoff is the Frankfurt international textile fair.

28 With great honesty, Brenda Azario, owner of Nattier and one of the main protagonists of the period, recalls: 'We were young and eager for success. We would go to Galeries Lafayette in Paris to buy pieces of French fabrics – because France still dominated in the sector – in order to copy them at home. My husband Vittorio was a very able technician and seeing how other people's fabrics were made gave him ideas for our own ones'. Interview with Brenda Azario, 18 January 2013

29 See Chiara Buss (ed.), *Seta il Novecento a Como*, exh. cat. (Milan, 2001), p.172

30 Margherita Rosina, 'Tessuti italiani anni Cinquanta: tradizione e fantasia', in *Annicinquanta. La nascita della creatività italiana*, exh. cat. (Milan, 2005), p.312

31 Other important champions of reversible fabrics were Valentino and Federico Forquet, who used them in many of their collections in the second half of the 1960s, often in highly original prints. See Pia Soli, *Il genio antipatico* (Milan, 1984), pp.160–62; Bonizza Giordani Aragno. (ed.) *Valentino trent'anni di magia* (Milan, 1991) and Valerie Steele, *Fashion, Italian Style* (New York, 2003), p.37

32 Patrizia Gatti (ed.), *M as Mila* (Milan, 2009), p.79

33 Daniela Ferretti and Tiziana Alvisi (eds), *Roberta di Camerino. La rivoluzione del colore* (Venice, 2011)

34 Ibid., pp.73–85

35 Francesco Forte, 'La moda come fattore produttivistico nel quadro del piano tessile', a presentation given at the conference 'La moda e la programmazione economica', Milan Fair, 18 April 1972

36 See Simona Segre Reinach's essay in this book

37 Enrica Morini and Nicoletta Bocca, 'Lo stilismo nella moda femminile', in Grazietta Butazzi and Alessandra Mottola Molfino (eds), *La moda Italiana. Dall'antimoda allo stilismo* (Milan, 1987), pp.64–94

38 For further details see the most complete and well-documented account of this subject, Nicoletta Bocca, *La moda pronta e la sua materia* (Florence, 1991)

39 Ibid., p.322

40 One of the most famous chains of fabric shops was Galtrucco, with branches in numerous Italian cities, which was commercially active from the beginning of the twentieth century until 2000.

41 'Lancetti il sarto pittore che inventa i tessuti', *Linea Italiana* (March 1978), no.89

42 Bonizza Giordani Aragno, 'Walter Albini e il tessuto stampato' in Gloria Bianchino, *Walter Albini*, (Parma, 1988), pp.59–79

43 Nicoletta Bocca, 'La coerenza dello stile' in Paolo Rinaldi (ed.) *Walter Albini lo stile nella moda* (Modena, 1988), pp.115–17

44 One example of this is an episode recalled by Michele Canepa in an interview with the author on 29 November 2012. His family firm, which specialized in ties, was notified in 1972 that Valentino was looking for a manufacturer capable of creating a figured crêpe satin woven with his logo, a fabric that was frequently used a great deal at that time for shirts, to the extent that Taroni, the Como firm that produced it, had a waiting list of up to a year. Technical considerations meant that the tie-weaving looms could not be used without lengthy and costly modifications. A skilled Como technician subsequently found a way round this hurdle.

45 Ingrid Sischy, 'Interview with Armani' and Catherine Perry, 'Armani and Textiles', in *Giorgio Armani*, exh. cat. (New York, 2000), pp.9–19, 225

46 Enrica Morini, 'Una storia di moda', in Adelheid Rasche (ed.) *Coats! Max Mara, 55 anni di moda italiana*, exh. cat. (Milan, 2006), p.37

47 Interview conducted by the author with Laura Lusuardi in Reggio Emilia, 19 November 2012

48 'For most of the textile companies who began collaborations with branded ready-to-wear firms, abandoning retail sales initially represented the quickest and simplest route to take. However, in many cases it meant losing contact with the market, which limited the choices of the companies and designers were now their only link.' Nicoletta Bocca, 'La moda pronta e la sua materia', in *Per una storia della moda pronta. Problemi e ricerche, Atti del V Convegno Internazionale del CISST* (Florence, 1991), p.322

49 Personal interview with Laura Lusuardi, 2012. The Max Mara archive holds large registers with references for the textiles they used for collections from the 1950s onwards, accompanied by tags with the names of the producers. They represent an extremely useful tool in reconstructing commercial production over a period of 50 years.

50 'Innovations are now launched and used in a different way. Once they were a source of pride, as it was for Piacenza to have 137 haute couture designs on the catwalk in Paris . . . Now it is even more profitable, because industrially it is even more profitable, given that for a single type of coat wool a brand like Max Mara can use 70,000 metres in a season, ensuring a presence in renowned stores like Harrods in London, because of the prestige of the fabric as well as demand for the garment style.' Interview with Riccardo Piacenza, a Biella wool manufacturer, in *Linea Italiana* (October 1983), no.151, p.107

51 Chiara Buss, 'La re-invenzione della materia', in Nicoletta Bocca and Chiara Buss (eds), *Gianni Versace. L'abito per pensare*, exh. cat. (Milan, 1989), pp.152–91; Richard Martin, *Gianni Versace* (New York, 1997), pp.111–18; and Chiara Buss and Richard Martin (eds), *Gianni Versace* (Milan, 1998)

52 Nicoletta Bocca and Chiara Buss (eds), *Gianni Versace. L'abito per pensare*, exh. cat. (Milan, 1989), pp.182–3

53 Maria Luisa Frisa (ed.), *Gianfranco Ferré. Lezioni di moda* (Venice, 2009), pp.87–109

54 Personal interview with Rita Airaghi, Ferré's right hand and the current director of the Gianfranco Ferré Foundation, 9 October 2012

55 Ibid.

56 'From a wind-tossed pergola in the sun comes the idea of a print in overlapping positive/negative patterns. Out of the weaving of a straw seat comes a woven lace design'. Interview with Gianfranco Ferré, in Nicoletta Bocca, *Moda: poesia e progetto* (Milan, 1990), p.22

57 Enrica Morini, *Storia della Moda XVIII-XXI secolo* (Milan, 2010), pp.468–81

58 Bonizza Giordani Aragno, *Callaghan 1966. La nascita del pret-a-porter italiano* (Milan, 1997), pp.163–245

59 Personal interview with Romeo Gigli, 12 December 2012

60 'With today's prices people require something special, particularly from me as the Mani collection provides a classic style . . . The novelty of my collection depends a lot on the fabrics as well, created to order, from the cotton ottoman printed with moiré stripes (a *trompe-l'oeil* effect that gives an impression of great heaviness, while in reality the textile is very fresh) to the batik-printed wool, which acquires an unexpected effect of three-dimensionality.' Giorgio Armani quoted in 'Un bel giorno da Giorgio Armani e Lauren Hutton', *Vogue Italia* (February 1981), no.371

61 'It is estimated that, against an hourly wage equivalent to 16.2 US dollars in Italy in 1993, the average hourly wage was less than 3 dollars in Turkey and only 36 American cents in China. Faced with such striking variations, no form of progress or technology can resist, style and taste are not enough to pull you through: firms are forced to admit that there is no sense in acquiring stylistic and technological advantages to then have them wiped out by such high labour costs. Therefore, transplanting aspects of textile and clothing production to emerging countries was actually instigated by firms in industrially-developed areas.' See Gian Maria Gros-Pietro, 'Aspetti strategici del mercato', in *Ricerca e impresa nel tessile verso il XXI secolo*, Atti del Forum Internazionale Tessile, Fondazione Antonio Ratti, Villa d'Este, Cernobbio, 17 September 1994, p.21

62 Laia Farran Graves, *The Little Book of Prada* (London, 2012)

63 Loro Piana's first experience in the female clothing sector was the

'Horsey' doublet in 1996, originally created for the Italian men's equestrian team at the Barcelona Olympics in 1992. Courtesy of Loro Piana Marketing Communication, Sara Tamburelli, 28 February 2013.

64 Personal interview with Donatella Ratti, 30 January 2013

65 On 30 October 1947 in Geneva, 23 countries signed the General Agreement on Tariffs and Trades (GATT) with the aim of promoting and regulating liberalization of global commerce. It was a way of controlling the complex commercial links between the United States, the European Union and other companies with a market economy who were part of the agreement. GATT's work was spread out over decades with a series of negotiating sessions, called rounds, in which an ever-increasing number of countries participated. In this context, in 1974, the Multifiber Arrangement (MFA) was signed, for the purpose of protecting developed countries from imports hailing from emerging countries that enjoyed significant advantages in the textile sector, because of the reduced labour costs. 'The Multifiber Arrangement grew out of a series of voluntary export restraints imposed, initially, by the United States on Japanese textile exports in 1955. By the end of the 1950s, the United Kingdom also began to limit imports from Hong Kong, India and Pakistan. The eighth round of GATT (Uruguay Round, 1986–93) established that the MFA would be abandoned after 10 years. A major development of the Uruguay Round was the signing of the Agreement on Textiles and Clothing (ATC) in 1994, which began the gradual process of integration of textile and clothing products with the rules of GATT and the World Trade Organization (WTO). Irene Brambilla, Amit Khandelwal and Peter Schott, China's experience under the Multifiber Arrangement (MFA) and the Agreement on Textiles and Clothing (ATC), Working Paper 13346, http//www.nber.org/papers/w13346, National Bureau of Economic Research, Cambridge, 2007, revised 2009

66 Personal interview with Roberto Belluzzi, purchasing manager at Ratti, 30 January 2013

67 Personal communication from Michele Canepa, 11 January 2005

68 Personal interview with Giuliana Sala, womenswear product manager, 21 February 2013

Craft and 'Made in Italy' — Catharine Rossi

1 Marya Mannes, 'The Fine Italian Hand', British Vogue (September 1946), pp.45–9, 81.The same article was reproduced in American Vogue in January 1947 under the title 'Italian Fashion'.

2 Ibid., p.45

3 Ibid., p.81

4 Rachel Sanderson, 'Overseas Sales Boost Italian Luxury Groups', The Financial Times, 30 March 2012, www.ft.com/cms/s/0/c79f7252-7a6c-11e1-839f-00144feab49a.html#ixzz2DhPxpoEl [accessed 30 November 2012]

5 Andrew Ross, 'The Trouble with Craft Capitalism', Antipode (2004), vol.36, no.2, p.210

6 Valerie Steele, 'The Italian Look', in Giannino Malossi (ed.), Volare: The Icon of Italy in Global Pop Culture (New York, 1999), p.92

7 Rachel Sanderson, 'The Real Value of Being "Made in Italy"', The Financial Times, 19 January 2011, www.ft.com/cms/s/0/ab98f3b4-2417-11e0-a89a-00144feab49a.html [accessed 30 November 2012]

8 Simona Segre Reinach discusses the concept of 'Made in Italy' in depth see pp.58–71

9 Ross (cited note 5), p.209

10 Susan Mosher Stuard, Gilding the Market: Luxury and Fashion in Fourteenth-Century Italy (Philadelphia, 2006), pp.1–3

11 Anna Cento Bull and Paul Corner, From Peasant to Entrepreneur: The Survival of the Family Economy in Italy (Oxford and Providence, RI, 1993), pp.154–5; John Foot, Milan Since the Miracle: City, Culture and Identity (Oxford and New York, 2001), p.112

12 Dana Thomas, Deluxe: How Luxury Lost its Lustre (London, 2007), p.217

13 Ibid., p.217; Samuele Mazza, Etro (Milan, 1998)

14 According to Michael L. Blim, in Italian law, businesses with 15 or fewer employees are considered artisanal firms. Michael L. Blim, Made in Italy: Small-Scale Industrialisation and its Consequences (New York and London, 1990), p.116

15 Ibid., pp.1–2

16 In addition to Blim's Made in Italy, notable texts on Italy's 'industrial districts' include Edward Goodman, Julia Bamford and Peter Saynor (eds), Small Firms and Industrial Districts in Italy (London and New York, 1989).

17 Emanuele Pantanella in an email interview with the author, 15 February 2013

18 Ibid.

19 For more on the artist-craftsman see the essays in Emanuele Pantanella: Opere dal 1972 al 2004 (Rome, 2004)

20 Marianne Lamonaca, 'A "Return to Order": Issues of the Classical and the Vernacular in Italian Inter-War Design', in Wendy Kaplan (ed.), Designing Modernity: The Arts of Reform and Persuasion, 1885–1945 (New York, 1995), p.209

21 Simona Segre Reinach, 'Milan: The City of Prêt-à-Porter in a World of Fast Fashion', in Christopher Breward and David Gilbert (eds), Fashion's World Cities (Oxford and New York, 2006), p.124

22 Stefania Ricci, 'Salvatore Ferragamo: An Evolving Legend', in Ricci (ed.), Salvatore Ferragamo: Evolving Legend 1928–2008 (Milan and London, 2008), pp.13–15

23 For more on the fashion industry under the fascist regime, see Eugenia Paulicelli, Fashion under Fascism: Beyond the Black Shirt (Oxford, 2004)

24 Fede Cheti was a self-taught textile weaver and designer who moved to Milan in the late 1920s, and whose collaborations included those with

Biki and Mariano Fortuny. Irina Inguanotto, 'Elda Cecchele and the Italian Fashion World: From Salvatore Ferragamo to Roberta di Camerino (1950–1970)', in Textile History, (2012), no.2, p.228; footnote 45, pp.246–7; 'CHETI, Fede', http://www.treccani.it/enciclopedia/fede-cheti [accessed 20 August 2013]

25 Jeffrey T. Schnapp, 'The Fabric of Modern Times', in Critical Inquiry (1997), vol.24, no.1, p.195; Inguanotto (cited note 24), p.228

26 Sarah Mower, Gucci by Gucci: 85 Years of Gucci (London, 2006), p.16; Schnapp (cited note 25), p.195; Inguanotto (cited note 24), p.22

27 'S.F.A. Announces the Arrival of Their New Italian Collection by Ferragamo, Shoemaker Principale', 11 November 1960, Salvatore Ferragamo Archive, Florence

28 Salvatore Ferragamo, Shoemaker of Dreams: The Autobiography of Salvatore Ferragamo (London, 1957, reprinted 1985), pp.45, 107

29 Ibid., pp.110–12

30 Ibid., p.122.

31 Glenn Adamson, introduction to Salvatore Ferragamo, 'Shoemaker of Dreams', excerpt in Adamson (ed.), The Craft Reader (New York and Oxford, 2010), p.244

32 Nicola White, Reconstructing Italian Fashion: America and the Development of the Italian Fashion Industry (Oxford, 2000), p.36

33 For more on this significant moment in Italy's fashion history, see Guido Vergani, The Sala Bianca: The Birth of Italian Fashion (Milan, 1992)

34 White (cited note 32), p.71

35 Thomas (cited note 12), p.211

36 White (cited note 32), p.71

37 Simona Segre Reinach, 'Italian Fashion: The Metamorphosis of a Cultural Industry', in Grace Lees-Maffei and Ktejil Fallan (eds), Made in Italy: New Perspectives on Italian Design (Oxford, 2013), p.241

38 White (cited note 32), p.71

39 Valerie Steele, Fashion, Italian Style (New York, 2003), pp.51, 54

40 Charlotte Fiell, Peter Fiell and Catharine Rossi, Masterpieces of Italian Design (London, 2013)

41 Steele (cited note 39), p.82

42 Ottavio Missoni in Silvia Giacomoni, The Italian Look Reflected (Milan, 1984), p.90

43 This enthusiasm for new technologies is as true of Italy's small firms as large enterprises. Ian Taplin, 'Segmentation and the Organisation of Work in the Italian Apparel Industry', in Social Science Quarterly (1989), vol.70, no.2, pp.416–17

44 Thomas (cited note 12), p.197

45 Ibid., pp.195–6

46 Ibid., p.10; Segre Reinach (cited note 37); 'The Family Way: Italy's Dynamic Design Dynasties and the Empires they Rule', Wallpaper*, 8 August 2012, www.wallpaper.com/fashion/family-fortunes-italys-leading-design-and-fashion-dynasties/5983#67222 [accessed 5 April 2013]

47 Thomas (cited note 12), p.10

48 For more on the global nature of fashion production, see the essays in Breward and Gilbert (cited note 21)

49 Segre Reinach (cited note 21), p.128

50 See also Mark Tungate, Luxury World: The Past, Present and Future of Luxury Brands (London and Philadelphia, 2009); Schiavi del Lusso, broadcast on the Italian television channel RAI3 in December 2007; Adam Lee-Potter, 'Made In Italy: Exclusive Gucci Dolce & Gabbana Prada . . . by Chinese Workers in Sweatshops on 2 Pounds an Hour', Sunday Mirror, 2 December 2007, p.40, http://search.proquest.com.ezproxy.kingston.ac.uk/uknews/docview/339720783/fulltext/13BD938440C44B6FF30/1?accountid=14557 [accessed 25 January 2013]; Thomas (cited note 12), p.204

51 Thomas (cited note 12), p.221

52 Different international regulations for labelling mean that not all of these suits were made in Egypt. As Thomas notes, 'In Europe, companies do not have to declare where their goods are produced. Valentino suits for the American and Japanese markets, which have stricter laws about provenance labelling, were produced in Italy.' Thomas (cited note 12), p.221

53 'New Rules on Designations of Origin and "Made in Italy": Designations', 1 June 2010, www.internationallawoffice.com/Newsletters/detail.aspx?g=d747a5c6-ca79-4208-9410-98c696355c3f [accessed 13 February 2012]

54 Ross (cited note 5), p.213; Imran Amed, 'Made in Italy: Time for Accountability', The Business of Fashion, 4 December 2007, www.businessoffashion.com/2007/12/made-in-italy-time-for-accountability.html [accessed 13 February 2013]

55 For a detailed account of this production set up see Ross (cited note 5), pp.209–15

56 In November 2012 an article appeared in The New York Times on this embrace of craftsmanship by brands including Fendi, Brunello Cucinelli, Etro and Valentino. J. J. Martin, 'In Italy, Standards of Excellence', The New York Times, 15 November 2012, www.nytimes.com/2012/11/16/fashion/16iht-fcraft16.html?pagewanted=all&_r=0 [accessed 8 April 2013]

57 Gialunca Lo Vetro, 'AlphabETRO', in Samuele Mazza (ed.), Etro (Milan 1998)

58 Miuccia Prada in Suzy Menkes, 'Throwing Down the Gauntlet', in The New York Times, 28 September 2010, www.nytimes.com/2010/09/29/fashion/29iht-rprada.html?_r=0 [accessed 5 February 2013]

59 Caroline Roux, 'Craft, Commerce and Couture', Crafts (March–April 2011), p.48

60 Ibid., p.48.

61 Matt Tyrnauer, 'Less is Maier', Vanity Fair, September 2008, www.vanityfair.com/style/features/2008/09/maier200809 [accessed February 2013]

62 Other examples include Gucci, who in 2009 re-issued the Jackie bag, first

produced in the 1950s. It takes 36 hours to produce just one *New Jackie*, all of which happens in Italy. See Roux (cited note 59), p.48
63 Martin (cited note 56); Segre Reinach, (cited note 37), p.249
64 Segre Reinach, ibid., p.246
65 In addition to Ross, see for example Eileen Boris, 'Crafts Shop or Sweatshop? The Uses and Abuses of Craftsmanship in Twentieth Century America', *Journal of Design History* (1989), vol.2 no.2/3, pp.175–92

Prato: Between Tradition and the Future — Filippo Guarini and Laura Fiesoli

1 Elisabetta Merlo, *Moda Italiana – Storia di un'industria dall'Ottocento a oggi* (Venice, 2003), p.104
2 E. Bruzzi, *L'Arte della lana a Prato* (Prato, 1920), p.87
3 Laura Fiesoli, 'I tessuti per lo Sportwear. Un elemento strategico di diversificazione produttiva. Casi d'eccellenza nel distretto tessile pratese', in *Superhuman Performance: L'evoluzione del tessuto per lo sport*, exh. cat (Prato, 2008)
4 The oil crisis started in 1973, due to the unexpected interruption of petrol supplies from the countries belonging to OPEC, and continued until 1975. The Italian government introduced a plan of economic austerity intended to save energy through regulations such as a Sunday driving ban, bringing forward the end of television programmes and lowering the level of street and commercial lighting.
5 The fair was launched thanks to the initiative of Pratotrade, a consortium created in 1979 by Prato's Industrial Union, comprising around 50 selected textile firms from the Prato area and bringing together the most creative producers of clothing for men, women and children.
6 In the 1990s, around a hundred wool producers were already taking part in Prato Expo. These were the companies who invested the most in stylistic research. 'Prato Expo' became notable for displays of samples, creativity, novelty and the richness of the range of textiles presented.
7 See Andrea Balestri, *Cambiamento e politiche industriali nel distretto tessile di Prato* (Milan, 1992), p.53
8 The brand Patrizia Pepe Firenze, launched in the 1990s in the Prato district, was one of the first to adopt this strategy.
9 See Prato's Industrial Union website, 2013 update. www.ui.prato.it/unionedigitale/v2/areastudi/numeri-distretto-pratese.asp
10 Data supplied by Prato's Industrial Union Study Centre from Istat CoEWeb.
11 In the mid-1980s there were 500 plants producing carded yarn but, by 2012, there were fewer than 100 (interview with Barbara Bigagli, Prato's Industrial Union Study Centre, March 2013).
12 Prato's Industrial and Artisan Chamber of Commerce, data gathered in the region of Prato, 2012.
13 'A very real ethnic industrial district producing low-cost clothing has developed in Prato, unique in Europe', '[the district of Prato] in 2001, provided work for 38,000 people and had a turnover of almost 5 billion euro . . . in ten years the textiles firms in Prato have halved (there were 5,800, now there are fewer than 3,000) and the employees are fewer than 18,000, resulting in a loss of 1.6 billion euro of textile turnover'. Silvia Pieraccini, 'Il tessile di Prato e il dilemma dell'integrazione con i cinesi', *Il Sole 24 Ore*, 10 August 2012, http://www.ilsole24ore.com/art/impresa-e-territori/2012-08-10/tessile-prato-dilemma-integrazione-064440.shtml?uuid=Ab3XuDMG [accessed 6 June 2013]
14 Graeme Johanson, Russell Smith and Rebecca French (eds), *Oltre ogni muro: I cinesi a Prato* (Pisa, 2010)
15 Silvia Pieraccini, 'Il tessile di Prato e il dilemma dell'integrazione con i cinesi', *Il Sole 24 Ore*, 10 August 2012, http://www.ilsole24ore.com/art/impresa-e-territori/2012-08-10/tessile-prato-dilemma-integrazione-064440.shtml?uuid=Ab3XuDMG [accessed 6 June 2013]; Gala Planigiani, 'Chinese Remake the "Made in Italy" Fashion label', *The New York Times*, 12 September 2010, http://www.nytimes.com/2010/09/13/world/europe/13prato.html?pagewanted=all&_r=1& [accessed 6 June 2013]
16 The current European norms penalise the export to China and the US, where branding and traceability are considered very important.
17 See p.92 of this book
18 Andrea Cavicchi in conversation with Filippo Guarini
19 Until now it has been possible to label products 'Made in Italy' if they have been designed in Italy but mainly produced abroad, with foreign semi-finished goods and labour.
20 From Prato's Industrial Union document on Industrial Politics, 'Imprese e territorio: idee e proposte di intervento per il future del distretto pratese', and 2012 guidelines.
21 22,000 tonnes of rags are recycled in Prato annually; see the Industrial and Artisanal Chamber of Commerce
22 The project's other initiatives are: using solar energy, increasing the use of recycled water, reducing the impact of transfers. http://www.cardato.it [accessed 23 April 2013]
23 In 2011 there were more than 50,000 firms and 400,000 employees, with an overall turnover of more than 50 billion euro, half of which came from exports. See ISTAT for the Sistema Moda Italia
24 The inspiration came from the archive of the École nationale supérieure des arts et industries textiles (ENSAIT) of Roubaix, France. See Filippo Guarini, in *Thirty Years of Donations*, exh. cat., Museo del Tessuto (Prato, 2007), p.45
25 Thanks to donations of entire private collections from businesses and private individuals and to acquisitions of particularly important pieces.
26 Since 2003, the museum has been run by the Prato Textile Museum Foundation, a body representing the Prato commune and province, the Chamber of Commerce, the Group of Industrialists and Artisans and Prato's Industrial Union, with support from the bank, the Fondazione Cassa di Risparmio di Prato.
27 This includes a rotating programme of the collections, with new displays, school tours, and the involvement of firms through competitions for young designers and practical workshops for adults.

Knitwear — Elizabeth Currie

1 Nicola White, *Reconstructing Italian Fashion: America and the Development of the Italian Fashion Industry* (Oxford, 2000), p.50
2 Gloria Bianchino, Grazietta Butazzi and Alessandra Mottola Molfino (eds), *Italian Fashion: The Origins of High Fashion and Knitwear*, vol.1 (Milan, 1987), p.266
3 Valerie Steele, *Fashion Italian Style* (New Haven and London, 2003), p.42
4 Russell King, *The Industrial Geography of Italy* (London, 1985), p.160
5 See Vicky Franzinetti, 'The informal sector in an industrialized country: Textile and garment workers in northern Italy', in Margaret Hosmer Martens and Swasti Mitter (eds), *Women in Trade Unions: Organizing the Unorganized* (Geneva, 1994), pp.161–9
6 Made in Italy Official Portal, www.italtrade.com/focus/4733.htm [accessed 1 February 2013]
7 Bianchino, et al. (cited note 2), p.268
8 Ibid., p.275, Gianni Versace wrestler's jumper, V&A: T.323–1985
9 Silvia Giacomoni, *Italian Look Reflected* (Milan, 1984), pp.108–9
10 See, for example, the catalogue of the 2012 knitwear exhibition held at Palazzo Morando, Milan. Emmanuelle Dirix and Federico Poletti (eds), *Maglifico! 50 Years of Extraordinary Made in Italy Knitwear* (Milan, 2012)
11 Simona Segre Reinach, 'The material speaks for itself', in Valerie Steele *Fashion Italian Style* (New Haven and London, 2003), p.121

Fur — Oriole Cullen

1 Judith Watt, 'To Die For', *Guardian*, 24 March 2000 [accessed 4 December 2012]
2 J.J. Martin, 'Fur: The All-Season Italian Must', *The New York Times*, 2 October 2005 [accessed 5 December 2012]
3 'Moda Italiana a New York', *La Donna*, (July 1952)
4 Federica Di Castro, 'Leather and Fur', in Anna Municchi's *Italian Fashion* (Milan, 1987), p.193
5 Ann Municchi, 'Stylized and Signed The Eighties', *Ladies in Furs 1940–1990* (Modena, 1993), p.118
6 Alessandra Ilari, 'Italians Add a Dash of Fashion to Fur', *Women's Wear Daily*, 3 May 2005
7 Pambianco report, 'The Italian Fur Industry in 2010, Production, Distribution and Consumption, Characteristics and development of the sector', www.infurmag.com/pdfs/Pambianco2011.pdf [accessed 4 December 2012]
8 United States of America Department of Agriculture, Global Agricultural Information Network Report, 25 May 2010, http://gain.fas.usda.gov/Recent%20GAIN%20Publications/Fur%20Animals%20and%20Products_Beijing_China%20-%20Peoples%20Republic%20of_5-25-2010.pdf [accessed 5 April 2013]
9 Alex Gorton, 'Designers Transform the Puffa', *The Financial Times* (online edition), 13 November 2009, www.ft.com/cms/s/0/ec41bbc6-cfe0-11de-a36d-00144feabdc0.html#axzz2KavZIBlm [accessed 5 December 2012]
10 Andrea Batilla, Sabrina Ciofi and Giulia Protto, 'Conceria Milanese', Wonder Furs website, www.wonderfurs.it/insidefur/conceria-milanese/?lang=en [accessed 4 December 2012]

Leather — Helen Persson

1 Personal communication with Mike Redwood, Museum of Leathercraft Council
2 Stefania Ricci, 'Made in Italy: Salvatore Ferragamo and the Twentieth-Century Fashion', in *Shoes: A History from Sandals to Sneakers* (Oxford and New York, 2006), p.315
3 Valerie Steele, *Fashion Italian Style* (New Haven, CT, 2003), pp.7–10
4 Ricci (cited note 2), pp.308–10
5 Nicola White, *Reconstructing Italian Fashion: America and the Development of the Italian Fashion Industry* (Oxford, 2000), p.36
6 Steele (cited note 3), p.91
7 Ibid., p.98

Portrait/Self-portrait: The Image of Fashion — Maria Luisa Frisa

1 'La fotografia e la moda', *Natura* (January 1937), vol.10, p.34
2 'In Milan there were photographers like De Marchi and Mauro Camuzzi working for the Studio Fotografico Crimella; in Turin, Luigi Bogino and Lucio Ridenti. Rome was represented by the Studio Bragaglia, by Elio Luxardo, who covered all genres, including fashion photography and still life, and by the society portraits of Arturo Ghergo, Ghitta Carrel and Eva Barret who has yet to be studied in depth. The photographers were the first to theorise about fashion photography, perceived as a new genre and field of action.' Mario Lupano and Alessandra Vaccari, *Fashion at the Time of Fascism* (Bologna, 2009), p.11

3 Gabriellasport was the fashion house run by Gabriella di Robilant, who was active first in Milan and then in Rome between 1932 and 1952. *Harper's Bazaar's* interest in Italian fashion grew in the post-war years. In the feature 'An Italian Skier Designs', published in December 1948, it was the turn of Emilio Pucci and his skiwear; the photographs were by Toni Frissell. Pucci would remain a constant presence in the magazine: the feature on his 'capsule' model, with photographs by Saul Leiter, dates from May 1960.

4 Elsa Robiola, 'Con la regia di Venezia', *Bellezza* (November 1954), no.11, p.22

5 Irene Brin, 'La moda nella città eterna', *I Tessili Nuovi* (July–September 1948), no.37, p.17

6 Maria Pia Beltrami (ed.), 'Le donne dei best-sellers in Italia', *Harper's Bazaar Italia* (October–November 1970), no.10; 'Italy: The Street Scene', American *Harper's Bazaar* (October 1970), no.3107

7 Flavio Lucchini founded *L'Uomo Vogue* in 1967, a revolutionary move with no parallel elsewhere in the world, as it was Condé Nast's first magazine of men's fashion. Initially a supplement to *Vogue Italia*, it became a magazine in its own right from September 1967, published at first every two months and later monthly (Franco Sartori was the first editor, until 1976)

8 Ferdinando Scianna, *Altrove: Reportage di moda* (Milan, 1995)

9 'Years of lead' is the name given to a period stretching from the end of the 1960s to the beginning of the 1980s that marked a deep crisis in Italian political and social life. During this decade, political debate descended into an extremism that threatened the stability of the Italian system, expressed at first through street violence and then through outright armed struggle, caught between the terrorism of the far left and the strategy of bombings implemented by the far right.

10 Quoted in Antonio Mancinelli, 'Styles Wide Shut: Dreams that Money Can Buy', in Maria Luisa Frisa (ed.), *Italian eyes: Italian fashion photographs from 1951 to today*, exh. cat., Rotonda di via Besana (Milan and Florence, 2005), p.267

11 Alessandro Mendini, 'Moda come Arte', *Domus* (March 1985), p.44. Occhiomagico was the pen name of the photographer Giancarlo Maiocchi, which he had used since 1971. In 1981 his photographs appeared in *Domus Moda*, a supplement of *Domus*, and between January 1982 and February 1984 on the covers of the magazine.

12 Gianfranco Ferré, 'The Forms of Emotions: Giving Form to Feelings', in Maria Luisa Frisa (ed.), *Gianfranco Ferré: Lessons in fashion* (Venice and Florence, 2009) pp.153–61

13 *Vanity* is a monthly magazine from the Condé Nast stable that was founded in 1981 as the brainchild of the journalist and fashion editor Anna Piaggi, an icon of international style. Conceived as a concept magazine, it experimented with a new language that, in addition to reviving the use of drawn illustration, made pioneering use of screenshots from the first videos of fashion shows. Piaggi was the editor until 1984

14 Antonio Lopez (1943–87), with his visionary illustrations, was directly involved in the *Vanity* project from its outset in 1981, and his work often appeared on the cover. The campaigns for Missoni were also published in *Donna*, *Linea Italiana* and *Vogue Italia*, to mention just a few of the magazines that defined the Italian style in fashion between the 1970s and '80s.

15 The most frequently cited scene in Michelangelo Antonioni's mysterious and mesmerizing film *Blow-Up* is the one of the photographic session between David Bailey/David Hemmings and Veruschka, which turns into a sort of sexual ballet, as was pointed out at the time by Adele Cambria in an article that appeared in *L'Europeo* on 26 March 1970, and set the seal on the erotic nature of the partnership between photographer and model.

16 Ugo Mulas in conversation with Arturo Carlo Quintavalle shortly before his death, in Eva Paola Amendola (ed.), *Vestire Italiano: Quarant'anni di moda nelle immagini dei grandi fotografi* (Rome, 1983), p.113

17 The philosophy behind the campaign is explained in Renzo Rosso, *Be Stupid: For Successful Living* (New York, 2011)

Italian Fashion Designers in Hollywood — Stella Bruzzi

1 Stella Bruzzi, *Undressing Cinema: Clothing and Identity in the Movies* (London and New York, 1997), pp.27–8

2 Simona Segre Reinach, 'The Fontana Sisters', in Valerie Steele (ed.), *The Berg Companion to Fashion* (Oxford, 2010), p.344

3 Lee Server, *Ava Gardner: Love is Nothing* (London, 2010), pp.361–3

4 Chris Laverty, 'American Gigolo: Armani Gere', 2012–13, http://clothesonfilm.com/american-gigolo-armani-gere/13314/ [accessed 26 July 2013]

5 Tim Edwards, *Men in the Mirror: Men's Fashion, Masculinity and Consumer Society* (London, 1997), p.3

6 Pamela Church Gibson, *Fashion and Celebrity Culture* (London and New York, 2012), p.64

7 Bob Foltman, 'The Actor's Friend', *Chicago Tribune*, 20 October 1994, http://articles.chicagotribune.com/1994-10-20/features/9410200286_1_nino-cerruti-film-lot-of-other-designers [accessed 26 July 2013]

8 Jennifer Craik, *The Face of Fashion: Cultural Studies in Fashion* (London and New York, 1994), p.83

9 The names of Versace, Armani and Cerruti have all been associated with *Miami Vice* (although Armani reputedly disliked the down-market way in which his styles were used, for example by turning up the jacket sleeves). However, another article attributes this look to Cerruti (see Liubomir Stoykov, www.fashion-lifestyle.bg/designers_en_broi28) [accessed 26 July 2013]

10 Stephen Gundle, *Glamour: A History*, (Oxford and New York, 2008), p.360

11 Ella Alexander, 'Miuccia Prada unveils *Great Gatsby* costumes', *Vogue News,* 21 January 2013, http://www.vogue.co.uk/news/2013/01/21/prada-great-gatsby-costumes-revealed-baz-luhrmann-film [accessed 26 July 2013]

12 Nakisha Williams, '*The Great Gatsby*: Costume Designer Catherine Martin on collaborating with Miuccia Prada', http://popstyle.ew.com/2013/01/24/the-great-gatsby-costume-designer-catherine-martin-on-collaborating-with-murcia-prada [accessed 26 July 2013]

13 Ibid.

Anna Piaggi — Judith Clark

1 *Anna Piaggi's Fashion Algebra: D.P. in Vogue* (London, 1998)

The Return of the Courtier: Men and Menswear — Christopher Breward

1 Ornella Kyra Pistilli, 'De-Branding Italy', *Zone Moda Journal 2*, (Italy, 2011), p.47

2 Germano Celant, 'Towards the Mass Dandy', in *Giorgio Armani,* exh.cat., (New York, 2003), p.18

3 Paola Colaiacomo, *Factious Elegance: Pasolini and Male Fashion* (Venice, 2007), p.56

4 Pier Paolo Pasolini, 'The Divine Mimesis, Canto II, 1963, 24', quoted in Colaiacomo (cited note 3), p.58

5 Valerie Steele, 'The Italian Look', in Giannino Malossi (ed.), *Volare: The Icon of Italy in Global Pop Culture* (New York, 1999), p.91

6 Colaiacomo (cited note 3), pp.105–7

7 Celant (cited note 2), p.17

8 Celant (cited note 2), p.15

9 Christopher Breward, 'Camp and the International Language of 1970s Fashion', in Maria Luisa Frisa and Stefano Tonchi (eds), *Walter Albini and his times: All power to the imagination* (Venice, 2010), p.16

10 Simona Segre Reinach, 'Milan: The City of Prêt-à-Porter in a Word of Fast Fashion', in Christopher Breward and David Gilbert (eds), *Fashion's World Cities* (Oxford, 2006), pp.123–5

11 Reka Buckley and Stephen Gundle, 'Flash Trash: Gianni Versace and the Theory and Practice of Glamour', in Stella Bruzzi and Pamela Church Gibson (eds), *Fashion Cultures* (London, 2000), pp.331–48

12 Karin Nelson, 'Playboy', in Frida Giannini (ed.), *Gucci: The Making of* (New York, 2011), p.208

13 John Wilkes, 'Tom Ford', in Giannini (cited note 12), p.54

14 www.pittidiscovery.com [accessed 24 April 2013]

15 Luigi Settembrini, *La Regola Estrosa: One Hundred Years of Italian Male Elegance* (Milan, 1993), p.20

'In The Things That Go Over Other Things' — Alistair O'Neill

1 'Sports Clothes (m. and f.) Designed in Italy', American *Vogue* (15 May 1953), pp.74–5

2 'Style in Six Different Languages', *Tailor and Cutter*, 25 July 1952, p.910

3 'The fashion makers', *Women's Wear Daily Italy* supplement, February 2000, p.102

4 'Style in Six Different Languages', *Tailor and Cutter*, 25 July 1952, p.910

5 'Pope Pius XII Speaks to Tailors in Rome', *Tailor and Cutter*, 24 September 1954, p.1210

6 'A Designer Out of Italy Offers New Look to Men', *The New York Times*, 29 September 1955

7 Farid Chenoune, *A History of Men's Fashion* (London, 1993), p.245

8 Gaetano Savini interviewed for *Men's Wear*, 28 January 1961, p.24

9 *Men's Wear*, 7 March 1964, p.22

10 Report on SAMIA ready-to-wear men's show in Turin, *Men's Wear*, 5 March 1966, p.19

11 'Men's Wear from Italy', *Men's Wear* supplement, 13 June 1964

12 Adrianna Grassi, untitled article, *Women's Wear Daily*, 25 May 1973

13 Flavio Lucchini, 'Vogue Men: International Style, '78: For Men, "Made in Italy" Means Inspired by America', American *Vogue* (1 April 1978), p.317

14 'Vogue Men: International Report/Milan: Updated Ease', American *Vogue* (1978), pp.246–7

15 'The Future is: The Jacket Non Jacket', *L'Uomo Vogue* (August 1978), p.142

16 Ted Polhemus, 'An Imagined Italy', in Giannino Malossi (ed.), *Volare: the icon of Italy in global pop culture* (Florence, 1999), p.64

17 Richard Martin, 'Post-Modern Menswear: Irony and Anomaly in Men's Attire of the 1980s', *Dress* (1982), issue 8

18 Iain R. Webb, 'Ain't Nothin' to the G-Thang': The Milan Revolution, *Arena Homme Plus*, Spring/Summer 1995, issue 3, pp.154–6

19 Marco Fortis, *Crescita economica e specializzazioni produttive: Sistemi locali e imprese del 'Made in Italy'* (Milan, 1996)

20 Carlo Antonelli and Peppino Ortoleva, 'The Italian Way to Modernity', in Malossi (cited note 16), p.69

21 *Italy in the World Economy*, report for 2011–2012, Italian Ministry of Economic Development

From Tennis Court to Football Terrace: Italian Sportswear and British Male Style — Jonathan Faiers

1 *Italian Re Evolution: Design in Italian Society in the Eighties*, exh. cat. (La Jolla, 1982) p.147

2 Bettina Ballard, *In My Fashion* (London, 1964), p.254. (Ballard was referring to women's fashion when she made this pronouncement)

3 There were of course other Italian brands worn by the casuals, most notably Ellesse, Benetton (especially the classic rugby shirt) and, to a lesser degree, Gabicci for some knitwear. The French label Lacoste was also extremely popular, alongside Scottish golfing brands such as Pringle and Lyle & Scott. But it was Italian tennis wear that was the most characteristic, highly prized and sought after. Other brands including the ubiquitous Burberry were of course also favoured by casuals, but this text is limited to a discussion of the significance of tennis wear rather than other items in the casual wardrobe.

4 The difficulty of finding a barber in Britain in the early 1960s who could execute an Italian style as opposed to a conventional haircut meant that potential clients had to pay almost three times as much: 'Not all barbers could do an Italian haircut as most of them still simply cut men's hair rather than styling it, but for about 6/- (as opposed to 2/6d) you could get the "Perry Como" cut.' Quoted in Richard Barnes (ed.), *Mods!* (London, 1991), p.9

5 Former mod Wayne Kirven speaking on 'British Style Genius Part 5: Loud and Proud The Street', BBC2, first broadcast 4 November 2008

6 Stephen had worked at Vince's Man Shop, widely regarded as the pioneer in bringing contemporary European-influenced men's fashion to the British male in the 1950s, before setting up His Clothes initially in Beak Street and then subsequently in Carnaby Street. In the 1960s, Stephen would go on to build an empire of similar men's fashion shops, including Domino Male, Mod Male and Male W1, earning him the epithet 'The £1m Mod'.

7 Niccolò Machiavelli, *The Prince* (1532) (London, 2009), p.18

8 'Why Italian men's shirts will always lead the way in Fashion' on shopping website www.reemclothing.com [accessed 25 February 2013]

9 While the subject under discussion is limited to tennis clothing, it should be noted that among the most coveted of all sports shoes were the white and gold Diadora 'Borg Elite' tennis shoes in kangaroo skin, Diadora trainers being another Italian sporting item endorsed and partially developed by Björn Borg. Released in 1981, they became highly prized by British casuals.

10 This particular Fila garment was to feature even more prominently in the British cultural landscape when it was adopted by Andrew Ridgley, one half of the 1980s pop duo Wham!, who wore it in a number of videos and when performing on stage. Since its first appearance in 1980, the 'Terrinda''s popularity has been revived with the release of Nick Love's 2009 film *The Firm*, featuring football hooligan Bex (Paul Anderson) sporting a scarlet version.

11 Cerruti designs have been featured in over 200 productions, including the wardrobes for Michael Douglas in *Wall Street* (1987) and Richard Gere in *Pretty Woman* (1990).

12 Machiavelli (cited note 7)

13 Dick Hebdige, *Subculture: The Meaning of Style* (London, 1979), p.93

14 Kevin Sampson and Dave Rimmer, 'The Ins and Outs of High Street Fashion', *The Face*, July 1983

15 Ibid.

Tailoring and Craft — Glenn Adamson

1 Nick Foulkes, *Rubinacci and the Story of Neapolitan Tailoring* (London, 2010), pp.46, 54

2 Nicholas Owen and Alan Cannon Jones, 'A Comparative Study of the British and Italian Textile and Clothing Industries', *DTI Economics Paper* 2 (London, April 2003), pp.31–2

3 Jane L. Collins, 'Mapping a Global Labor Market: Gender and Skill in the Globalizing Garment Industry', *Gender and Society*, (2002), vol.16, no.6, pp.921–40

4 Amanda Zlatkus, *Overcoming The Tides Of Change: A Look At Globalization And The Italian Textile Industry*, PhD thesis, University of Delaware, Spring 2009

5 Laura Ugolini, 'Ready-to-Wear or Made-to-Measure: Consumer Choice in the British Menswear Trade, 1900–1939', *Textile History* (2003), vol.34, no.2, pp.192–213

6 Fiona Anderson, 'Fashioning the Gentleman: A Study of Henry Poole and Co., Savile Row Tailors 1861–1900', *Fashion Theory* (2000), vol.4, no.4, pp.405–426

7 Owen and Jones (cited note 2), p.43

8 Interview with Chiara Rubinacci, 17 January 2013

9 Interview with Simon Cundey of Henry Poole and Co., 4 February 2013

10 Luca Rubinacci, 'What a Pitti . . . I'm in Aspen', blog post, 11 January 2012, http://www.marianorubinacci.net/club/?p=849 [accessed 2 March 2013]

11 Greg Hudson, 'The $50,000 Suit', undated blog post, http://sharpformen. com/style/the-50000-suit/ [accessed 3 March 2013]

12 Company website, www.brioni.com [accessed 2 March 2013]

The Business of Fashion — Emanuela Scarpellini

1 Eugenia Paulicelli, *Fashion under Fascism: Beyond the Black Shirt* (Oxford, 2004)

2 Banca Commerciale Italiana, *Movimento Economico dell'Italia per l'anno 1930* (Milan, 1931), p.433

3 Adriana Castagnoli and Emanuela Scarpellini, *Storia degli imprenditori italiani* (Turin, 2003), pp.191–8; Elisabetta Merlo, *Moda italiana: Storia di un'industria dall'Ottocento a oggi* (Venice, 2003); Ivan Paris, *Oggetti cuciti: L'abbigliamento pronto in Italia dal primo dopoguerra agli anni Settanta* (Milan, 2006)

4 Guido Vergani, *La Sala Bianca. Nascita della moda italiana* (Milan, 1992); Nicola White, *Reconstructing Italian Fashion. America and the Development of the Italian Fashion Industry* (Oxford, 2000)

5 Cinzia Capalbo, *Storia della moda a Roma* (Rome, 2012)

6 Elizabeth Wilson, *Adorned in Dreams: Fashion and Modernity* (London, 2003)

7 Valerie Steele, *Fashion, Italian Style* (New York, 2003); Carlo Marco Belfanti and Fabio Gusberti (eds), *Storia d'Italia, Annali 19, La moda* (Turin, 2003) and Sofia Gnoli, *Un secolo di moda italiana 1900–2000* (Rome, 2005)

8 Giacomo Becattini, *Dal distretto industriale allo sviluppo locale: svolgimento e difesa di una idea* (Turin, 2002)

9 Law no.317/1991

10 Istat, *8° Censimento generale dell'industria e dei servizi 2001* (Rome, 2006), p.29

11 Ibid., pp.32–3

12 Ibid., p.30

13 Ibid., pp.62–6

14 Luca Zanderighi, *Piccole e medie imprese e sviluppo commerciale* (Milan, 1990)

15 Daniele Boldizzoni, *L'impresa familiare: Caratteristiche distintive e modelli in evoluzione* (Milan, 1988); Piero Melograni (ed.), *La famiglia italiana dall'Ottocento a oggi* (Rome, 1988)

16 Katrina Honeyman, 'Engendering enterprise', *Business History* (January 2001), vol.43, pp.119–26; Angel Kwolek-Folland, 'Gender and business history, Introduction', *Enterprise & Society* (2001), vol.2, pp.1–10; Lina Gálvez Muñoz and Paloma Fernández Pérez, 'Female Entrepreneurship in Spain during the Nineteenth and Twentieth Centuries', *Business History Review* (September 2007), vol.81, pp.495–515

17 Paola Colaiacomo (ed.), *Fatto in Italia: La cultura del Made in Italy 1960–2000* (Rome, 2006); Guido Vergani (ed.), *Fashion Dictionary* (Milan, 2006); Enrica Morini, *Storia della moda XVIII-XXI secolo* (Milan, 2010)

18 Simone Marchetti, 'Ottavio Missoni, campione del Made in Italy: una vita tra moda, famiglia e discrezione', 9 May 2013, www.repubblica.it/ persone/2013/05/06/news/ottavio_missoni_campione_del_made_in_italy_ una_vita_tra_moda_famiglia_e_discrezione-57849248/ [accessed 9 May 2013]

19 Prada, Interim Financial Review 2012, p.12

20 Emanuela Scarpellini, *Material Nation: a Consumers History of Modern Italy* (Oxford, 2008), pp.266–9

21 Data from SMI Federazione Tessile Moda

Communication in the Fashion System — Elena Puccinelli

1 *Milano Collezioni* is the title of the first event that brought together the fashion shows of different designers in the capital of Lombardy.

2 Victoria de Grazia, *Irresistible Empire: America's Advance Though Twentieth-Century Europe* (Cambridge, MA, 2005); Emanuela Scarpellini, *Material Nation: A Consumer's History of Modern Italy* (Oxford, 2008)

3 G. Butazzi and Alessandra Moltino, *La Moda Italiana: dell'antimoda allo stilismo* (Milan, 1987); Marco Belfanti and Fabio Giusberti (eds), *La moda, Storia d'Italia, Annali 19* (Turin, 2003); Paola Colaiacomo (ed.), *Fatto in Italia: La cultura del Made in Italy 1960–2000* (Rome, 2006); Sofia Gnoli, *Moda: Dalla nascita della Haute Couture a oggi* (Rome, 2012); Elisabetta Merlo, *Moda italiana: Storia di un'industria dall'Ottocento a oggi* (Venice, 2003); Enrica Morini, *Storia della Moda, XVIII–XXI secolo* (Milan, 2010); Ivan Paris, *Oggetti cuciti: L'abbigliamento pronto in Italia dal primo dopoguerra agli anni settanta* (Milan, 2006)

4 Elena Puccinelli, *Professione PR: Immagine e comunicazione nell'Archivio Vitti* (Milan, 2011)

5 Barbara Vitti is the daughter of the fashion journalist Gemma Vitti. In 1965 she was employed by SNIA Viscosa to manage its public relations. In 1971 Vitti set up her own business, Studio Vitti. In the following years she took charge of public relations, press and advertising for the Swedish fashion company Hettemarks. Vitti then worked for the Gruppo Finanziario Tessile. In 1981 she started her collaboration with Giorgio Armani, under the direction of Sergio Galeotti. In 1986 Vitti left Armani to work for Valentino. From the 1990s Vitti also specialized in special events.

6 Interview with Barbara Vitti, *Leader* (March 1988)

7 Franco Savorelli di Lauriano is a marketing and public relations specialist. Born in Milan, he studied economics and in 1958 he started working with the Helena Rubinstein company, a collaboration that lasted until 1997. His client list has also included Sergio Galeotti for Giorgio Armani, shoe designer Mario Valentino, the Fendi sisters and their designer Karl Lagerfeld. He also contributed to the realization of important fashion events such as the textile fair Idea Como and also Idea Biella for drapery, as well as the beginnings of the Pitti Uomo fashion event.

8 Lina Sotis, 'L'importanza di chiamarsi pierre', *Corriere della Sera*, 4 October 1998

9 R. Carrarini and M. Giordano (eds), *Bibliografia dei periodici femminili lombardi 1786–1945* (Milan, 1993); V. Castronovo and N. Tranfaglia (eds), *La stampa del neocapitalismo* (Rome, 1976); V. Castronovo and N. Tranfaglia (eds), *La stampa italiana nell'età della TV: Dagli anni Settanta a oggi* (Rome, 2008); F. Colombo (ed.), *Libri, giornali, riviste a Milano: Storia delle innovazioni nell'editoria milanese dall'Ottocento a oggi* (Milan, 1998); Maria Luisa Frisa (ed.), *Lei e le altre. Moda e stili nelle riviste RCS dal 1930 a oggi* (Venice, 2001); G. Turi (ed.), *Storia dell'editoria nell'Italia contemporanea* (Florence, 1997)
10 *Vogue & Novità* was established in 1965 and edited by Lidia Tabacchi. The first issue of *Vogue Italia* was published in November 1966 and was edited by Franco Sartori.
11 Mondadori is today owned by Silvio Berlusconi.
12 'Alta Moda e tessuto italiano', in *Linea Italiana,* Spring/Summer 1966, no.3, p.4
13 Ibid.

La Moda in *Vogue* — Lucia Savi

1 In the text, British *Vogue* will be referred to simply as *Vogue*.
2 Marya Mannes, 'The Fine Italian Hand', *Vogue* (September 1946), p.45. The featured designers were Ventura, Corradoni, Gattinoni of Milan, Gabriellasport and Irene Galitzine of Rome and Ferragamo of Florence.
3 Ibid.
4 Ibid., pp.45, 81: 'fifty percent of all Italian collections consisted in Paris models'
5 Ibid., p.81. 'With post-war easing of materials and labour and with, perhaps, more expert fashion direction than their local publications are equipped to give, Italian clothes should command a distinguished audience.'
6 Several articles were published in British *Vogue* during these years on Italian cities and regions such as Sardinia (July 1949, p.57), Palermo (July, 1949, p.58), the Island of Giglio (May 1950, p.106), Venice (November 1951, p.97), Sicily (March 1954, p.197) and the Marche (May 1954, p.112).
 The Italian landscape was also used as a photographic backdrop for English fashion, with featured locations including Sicily (May 1949, p.54 and January 1955, p.44), Milan and Portofino (February 1955, p.110).
7 'Talent in Italy', *Vogue*, (October 1946), p.52
8 'Capri', British *Vogue* (July 1947), p.31: 'The perfection of hand-made sandals sculptured on the foot, with irresistible colours of superb leather to choose from'.
9 Mannes (cited note 2), p.45
10 'Capri' (cited note 8) and 'Black on the Beach', British *Vogue* (November 1948), pp.60–61
11 An article in the May 1949 issue was evocatively titled 'Background Italy', pp.84–7
12 British *Vogue* (September 1951), p.102. For more on the Florentine fashion shows, see Guido Vergani, *The Sala Bianca: The Birth of Italian Fashion* (Milan, 1992) and the introduction to this publication by Sonnet Stanfill.
13 British *Vogue* (May 1952), p.118
14 More of these adverts were published in November and December 1951 and in February 1952.
15 British *Vogue* (April 1952 and July 1952)
16 'Vogue's eye view of Europe's fashion centres', British *Vogue* (March 1953), p.105. It is interesting to note that no specific city in Italy was chosen to represent Italian fashion, unlike London in the UK and Paris in France.
17 'Europe's fashion centres'. *Time* magazine, 4 February 1952; British *Vogue* (May 1952), p.118
18 British *Vogue* (March 1954), p.152: 'We photographed some joint outcome of current Roman originality: new designs in architecture and fashion design'
19 British *Vogue* (April 1954), p.139
20 'Knitwear the New Italian Way', British *Vogue* (February 1955), p.112

Nattier: Textile innovators — Margherita Rosina and Lucia Savi

1 'The People Page by Ernestine Carter', *The Sunday Times*, 16 August 1964, p.34
2 Interview with authors, 18 January and 5 July 2013
3 From a lecture entitled 'Fashion 1900 to 1982', given by Brenda Azario at the V&A, 29 March 1982
4 Marc Bohan, Dior's creative director from 1960 to 1989, used it for his famous 'Gamine' suit.
5 These patterns for Ungaro were designed in collaboration with the artist Sonia Knapp. All the printed textiles were printed in Como by the company Jermi.
6 V&A lecture (cited note 3)

The Sozzani Sisters — Oriole Cullen

1 Carla Sozzani interview with the author, 1 May 2013
2 Franca Sozzani interview with Carlo Antonelli, *COS* magazine, 25 August 2010
3 Carla Sozzani interview with the author, 1 May 2013
4 Ibid.
5 Ibid.

6 Cathy Horyn, 'A Page Out of History', *T* magazine, *The New York Times*, 28 August 2005
7 Carla Sozzani interview with Oriole Cullen, 1 May 2013
8 Ibid.
9 Ibid.
10 Ibid.
11 Stefania Ricci, 'Fashion Magazines: Two different cases', *Italian Fashion: From Anti-fashion to Stylism*, Volume 2 (Milan, 1987), p.277
12 Franca Sozzani interview with Carlo Antonelli, *COS* magazine, 25 August 2010
13 Lee Adams, William, *Franca Sozzani: Fashion's Rebel with A Cause*, *Time* magazine, 16 September 2011 [accessed 4 July 2013]
14 Essence of Italy website http://www.essenceofitaly.net/journal/2011/05/tell_it_like_it_is_franca_sozz.php [accessed 22 June 2013]
15 Franca, Sozzani, Editor's blog, *A Special Day*, *Vogue Italia* website http://www.vogue.it/en/magazine/editor-s-blog/2012/03/march-15th [accessed 5 July 2013]
16 Francesca Crozier-Fitzgerald, *Vogue Italia's Franca Sozzani on 'Making It' in the Magazine Industry* I-Italy website, 9 May 2011 http://www.i-italy.org/17218/vogue-italias-franca-sozzani-making-it-magazine-industry [accessed 22 June 2013]
17 Franca Sozzani, Editor's blog, *FIT lecture*, *Vogue Italia* website 7 May 2012 http://www.vogue.it/en/magazine/editor-s-blog/2012/05/may-7th [accessed 5 July 2013]
18 Franca Sozzani, Editor's blog, *FIT lecture*, *Vogue Italia* website 7 May 2012 http://umbraco.vogue.it/en/magazine/editor-s-blog/2012/05/may-7th [accessed 4 July 2013]
19 Franca Sozzani, Editor's blog, *Creativity Lives Here in Italy*, *Vogue Italia*, 20/06/2013 http://umbraco.vogue.it/en/magazine/editor-s-blog/2013/06/june-20th
20 Carla Sozzani interview with Oriole Cullen 01/05/2013 [1 May 2013]
21 Ibid.

Biographies

Kate Bethune [KB]
Elizabeth Bisley [EB]
Silvia Casagrande [SC]
Sofia Gnoli [SG]
William Newton [WN]
Lucia Savi [LS]
Suhashini Sinha [SuS]
Sonnet Stanfill [SS]
Kristian Volsing [KV]

Albertina

Albertina is a Roman atelier that specializes in the production of knitted coats and dresses. As an adolescent, Albertina Giubbolini (1921–2009) learned how to operate a knitwear machine from her mother. During the Second World War, due to the scarcity of raw materials, she developed an almost religious respect for the wool thread. This led to Albertina's distinctive technique, characterized by a minimal use of scissors to work the threads. The final look was achieved through the skilful use of articulated and modular techniques that allowed her garments to have an almost continuous knit. In 1954 she opened her first atelier at 15 via Bellinzona. During her career, Albertina worked with designers such as Mario Vigolo (from 1957 to 1958), Brunetta Mateldi (from 1962 to 1965) and Alberto Lattuada (from 1966 to 1985). After Albertina's death in 2009, her sister Maura assumed the role of running the boutique on via Lazio and promoting the atelier's traditional production, which remains limited and intended for an elite market. [LS]

Walter Albini

Walter Albini (1941–1983) was born in Busto Arsizio, near Milan, and studied fashion design at the Istituto Statale d'Arte per il disegno di moda in Turin. From 1961 to 1964, he worked between Paris and Milan as a correspondent and illustrator for the publications *Corriere Lombardo* and *Vanità*. Once back in Milan, Albini started working for Mariuccia Mandelli at Krizia, where he designed knitwear until 1968. Throughout his career, Albini collaborated with many different fashion labels, including Billy Ballo (from 1964 to 1970), Cadette (from 1964 to 1968) and Callaghan (from 1968 to 1972), devoting particular attention to textile design and collaborating directly with textile manufactures such as Etro. In 1971 Albini and other designer labels such as Krizia and Missoni decided to present their Autumn/Winter 1971 collections in Milan instead of Florence. In conjunction with distributor FTM, Albini organized a fashion show at the Circolo del Giardino in Milan, where he presented the collections he had designed for five different brands: Basile (coats and jackets), Callaghan (jersey knitwear), Diamant's (blouses), Escargot (knitwear) and Misterfox (cocktail and evening dresses). In 1972 Albini launched his own label and presented his first collection, titled *Grande Gatsby*, under his own name. At the invitation of Browns boutique, he showed these designs in London at Blakes Hotel. In 1975 he launched Walter Albini menswear. During the last ten years of his life, Albini continued to design his own lines as well those of other brands. [LS]

Antonelli

Maria Antonelli (1903–1969) started her career as an apprentice at the Roman dressmaker Battilocchi. At the beginning of the 1940s she opened her own couture house. From the start, she dressed well known Italian actresses. In 1954 she designed the wedding dress for English actress Dawn Addams for her wedding to Prince Massimo. Antonelli's collections were characterised by rigorous cut and refined details. In 1958 she launched Antonelli Sport a ready-to-wear line that had a great success with American buyers. Throughout her career Antonelli collaborated with many designers such as Chino Bert, Pino Pascali, Pino Lancetti and André Laug. The collaboration with the latter was important for the creation of the successful line 'Dinamica' in 1963 followed by the 'Fuso' and 'Optical' lines. Antonelli's atelier closed after her death in 1969. [LS]

Giorgio Armani

Giorgio Armani was born in Piacenza in 1934. After studying medicine for several years, from 1957 Armani worked in various roles for the Milanese department store La Rinascente, then as a designer for Nino Cerruti. Following several years as a freelance designer for a variety of ready-to-wear companies, in 1975 Armani launched his own men's and women's ready-to-wear label with the help of business partner Sergio Galeotti. Armani's designs for Richard Gere in the 1980 film *American Gigolo* showcased the unstructured tailoring, soft palette and understated approach to dressing that would become his signature. The designer's 1978 financial agreement with textile company Gruppo Finanzario Tessile (GFT) helped Armani translate the urban energy and design rigour of Milan to a global audience. When *Time* magazine featured the designer on its cover in 1982, this heralded not just Armani's arrival, but that of Italian ready-to-wear. Armani's international recognition was extended through a varied stable of collections including A/X: Armani Exchange, Emporio Armani, Armani Casa and, since 2005, the Armani Privé couture line. [SS]

Benetton

Benetton was established in Treviso by the Benetton siblings Luciano, Gilberto, Giuliana and Carlo Benetton in 1965. A year later they opened their first shop, called My Market, in Belluno and in 1967 the first outside Italy, in Paris. The Benettons created non-traditional shops without counters where customers could choose their own garments. From 1969, Benetton expanded internationally through a franchise system, acquiring the French chain Sisley in 1974 and developing it into an upmarket subsidiary. Benetton's collaboration with photographer Olivero Toscani began in 1982. Their first advertising campaign featured children from different countries and ethnic groups, united in the colours of Benetton clothes. Later campaigns would cause controversy through their depictions of challenging subjects such as AIDS victims and Mafia murders. The Benetton Group operates over 6500 stores in 120 countries (2011). Benetton remains a family-run business. [KV]

Biki

Leonardi Bouyeure Elvira (1906-1999) was the granddaughter-in-law of the composer Giacomo Puccini, whose nickname for her eventually became the name of her fashion company: Biki. She began her career with Countess Cicogna in 1934. Together they designed beachwear and sportswear inspired by French fashion, under the name 'Domina'. In 1936 Biki started out on her own and held her first fashion show. In 1939 she opened her first boutique in via Sant'Andrea in Milan. Throughout the 1950s and 1960s she dressed the elite of Milanese business, culture and high society. In 1951 she met the soprano Maria Callas, who became her most important client. Her astute collaboration with Italian clothing manufactures was pioneering. From 1960 until 1966 she designed the Cori-Biki line for the ready-to-wear manufacturer Gruppo Finanziario Tessile (GFT). [LS]

Bulgari

Sortirio Bulgari, the son of a family of Greek silversmiths, arrived in Rome in 1881. In 1884 he opened his first shop in Rome's via Sistina selling silver and antique jewellery. In 1895 Bulgari opened a second shop near the Spanish Steps, on via Condotti, still in operation today. Over time, Bulgari established itself as a fine jeweller. When Sortirio Bulgari died in 1932, his sons Costantino and Giorgio took over the business and oversaw an evolution in the firm's jewellery design, from the lavish diamonds of the 1950s to Bulgari's bold juxtapositions of different colored stones in the early 1960s. Upon Giorgio Bulgari's death in 1966, the company's management passed to his sons Gianni, Paolo and Nicola, who modernised the firm still further. Bulgari became known for its experiments with yellow gold, unusual color combinations and the establishment of its 'gem coin' jewellery which incorporated antique coins into Bulgari designs. In more recent years, the company continued to innovate with new collections, such as the 1991 launch of the nature-inspired 'Naturalia' collection and the 2013 'Diva' collection. [SS]

Roberto Capucci

Roberto Capucci was born in Rome in 1930. After leaving the Accademia di Belle Arti, Capucci first gained employment in the studio of Emilio Schuberth before establishing his own house in 1950. Capucci travelled to Florence the following year, where, according to a 1952 press release from the office of Giovanni Battista Giorgini, 'his models were overwhelmingly acclaimed'. From his first collections, Capucci became associated with elegant, highly sculptural creations. In 1958 he received the Filene's Young Talent Design Award. In 1962 Capucci moved to Paris, returning to Rome in 1968 where he continued to work as a designer. Not wishing to be constrained by trends and seasons, in 1980 Capucci resigned from the official couture calendar, electing to present only a single collection each year, in a different city, until 1996. [WN]

Carosa

The name of the Roman high fashion house Carosa (1947–1974), was the anagram of the names of the two aristocrats who opened it in 1947: Princess Giovanna Caracciolo Ginetti (1910-1983) and Countess Barbara Rota Angelini Desalles. The latter decided to leave the venture after few years, while Caracciolo continued to work in the atelier until it closed in the early 1970s. Carosa participated in the first of Giorgini's fashion shows in February 1951. Carosa was also one of the eight houses that participated in the 'The Transatlantic of Fashion', a promotional venture organized by Giorgini to publicize Italian fashion in America. The success of Carosa's collections relied upon the skills of the young designers who collaborated with the house, such as Patrick de Barentzen, Mario Vigolo, Angelo Tarlazzi and Pino Lancetti, designers who brought innovation and research to the atelier. The Carosa atelier closed in 1974, just as ready-to-wear began its rapid rise. [LS]

Roberto Cavalli

Roberto Cavalli (b.1940) studied fine art at the Accademia di Belle Arti in Florence. He began his fashion career in the mid-1960s by experimenting with techniques for printing on leather. In 1970 Cavalli showed his first collection in Paris. In 1972, he presented at the *Sala Bianca* for the first time. That same year the designer opened a boutique in St. Tropez. The printed leather and leather patchwork designs of Cavalli's early work typified the mainstream adoption of 1970s 'hippie chic'. Throughout his career, Cavalli's designs have often referenced elements of the animal kingdom; wild animal prints as well as reptile and fish skin patterns have been constant Cavalli motifs. Throughout the 1980s and '90s Cavalli continued to expand his business. In 1985 Cavalli organized a fashion show in New York's Studio 54; in 1997 he opened his first Italian boutique, in Venice's Piazza San Marco; he began his menswear line in 1999; in 2000 he launched a dedicated denim line. In 2007 Roberto Cavalli created a collection for retailer H&M. [SS]

Dolce & Gabbana

Domenico Dolce (b.1958), originally from Sicily and Stefano Gabbana (b.1962) from Lombardy, met in Milan in 1980. Dolce studied fashion design in Sicily and gained experience in his parents' clothing business. Gabbana, studied graphic design and gained some work experience in fashion, as an assistant in an atelier in Milan. In 1982 they opened their first fashion consulting studio and in 1985 Beppe Modenese invited them to show in the New Talent Collections during Milan fashion week. Their designs, produced in a series of Sicilian workshops, gained the attention of the press. In 1990 they designed their first menswear collection and in 1991 they were awarded the Woolmark Award for the most innovative men's collection of the year. In 1993 they designed 1,500 costumes for Madonna's Girlie Show tour. Their overtly sexual style takes direct inspiration from their Italian heritage and borrows imagery from Italian cinema, such as the films of Luchino Visconti. By 2005 their turnover was €597 million, making the duo's business one of the biggest global brands in the fashion industry. In 2012, they expanded from producing solely ready-to-wear by launching an exclusive couture collection, named *Alta Moda*. [LS]

Etro

Since its founding in 1968 by Gerolamo 'Gimmo' Etro (b.1940), the Etro textile firm became known for richly patterned fabrics woven at their factory in Fino Mornasco, outside Como. Etro soon developed a reputation for collaboration. The firm worked closely with both Italian designers and those from elsewhere to develop patterned textiles that would suit their collections: densely figured fabrics for Walter Albini; exotic florals for Pino Lancetti; ethereal prints for Sonia Rykiel, among others. Since 1996 the firm has also designed seasonal ready-to-wear collections. Their clothing uses textiles which often feature an Etro speciality: the paisley motif. Most of these patterns are still designed by hand, rather than on a computer, by specially trained technicians. Like many Italian fashion and textile firms, Etro remains a family business. [SS]

Fabiani

Alberto Fabiani (1910–1987) was best known for his tailored suits, elegant coats and stylish dress designs, summarised by the American fashion editor Eugenia Sheppard in a 1954 report as 'superbly tailored and strictly disciplined'. Fabiani was born in Tivoli to couturier parents who had launched a fashion house in Rome in 1909. After a three year apprenticeship in Paris, Fabiani moved back to Rome to take over the family's fashion business. Fabiani presented at Giorgini's first fashion show in 1951. In 1952 Fabiani married the Italian designer Duchessa Simonetta Colonna di Cesarö, known professionally as Simonetta. One of their early collaborations was a small, 1954 coat collection designed for the American wholesale market. Together, they opened a fashion house in Paris in 1961 under the name 'Simonetta et Fabiani'. They launched their first joint collection the following year. After moderate success, the pair parted ways, divorcing in 1973. Fabiani spent several years travelling back and forth between Paris and Rome, then continued to work in Rome until his death. [SuS]

Fendi

The Italian firm Fendi was established in Rome in 1925 by Adele Casagrande (1897–1978) and her husband Edoardo Fendi (d.1954). From the outset, Fendi specialized in the production of luxury goods, most notably leather and fur clothing. The founders' five children – Paola, Anna, Franca, Carla and Alda – were instrumental in rejuvenating the company. They expanded Fendi internationally and began a long-term collaboration with Karl Lagerfeld from 1965. In 1968 the company opened their boutique on via Borgognona. Fendi's bold experiments with new fur-making techniques have resulted in unexpected silhouettes, colours and construction methods. The label is also recognized for its luxury ready-to-wear lines and its accessories, including eyewear, watches, belts, handbags and purses. The new millennium ushered in two important moments for the label: in 2001 LVMH became Fendi's majority shareholder and in 2013 Fendi opened its flagship store in Paris. [KB]

Salvatore Ferragamo

Salvatore Ferragamo (1898–1960) was born in Bonito, near Naples. As a boy, he was apprenticed to a cobbler. He emigrated to Boston at the age of fourteen, where he worked in a large footwear company. In 1923 he moved to California and opened a shoe shop. A contract to make shoes for the American Film Company ensured the shop's success and Ferragamo stayed in California until 1927, when he moved his business to Florence. From its beginnings, Ferragamo's company became associated with fine leatherwork and also with the use of inventive materials. Woven raffia, plastic filaments and cork all featured in early Ferragamo designs. In 1947 he won the Neiman Marcus Award, the so-called 'Fashion Oscar'. While committed to Florentine traditions of skilled handcraft, Ferragamo introduced contemporary production ideas into his workshop by subdividing labour – each part of the shoe-making process was given to one specialist in a production line. Inventive design and materials helped his workshop to stay in business through the Depression and the war. He was then internationally celebrated as part of Italy's glamorous post-war reconstruction. Upon Ferragamo's death, his wife Wanda and eldest daughter Fiamma took the company forward. They initiated new lines, including Ferragamo ready-to-wear and menswear collections. The administration of the firm remains in family hands. [EB]

Gianfranco Ferré

Gianfranco Ferré (1944–2007) was from Legnano, a textile-producing town near Milan. Trained initially as an architect, he received his degree in 1969 from the Politecnico di Milano. That same year, jewellery he had designed and given to friends was noticed by Milanese boutique owner Rosy Biffi, launching his fashion career. In 1971, the magazine *Arianna* featured one of Ferré's designs on its cover. The designer launched his first ready-to-wear collection in 1974, and founded his eponymous company in 1978. He spent the remainder of the 1970s refining his style. In 1982 he launched his menswear line. In 1983 he joined the Domus Academy as founding Professor of the Department of Fashion Design. He presented his first couture collection in Rome in 1986. Ferré's architecture training meant he designed on the page; his sketches were deft and his technical drawings precise. Ferré became known for both the elemental statement of his crisp white shirt, and the extravagant textiles of his couture designs. His appointment in 1989 as Stylistic Director for Dior was somewhat controversial, due in part to his nationality. He remained in this role for eight years. In 2002 the Gianfranco Ferré company was taken over by IT Holding, with Ferré remaining as artistic director. In 2011 the Dubai-based Paris Group purchased the company. [WN]

Fiorucci

Elio Fiorucci was born in Milan in 1935. At 17 he began working in his father's shoe shop, inheriting it in 1962. Expanding his company in 1967, he developed a store concept to rival that of London's Biba. He introduced his own designs alongside creations by designers such as Zandra Rhodes and Ossie Clarke, adding Japanese pop culture and the music and ambiance of Carnaby Street. Fiorucci opened a second store in Milan (1974) and a store in London (1975). The New York store, which opened in 1976, had a particularly festive atmosphere and earned the title 'daytime Studio 54'. Fiorucci became known for his denim jeans, signing the Italian license for Wrangler in 1985. A Japanese company, Edwin International, purchased the Fiorucci brand in 1990. Elio Fiorucci remained art director until 2001, selling the original Milan store in 2003. [KV]

Sorelle Fontana

The Fontana sisters, Zoe (1911–1978), Giovanna (1915–2004) and Micol (b.1913), grew up in Traversetolo near Parma. Following in their mother's footsteps, they began working as dressmakers. In the late 1930s they moved to Rome and opened an atelier in their house on via Firenze. Working throughout the Second World War, the sisters developed a small but distinguished clientele of aristocratic woman. After the war, when many Hollywood actresses came to Rome to film in the Cinecittà studios, the Fontanas secured a number of prominent film stars as clients, including Ava Gardner, Anita Ekberg and Ursula Andress. In 1949 the Fontana sisters designed the wedding dress for Linda Christian's marriage to Tyrone Power. In February 1951 they participated in Giorgini's first fashion show at his house in Florence. With their growing success, they moved their atelier to Piazza di Spagna, where the Micol Fontana Foundation is still located. They became known for decorative evening gowns that featured exquisite textiles, fine embroidery and the inclusion a variety of surface embellishments. In response to the American market, in the 1960s the Fontana sisters launched a ready-to-wear line. In 2000 the company sold the Sorelle Fontana Alta Moda company and trademark to a third party. [LS]

Forquet

Federico Forquet was born in Naples in 1931 into a family of French origin. His encounter with Balenciaga in 1954 was crucial for his career, and from 1955 to 1957 he was Balenciaga's assistant in Paris. Returning to Italy in 1958, he worked for Fabiani and Galitzine before opening his own atelier in 1961. His clean and elegant style earned him the nickname 'Frederick the Great' in the international press in 1966. In 1971 he chose to close the atelier rather than adapt to the new demand for serial production. Subsequently he devoted himself to textile design, with his friend Marella Agnelli, and later to interior design. [SG]

Irene Galitzine

Princess Irene Galitzine (1916–2006) was born in Tiflis, Russia (today, Tbilisi). Her aristocratic family, forced to flee during the Revolution, moved to Rome when she was a young child. Galitzine went on to study art and design, starting her career in 1945 as an assistant at the Roman couture house Sorelle Fontana. Galitzine left Sorelle Fontana to open her own atelier, showing her first collection in 1959, for which she received the Filene's Talent Award. In 1960, Galitzine showed what became her signature design – an evening trouser suit dubbed 'palazzo pyjamas' by Diana Vreeland – at Florence's Pitti Palace. Galitzine's pyjamas were taken up by the international jet set and in 1963 Jacqueline Kennedy became a client. In 1962 Galitzine received the Fashion Critics Award for best collection of the season. [EB]

Fernanda Gattinoni

Fernanda Gattinoni (1907–2002) moved to London with her family before her 18th birthday. In London she worked as an apprentice at the British fashion house Molyneux. In the late 1930s she moved to Rome, where she worked with the established couture house Ventura, which at the time was dressing the Roman aristocracy as well as the House of Savoy. In 1944 Gattinoni opened her own atelier and soon benefited from the patronage of many Hollywood actresses, including Audrey Hepburn, Ingrid Bergman and Lana Turner. In 1955 she designed the costumes worn by Hepburn in the film *War and Peace*. The Empire lines of these costumes inspired Gattinoni's couture collection of the same year, titled *Natascia*. In the mid-1950s she created a ready-to-wear line, Gattinoni Sport. In 1981 Gattinoni's son Raniero (1953–1993) joined the business, followed by Stefano Dominella. [LS]

Romeo Gigli

Romeo Gigli was born in 1949 in Castel Bolognese, near Ravenna. He studied architecture at university and then began a series of extended travels in the Far East. His parents were antiquarian book dealers and he found inspiration in their library. After a brief period in New York, in 1983 Gigli returned to Italy and designed his first collection. His label was produced by Zamasport from 1985. In this period, he began a collaboration with Callaghan. In 1986, Gigli started to present his collections in Milan and from 1989 he showed during Paris fashion week. His first Paris catwalk presentation received a twenty-minute standing ovation. In the 1980s, Gigli's designs represented a romantic alternative to the power dressing so prevalent in fashion of that decade. An experimental colourist, Gigli also embraced luxurious textiles, elaborate embellishment and layered, cocoon-like silhouettes. In 2009, a disagreement with IT Holdings, majority owners of the Romeo Gigli label, resulted in Gigli losing the rights to his name. In 2009 he began again, launching a new brand, Io Ipse Idem. In 2013 he designed a collection for luxury Hong Kong retailer Joyce. [LS]

Maria Grimaldi

Little is known about the *sartoria*, or dressmaker, Maria Grimaldi. Public records show that she was located in Turin from the late 1940s until the end of the 1960s. Grimaldi was the favoured dressmaker of Margaret Abegg, wife of Turin textile manufacturer Werner Abegg. Though Mrs Abegg could have afforded the best of Paris couture, she preferred the abilities of her local dressmaker. By frequenting a regional establishment rather than a prominent couture house, Mrs Abegg observed an Italian tradition that was well established by the mid-twentieth century, and which continued for some time after the end of the Second World War. Throughout the 1950s, Mrs Abegg purchased both tailored daywear and formal evening gowns at the Grimaldi atelier. Grimaldi's clothing demonstrates details of expert construction: economical cut and precise seams employed to achieve flattering fit. Not surprisingly, given her husband's profession, the textiles of Mrs Abegg's Grimaldi designs are of the highest quality; they include fine wools, rich silk satin and linings of soft silks in contrasting colours. [SS]

Gucci

Established in Florence by Guccio Gucci (1881–1953) in 1921, the company first specialized in handcrafted leather travel goods and accessories. The Gucci name was also linked to equestrian accessories, with the stirrup and bit becoming the company's symbols. In 1938 Gucci opened his first shop in Rome and in 1951 in Milan. During the Second World War, due to the lack of raw materials, Gucci experimented with alternative materials such as bamboo and hemp. From the mid-twentieth century, celebrity clients such as Grace Kelly and Audrey Hepburn helped raise the company profile. In 1982 Gucci became a publicly traded company. In 1994 Tom Ford became the creative director for all Gucci production lines; Ford's commissions of photography from Mario Testino created some of that decade's most influential advertising imagery. The public battle between LVMH and PPR at the end of the decade for majority ownership of Gucci ended with PPR's victory in 2001. In 2006 Frida Giannini was named the sole creative director of the label. [LS]

Krizia

Krizia founder Mariuccia Mandelli (b.1933) spent the first few years after her studies teaching at a primary school in Cassano d'Adda, outside Milan. Curious to extend a childhood interest in clothes-making, in 1954 Mandelli, along with her friend Flora Dolce, began to create small collections of skirts and dresses, selling them under the label Krizia (a name borrowed from a character in Plato's dialogues). Soon after, Mandelli began a fruitful three-year collaboration with designer Walter Albini. In 1964 Krizia presented for the first time at the *Sala Bianca*, then showed in Milan from her Autumn/Winter 1974 collection onwards. Krizia's dressed-up simplicity typifies Italy's ready-to-wear tradition. From the late 1970s, Mandelli became associated with her experiments with pleated garments. Her parallel interest was inventive knitwear, which often featured animal motifs ranging from leopard prints and zebra stripes to realistic feline imagery. Mandelli is a supporter of the arts, and since 1985 her Spazio Krizia, a large hall within Krizia's Milan headquarters, has hosted cultural events featuring writers, artists, designers and musicians. [SS]

Lancetti

Giuseppe (Pino) Lancetti (1932–2007) was born in Umbria, where he studied art at the Fine Art Academy in Perugia. In 1954 he moved to Rome, where he worked as a freelance designer for several couture houses, such as Simonetta and Fabiani, Carosa, De Luca and Antonelli. Because of Lancetti's appreciation of fine art, the press nicknamed him the 'artist-couturier'. A successful collection he designed in 1956 for De Luca was inspired by Modigliani's paintings of women and was characterized by long, thin silhouettes. In 1961 Lancetti opened his own atelier and in 1963 he showed a collection at the *Sala Bianca* based on military detailing. The collection was endorsed by fashion editor Irene Brin and Palma Bucarelli, the director of Rome's Modern Art Gallery. Lancetti continued to create clothes inspired by artists such as Picasso, Kandinsky and Klimt and from the early 1970s he also began to reference ethnic and folk dress. In 1972 he launched his ready-to-wear line. In 2000, Lancetti sold his company to Ugo Paci, a Tuscan industrialist and the owner of the clothing manufacturer Compafin. [LS]

André Laug

André Laug (1931–1984) was a designer of French origin who first worked as a military trainer in northern France. In 1958 he moved to Paris and began a career in fashion. After working at the house of Raphael, which specialized in women's tailored day suits, he was hired first by Nina Ricci and then by Courrèges as a freelance designer. In 1963 he moved to Rome to work for the house of Maria Antonelli for five years, designing both couture and ready-to-wear collections. Known as 'the Parisian of Rome', in 1968 Laug opened his own atelier in Piazza di Spagna and that same year he presented his first collection of couture designs. His designs were characterized by a keen interest in fabrics, rigorous cut combined with elegant proportions, and were a great success with actresses and aristocrats. Audrey Hepburn was one of his most important clients. [LS]

Marucelli

Germana Marucelli (1905–1983) was born in Settignano near Florence. As a young girl she developed her love for clothes-making in her family's atelier. A trailblazer of Italian fashion, during the war she distanced herself from French haute couture and began to establish her own personal style. In the early 1950s she joined Giovanni Battista Giorgini in the battle to promote Italian fashion and participated with enthusiasm in the events to celebrate its launch. The 'cerebral seamstress' succeeded in uniting her passions for art and literature with fashion: alongside her sartorial activities she set up the San Babila poetry prize and a cultural salon, which became a meeting place for the intelligentsia of the day. A patron of the arts, she invited avant-garde artists, including Paolo Scheggi and Getulio Alviani, to collaborate on her designs. Germana Marucelli retired in 1972, although she continued to pursue her passions in art and fashion until her death in 1983. [SC]

Max Mara

The House of Max Mara was founded in 1951 by Achille Maramotti (1927–2005) when he opened his first factory in Reggio Emilia in northern Italy. Although Maramotti trained as a lawyer, because his mother owned a dressmaking school, he was no stranger to fashion. Maramotti's daring vision was to produce well-made, designer-quality clothing for the mass market. This was an ambitious goal at a time before ready-to-wear, when haute couture still dominated luxury fashion. Max Mara is recognized for its understated, informal but luxurious clothing that emphasizes quality of cut and production and a distinctly softened Italian tailoring. The label has collaborated with a number of designers including Karl Lagerfeld, Guy Paulin and Jean-Charles de Castelbajac. In 1969 Maramotti introduced by way of a proto-diffusion line a range of sportswear to appeal to a younger clientele. Max Mara now encompasses 35 labels, although womenswear remains its core. In 2013, the company operated more than 2,250 stores in over 90 countries. As with many Italian fashion companies, the firm remains in family hands. [KB]

Missoni

Ottavio Missoni (1921–2013) and Rosita Jelmini (b.1931) established a knitwear workshop in the basement of their house in Gallarate near Milan in 1953, the year they married. They rediscovered the traditional Raschel knitting machines that belonged to Rosita's family and used them to create the first of their colourful, lightweight knits. The Missonis secured the early endorsement of journalist Anna Piaggi and her husband, the photographer Alfa Castaldi. In 1966 the Missonis held their first fashion show in a Milanese theatre in collaboration with fashion designer Emmanuelle Khanh, and the following year they showed in the *Sala Bianca*. In1969 the Missonis built their factory in Sumirago, near Milan, and that same year they were featured on the April cover of *Woman's Wear Daily*. In 1973 Missoni received the Neiman Marcus Fashion Award, the first of a series of international recognitions. Ottavio and Rosita handed over the running of the firm to their children in 1997. [LS]

Miu Miu

Miuccia Prada took over her grandfather's Milanese luxury goods business in 1978. She launched the Miu Miu brand in 1992, with her husband and business partner Patrizio Bertelli. Miu Miu, after Miuccia's childhood nickname, was started as a separate fashion house in Milan, offering younger, more playful and slightly less expensive clothing than its older sister Prada. While initially designing for both men and women, the company stopped its menswear line in 2008 to focus on womenswear. Miu Miu's collections are shown in Paris and sold in Miu Miu stores worldwide. [EB]

Moschino

Franco Moschino (1950–1994) studied fine art at the Accademia di Belle Arti di Brera in Milan. Between 1971 and 1977 he worked as an illustrator for Gianni Versace and then designed for the Italian ready-to-wear label Cadette. In 1983 Moschino started his fashion label Moschino Couture!. His designs were characterized by a witty mockery of the fashion system. In 1986 he created the diffusion line Moschino Jeans (known as Love Moschino since 2008). In 1988 he launched his less expensive Cheap and Chic clothing line. In October of that year his so-called 'teddy bear dress' was featured on the cover of American *Vogue*. In 1993 the Permanente di Milano, the art gallery of the Society of Fine Art, mounted a retrospective of the Moschino label's first decade. Titled *Ten Years of Chaos*, the exhibition also included examples of Moschino's own paintings. When Moschino died in 1994, his closest collaborator, Rossella Jardini, became the company's creative director. Moschino became part of the Aeffe fashion group in 1999. [LS]

Noberasco

Vita Noberasco founded her eponymous fashion label in Milan and the business remained open throughout the Second World War. She supplied models to Italian dressmakers and also, when possible, to those in other countries. In 1946 and 1947 she presented her collections in Paris. In February 1951 she was one of the couturiers who took part in Giorgini's fashion show at his home in Florence. Shortly after this Florentine debut, models by Noberasco were available in Gimbels department store in Philadelphia and Morgan's of Toronto. The success of the atelier in the American market was confirmed when a full-page photograph of a black Noberasco evening gown was featured in the September 1951 issue of American *Vogue*. Vita Noberasco is remembered as a forward-thinking woman and for her important fashion library. When the atelier closed, this library was purchased by Giuliano Fratti and the young Walter Albini. [LS]

Carlo Palazzi

Carlo Palazzi (1928–2000) was born in Urbino and opened his elegant menswear boutique in 1965 on via Borgognona in the centre of Rome. In 1968 he presented a successful first collection in Capri at the Mare Moda fashion show. That same year he also presented a collection designed with Monsanto textiles at the Saint Regis Hotel in New York. Palazzi was among the first Italian designers to license his name in America, accomplished with the help of the British company Jaeger. Palazzi had international ambitions, opening shops in London, New York and Palm Beach. From the start of his career, Palazzi linked himself with the Italian film industry, designing costumes for over 40 films. [LS]

Bruno Piattelli

Bruno Piattelli was born in Rome in 1927 and studied law at Sapienza University. His father had a tailoring shop on Piazza San Silvestro, where Bruno started his career in fashion. In the 1960s he designed menswear for large manufacturers such as Ellesse and Lanerossi. In 1969 the first so-called 'Piattelli corners', or concessions, opened in department stores such as Barneys in New York, Takashimaya in Tokyo and later on London's Haymarket. As Piattelli's reputation grew, his work expanded. From 1973 he designed collections for Burberry. Piattelli also designed uniforms for Alitalia (1960) and for hostesses at Dunhill of London (1971). In Italy, Piattelli developed close links with cinema and theatre, designing costumes for actors including Italian stars like Marcello Mastroianni. He worked with directors Franco Zeffirelli, Luchino Visconti and Vittorio de Sica, contributing costumes to de Sica's 1964 film *Matrimonio all'italiana (Marriage Italian Style)*. [LS]

Prada

Born in Milan in 1949, Miuccia Prada completed her doctorate in political science at the University of Milan in 1970. In 1978 she joined the luggage company founded by her grandfather in 1913, transforming it, with the help of her husband Patrizio Bertelli, from an august purveyor of leather goods to an influential high-fashion label. Prada's design and business choices have often contradicted convention: her must-have nylon backpack, launched in 1985, rejected the Italian worship of fine leather. The company's open admission, even celebration, of overseas manufacture denied the accepted wisdom of 'Made in Italy'. Prada's 2011 listing took place on the Hong Kong stock exchange, the first of an Italian brand in the region. Prada's aesthetic has been adopted by the fashion cognoscenti as a preferred urban uniform. The company's launch of womenswear in 1988 further extended the reach of the Prada domain, yet driven by consumer desire for the season's 'it' bag or shoe, today Prada's accessories generate a sizeable portion of the company's revenue. Preoccupied with architecture, art and design, Miuccia Prada has collaborated with noted architects such as Herzog & de Meuron and Rem Koolhaas/OMA. The Prada Foundation was founded in 1995 and dedicated to contemporary art. Prada's prescient fashion film commissions have included director Roman Polanski and illustrator James Jean. Miuccia Prada has stated, 'Fashion is a vehicle for me to do other things'. [SS]

Emilio Pucci

Emilio Pucci (1914–1992) was a designer of aristocratic Neapolitan-Russian origins. In 1947, while Pucci was on a skiing holiday, a photographer for *Harper's Bazaar* took a snapshot of him and a friend wearing matching Pucci-designed ski outfits. A year later Pucci's first collection of sportswear appeared on the cover of the same magazine. In 1949 he launched his first beachwear collection and shortly afterwards he opened a boutique in Capri called Emilio of Capri. In February 1951 Pucci showed his designs at Giovanni Battista Giorgini's first Italian fashion show. He participated in every Florentine fashion show until 1967, when he began showing in his own palazzo on via dei Pucci in Florence. In 1954 he received the Neiman Marcus Award for best designer. Pucci became known for his bold use of colour and stylized printed fabrics. His notable collections included the 1955 *Sicilian* collection; his 1957 *Palio* collection, inspired by the horse races of Siena; the 1959 *Botticelli* collection, and in 1962, his first collection of couture. After his death in 1992, his daughter Laudomia continued to design under the Pucci name for some years. In 2000 a majority stake of the company was sold to LVMH, with Laudomia as the company's Image Director. [LS]

Roberta di Camerino

Roberta di Camerino is the fashion label created by Giuliana Coen Camerino (1920–2010). Camerino began her design career by creating velvet handbags during her forced stay in Switzerland during the Second World War. After the war, she returned to her native Venice and founded the Roberta di Camerino label. To create her handbags, she began with a wooden understructure created by skilled Venetian gondola makers. In 1956 she received the Neiman Marcus Award. Giovanni Battista Giorgini invited her to show her clothing line in the *Sala Bianca* in 1963. The Roberta di Camerino label also became known for practical and whimsical jersey dresses printed with trompe-l'œil designs. [LS]

Mila Schön

Mila Schön (1919–2008), born Maria Carmen Nutrizio to aristocratic parents, started her fashion atelier when her marriage to Aurelio Schön ended. In 1958 she opened a small studio in Milan and in 1965 she showed her couture collection for the first time at the *Sala Bianca*. The following year, Marella Agnelli and Lee Radziwill both wore Mila Schön evening gowns to Truman Capote's Black and White Ball; they were nominated first and third best-dressed woman respectively by *Women's Wear Daily*. In the same year Schön received the Neiman Marcus Award for colour. Schön's style is characterized by a clean linearity of cut and frequent use of double-faced fabrics, as well as rigorous geometric construction and striking colour. In 1972 Schön designed her first ready-to-wear collections for men and women. In 1986 she exported her label to Japan. In 1995 the couture line ceased; the ready-to-wear collection continues. [LS]

Emilio Schuberth

Emilio Schuberth (1904–1972) was a couturier of Neapolitan origin. In 1938 he opened a millinery shop with his wife in Rome, followed in 1940 by a couture atelier. Schuberth participated in Giorgini's first fashion show in February 1951. His sumptuous style was characterized by the use of luxurious fabrics and intricate embroidery. His atelier was frequented by Hollywood actresses such as Gina Lollobrigida, Sophia Loren and Brigitte Bardot. Schuberth also dressed aristocratic women, such as Princess Soraya of Persia. In 1957 he entered into an agreement with Delia Biagiotti, mother of Laura, to export her ready-to-wear line to American and German markets. [LS]

Simonetta

Duchess Colonna di Cesarò, known as Simonetta, was born in Rome in 1922. Simonetta was imprisoned briefly during the Second World War for having professed ideas contrary to fascism. She opened her own fashion studio in Rome in 1946. Her first fashion collection was presented directly after the war; due to lack of materials she made dresses from dishcloths, gardeners' aprons, butlers' uniforms, strings and ribbons. Simonetta showed at Giovanni Battista Giorgini's first fashion show in February 1951. Her reputation grew in the 1950s, and became established with the success of her signature cocktail dresses, evening gowns and coats. Simonetta had been married since 1944 to Count Galaezzo Visconti di Modrone, but they divorced in 1959. She married fashion designer Alberto Fabiani in 1962 and they opened a couture house in Paris, named Simonetta et Fabiani. They presented their last joint collection in 1964 and Simonetta opened a solo boutique, while Fabiani returned to Rome. They divorced in 1973. In the 1970s, Simonetta left Paris for India, devoting herself to philanthropy. She returned to Europe in 1985, dividing her time between Paris and Rome. [KV]

Valentino

Valentino Clemente Ludovico Garavani was born in Voghera (Lombardy) in 1932. After studying in Paris at the École des Beaux-Arts he swiftly rose to become an important name in global couture. Following his formal studies, Valentino worked for Jean Dessès, then from 1957 to 1959 for Guy Laroche. In 1959 he returned to Rome and opened his own fashion house along with Giancarlo Giametti. In 1962 Valentino presented his collection on the catwalk of the *Sala Bianca*, and he was soon flooded with orders from important clients. In 1968 he designed Jacqueline Kennedy's dress for her second wedding and also presented his famous all-white 'V' collection to considerable acclaim. Although Valentino designed ready-to-wear, he is best known for his overtly luxurious couture creations. In 1985 Valentino was knighted by the Italian President. The formative years he spent in Paris were recognized in 2006, when he was awarded the *Légion d'honneur*. Valentino retired in 2008, and Maria Grazia Chiuri and Pierpaolo Piccioli were named joint Creative Directors. In 2012, a Qatari investment group purchased the house. [WN]

Vanna

Anna Carmeli and Manette Valente founded their dressmaker's shop in the1930s, naming it Vanna. The shop was located on Corso di Porta Nuova in Milan and operated throughout the Second World War. Vanna was one of the four Milanese ateliers that took part in Giorgini's first fashion show in February 1951 at his villa on via dei Serragli. Their success on the Florentine runway with American buyers was such that in March 1953 American *Vogue* featured Vanna in an article titled 'Italian Collection Bubbling with Ideas'. The magazine showed a photograph of Vanna's 'dragoon coat' alongside models by Veneziani and Fabiani. [LS]

Veneziani

Jole Veneziani's (1901–1989) first job in a French fur company was a pivotal experience. This early role introduced her to working with raw leather and fur and their manufacturing techniques. Veneziani opened her own fur workshop in Milan in 1937, joined in 1943 by her clothing atelier. In 1946 she opened a couture salon at 8 via Montenapoleone that continued trading until she retired in 1984. Veneziani transformed fur from an item of luxury into a material of experimentation. One of the designer's trademarks was her use of fur trims on tailored women's garments such as coats and suits. She participated in Giorgini's first fashion show in 1951, and the following year her collection was praised by *Time* magazine, which featured one of her dresses on its April cover. Together with Germana Marucelli and Biki, Jole Veneziani was a key figure in mid-century Milanese couture. [LS]

Gianni Versace

Gianni Versace (1946–1997) was born in Reggio Calabria. After working in his mother's dressmaking atelier, from the early 1970s he designed for ready-to-wear labels Callaghan, Jenny and Complice. He showed his first collection for women under his own label in 1978. Working with his brother Santo and sister Donatella, Versace soon expanded his business worldwide. A confident and energetic experimenter, in 1982 Versace developed the specialist metallic chain mail Oroton and in the mid-1980s was an early proponent of computerized knitwear manufacture. A designer with a particular affinity for the arts, in 1985 Versace participated in an exhibition and conference devoted to his work at the V&A. In 1989 he opened Atelier Versace for couture designs. Two years later, the supermodel was born when Versace included all the top models of the day in his Autumn/Winter 1991 catwalk show. Known for creating extravagant, overtly sexy wardrobes for both men and women, Versace also designed theatre costumes, with dramatic results. Though Versace's high style clothing was favoured by a wealthy elite, his impact was felt in a wider section of society through diffusion lines. With Gianni Versace's death in 1997,his sister Donatella (b.1955) took on the role of artistic director. Under her stewardship, the company added cosmetics lines, expanded the couture business and continued the tradition of provocative advertising campaigns. [SS]

Bibliography

A

Glenn Adamson (ed.), *The Craft Reader* (New York and Oxford, 2010)

Rasche Adelheid and Marco Belpolti, *Coats! Max Mara, 55 Years of Italian Fashion* (Milan, 2007)

Rita Airaghi (ed.), *Gianfranco Ferré Disegni* (Milan, 2010)

Imran Amed, 'Made in Italy: Time for Accountability', *The Business of Fashion*, 4 December 2007, www.businessoffashion.com/2007/12/made-in-italy-time-for-accountability.html (accessed 13 February 2013)

Richard Avedon and Gianni Versace, *The Naked and the Dressed: 20 years of Versace by Avedon* (London, 1998)

B

Bettina Ballard, *In My Fashion* (New York, 1960)

Roland Barthes, *The Language of Fashion* (Oxford and New York, 2006)

Andrea Batilla, Sabrina Ciofi and Giulia Porotto, 'Conceria Milanese', *Wonder Furs*, www.wonderfurs.it/insidefur/conceria-milanese/?lang=en (accessed 4 December 2012)

Giacomo Becattini, *Dal distretto industriale allo sviluppo locale: Svolgimento e difesa di una idea* (Turin, 2000)

Carlo Marco Belfanti and Fabio Gusberti (eds), *Storia d'Italia, Annali 19, La moda* (Turin, 2003)

Gloria Bianchino, *Italian Fashion Designing 1945–1980* (Parma, 1987)

Gloria Bianchino, *Walter Albini* (Parma, 1988)

Gloria Bianchino, Grazietta Butazzi and Alessandra Mottola Molfino (eds), *Italian Fashion: The Origins of High Fashion and Knitwear, vol.1* (Milan, 1987)

Gloria Bianchino, Grazietta Butazzi, Alessandra Molfino Mottola and Arturo Carlo Quintavalle (eds), *La moda italiana: Dall'antimoda allo stilismo, vol.2* (Milan, 1987)

Michael L. Blim, *Made in Italy: Small-Scale Industrialization and its Consequences* (New York, 1990)

Nicoletta Bocca, 'La moda pronta e la sua materia', in *Per una storia della moda pronta. Problemi e ricerche, Atti del V Convegno Internazionale del CISST, Milano, 26–28 febbraio 1990* (Florence, 1991)

Nicoletta Bocca and Chiara Buss (eds) *Gianni Versace. L'abito per pensare* (Castello Sforzesco, exh. cat., Milan, 1989)

Daniele Boldizzoni, *L'impresa familiare. Caratteristiche distintive e modelli in evoluzione* (Milan, 1988)

Alessandra Arezzi Boza and Margherita Anselmi Zondari Margherita (eds), *Emilio Pucci 1957: La Collezione Palio* (Colle di Val d'Elsa, 2007)

Christopher Breward and David Gilbert (eds), *Fashion's World Cities* (Oxford, 2006)

Stella Bruzzi, *Undressing Cinema: Clothing and Identity in the Movies* (London and New York, 1997)

Ampelio Bucci, Vanni Codeluppi and Mauro Ferarresi (eds), *Il Made in Italy. Natura, settori e problemi* (Rome, 2011)

Reka Buckley and Stephen Gundle, 'Flash Trash: Gianni Versace and the theory and practice of glamour', in Stella Bruzzi and Pamela Church Gibson (eds), *Fashion Cultures* (London and New York, 2000)

C

Patrizia Calefato, *La moda oltre la moda* (Milan, 2011)

Cinzia Capalbo, *Storia della moda a Roma* (Rome, 2012)

Vittoria Caterina Caratozzolo, *Irene Brin: Lo stile italiano nella moda* (Venice, 2006)

Vittoria Caterina Caratozzolo, Judith Clark and Maria Luisa Frisa (eds), *Simonetta: La prima donna della moda italiana* (Venice, 2008)

Adriana Castagnoli & Emanuela Scarpellini, *Storia degli imprenditori italiani* (Turin, 2003)

Luigi Luca Cavalli-Sforza (ed.), *La cultura italiana* (Turin, 2009)

Germano Celant (ed.), *The Italian Metamorphosis 1943–1968* (Guggenheim Museum, exh. cat., New York, 1994)

Germano Celant and Harold Koda, *Giorgio Armani* (Guggenheim Museum, exh. cat., New York, 2000)

Anna Cento Bull and Paul Corner, *From Peasant to Entrepreneur: The Survival of the Family Economy in Italy* (Oxford and Providence, RI, 1993)

Caterina Chiarelli (ed.), *Moda Femminile tra le due Guerre* (Livorno, 2000)

Armando Chitolina (ed.), *Emilio Pucci Fashion Story* (Cologne, 2010)

Pamela Church Gibson, *Fashion and Celebrity Culture* (London and New York, 2012)

Enrico Cietta, *La rivoluzione del fast fashion* (Milan, 2009)

Judith Clark, *Anna Piaggi: Fashion-ology* (Victoria and Albert Museum, exh. cat., London, 2006)

Paola Colaiacomo (ed.), *Fatto in Italia. La cultura del Made in Italy 1960–2000* (Rome, 2006)

Paola Colaiacomo and Vittoria Caterina Caratozzolo, 'The Impact of Traditional Indian Clothing on Italian Fashion Design from Germana Marucelli to Gianni Versace', in *Fashion Theory* (2010), vol. 14, issue 2, pp.183–214

Paola Colaiacomo, *Factious Elegance: Pasolini and Male Fashion* (Venice, 2007) Jennifer Craik, *The Face of Fashion: Cultural Studies in Fashion* (London and New York, 1993)

'La cultura della moda italiana. Made in Italy', *ZoneModa Journal* (2011), vol. 2

D

Deborah Davis, *Party of the Century: The Fabulous Story of Truman Capote and His Black and White Ball* (Hoboken, 2006)

E

Tim Edwards, *Men in the Mirror: Men's Fashion, Masculinity and Consumer Society* (London 1997)

F

'The Family Way: Italy's dynamic design dynasties and the empires they rule', *Wallpaper**, 8 August 2012

Salvatore Ferragamo, *Shoemaker of Dreams: The autobiography of Salvatore Ferragamo* (London, 1957)

Charlotte Fiell, Peter Fiell and Catharine Rossi, *Masterpieces of Italian Design* (London, 2013)

John Foot, *Milan Since the Miracle: City, Culture and Identity* (Oxford and New York, 2001)

John Foot, *Modern Italy* (Basingstoke and New York, 2003)

Leopoldina Fortunati and Elda Danese, *Manuale di comunicazione, sociologia e cultura della moda*: Volume III, Il made in Italy (Rome, 2005)

Maria Luisa Frisa (ed.*), Lo sguardo italiano. Fotografie italiane di moda dal 1951 a oggi* (Rotonda di via Besana, exh. cat., Milan, 2005)

Maria Luisa Frisa (ed.), *Gianfranco Ferré. Lezioni di moda* (Venice, 2009)

Maria Luisa Frisa (ed.), *Lei e le altre. Moda e stili nelle riviste RCS dal 1930 a oggi* (Museo della Permanente, exh. cat., Milan, 2011)

Maria Luisa Frisa (ed.), *Pasquale De Antonis. La fotografia di moda 1946–1968* (Palazzo Fontana di Trevi, exh. cat., Rome, 2008)

Maria Luisa Frisa and Stefano Tonchi (eds), *Excess, moda e underground negli anni '80* (Stazione Leopolda, exh. cat., Florence, 2004)

Maria Luisa Frisa, *Italian Fashion Now* (Venice, 2011)

Maria Luisa Frisa and Stefano Tonchi, *Walter Albini and His Times: All Power to the Imagination* (Venice, 2010)

G

Patrizia Gatti (ed.), *M as Mila* (Milan, 2009)

Minnie Gastel, *50 anni di Moda italiana. Breve storia del pret-à-porter* (Milan, 1995)
Silvia Giacomoni, *The Italian Look Reflected* (Milan, 1984)

Bonizza Giordani Aragno (ed.), *Il Disegno dell'Alta Moda Italiana 1940–1970 I. Progetto e stile. Creatori della linea italiana* (Rome, 1982)

Bonizza Giordani Aragno, *Irene Galitzine: La principessa della moda* (Azzano San Paolo, 2006)

Sofia Gnoli, 'Camaleontica Irene Brin', *Velvet* (January 2011), p.60

Sofia Gnoli, *Fernanda Gattinoni: Moda e stelle ai tempi della Hollywood sul Tevere* (Milan, 2010)

Sofia Gnoli, 'Gabriella di Robilant. A Majestic life', *Unique Supplemento al numero 709, Vogue Italia*, September 2009, pp.114–20

Sofia Gnoli, *Gran Sera: Dalla Hollywood sul Tevere agli anni Ottanta* (Rome, 2003)

Sofia Gnoli, *Moda: Dalla nascita della haute couture a oggi* (Rome, 2012)

Sofia Gnoli, *Moda Italiana 1950–1970* (Rome, 2000)

Sofia Gnoli, *Un secolo di moda italiana 1900–2000* (Rome, 2005)

Sofia Gnoli and Gianni Rizzoni (eds), *Agenda della moda* (Milan, 2002)

Edward Goodman, Julia Bamford and Peter Saynor (eds), *Small Firms and Industrial Districts in Italy* (London and New York, 1989)

Clara Goria and Andrea Merlotti (eds), *Moda in Italia: 150 anni di eleganza 1861–2011*, (Reggia di Venaria Reale, exh. cat., Turin, 2011)

Alex Gorton, 'Designers transform the puffa', *Financial Times*, 13 November 2009, www.ft.com/cms/s/0/ec41bbc6-cfe0-11de-a36d-00144feabdc0. html#axzz2KavZIBlm (accessed 5 December 2012)

Laia Farran Graves, *The Little Book of Prada* (London, 2012)

Stephen Gundle, *Bellissima: Feminine Beauty and the Idea of Italy* (New Haven, 2007)

Stephen Gundle, *Glamour: A History* (Oxford and New York, 2008)

H

James Hillman et al., *Ermenegildo Zegna: An Enduring Passion for Fabrics, Innovation, Quality and Style* (Milan, 2010)

I

Alessandra Ilari, 'Italians add a dash of fashion to fur', *Women's Wear Daily*, 3 May 2005, vol. 189, no. 93, p.12
Irina Inguanotto, 'Elda Cecchele and the Italian Fashion World: From Salvatore Ferragamo to Roberta di Camerino (1950–1970)', *Textile History* (November 2012), vol. 43, no. 2, pp.223–49

K

Shirley Kennedy, *Pucci: A Renaissance in Fashion* (New York, 1991)

Russell King, *The Industrial Geography of Italy* (London, 1985)

Patricia Kinsella, *Superhuman Performance: The evolution of textiles for sports* (Museo del Tessuto, exh cat., Prato, 2008)

L

Marianne Lamonaca, 'A "Return to Order": Issues of the Classical and the Vernacular in Italian Inter-War Design', in Wendy Kaplan (ed.), *Designing Modernity: The Arts of Reform and Persuasion, 1885–1945* (New York, 1995)

Alberto Lattuada, *Progetti di Scuola* (Milan, 2012)

Grace Lees-Maffei and Ktejil Fallan (eds), *Made in Italy: New Perspectives on Italian Design* (Oxford, 2013)

L'Europeo. Nel segno della moda (October 2003), no.5

Mario Lupano and Alessandra Vaccari (eds), *Fashion at the Time of Fascism: Italian Modernist lifestyle 1922–1943* (Bologna, 2009)

M

Gianna Manzini, 'La moda tende a un linguaggio universale', in Nicoletta Campanella (ed.), *La moda di Vanessa* (Palermo, 2003)

Giannino Malossi (ed.), *La Regola Estrosa: One Hundred Years of Italian Male Elegance* (Milan, 1993)

Giannino Malossi (ed.), *Volare: The Icon of Italy in Global Pop Culture* (New York, 1999)

J.J. Martin, 'Fur: the all-season Italian must', *New York Times*, 2 October 2005, www.nytimes.com/2005/10/02/style/02iht-rfur.html?pagewanted=all&_r=0 (accessed 5 December 2012)

J.J. Martin, 'In Italy, Standards of Excellence', *The New York Times*, 15 November 2012, www.nytimes.com/2012/11/16/fashion/16iht-fcraft16. html?pagewanted=all&_r=0 (accessed 8 April 2013)

Richard Martin, *Fashion and Surrealism* (London, 1989)

Samuele Mazza, *Etro: alphabEtro* (Milan, 1998)

Samuele Mazza (ed.), *Moschino* (London, 1997)

Agnes McCarthy, 'A Designer Out of Italy Offers New Look to Men', *The New York Times*, 29 September 1955, p.29

Suzy Menkes, 'Throwing Down the Gauntlet', *The New York Times*, 28 September 2010

Elisabetta Merlo, *Moda italiana: Storia di un'industria dall'Ottocento a oggi* (Venice, 2003)

Enrica Morini, *Storia della Moda XVIII–XXI secolo* (Milan, 2010)

Franco Moschino and Lida Castelli (eds), *X Years of Chaos!: 1983–1993* (Milan,1993)

Sarah Mower, *Gucci by Gucci: 85 Years of Gucci* (London, 2006)

Adriana Mulassano, *The Who's Who of the Italian Fashion* (Florence, 1979)

Anna Municchi, *Ladies in Furs 1940–1990* (Modena, 1993)

Maria Giuseppina Muzzarelli, *Breve storia della moda in Italia* (Bologna, 2011)

N

Edoardo Nesi, *Story of My People* (Milan, 2010)

O

Anne O' Connor, 'L'Italia: La Terra dei Morti?', in *Italian Culture* (2005), vol.23, pp.31–50

P

Ivan Paris, *Oggetti cuciti: L'abbigliamento pronto in Italia dal primo dopoguerra agli anni Settanta* (Milan, 2006)

Eugenia Paulicelli, *Fashion under Fascism: Beyond the Black Shirt* (Oxford and New York, 2004)

Richard Peduzzi, Emanuele Pantanella and Pierre Chevalier, *Emanuele Pantanella: Opere dal 1972 al 2004* (Accademia di Francia, exh. cat., Rome, 2004)

Mark Petry, Bao Liting and Michael Woolsey, *United States of America Department of Agriculture, Global Agricultural Information Network Report, 25 May 2010*, http://gain.fas.usda.gov/Recent%20GAIN%20Publications/Fur%20Animals%20and%20Products_Beijing_China%20-%20Peoples%20Republic%20of_5-25-2010.pdf (accessed 5 April 2013)

Fernanda Pivano, *Le favole del ferro da stiro, ricordi di Germana Marucelli* (Milan, 1964)

Federico Poletti (ed.), *Maglifico! 50 Years of Extraordinary Made in Italy Knitwear* (Milan, 2012)

John Potvin, 'From Gigolo to New Man: Armani, America, and the Textures of Narratives', in *Fashion Theory: The Journal of Dress, Body & Culture*, September 2011, vol. 15, no. 3, pp. 279–98

John Potvin, *Giorgio Armani: Empire of the Senses* (Aldershot and Burlington, 2010)

Q

Enrico Quinto & Paolo Tinarelli (eds), *Un secolo di moda. Creazioni e miti del XX secolo* (Accademia di Francia, , exh. cat., Rome, 2003)

R

Jacqueline Reich, *Beyond the Latin Lover, Marcello Mastroianni, Masculinity and Italian Cinema* (Bloomington, IN, 2004)

Marco Ricchetti and Enrico Cietta, *Il valore della moda: industria e servizi in un settore guidato dall'innovazione* (Milan, 2006)

Stefania Ricci (ed.), *Salvatore Ferragamo: Evolving Legend 1928–2008* (Milan and London, 2008)

Paolo Rinaldi (ed.), *Walter Albini: lo stile nella moda* (Bologna, 1988)

Michael Rock (ed.), *Prada* (Milan, 2009)

Margherita Rosina, 'Una passione per i bei tessuti', in Enrica Morini & Margherita Rosina (eds), *La moda come passione e come professione. La donazione Silvana Bernasconi* (Castello Sforzesco, exh. cat., Milan, 2005)

Margherita Rosina, 'Sete stampate comasche per abbigliamento: un secolo di tradizione e innovazione', in Chiara Buss (ed.), *Seta il Novecento a Como* (Villa Olmo, exh. cat., Milan, 2000)

Margheria Rosina, 'Tessuti italiani anni cinquanta: tradizione e fantasia' in *Annicinquanta. La nascita della creatività italiana* (Palazzo Reale, , exh. cat., Milan, 2005)

Margherita Rosina and Francina Chiara (eds), *Carla Badiali disegnare il tessuto* (Fondazione Antonio Ratti, Museo Studio del Tessuto, exh. cat., Como, 2007)

Margherita Rosina and Francina Chiara (eds), *L'età dell'eleganza. Le filande e tessiture Costa nella Como degli anni Cinquanta* (Fondazione Antonio Ratti, Museo Studio del Tessuto, , exh. cat., Como, 2010)

Margherita Rosina and Francina Chiara (eds), *Guido Ravasi il signore della seta* (Fondazione Antonio Ratti, Museo Studio del Tessuto, exh. cat., Como, 2008)

Caroline Roux, 'Craft, Commerce and Couture', in *Crafts* (March–April 2011), no. 229, p. 44

Penelope Rowlands, *A Dash of Daring: Carmel Snow and her Life in Fashion, Art, and Letters* (New York, 2005)

S

Rachel Sanderson, 'Overseas sales boost Italian luxury groups', *Financial Times*, 30 March 2012

Rachel Sanderson, 'The real value of being "Made in Italy"', *Financial Times*, 19 January 2011

Stefania Saviolo and Salvo Testa, *Le imprese del sistema moda: Il management al servizio della creatività* (Milan, 2000)

Emanuela Scarpellini, *L'Italia dei consumi: Dalla Belle époque al nuovo millennio* (Rome, 2008)

Emanuela Scarpellini, *Material Nation: A Consumer's History of Modern Italy* (Oxford, 2011)

Emanuela Scarpellini and Stefano Cavazza (eds), *La rivoluzione dei consumi: Società di massa e benessere in Europa 1945–2000* (Bologna, 2010)

Jeffrey T. Schnapp, 'The Fabric of Modern Times', in *Critical Inquiry* (Autumn 1997), vol. 24, no. 1, pp. 191–245

Simona Segre Reinach, 'China and Italy. Fast Fashion vs Prêt à Porter. Towards a new Culture of Fashion', in *Fashion Theory* (2005), vol. 9, no. 1, pp.1–12

Simona Segre Reinach, 'The Fontana Sisters', in Valerie Steele (ed.), *The Berg Companion to Fashion* (Oxford, 2010), pp.343–45

Simona Segre Reinach, 'If You Speak Fashion You Speak Italian: Notes on present day Italian fashion industry', in *Critical Studies in Fashion & Beauty* (2010), vol. 1, no. 2, pp.203–15

Simona Segre Reinach, 'Milan as a Fashion City', in Joanne B. Eicher (ed.), *Berg Encyclopedia of World Dress and Fashion* (Oxford and New York, 2010)

Simona Segre Reinach, *Mode in Italy: una lettura antropologica* (Milan, 1999)

Simona Segre Reinach, 'La moda nella cultura italiana dai primi del Novecento a oggi', in Luigi Luca Cavalli-Sforza, Carlo Petrini and Ugo Volli (eds), *La cultura italiana*. vol. VI *Gioco, festa, turismo e moda* (Turin, 2009), pp.602–61

Simona Segre Reinach, 'National Identities and International Recognition', in *Fashion Theory* (June 2011), vol. 15, no. 2, pp. 267–72

Simona Segre Reinach, *Un mondo di mode: Il vestire globalizzato* (Rome, 2011)

Raffaella Sgubin (ed.), *Caleidoscopio Missoni* (Museo Provinciali di Gorzia, exh. cat., 2006)

Pia Soli, *Il genio antipatico* (Milan, 1984)

Carla Sozzani (ed.), *Alfa Castaldi* (Galleria Carla Sozzani, exh. cat., Milan, 2013)

Valerie Steele, *Fashion, Italian Style* (New Haven and London, 2003)

T

Ian M. Taplin, 'Segmentation and the Organisation of Work in the Italian Apparel Industry', in *Social Science Quarterly* (June 1989), vol. 70, no. 2, pp.408–24

Dana Thomas, *Deluxe: How Luxury Lost its Lustre* (London and New York, 2007)

Elisa Tosi Brandi, *Artisti del Quotidiano. Sarti e sartorie storiche in Emilia-Romagna* (Bologna, 2009)

Mark Tungate, *Luxury World: The Past, Present and Future of Luxury Brands* (London and Philadelphia, 2009)

Matt Tyrnauer, 'Less is Maier', *Vanity Fair*, September 2008

V

Guido Vergani (ed.), *Fashion Dictionary* (Milan and New York, 2006)

Guido Vergani, *Mantero 100 anni di storia e di seta* (Florence, 2002)

Guido Vergani, *La Sala Bianca: nascita della moda italiana* (Milan,1992)

Nora Villa and Mariella Passerini, *Albertina: un filo di lana lungo sessanta anni* (Rome, 2005)

Paolo Volonté, 'Social and Cultural Features of Fashion Design in Milan', in *Fashion Theory* (December 2012), vol. 16, no. 4, pp.399–432

W

Judith Watt, 'To die for', *Guardian*, 24 March 2000, www.theguardian.com/lifeandstyle/2000/mar/24/fashion4 (accessed 4 December 2012)

Nicola White, *Reconstructing Italian Fashion: America and the Development of the Italian Fashion Industry* (Oxford and New York, 2000)

Claire Wilcox, Valerie Mendes and Chiara Buss, *The Art and Craft of Gianni Versace* (London, 2002)

Elizabeth Wilson, *Adorned in Dreams. Fashion and Modernity* (New Brunswick and London, 2003)

Acknowledgements

The exhibition would not have been possible without the support of our sponsors, particularly Bulgari. I am also grateful to Nespresso and the Blavatnik Family Foundation.

This publication, which accompanies the V&A's major exhibition, *The Glamour of Italian Fashion: 1945-2014*, has been realised with the assistance and support of many individuals. I would like to thank those contributors who have added their research to this publication: Glenn Adamson, Christopher Breward, Stella Bruzzi, Vittoria Caratozzolo, Judith Clark, Oriole Cullen, Elizabeth Currie, Jonathan Faiers, Maria Luisa Frisa, Sofia Gnoli, Filippo Guarini, Gianluca Longo, Alistair O'Neill, Helen Persson, Elena Puccinelli, Margherita Rosina, Catharine Rossi, Emanuela Scarpellini and Simona Segre Reinach. These experts contributed not only their writings but also creative ideas and generous introductions. I also thank Kate Bethune, Elizabeth Bisley, William Newton, Suhashini Sinha, Kristian Volsing along with Silvia Casagrande from the Germana Marucelli Archive for their contributions. A special thanks to the project's Research Assistant Lucia Savi for her intellectual curiosity, her written contributions to this volume and her tireless efforts in every stage of its development.

I am indebted to my colleagues within V&A Publishing: Mark Eastment, Frances Ambler and Clare Davis, with special thanks to the calm professionalism of Anjali Bulley. Vicky Haverson and Liz Edmunds also deserve praise.

I am also grateful to former V&A Director Mark Jones and his successor Martin Roth and to the support of Damien Whitmore, Jane Lawson, Sophie Hargroves, Olivia Collins, Zoe Franklin, Jane Rosier and Sarah Armond.

I am immensely grateful to colleagues who shared their expertise with us. Within the Furniture, Textiles and Fashion Department I thank Christopher Wilk, Claire Wilcox, Lesley Miller, Clare Brown, Edwina Ehrman, Suzanne Smith, Sue Prichard and Jana Scholze as well as the unfailing support of Stephanie Wood. I also wish to thank to colleagues within the Exhibitions Department including Linda Lloyd-Jones, Stephanie Cripps, Rosie Wanek and Sarah Scott along with Natalia Ferreiro and Robyn Earl with Sophie Parry and Jemma Davey providing particularly graceful support. I also wish to recognise Research Department colleagues Helen Woodfield, Katherine Elliott, Nicola Froggatt, Ilaria Purini and Luisa Coscarelli and the encouragement of Susanna Brown of the Word and Image Department. Textile conservators Sam Gatley and Sarah Glenn worked skilfully to present the garments at their best as did Jaron James of the Photo Studio; we greatly appreciated his keen eye and enormous patience. Thanks also to Mark Kilfoyle for his expertise and sense of humour, to Maria Cristina Giusti for her fruitful research and to Federico Poletti, Francesca Ferlin and Matteo Augello.

The V&A also acknowledges the support of the former Italian Ambassador to Britain, His Excellency Alain Giorgio Maria Economides and his successor His Excellency Pasquale Terracciano. First Counsellor Press and Foreign Affairs Nicola Todaro Marescotti deserves our gratitude for his unwavering interest in this project.

Others who lent their expertise and resources include Caterina Cardona of the Italian Cultural Institute, London and Fortunato Celi Zullo and Fabrizio Labrozzi of the Italian Trade Commission, Giulia Pirovano of the Camera Nazionale della Moda and, Guido Tettamanti, secretary of the Sezione Serica Italiana di Confindustria Comoalso Sistema Moda Italia, Andrea Cavicchi, President of Unione Industriale di Prato; Barbara Bigagli and Enrico Mongatti, Unione Industriale Pratese, Camera di Commercio Industria e Artigianato di Prato, Roberto Badiani, B' Grup.

A number of fashion design houses and their archives were instrumental in realising this publication and the exhibition which it accompanies, including Maura Giubbolini at Albertina; Giorgio Armani and Cecilia Dessalles d'Epinoix, Armani; Benetton; Laura Biagiotti; Brioni; Amanda Triossi, Bulgari; Roberto Cavalli; Dal Co'; Dolce & Gabbana and Andrea Caravita; Jacopo Etro and Etro; Roberto and Monica Sarti at Faliero Sarti & Figli; Silvia Venturini Fendi; Stefania Ricci of the Museo Salvatore Ferragamo; Rita Airaghi of the Fondazione Gianfranco Ferré; Federico Fourquet; Edoardo De' Giorgio of Gattinoni; Romeo Gigli and Lara Aragno; Grazia Venneri of Museo Gucci; Stella Jean; Litrico; Giancarlo Calza of the Germana Marucelli Archive; Federica Fornaciari and the Max Mara Archive; Marni; Antonio Marras; Luca Missoni, Angela Ward and Paolo Meneghello and their colleagues within the Missoni Archive; Moschino; Emanuele Pantanella; Bruno Piattelli; Simon Cundey of Henry Poole; Miuccia Prada and Simona Chiappa, Prada; Laudomia Pucci and the Fondazione Emilio Pucci; Fausto Puglisi and Leila Palermo; Ratti; Mila Schön; Luigi Ricceri at Lanificio Luigi Ricceri; Mariano and Chiara Rubinacci; Trussardi; the house of Valentino; Giambattista Valli; Francesca Versace and the house of Versace and Anna Zegna. We also thank Luca Dotti and Sean Ferrer and the Audrey Hepburn Fund, Enrico Minio and the Fondazione Roberto Capucci.

A number of additional archives and museums also supported this project: Neri Fadigati of Archivio Giorgini; Roberto Fuda and his colleagues within the Archive di Stato di Firenze; Paola Pagliari and Gloria Bianchino of CSCA Università degli Studi di Parma; the staff of The Costume Institute at the Metropolitan Museum of Art; Caterina Chiarelli of the Galleria del Costume Palazzo Pitti, Laura Fiesoli and Daniela Degl'Innocenti of Prato's Museo del Tessuto, Anna Jolly of the Abegg-Stiftung, Fondazione Micol Fontana, Maria Paola Ruffino of Palazzo Madama-Museo Civico d'Arte Antica, Palazzo Morando and the Fondazione Bano.

We also extend our gratitude to Erika Ghilardi of Foto Locchi, to *Vogue Italia* and *British Vogue*, the expert staff at The Picture Desk, Eve Demoen of Modemuseum Hasselt, and the MIC (interdepartmental centre for Fashion, Image and Consumer culture), Raffaello Napoleone of Pitti Immagine and 80s Casual Classics.

Several photographers deserve particular thanks for their generosity including Gian Paolo Barbieri and Paolo Roversi, along with Paolo Castaldi of the Alfa Castaldi archive.

Specialists consulted also included Bonizza Giordani Aragno, Brenda Azario, Alessandra Arezzi Boza, Nathan Cockrell, Rana Foroohar, Stephen Gundle of University of Warwick, Gabriele Monti of IUAV University, Venice, Enrica Morini, Professor of Contemporary Fashion, IULM University, Milan, Emanuele Pantanella, Adelheid Rasche of Mode und Kunsthistorikerin, Alice Rawsthorn, Gaia Servadio, Claire Smith of British Film Institute and Raffaella Sgubin of Musei Privinciali di Gorizia.

I extend special thanks to all the lenders to the exhibition. In addition to the design houses, museums and archives this includes Barbara and Marisa Curti, Francesca Galloway, Cecilia Matteucci Lavarini, Enrico Quinto and Paolo Tinarelli.

Thanks also to Francina Chiara, Anna Castelli, and the library of Museo Studio del Tessuto of The Fondazione Antonio Ratti, Como and Jane Holt of London College of Fashion.

Lastly, I thank my family, especially my parents, who started this project with me many years ago.

Picture Credits

AFP/Getty Images: pl.129
Photographs by Aldo Fallai: pls 189, 190
Photograph by Aldo Fallai/Courtesy of Giorgio Armani, Milano: pls 136, 137
© *Amica*/RCS Media Group: pl.231
© Andrea Spotorno: pl.151
© Antonelli: pl.82
© Andy Willsher. Courtesy of '80s Casual Classics Ltd: pls 196, 197, 202
ArchiviFarabola: pl.171
Archivio Alfa Castaldi, Milano: pls 54, 58–62, 66, 70, 146, 160
Archivio Alinari, Firenze: pl.104
Courtesy of Archivio de Antonis, Roma: pl.41, 42, 131
Archivio della Fondazione Gianfranco Ferré: pl.89–92
Courtesy of Archivio Forquet: pl.11
Archivio Marisa Curti: pl.56
Archivio Storico Ratti Spa: pl.81
The Art Archive/DeA Picture Library: pl.67
The Art Archive/Mondadori Portfolio/Electa: pls 40, 213, 215
The Art Archive/Mondadori Portfolio/Marisa Rastellini: pl.216
The Art Archive/Mondadori Portfolio/Rocco Barocco Archive: pl.57
Art Partner: pls 149, 175
© Banca Dati dell'Archivio Storico Foto Locchi Firenze: pls 2, 7, 12, 13
Photo by Bardo Fabiani: pl.161
Bazmark Films/The Kobal Collection: pl.159
Bentley Archive/Popperfoto/Getty Images: pl.174
© Bettman/Corbis: pl.167
Courtesy of Brenda Azario: pls 239-45
Brioni Archive: pl.181
Buena Vista Pictures/Photofest: pl.158
Courtesy of Casa Zegna Archives, part of Fondazione Zegna
Catwalking: pl.225
Charles Knight/Rex Features: pl.201
Clifford Coffin/*Vogue* © Condé Nast Publications Ltd: pls 46, 235
CSAC Universita di Parma, Italia, Sezione Moda: pl.227
Photo: Dario Garofalo: pls 105, 110, 111
David Bailey/*Vogue* © Condé Nast Publications Ltd: pl.212
Courtesy of D la Republica: pl.233
Courtesy Doug Ordway: pl.175
© Dusan Reljin: pl.249
Elle Italy: pl.234
© Courtesy of Emilio Pucci Archive: pl.73
© Enrico Carlo Saraceni: pls 31, 37
The Face magazine/Bauer Media: pl.203
Courtesy Faliero Sarti & Figli: pls 114, 115
Courtesy of *Fantastic Man* magazine. Photograph by Daniel Riera: pl.193
© Fendi: pl.122
© Ferdinando Scianna/Magnum Photos: pl.134
Foc kan/Getty Images: pl.248
Courtesy Fondazione Ottavio e Rosita Missoni, Sumirago: pls 140, 141
Fondazione Micol Fontana, Rome: pl.154
Fried/*Vogue* © Condé Nast: pl.17
Gamma-Rapho/Getty Images: pl.225
Courtesy of Gattinoni Couture: pl.30
Getty Images: pl.20
Gian Battista Colombo (Giancolombo): pls 39
© Gian Paolo Barbieri: pls 75, 76, 80, 83, 121, 124, 138, 144
Giorgini Archive, Florence: pls 5, 6, 29, 38, 52
Courtesy Guido Harari: pl.69
Copyright Glen Luchford: pl.150
Henri Cartier-Bresson/Magnum Photos: pl.3
Henry Clarke/*Vogue* © The Condé Nast Publications: pls 120, 237, 239
Courtesy of the Historical Archive Maison Galitzine: pl.36
Hulton Archive/Getty Images: pl.123
Courtesy of the Italian Tourist Board/Gattinoni Couture: pl.236
Jean-Philippe Charbonnier/Getty Images: pl.168
Courtesy Lanificio Luigi Ricceri: pl.112
Library of Fratelli Alinari, Museum of the History of Photography, Florence: pl.224
Courtesy London College of Fashion: pl.183, 184
Lonely Planet/Getty Images: pl.247
Courtesy Maison Mila Schön: pl.18
Courtesy Manuela Pavesi: pl.145

Maria Vittoria Backhaus, Milano: pl.130
Photo: Mario Ciampi: pls 115, 116
Marzotto Group: pls 74, 77
Max Mara Company Archive: pls 68, 88
Illustration by Mats Gustafson: pl.143
Photo: Mike Reinhardt: pl.79
Monty Fresco/*Daily Mail*/Rex Features: pls 198, 200
Courtesy Moschino Spa, Milano: pl.142
Museo Studio del Tessuto, Fondazione Antonio Ratti, Como: pl.72
© The National Gallery, London: pl.166
© Norman Parkinson Ltd/Courtesy Norman Parkinson Archive: pl.47
Photo: Officine Fotographiche: pls 107–9
Courtesy Oliviero Toscani, Pisa: pls 132, 135, 139, 191
Courtesy Paolo Roversi: pls 162–4
Paul Himmel/*Vogue* © The Condé Nast Publications: pl.238
Paramount/The Kobal Collection: pls 14, 15, 156
Paramount Pictures/Photofest: pl.155
Paris Match/Getty Images: pl.223
Peter Lindbergh: pl.194
Courtesy of Prada: pls 102, 103, 195
Courtesy Prada Spa, Milano/Art Partner: pl.148
Courtesy Prato Textile Museum, Fossombroni collection: pl.106
Rex/PixelFormula/SIPA: pl.124
Rex/Sharp Stills: pl.152
Riama-Pathe/The Kobal Collection: pl.165
Salvatore Ferragamo Archive: pl.100
© Scott Schuman: pls 208–211
Studio H2o: pl.1
© 1982 Time Inc. Used under license: pl.230
© Courtesy Thomas Zanon-Larcher: pl.246
TopFoto/Alinari Archives/2000: pl.221
Toscani Archive/Alinari Archives Management. Florence: pl.222
Trussardi, AW 1993–4: pl.65
Ullstein Bild/Alinari Archives/Special Credit: Rich: pl.220
Photo Ugo Mulas © Ugo Mulas Heirs. All rights reserved: pl.71, 147
United Artists/Photofest: pl.153
Photograph © Victoria and Albert Museum: pls 4, 8, 9, 10, 19, 20–28, 32-5, 48, 49, 53, 63, 64, 85, 86–7 (private collections, Milan), 93–9, 101, 118, 119, 126, 127, 128, 133, 169, 170, 178, 179, 180, 185, 192, 204–7, 217–9
Vogue © Condé Nast: pl.182
Warner Bros/Everett/Rex Features: pl.199
Warner Bros/Photofest: pl.157
© World Copyright Graziella Vigo: pls 228, 229

283

Index

Page numbers in *italic* refer to the illustrations

A

A (magazine) 245
Abegg, Margaret 16
Abegg, Werner 16
Abraham 85–6
Accademia nazionale dei Sartori (Italian Academy of Tailors) 196
Accattone 182, *186*
Acqua di Parma 238
Adamson, Glenn 98
advertising 240, 244
Agnelli, Gianni 139
Agnelli, Marella 16
Agnona 87, 90
Aimo Richly 118
Air Force One 167
Airaghi, Rita 244
Alaïa, Azzedine *263*
Alas, Mert *137*, *156*, 160, *189*
Alba, Massimo 71
Albertalli, Norberto 125
Albertina 116, *117*
Albini, Franco 54, 231
Albini, Walter *60*, *62*, 66, *86*, 142, 247
 advertising 136, *137*
 and Etro 88, 97
 fashion shows 228, 240–42, 262
 menswear 185–91, *186*, *198*, 199
 ready-to-wear 228
 rise of the *stilisti* 22–4, 62
Almodóvar, Pedro 168
Alta Moda 240
Altara, Edina 136
Altman department store, New York 12
Alvaro, Corrado 139
Alviani, Getulio 42, 57, *80*, 85
Amalfi coast 183
American Film Company 163
American Gigolo 162, *165*, 167, 185, 231
Amica 245–6, *245*
Anfossi, Tommaso 71
Angelico, Fra 57
Anna 245
Anna, Madame 37, 42
Annabella 172, 245
Annapurna 118
anni di piombo 22, 147
Antonelli, Maria *33*, 34
Antonelli Alta Moda Pronta *85*
Antonelli Sport 34
Antonioni, Michelangelo 42, 182
Apem 66
Aquascutum 215
Aquiliano Rimondi 101
Aracne 246
Archizoom Associates 68
Arden, Elizabeth 123
Arena Homme Plus 202
Arflex 66
Arianna 172
Armani, Giorgio *65*, 70–71, *86*, 99, 116, 142, 177, 182, 242, *243*, 247
 advertising 147, *147*, 244
 agreement with GFT 62–5, 231

on cover of *Time* magazine 89, *244*
 early career 184
 Emporio Armani 147, *147*, 184, 231, 244
 film costume design 162, *165*, 167
 menswear 168, 184–5, *189*, 191, 199–200, 202, *202*, 213, 214, 215
 textiles 112, 212
Arnault, Bernard 238
art 57, 58
Arzignano 130, 232
As Good as it Gets 167
Aspesi, Natalia 65
Associazione Industriali dell'Abbigliamento (Industrial Clothing Association) 242
Associazione Italiana Fabbricanti di Seteria (Association of Italian Silk Manufacturers) 86
Astaire, Fred 44
Attolini, Cesare 196
Attolini, Vincenzo 222
Avon Celli 118, 198
L'Avventura 182
Azario, Brenda 256–9, *258*
Azario, Vittorio 256–9, *257*

B

Bacall, Lauren 37, *252*, 253
Backhaus, Maria Vittoria 136–9, *137*
Backlund, Sandra 118
Badiali, Carla 78
Bailey, David *226*
Bailly, Christiane 240
Baker, Josephine 42
Balduzzi, Francesco 246
Balenciaga 41
Ballard, Bettina 12, 37, 46, 208
Balmain, Pierre 15
Balzani *48*, 50
Barbarella 85
Barbera 211
Barberini Colonna di Sciarra, Princess Nadia *251*
Barbieri, Gian Paolo *80*, *83*, *85*, *86*, *123*, *126*, 148, *149*, 153, *153*
Barcelona 259
Bardot, Brigitte 193
The Barefoot Contessa 32, 165, *165*
Bari 122
Barocco, Rocco *60*
Baron, Fabien 172
Barzini, Benedetta 153, 160
Basile *62*, 68, 142, 200, 240, 242
Baths of Diocletian, Rome 139, *139*
Battilocchi 32
Bauhaus 199
beachwear 51
Beene, Geoffrey 242, 257
Béjart, Maurice 191
Bellezza 42, 48–50, *48*, 51, *53*, 57, 136, *153*
Bellinzago Novarese 212
Bellotti 68
Bellucci, Monica 153
Benetton 116, 142, *143*
Benetton, Luciano 142

Benjamin, Walter 172
Bergamo 76
Bergdorf Goodman 12, 37, 49, 57, 116
Bergman, Ingrid 7, 34, 165
Berkley, Elizabeth 168
Berlin 259
Bernasconi 78
Bert, Chino 87, 245
Bertelli, Patrizio 236
Berthoud, François 148
Besson, Luc 169
Besson, Pierre 257
Bevilacqua 87
Biagiotti 142, 242
Biagiotti, Laura 247
Biba 66
Biella 22, 69, 70, 76, 89, 116, 211–12, 232
Biki 42–4, *44*, 66, 228, *228*
Bilgorri of Bishopsgate 211
Billy Ballo 240
Bini 90
The Birdcage 168–9
Bises 256
Black and White Ball 16, *20*
Blanks, Tim 204
Blige, Mary J. 132
Boboli Gardens, Florence 15
Bonami, Francesco 58, 65
Bonnie and Clyde 167, *167*
Borg, Björn 208–11, *210*, 212, 213
Borghese, Paolina Bonaparte *48*, 50
Borioli, Gisella 148, 247
Borsalino 198
Boscono, Mariacarla 153
Bosé, Lucia 42
Bottega Veneta 27, 28, 101, 132, 202, 219, 238
Botti, Augusta Carlotta 49
Botti, Fernanda 49
Botti, Sorelle 49
Botticelli, Sandro 48
Bourdieu, Pierre 60
boutique fashion (*moda boutique*) 16, 51–5, 60
La Boutique of Rome *251*
Braghenti 78
brands 68, 70, 242
Brazil 94, 238
Brescia 69
Brianza 97
Brigidini, Cristina 245
Brin, Irene 34, 37, 41, 51, 57, 139
Brioni 28, 29, 70, 180, 194, *195*, 196, *197*, 212, 219, 222, 238
Britain
 Carnaby Street 66, 211, 231
 Italian menswear in 208–15
 tailoring 218–19
 Vogue 249–53
Brodovitch, Alexey 172
Brooklyn Museum, New York 12
Brooks Brothers 169, 238
Brossin de Méré, Andrée 78
Bruzziches, Benedetta 71, 101
Buck, Joan Juliet 76
Buckley, Reka 57
Bulgari *6*, 7, 238
Burberry 111
Burton, Richard 7, *123*
Bussola, Gianfranco 246

Busto Arsizio 76, 232
Buzzati, Dino 245
Buzzi, Carla 244
Byron, Lord 58

C

Cadette *86*
Caffè, Federico 234
La Cage aux Folles 169
Callaghan 62, 91, *93*, 142, 202, 242
Callas, Maria 44
Calvino, Italo 193
Calzaturificio Società manifatturiera pellami e cuoi 69
Calzaturificio di Varese 69
Cambridge, Duchess of 111
Camerana, Anna Bozza 199
Camerino, Roberta di 44, *86*, 87
Campania 130
Campigli, Massimo 57
Campolmi *107*
Camporesi, Silvia 161
Canali 222
Canepa 90, 91
Canova, Antonio *48*, 50
Cantoni 226
Capote, Truman 16, *20*
Capri 37, 41, 139
Capucci, Roberto *27*, 32, 42, *56*, 57, 66, 78, 125, 182
Caracciolo, Princess Giovanna 37–41, 57, 60
Caracciolo di Castagneto, Princess Marella 32, 139
Caraceni 32, 222, *223*
Caraceni, Agostino 196
Caraceni, Nicoletta 222–3
Caravel 198
Cardin, Pierre 66
Cardinale, Claudia 41, 157
Carnaby Street, London 66, 211, 231
Carosa 12, 37–41, 57
Carpi 116, 232
Carraro, Anna 161
Cartier-Bresson, Henri *11*
cashmere 70, 89
Casoratti, Felice 42
Cassina 66
Castaldi, Alfa *58*, *62*, *65*, 66, *68*, *73*, *154*, 160, 172, *173*, *200*
Castel Goffredo 70, 232
Castiglione, Baldassare 180, 193
Castiglioni, Achille 66, 231
Castiglioni, Livio 231
Castiglioni, Pier Giacomo 231
Castro, Federica di 125
casuals 208–11, 213–15
Catholic Church 182
Cattelan, Maurizio 160
Caumont 62, 142, 228, 242
Cavalli, Roberto 132
Cavicchi, Andrea 110
Cecchele, Elda 97
Cederna, Camilla 44
Celant, Germano 182, 184, 204
Centro di Firenze per la Moda Italiana *56*
Centro Italiano Tessile Abbigliamento Alta Moda 85
Cerruti 28, 89, 184, 208, 212–13,

212
Cerruti, Antonio 211
Cerruti, Nino 112, 167–8, 169, 199, 200, 212
Chanel, Coco 37, 49, 168, 259
Charbonnier, Jean-Philippe *184*
Chenoune, Farid 197
Cheri Moda 262
Cheti, Fede 97
Chiari, Walter 193
Chicago Daily Tribune 16
China 27, 28, 70, 92–3, 94, 97, 99–100, 109–10, 125, 182, 236, 238
Chiuri, Maria Grazia 27, 44
Chloé 111
Christian, Linda 32, 163–5
Church's 238
Ciano, Edda 37
Cicogna, Gina 42
Cietta, Enrico 71
Cignitti, Enrico *85*
Cinecittà film studios 32
Cini 89
Civitanova Marche 232
Clark, Ossie 185
Clarke, Henry *119*, 194, *251*
Clayton, Jack 169
Clerici Tessuto 78, *88*, 91
Coen, Giuliana *see* Camerino, Roberta di
Coffin, Clifford *52*, 55, *251*
Colaiacomo, Paola 68, 182, 183–4
Colonna di Cesarò, Duchess Nina *52*, 55
Colonna di Cesarò, Simonetta 32, 37, 49, *52*, 55, 57, 60, 234
 see also Simonetta
commedia dell'arte 160
communication 240–47
Como 22, 41, 70, 76, 78, 85–6, 88, 90, 91, 92, 93, 97, 98, 232
Como, Perry 211
Compasso d'Oro prize 66, 184
Complice 202, 242
Conceria Milanese 125
Condé Nast 177, 245, 247, 265
Confezioni Marzotto *83*
Connors, Jimmy 208, 211, 212, *212*, 213
Copenhagen 122
Cori 66, 70, 83
Corneliani 222
Corporazione della Lana 104
Correggiari 68
Corriere della Sera 245, 247
Corso, Gaspero del 57
10 Corso Como, Milan 262, 263, *263*
Corti, Countess Mita *52*, 55
Cose 240
Costa 78
cotton 70, 76, 226
Courrèges, André 259
The Covered Wagon 163
Coveri, Enrico 68, *68*, 118, 247
craft 94–8, 101
Crafts magazine 101
Crawford, Joan 163
Crescent, Francine 76
Crespi 226
Cruze, James 163
Curiel, Gigliola 42, 44, 244

D

D – La Repubblica delle donne 247, *247*
D'Annunzio, Gabriele 37, 42
Datini, Francesco di Marco 104
d'Avenzaor 198
Dazed and Confused 154
De Antonis, Pasquale *47, 48*, 49, 50, 139, *139*
De Gasperi Zezza 139, *139*
de la Renta, Oscar 257
De Luca 57
de Palma, Brian 162
De Rossi *85*
Del Corso, Gaspero 139
del Grande, Sergio *226*
Del Vecchio family 238
Delaunay, Sonia 90
Dell'Atte, Antonia 147
Della Valle, Diego 28, 70
Dello Russo, Anna 122
DeMille, Cecil B. 163
democratization of fashion 70, 71
Derrick, Robin 263
designers 231, 240
D'Este *85, 86*
Diamant's 62
DiCaprio, Leonardo *168, 169*
Die Hard: With a Vengeance 167
Diesel 160
Dietrich, Marlene 123
Dietsch, Roger 257
diffusion ranges 91–2
Dior, Christian 32, 91, 215, 259
distretto industriale (industrial districts) 97, 231–3, *231*, 238
distribution channels 238
Dolce, Domenico 65, 193, 238
Dolce & Gabbana 101, *131*, 132, 142, *143*, 193, *193*, 215, 238, 244
la dolce vita 197, 215
La Dolce Vita (film) 34, *162*, 165, *180*, 182
Domina 42
Domus 147
Dondi 88
La Donna *83*, 123, 148, *149*, 247
Donna più 247
Dorfles, Gillo 148
D'Oris, Enzo 219
double-faced fabrics 86–7
Douglas, Michael 167
Dova, Gianni 85, *85*
Drago, Eleonora Rossi 44
Drago, Princess Marcello del 253
drawings 148–53
Dredd 169
Dubai 238
Dunaway, Faye 167, *167*
Dunst, Kirsten *137, 156*, 160
DuPont 70, 257
dyes 86–7

E

e-commerce 247
Edgerton, Joel *168*
Edimoda 247
Egypt 99
Ekberg, Anita 34, 123, *162*, 165
Elizabeth II, Queen 111
Elle 247, *247*, 263
Ellesse 214
Emilia-Romagna 69, 180
Emmer, Luciano 32
employment
 industrial districts 232
 women 233–6
Ente Moda Italiana (Italian Trade Commission) 97
Ente Nazionale della Moda 8, 226
Enzo *85*
Epoca 183
Ermenegildo Zegna 69, 70, 180, 199, 211, 222, 226, *228*
Escabosa, Hector 15
Escargots 62
Esposizione Universale Roma 194
L'Espresso 172
Etro 22, *60*, 88, 97, 99, 101, 202, *204*

Etro, Gimmo 101
Europa 51 34
European Union 110, 238
Every Day's a Holiday 165, 167, *167*

F

Fabiani, Alberto 12, *22*, 32, 37, 54, 57, 253
Fabro, Luciano 136
The Face 213–14, *214*
Facist brand 70
Fadigati, Giovanni Maria *53*
Failli of Florence 42
Fairbanks, Douglas 163
Fairchild, John B. 62
Faliero Sarti & Figli 24, 90, 112, *112*
Fallai, Aldo 147, *147*
'fantasy textiles' 106
Faraoni 57
Farrow, Mia 169
fascism 8, 60, 97, 226
fashion designers 231, 240
fashion photography 136–61
fashion system 231
Fellini, Federico 34, 42, *162*, 165, 182
Fendi 28, 29, 44, *123*, 125, 142, 238, 242
Fendi, Silvia Venturini 44
Fenghi, Marina 244
Ferragamo, Ferruccio 94
Ferragamo, Salvatore 16, 28, *48*, 50, 70, 94, 97–8, *97, 98*, 101, *101*, 130, *132*, 139, 162–3, 167, *236*, 253
Ferragamo, Wanda 236, *236*
Ferrari, Francesco 71
Ferrarin 89
Ferré, Gianfranco 28, 65, *66, 88*, 91, *91*, 112, 148, *149*, 238, 242–4, *243*, 247
Ferretti, Alberta 65
Ferretti, Massimo 65
Ferretti Veroni, Deanna 116–18
Ferri, Fabrizio 148, 247
Fiera Campionaria di Milano 242
The Fifth Element 169
Fila 90, 208–11, *209, 210*, 212–14
Filene's Talent Award 41
films 16, 32–4, 42, 162–9, 182, 185, 211, 228, 231
Fini, Leonor 37
Fiorucci *22*, 24, *24*, 66, *66*
The Firm 212
First World War 70
Fisac 78
Florence *11*, 139
 fashion shows 12–16, 22, 54, 60–62, 76, 194, 228, 240
 guilds 104
 leather 28, 130
 menswear 223
 straw products 232
 textiles 76, 97
 trade fairs 204
Fondazione Sandretto Re Rebaudengo, Turin 58
Fontana, Lucio 42, 157–60
Fontana, Zoe 163, *165*
Fontana sisters (Sorelle Fontana) 12, 32–4, *36*, 41, 49, 57, 163–5, *165*, 228, 262
Fonticoli, Nazareno 196, 197
football 213
footwear *48*, 69, 70, 97–8, *97, 98, 101*, 130, *132*, 162–3, *232, 236*
Ford, Harrison 167
Ford, Tom 29, 160, 193, *193*, 202
Forlano, Sante *50*
Fornasetti, Piero 116, 253
Forquet, Federico *16*, 22, 41
Fortis, Marco 202
Fortnum & Mason 116, 253
Fortuny, Mariano 173
Frankau, Ethel 12
Frare, Therese *143*
Fuga, Diego 161
fur 121–5
Fur 247
Furnari, Alice *154*, 157
furniture design 54, 231

G

Gabbana, Stefano 65, 193, 238
Gabriellasport 37, 49, 139
Galeotti, Sergio 65, 199, 231
Galeries Lafayette, Paris 257
Galitzine, Irene 32, 37, *38*, 41, *83*, 125, 262
Galleria Borghese, Rome 50
Gallery of Modern Art, Rome 125
Galliano, Alessandro 212
Gallotti, Baroness Clarette 34–7
Galuzzi, Stefano 161
Gandini 256
Gardella, Ignazio 54, 231
Gardner, Ava 32–4, *36*, 116, 165, *165*, 193
Gastaldi of Genoa 42
Gastel, Giovanni 148, 247
Gatti, Juan 172
Gattinoni, Fernanda 34, *35*, 78, *251*, 253
Gaultier, Jean Paul 165–7, *168*, 169
Genny 242
Genoa 69, 76
Genoni, Rosa 48
Gere, Richard 162, *165*, 167, *167*, 168, 185, 231
Gernreich, Rudi 42
GFT *see* Gruppo Finanziario Tessile
Gherardi, Piero 34
Giacomoni, Silvia 58
Giamaica bar, Milan 66
Giammetti, Giancarlo 65, 142
Gianfelici, Simonetta 153
Giannini, Frida 27, 44, *132*
Giardina, Daniela 244
Gigli, Romeo 68, 91, *93*, 112, 153, *153, 176*, 177, *204*, 263
Gill, Leslie 139
Giorgini, Giovanni Battista 8, 12–15, 16, 32, 34, 37, 41, 50, 54, 60, 62, 76, 98, 165, 194, 253
Giorgini, Matilde *12*
Girombelli 240
Giulietta degli spiriti (*Juliet of the Spirits*) 42
Giussani, Daniela 247
Giusti, Tiziano 65
globalization of fashion 236–8
Gnoli, Sofia 12, 15
Goddard, Paulette *16*
Gonzaga, Vincenzo 62
Graham, Theo *35*, 41
Gramigna, Enrico 245
Grand Tour 57, 58, 139
Grazia 34, *228*
The Great Gatsby *168*, 169
Gregorius XIII, Pope 196
Grenville, Georgina 160
Grès, Madame 34
Grésy, Marchesa Olga di 34, 51, 57
Griffiths, D.W. 163
Grimaldi, Maria *14*, 16
'Group of Five' 246
Gruppo Finanziario Tessile (GFT) 62–5, *62*, 66, 70, 136, 180, 228, 231, 246
Gruppo Furpile 111–12
Gualino, Riccardo 226
Gucci 27, 44, 94, 180, 219
 advertising *159*
 bags 97, *97, 132, 189*
 catwalk shows *238*
 computer design 99
 furs 125
 leather products 28, 130
 menswear 202, 215
 ownership 28, 29, 70, 238
 Tom Ford and 29, 160, 193, *193*
Gucci, Guccio 130
Guercino 55
Guglielmi, Marchesa Marita 32
Gulf War, First (1990–91) 92, 93
Gundle, Stephen 57, 168
Gustafson, Mats 153, *153*

H

H&M 93
Hachette 245, 247
Hammond, Fay 15
Hanks, Tom 167
Hanonia, Stella 12
Harari, Guido 70
Harper's Bazaar 37, 41, 50, 51, 136, 139, 172
Harper's Bazaar Italia *83*, 139
Harrison, Martin 176
Harvey Nichols 253
Hearst 245
Hepburn, Audrey 7, *16, 19*, 32, 34, *35*, 41, 165
Hettemarks 246
Himmel, Paul *252*
Hitman 199
Hollywood 16, 116, 123, 160, 162–9, 177, 185, 228, 236, 253
Hollywood on the Tiber 32–4
Horowitz, Vladimir 42
Horyn, Cathy 263
Hurley, Elizabeth 168

I

Ida, Signora 98
Ideacomo 86
Incontri, Andrea 71
India 94, 97, 101, 236, 238
Inditex 108
Industria Serica Asnago 85
industrial design 66–8
industrial districts 97, 231–3, *231*, 238
Industrial Revolution 104–6
Institution for Foreign Commerce (ICE) 246
International Tailoring Congresses 196
International Textile Machine Exhibition, Milan (1983) 118
internet 247
Interstoff 86
Io Donna 247
Italian Fur Trade Association (AIP) 122, 125
Italian Institute of Foreign Trade 198
'Italian Look' 62, 94, 183, 200, 211
Italian State Tourist Office *251*, 253
Italian Trade Centre, London 198
Italianstyle 83
'Italy at Work' exhibition, New York (1950) 12
Italy Today trade fair, New York (1952) 123

J

Japan 70, 71, 92, 101
Jones, Tanya 161
Judge Dredd 169

K

Kalman, Tibor *143*
Kamali, Norma 247
Kandinsky, Wassily 118
Kawamura, Yunika 71
Kelly, Grace 7, 44, 165
Kennedy, Jacqueline 16, 41, 228
Kenzo 116
Kering 28, 29, 219, 238
Khanh, Emmanuelle 240
Kidron, Beeban 168
Kika 168
Kiton 219, 222
Klein, Calvin 247
Knapp, Peter 176
Knight, Nick 263
knitwear 69, 70, 99, 115–18, 198–9, 211
Koenig, Pierre 160
Koolhaas, Rem 160
Kravitz, Lenny 132
Krizia 44, 62, 65, *117*, 118, 142, 228, 234, *235*, 242, 244, 247
Kuster, Emilia Rosselli 245

L

La Scala, Milan 42, 191
labelling 28
Laborioli, José 177
Lacoste 214
Lagerfeld, Karl 125, 173, 240, 247
Lamartine, Alphonse de 58
Lambert, Vern 172
Lamonaca, Marianne 97
Lampedusa, Giuseppe Tomasi di 193
Lancashire 231
Lancetti, Pino 22, 66, 68, *68*, 88, 97
Lane, Nathan 169
Lanerie Agnona *86*
Lanerossi 70, *80*, 83
Lanificio Giuseppe Gatti *86*, 88
Lanificio Luigi Ricceri 99, *110*, 111
Lanificio Piacenza *88*
Lanificio Puma 136
Lario 92, 93
Latis, Vito 54
Lauder, Estée 37
Laug, André 34
Lauren, Ralph 169, 191, 247
Le Marche 97
leather 28, 62, 129–32, 226, 232
Lehndorff, Vera *153*
Lei (magazine) 177, 245, 263
Lei (television channel) 247
Leiweb.it 247
Leonardi Bouyeure, Elvira 42–4
Levi, Sergio 246
Levine, Sherrie 142
Life magazine 143
Lindbergh, Peter *204*, 265
Linea Italiana *80, 83*, 85, *85, 86, 126*, 172, *186*, 245, 246, *247*
linen 70, 76
Linificio e Canapificio Nazionale 226
Litex (Lanificio Italiano Export) 256–9, *257*
Liverpool 213
Lollobrigida, Gina 123
Lombardy 69, 76, 232
London 24, 28, 34, 219, 226, 231
Lopez, Antonio *150*, 153
Loren, Sofia 123, 165
Loro Piana 28, 29, *85*, 90, 92, 211, 238
Los Angeles 160
Los Angeles Times 15
Lotto 69
Louis Vuitton Moët Hennessy (LVMH) 28
Lubiam di Mantua 69
Lucchini, Flavio 139, 148, 177, 200, 245, 247
Luce, Clare Boothe 37
Luchford, Glen *159*, 160
Luhrmann, Baz 169
Lurex *83, 85*
LVMH 29, 238
Lyle & Scott 214
Lynch, David 160
Lyons 22, 86

M

McCartney, Stella 219
McDean, Craig 265
McEnroe, John 208, 211, 212, *212*, 213, 215
McGraw, Ali 66
Machiavelli, Niccolò 211
McKinley, Barry *186*
McQueen, Alexander 219
'Made in Italy' 28, 58, 62–5, 68, 71, 94–101, 110, 111, 112, 136, 142, 182, 208, 236–8, 245
Madonna 160, 167, 265
magazines 48, 161, 172, 183, 244–7, 262–5
 see also individual magazines
Magistretti, Vico 66
Maglificio Miles 118
Magnani, Anna 34, 139
Magnin (I.) department store, San Francisco 12, 15
Maier, Tomas 27, 101
Malkovich, John *204*

Malo 118
man-made fibres 70, 83, 92, 226, 257
Manaigo, Carlotta 161
Mandelli, Mariuccia 65, *65*, 118, 234, *235*, 242
Mankiewicz, Joseph 32
Mannes, Marya 50, 51, 94, 250–53
Mantero 78, 86, 91, 93, 97
manufacturing
industrial districts 97, 231–3, *231*, 238
small firms 233
women in 233–6
Manzino, Gianna 57
Manzù, Giacomo 42
Maramotti, Achille 70, 89, 240, 246
marca d'oro ('mark of gold') 12
Marche 69, 70, 130, 232
Marcus, Stanley 257
Margiela, Martin 118
Marie Claire 247
Marini & Cecconi 89
Marioboselli 88
'mark of guarantee' 8–12, *12*
Marni 99, 125, 202
Marpessa 142
Marshall, Alfred 231
Marshall, Garry 168
Marshall and Snelgrove 97
Marshall Field's, Chicago 37
Marshall Plan 12, 62, 76, 180
Martin, Catherine 169
Martin, Richard 202
Martinelli, Elsa 153
Marucelli, Germana 12, 41, 42, *53*, 57, *80*
Marzotto 69, 70, 83, 89, 226, 246
Massei 68, 242
Mastrelli Foundation 196
Mastroianni, Marcello *180*
Mateldi, Brunetta *56*, 136, *240*, 245
Matteis, Maria de 34
Matti 122, 123, 125
Mattioli, Franco 65
Mattotti, Lorenzo 148
Mauri, Rossella 244
Mauss, Marcel 60
Max 247
Max Mara *68*, 70, *88*, 89, 246
Maxwell, Elsa 37, 44
Mayhoola for Investments 238
mechanization 98–9, 106, 118
Medici, Eleonora de' 62
Meisel, Steven 160, 263, 265
Memphis 66
Mendini, Alessandro 66, 147
Men's Wear 196, 198, *198*
menswear 179–93, 194–204
celebrity endorsement 212
elegance 222–3
fashion shows 194
knitwear 198–9, 211
mod style 211
playboys and courtiers 192–3
sportswear 208–15
street style 180–2
success in Britain 208–15
tailoring 194–7, 218–19, 222
textiles 191–2, 219
Menta 90
Mert & Marcus 160
Metropolitan Museum of Art, New York 70
Metternich, Klemens von 58
Miami Vice 168
Middle East 93, 238
MIFUR 125
Milan 16, 180, 183, 191, 226
advertising 142–7
ateliers 41–4
as fashion capital 22, 62, 65–8, 228–31, 262–3
fashion shows 62, 228, 242
Fiera Campionaria di Milano 242
as Italy's fashion capital 240, 242, 244
knitwear 69
magazines 245–7
menswear 222
ready-to-wear 60, 62–6, 199, 228

supply chains 70
trade fairs 86
Milano Collezioni 240, 242
MilanoVendeModa 228
Milo, Sandra 42
Ministry of Foreign Commerce 85, 246
Miroglio 70
Mirsa 34, *53*
Miss Deanna, 116–18
Missoni 62, 66, 94, 98–9, *98*, 118, *119*, 142, *150*, 153, 198–9, *198*, 228, 240, 242, 244
Missoni, Ottavio 65, 99, 118, 142, 199, 234–6, *236*, 247
Missoni, Rosita 65, 99, 118, 142, 199, 234–6, *236*, 247
Misterfox 62
MITAM textile fair, Milan 86, *257*
Miu Miu *137*, *156*, 160, 236
Miyake, Issey 242
mod style 211
models 68, 231
Modenese, Beppe *58*, 62, 242, 244
Modit 62, 228
Modo 66
mods 213, 215
Molinaro, Eduardo 169
Molyneux 34
Mondadori 245, 246
Monreale, Sicily 55
Monroe, Marilyn 163
Montana, Claude 247
Montanari, Vera 247
Montebelluna 69, 232
Monti 242
Morace, Francesco 263
Moravia, Alberto 139
Morgan, Henry & Co 12, *12*
Moroni, Giovanni Battista *182*
Moschino, Franco 22, 65, 70, 125, 148, *150*, 247
Mugler, Thierry 247
Mulas, Ugo *156*, 157–60, 245
Mulassano, Adriana 62, 65
Mulligan, Carey *168*, 169
Multifiber Arrangement (MFA) 92
multinational corporations 236–8
Mussolini, Benito 37

N
Nagel, Charles 12
Naples 58, 218, 222, 223, 232
National Chamber of Italian Fashion 65
Nattier 87, 255–9, *257*, *258*
Natura 136
Navone, Paola 66
Neapolitan jackets 196, 212, 218–19, *219*, 223
Negri, Pola 163
Neiman Marcus 44, 116, 257
Nelson, Karin 193
Nesi, Edoardo 27
New Look 32, 165
New York 28, 37, 49
New York Herald Tribune 34
The New York Times 16, 122, 197, 263
Newhouse, Jonathan 265
newspapers 247
Newton, Helmut 153
Nichols, Mike 168–9
Nicholson, Jack 167
Nixon, John 12
Noberasco, Vita 12, 41
nobility 34–41
Nordiska Kompaniet, Stockholm 54
Novak, Kim 165
Novarra 212
Novità 50, *53*, 54, 245, 263–5
nylon 70

O
L'Obelisco, Rome 57, 139
Occhiomagico 147
Oggi 183
On the Beach 165
Ordway, Doug *191*

Originala 257
Orlon® Du Pont *76*
Oroton 90
Ortoleva, Peppino 48
Otto, Karla 244
outsourcing 68, 99, 236–8

P
Pakistan 92
Palampur, Maharani of 34
Palazzi, Carlo 182, *184*
Palazzo Grassi, Venice 32
Palazzo Pitti, Florence 15, 41, 78, 98, 234
palazzo pyjamas *38*, 41, *83*
Palazzo Vecchio, Florence 62
Palio di Siena 55
Pallavicini, Federico 136
Palmer, Laura 160
Palmer, Marta 49
Pancaldi 198
Panorama 172
Pantanella, Emanuele 95, 97
Paoletti 89
Papini 240
Paris 12, 15, 22, 28, 46, 51, 60, 70, 212, 226
Paris Group 238
Paris Peace Treaties (1947) 8
Parkinson, Norman *52*
Pasolini, Pier Paolo 139, 182, 183–4, *186*
Passalacqua, Rossana 161
Pater, Walter 58
Patou, Jean 37, 49
Paulicelli, Eugenia 8
Pavesi, Manuela *154*, 157
Peck, Gregory *19*
Pelicce Moda 123
Pellegrini 123
Pende, Stella 142
Penn, Arthur 167
Pepall, Rosalind 12
Per Lui 263
Peretti, Elsa 153
Peron, Eva 34
Peru 101
Petteni, Mirella 153
Pezzi, Maria 42
Philadelphia 167
photography 136–61
Piacenza 211
Piaggi, Anna 65, 66, 68, 70, 71, 148, 171–3, *173*
Piattelli, Bruno 182, *184*
Picasso, Pablo 118
Piccioli, Pier Paolo 27, 44
Pickford, Mary 163
Piedmont 69, 211, 232
Pietracupa, Marco 161
Piggott, Marcus *137*, *156*, 160, *189*
Pinault, François-Henri 219, 238
Pinto, Aldo 65
Pistilli, Ornella Kyra 180
Pitti Immagine 204
Pitti Uomo fair 204
Pius XII, Pope 196–7
Pivano, Fernanda 42
Plank, Reinhard 71
playboys 192–3
Polhemus, Ted 202
polo shirts 211
Ponti, Giò 42, 54, 66, 231
Pontoglio 91
Poole, Henry *219*
Pop art 148
Porter, Cole 37
Portmeirion 198
Portoghesi, Paolo 147
postmodernism 147–8
Potvin, John 62
Power, Tyrone 32, 163–5
PPR 28, 29, 219
Prada *24*, 68, 94, *154*, *159*, 238
advertising *159*, 160
furs 125
globalization 70
leather products 28
Made In ... line 101, *101*
menswear 202, 204, *204*, *207*, 215

stores 238
takeovers 238
textiles 92
women's role in 236
Prada, Luisa 236
Prada, Mario 44, 236
Prada, Miuccia 27, 28, 44, 68, 70, *70*, 101, 160, 169, 173, 193, 202, 204, 236
Prato 27, 70, 76, 99–101, 104–12, *108*, 232
Prato distretto verde 111
Prato Expo 106
Prato Textile Museum 112, *113*
Première Vision, Paris 92, 108
prêt-à-porter 62, 70, 148, 262
Pretty Woman 167, *167*, 168
Pria 83
Pringle 214
Proclemer, Anna 42
public relations (PR) 242–4
Pucci, Emilio 32, 46, 49, 54, 57, 60, 66, *226*, 262
advertising 238
American sales 50
beachwear 16, *24*, *53*
fur 125
mechanization 98
ownership of 28, 238
printed textiles 55, *76*, 78, *78*, 99
sportswear 51
Puccini, Giacomo 42
Puglisi, Fausto *8*, 27

Q
Qatar 238
Qiana *60*
Quaranta, Fabio 193
Quarry, Miranda *189*

R
Rabanne, Paco 85
Rabinowitz, Paula 55
Radkai, Karen 51
Radziwill, Lee 16, *20*
Le Ragazze di piazza di Spagna (*Three Girls from Rome*) 32
Ralli, Giovanna 42
Ratti 85–6, 90, 91, 93, 97
Ratti, Antonio 85
Ratti, Donatella 92
Ravasi 78, *78*
Ravasi, Giuseppe 78–83
Ravenna 176
rayon 226
RCS Mediagroup 245, 247
ready-to-wear
boutique fashion 16, 51–5, 60
fast fashion 71
hand tailoring 218
industrial production of 231
Milan and 60, 62–6, 228
rise in status 57
textiles 88–9, 108
recycling textiles 106, 111
Redford, Robert 169
Reggiani 91
Reinhardt, Mike *83*
Relijn, Dusan *265*
Renaissance 48, 55, 58, 60, 62, 97, 104
reportage, photography 139–42
La Repubblica 247
resort wear 200–202
Retail Brand Alliance 238
Reutern, Baroness 253
reversible fabrics 86–7
Reynaud, Alain 44
Rhodiatoce 83
Ricchetti, Marco 71
Ricci, Stefania 265
Ricci, Valentino *223*
Ridenti, Lucio 136
Riera, Daniel *204*
Rimmer, Dave 214–15
Rinaldi, Paolo 142
La Rinascente 57, 66, 184
Risorgimento 32, 58, 196

Rivella 122, 123
Rivetti 83, *83*, 226, 228
Rivetti, Carlo 62
Rivetti, Silvio 62
Rizzi, Gigi 193
Rizzoli 245, 247
Roberta 44
Roberts, Julia *167*, 168
Robilant, Andrea di 37
Robilant, Countess Gabriella di 37, 49
Robinson, Mrs J.K. 37
Robinson, Smokey 162
Robiola, Elsa 42, 55, 139
Rodier 257
Rogers, Ginger 44
Roitfeld, Carine 160
Rolando, Pier Luigi 208, 212
Roman Holiday 19
Rome 7, *11*, 16, 22, 32, 58, 65, 139, 183, 223, 228
Romeo + Juliet 169
Rosasco 78
Rosenwald, Laurie *66*
Rose's Roses 71
Ross, Andrew 94, 101
Rossellini, Isabella 153
Rossellini, Roberto 34, 139
Rossetti, Dante Gabriel 176
Rossi 226
Rossi, Sergio 28, 238
Rossi, Vera 51
Rossimoda 132
Rosso, Renzo 160
Rota Angelini Desalles, Countess Barbara 37
Roux, Caroline 101
Roversi, Paolo 27, 175–7, *176*, 263, 265
Rubartelli, Franco 153
Rubinacci 218, 219, *219*
Rubinacci, Gennaro 218, 222
Rubinacci, Luca 219, 223, *223*
Rubinacci, Mariano 196
Ruffo 132
Ruggeri 246
Ruhs, Kris 263
Rusconi 245
Russia 94, 125, 238

S
Saint Laurent, Yves 41, 86, 111, 185, 200, 215, 219, 247, 262, 265
St Petersburg 122
Saks Fifth Avenue 98, 116
Sala Bianca, Florence 15, *16*, 22, 28, 34, 41, 44, 240
Sampson, Kevin 213–14
Sander, Jil 92
Sanlorenzo 242
Santa Croce sull'Arno 232
Sarfatti, Gino 54
Sarti, Roberto 24
Sartimaglie 88
Sartori, Franco 245, 265
The Sartorialist 223
Sassi 256
Satam 256
Savelli, Angelo 139
Savile Row jackets 218–19, *219*
Savini, Gaetano 197, 200
Savinio, Alberto 42, 139
Saviolo, Stefania 68
Savorelli di Lauriano, Franco 244
Savoy Kingdom 58
Scarpellini, Emanuela 12
Schiano, Marina 153
Schiaparelli, Elsa 37, 42, 70, 165–7, 234
Schlemmer, Oskar 173
Schmeidler, Emanuela 244
Schön, Mila 16–22, *20*, 44, *56*, *76*, *86*, 87, 125, *156*, 157–60
Schrader, Paul 162, 185
Schuberth, Emilio 12, 32, 57, *80*, 182, 262
Schuman, Scott *180*, 223
Scianna, Ferdinando 142, *143*
Scotland 101
Scott, Ken 66, 142, *154*, 160,

228, 242
Seattle 122
Second World War 46, 76, 106, 122
Segre Reinach, Simona 98, 99, 101
Sellers, Peter *189*
Seoul 263
Settembrini, Luigi 51–4, 193
La Settimana Incom 172
Shanghai 263
Sheffield 231
Sheppard, Eugenia 34
shoes *48*, 69, 70, 97–8, *97*, *98*, *101*, 130, *132*, 162–3, *232*, *236*
Showgirls 168
Sicily 142, *182*, 183, 193
La signora senza camelie (The Lady Without Camellias) 42
silk 22, 70, 76, 78, 85–6, 90, 92, 97, 194
Simonetta *33*, *35*, 36, 37, *41*, *47*, 49, *52*, 54, 55–7, *86*, *251*, 253
Simonetta e Fabiani 37
Simpson's of Piccadilly, London 57, 253
Sinatra, Frank 193
Sioli, Giovanna 244
sizing system 70
Snia Viscosa 226, 257
Snipes, Wesley 168
Snow, Carmel 22, 29, 50–51
Solbiati 90
Soldano 125
Solofra 130
Soprani, Luciano 240, 247
Sottsass, Ettore 66, 231
South Africa 238
Sozzani, Carla 247, 262–5, *263*
Sozzani, Franca 172, 177, 247, 262, 263–5, *263*
Spalletti, Countess 253
SportMax *68*
sportswear 49, 208–15, 236
Spotorno, Andrea 161, *161*
Stallone, Sylvester 169
Starrabba di Giardinelli, Francesco 37
Steele, Valerie 94, 183
Steinem, Gloria 16
Stendhal 58
Stephen, John 211
Stern 153
stilisti 22–4, 60, 62, 65, 71, 88
Stockholm 54
Stoppi, Isa 153, 160
Stoppini, Luca 172
stores 238
Strada, Nanni 66
straw products 232
street style 179–82
Strong, Sir Roy 192
Studio Alchimia 66
Style.com 204
Style.it 247
The Sun Also Rises 165
supermodels 68
supply chains 68–9
Swanson, Gloria 116, 163
Swayze, Patrick 168
synthetic fibres 70, 83, 92, 226, 257

T

Tacchini 212–13, *212*, 214, *214*, 215
Tacchini, Sergio 208–11, 212
Tailor and Cutter 196
tailoring 194–7, 218–19, 222
Tamburi, Orfeo 139
Tarlazzi, Angelo 41
Taroni 78, *83*, 91, 93
Taylor, Elizabeth 7, 32, 41, 123, *123*, 165, 228
The Ten Commandments 163
tennis 208–11, 212–13
Terital (Terylene) 83
Terragni *83*
Terragni, Giuseppe 231
I Tessili Nuovi 51, 139, *139*
Testa, Michelangelo 48–9, 50
Testa, Salvo 68
Testino, Mario *159*, 160

textiles 22, 76–93, 226
 Chinese 109–10
 diffusion ranges 91–2
 dyes 86–7
 'fantasy textiles' 106
 history 69–70
 knitwear 115–18
 man-made fibres 70, 83, 92, 226, 257
 Marshall Plan 62
 mechanization 70
 menswear 191–2, 219
 Nattier 255–9, *257*, *258*
 Prato 104–12
 printed 78–83, 85–6, 88
 and ready-to-wear 88–9, 108
 recycling 106, 111
 Renaissance 104
 reversible fabrics 86–7
 supply chains 68–9
 weaving 87
 see also knitwear; silk, wool *etc*
Thailand 97
The Thief of Bagdad 163
Third Italy 97, 180
Thomas, Dana 99
Tiburzi, Alberta 153
Time magazine 89, 185–91, *245*, 253
TJSS 90
To Wong Foo, Thanks for Everything, Julie Newmar 168
Tod's 28, 70
Togno, Rita 125
Tokyo 28, 259, 263
Tortonese *12*
Toscani, Oliviero 139, *139*, 142, *143*, 148, *149*, 177, 202, *202*, 245, 247, *247*
Toscanini, Arturo 42
Toscanini, Wally 42
Toulouse-Lautrec, Henri de 57
Trell 62, 228
Treviso 116
Trissel, Julia 12, *12*
trompe-l'œil 44, 87
Troy, Hannah *12*
Trussardi *66*, 68, 112
Turin 16, 22, 69, 226
Turkey 92, 236
Turner, Lana 34, 116
Tuscany 69, 97, 99–101, 130, 232

U

Umbria 130
Ungaretti, Giuseppe 139
Ungaro 62, 199, *258*, 259
United States of America
 department stores 37
 films 16, 32–4, 162–9, 185, 228, 253
 and Florence fashion shows 12–15
 Italian exports to 109
 labelling regulations 28
 Marshall Plan 12, 62, 76, 180
 and Paris fashion 46
 and reconstruction of Italian fashion 16, 60
 sizing system 70
The Untouchables 162
L'Uomo Vogue 139, *176*, 177, 183, *191*, 200, *200*, 202, *202*, 245
US Department of Agriculture 125

V

Vaghe stelle dell'Orsa (Of These Thousand Pleasures) 157
Valditevere 78–83
Valentino 27, 44, 62, 65, *83*, 142, *144*, 153, *226*, *231*, 242, *243*, 244, 247
 knitwear 118
 outsourcing 99
 ownership 28, 70, 238
 ready-to-wear 231
 textiles 78, 97
Valentino, Rudolph 163
Valletta, Amber *159*, 160

Valli, Alida 34
Valli, Giambattista 125
Valsecchi, Dr Augusto 125
Vance-Straker, Marilyn 162
Vanity 148, 172
Vanna 12, 41, 253
Varese 69, 234
Veneto 69, 76, 89, 130, 180, 232
Veneziani, Jole 12, 41–2, *42*, 44, *48*, *50*, 54, 123, *126*, 253
Veneziani Sport 42, 132
Venice 32, 44, 76, 87, 97, 139
Venice Architecture Biennale (1980) 147
Ventura 34, 37, 42
Venturi, Clelia 57
Venturi, Gian Marco 247
Verga 78, *80*, 91, 93
Verhoeven, Paul 168
Versace, Donatella 192
Versace, Gianni 24, 70, 71, 142, *149*, 177, 240, 242, *243*, 247
 advertising 160
 film costumes 168–9
 knitwear 118
 leather *131*, 132
 menswear 191–2, *191*, 193, 200, 202, *202*, 213, 214, 215
 models 68, 231
 public relations 244
 ready-to-wear 24
 textiles 24, 90, 112, 191–2
Versace, Santo 192
Versace family *73*
Veruschka 66, 153, *153*, 193
Vezzoli, Francesco 153, *153*
Viaggio in Italia 34
Vicenza 232
Victoria and Albert Museum, London 172
Vidor, King 34
Vigevano 69
Vigo, Graziella *243*
Villa Giorgini, Florence *12*
Villa Torrigiani, Florence 50, 194
La Viola 242
Vionnet, Madeleine 28
Viscardi 122, 123
Visconti, Luchino 157, 192, 193
Visconti, Simonetta 12, 49, 50
Vitti, Barbara 242–4, *243*, 246
Vitti, Monica 41
Vitucci, Angelo *195*
Vogue (American) 12, 37, 42, 50, *52*, 55, 153, 177, 194, *196*, 200, 253, 257, *257*, 263
Vogue (British) 37, *48*, 94, 116, *119*, 177, *226*, 249–53, *251*, 252
Vogue Bambini 262, 263
Vogue Italia 60, *123*, 136, 142, 160, 172, *176*, 177, *198*, 199, 200, 245, 247, 262–5, *265*
Vogue News 169
Vogue Paris 76
Vogue Sposa 247
Vogue.it 247
Volonté, Paulo 66–8
Vreeland, Diana 41, 153, 172, 263

W

Walsh, Raoul 163
War and Peace 34, *35*
Warhol, Andy 90
Watt, Judith 122
Way Down East 163
weaving 87
Webb, Iain R. 202
Weber, Bruce 263, 265
West, Mae 165, 167, *167*
Westwood, Vivienne 112, 247
White, Nicola 51, 54–5, 60, 98
Williams, Robin 169
Williams-Ellis, Sir Clough 198
Wimbledon 208–11, 212
Windsor, Duchess of 37
The Witches of Eastwick 167
women
 magazines 245
 role of 233–6
Women's Wear Daily 16, 54–5, 62,

76, 86, 199
wool 22, 69, 70, 76, 83, 86–7, 89, 104–6, *105*, 111, 226
World Federation of Master Tailors 196
World Trade Organization 92, 110
Worth, Charles 62

Y

Yamamoto, Yohji 111
Yavel, Mike *88*
'years of lead' (*anni di piombo*) 22, 147

Z

Zanini 240
Zanuso, Marco 66
Zara 93, 108
Zecca 32
Zegna *see* Ermenegildo Zegna
Ziminsky, Gertrude 12, *12*
Zoffany, John 58
Zoran 92
Zuckerman, Ben 257
Zuffi, Pietro *53*, 57
Zumsteg, Gustav 85
Zunino, Antonella 244